Sheila Hicks

Sheila Hicks
50 Years

JOAN SIMON *and* **SUSAN C. FAXON**

With an essay by **WHITNEY CHADWICK**

ADDISON GALLERY OF AMERICAN ART
Phillips Academy, Andover, Massachusetts

YALE UNIVERSITY PRESS
New Haven and London

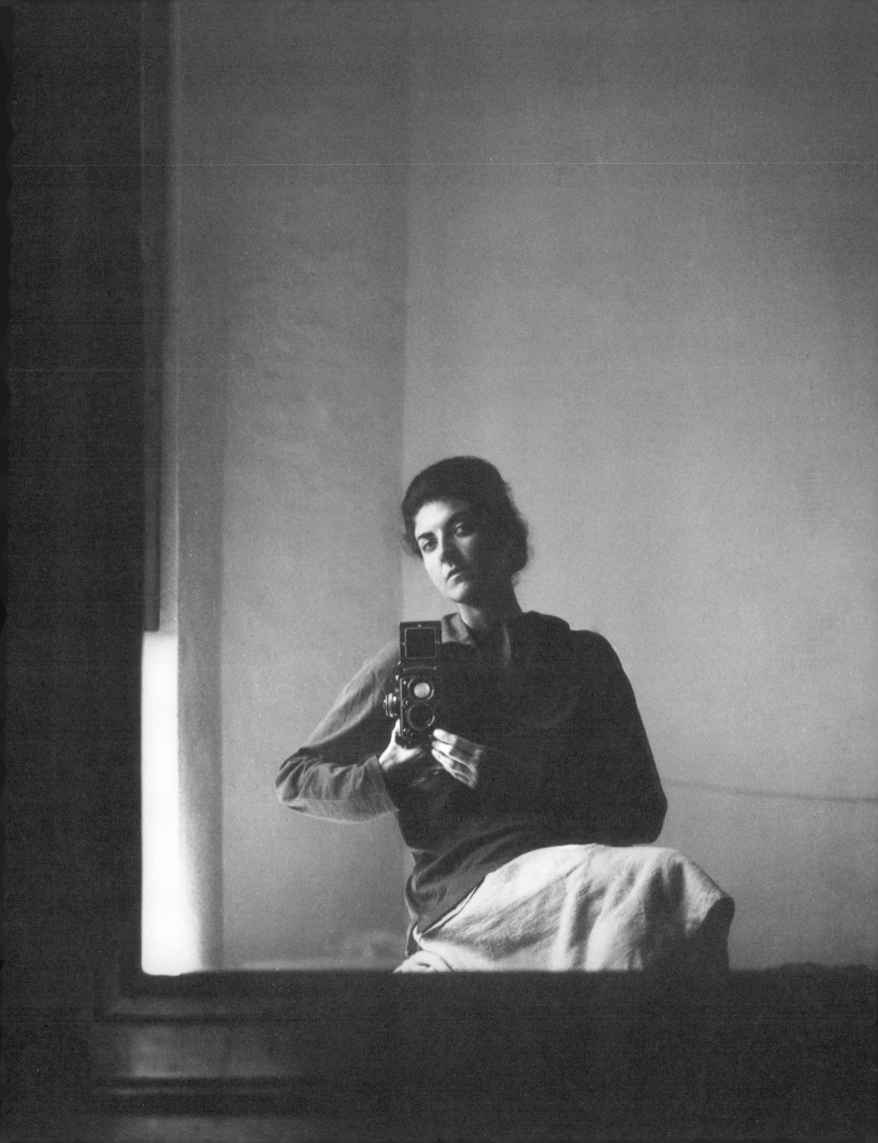

Foreword

When our respected colleague and friend Joan Simon arrived at the Addison Gallery of American Art to share images of Sheila Hicks's miniatures in 2004, the curatorial staff and I were mesmerized by what we saw. Page after page emerged from the neat storage box, one more jewel-like than the other, each one dazzling in the complexity of its fabrication and the vibrancy of its color. Here was painterly color, intricate interweaving, intriguing experimentation, artistic mastery, and a wonderful sense of élan.

The history of Sheila Hicks's life and work that Joan shared with us was equally compelling. Hicks's early training at Yale had been under the tutelage of Josef Albers, the Bauhaus artist with whom the Addison had forged a close and highly productive relationship from the museum's beginnings. The Addison was the first museum in the United States to show Albers's work, in 1935. Over the years our collection has been enriched with Albers's work in all media. This was an intriguing connection between the Addison's history and the splendid work that was unfolding before us.

Several ideas were floated that day. Certainly if one considered simply what Hicks calls her miniatures, there was an exciting exhibition in the making. Then too, the miniatures were only one part of what this Nebraska-born, Paris-based artist has made and accomplished in her career. We were eager to explore a larger, more comprehensive exhibition, one that would acknowledge Hicks's critical participation in the 1960s experimentations in sculpture and artmaking, her significant contributions to production fabric-making, her constant explorations of and experimentation with materials and methodologies, her fearless embrace of the challenges of national and international architectural commissions, the bravado of her monumental wrapped, tied, woven, and draped sculptures, and her reverence for and her openness to diverse cultural traditions and the ways that such influences could energize and transform her own work.

The prospect of exposing the students of Phillips Academy and the museum's many regional and national audiences to the work of an artist whose international career is one of great renown and extraordinary breadth was immediately enticing and one we embraced.

Getting to the point of presentation and publication has been a lengthy process, as the project's initial schedule was postponed to accommodate the Addison's addition of a new wing and transformation of our beloved 1931 building. Whatever delay this has meant is outweighed by our delight that Sheila Hicks's retrospective will be the inaugural loan exhibition in our newly refurbished spaces. Through all this shifting, Sheila Hicks has remained steadfastly engaged in our joint effort. She has earned our most sincere admiration not only for the brilliance of her work but also for her keen commitment and energetic support of this exciting project, the fruits of which are evident in this publication and its accompanying exhibition.

Guest curator Joan Simon has been uncompromising in her efforts on behalf of this endeavor. Her brilliant insight, her determined perseverance, and her perceptive vision have been inspiring. Her essay underscores the significance of Hicks's remarkable and groundbreaking career. The Addison is grateful to Whitney Chadwick for her scholarly essay situating Hicks's accomplishments within the context of contemporary art. She effectively exposes the limitations of traditional divisions between craft and art, art and design, studio work and public commissions, to allow a full appreciation of Hicks's contributions. Co-curator Susan C. Faxon's introduction beautifully explores the interconnections between Hicks's Yale training and the educational mission of Phillips Academy in the teaching and appreciation of art.

Textiles are complicated and light-sensitive objects, and we are most grateful to the institutions and individuals listed elsewhere

who have been willing to share the works in their collections for the duration of this exhibition. The enthusiasm they have shared with us for the artist's work and their eagerness to participate in making the range and depth of her oeuvre more fully known is appreciated.

We are enthusiastic about the tour of this exhibition and special mention goes to our institutional collaborators and their staff: at the Institute of Contemporary Art, University of Pennsylvania, Philadelphia: Claudia Gould, Director; Ingrid Schaffner, Senior Curator; Jenelle Porter, Curator; and at the Mint Museum of Craft + Design, Charlotte, Annie Carlano, Director. Their shared belief in the importance of this exhibition will bring the work of Sheila Hicks to many new publics.

Among the many individuals who have assisted in the assembly of this project, we first offer thanks to the skillful and gracious studio assistants at the Sheila Hicks "Pas de Mule" Atelier, Eva Zeibekis, Taeko Baba, Anna Seo, and Noémie Quéla. They have earned both our admiration and our gratitude for their prodigious efforts over the last four years in compiling information, photographs, and objects in the artist's impressive archives. Hicks's atelier is a model of efficiency and cooperation, and we salute those additional assistants who have worked with her in recent years: Marinette Christian, Lucille Douillez, Encarnacion Mateu, Kim Sang Lan, Ileana Altmann, Cynthia Young, M. K. Wong, Claudia Bedrick, and Jocelyn Valenzuela Lopez.

On Hicks's behalf, we gratefully acknowledge those who have supported, encouraged, and celebrated the artist over many years. Special thanks are offered to Karel Ankerman; Junichi Arai; Emilio Ambasz; Hilary Baum; Micheline Beauchemin; Melvin Bedrick; Ann and Arnie Berlin; Judith Bettelheim; Chantal and Henri Bismuth; Irma Boom; Ernest Boyer; Michel Boyer; Barbara Chase-Riboud; the late Mildred Constantine; Liesbeth Crommelin; Arthur Danto; Claude de Muzac; Michel de Potestad; Sophie de Rosier; Michelle de Souza; the late Cora de Vries; Michael Francis; Martine Franck; Jacqueline Friedman; Daniel Graffin; Fanny Guillon-Laffaille; Mary Jane Jacob; Lynn and Robert Johnston; Philip Johnston; Nobuko Kajitani; Tadao Kamei; Alan Kennedy; Naomi Kobyashi; Craig Konyk; Josef Koudelka; Estelle and Harold Kuhn; Suzy Langlois; Sergio Larrain; Jack Lenor Larsen; Matthieu Lévi-Strauss; Monique Lévi-Strauss; Willy Lipton; Chiaki Maki; Itaka and Enrico Martignoni; Lanny and Sharon Martin; Turner McGehee; Edward Merrin; Craig Miller; Elena Phipps; Marc Riboud; Michael Rubenstein; Marielle Segal; Hiroyuki Shindo; Nina Stritzler-Levine; Chiyoko Tanaka; Judith Tannenbaum; Maria Tolukas; Jun Tomita; Julius Vermeulen; Massimo, Lella, and Luca Vignelli; Robert Weil; Barbara Westman; Juame Xifra; Pia Zañartu; Rebecca and Cristobal Zañartu; and Valentina and Andreas Zimmer.

We have also benefited from the generous assistance of the following individuals, collectors, scholars, institutions, and staff members who have offered their time and knowledge: Akron Art Museum, Ellie Ward; The Josef and Anni Albers Foundation, Oliver Barker; Alexander and Bonin, Kathryn Gile; American Craft Council, David Shuford; Archives of American Art, Justin Brancato, Liza Kirwin, John Smith, and Joy Weiner; Archives Municipales, Sèverine Soubsol; the Art Institute of Chicago, Jackie Maman, Aimee L. Marshall, Ryan Paveza, and Bart H. Ryckbosch; Art Resource Inc., Jennifer Belt, Humberto DeLuigi, Kerry Gaertner, and Ryan Jensen; Artist Rights Society, Cristin O'Keefe Aptowicz; Bard Graduate Center for Studies in the Decorative Arts, Design, and Culture, Alexis Mucha, Susan Weber Soros, Nina Stritzler-Levine, and Ian Sullivan; Elaine Benson Gallery, Kimberly Goff; Bibliothèque Kandinsky, Béatrice Sarno; Boijmans Museum, Rotterdam, Sjarel Ex; Anya Bondell; Brown Grotta, Rhonda Brown, and Tom Grotta; Yvonne Brunhammer; Camden Arts Centre, Anne-Marie Watson; Carnegie Museum of Art, Elizabeth Tufts Brown; Centre Pompidou, Valerie Guillaume; The Cleveland Museum of Art, Louise Mackie, Elizabeth Saluk, and Deirdre L. Vodanoff; Cincinnati Art Museum, Rebecca A. Hosta; Contemporary Art Center of Virginia, Heather Hakimzadeh; Cooper-Hewitt, National Design Museum, Caroline Baumann, Greg Herringshaw, Chul R. Kim, Steve Langehough, Cara McCarty, Matilda McQuaid, and Kimberly Randall; Craft Alliance, Stefanie Kirkland; Davis & Langdale Company, Roy Davis, Elizabeth Kroenlein, Cecily Langdale, and Michelle Lea Tift; Esto, Christine Cordazzo, Amanda Jinks, and Erica Stoller; Fondation Toms Pauli, Anic Zanzi; Fondazione La Triennale di Milano, Claudia Di Martino; Fondazione Lucio Fontana, Silvia Ardemagni; Fundación Gego, Marcela Elgueda; Gavlak Projects, Sarah Gavlak and Dana Funaro; Gladstone Gallery, Eric Nylund.

We are also grateful to Cristina Grajales Inc., Cristina Grajales, Lindsay Johnson, and Elizabeth Murphy; Guggenheim Museum, Kim Bush; Ann Hamilton; Harvard Art Museum, Christopher Wm. Linnane; Hauser & Wirth Zurich, Sylvia Bandi; High Museum of Art, Nicole Johnson; Hunter Museum of American Art, Elizabeth Le; Indianapolis Museum of Art, Sherry Peglow; Institute for Advanced Study, Christine Ferrara and Michael Gehret; Katonah Museum of Art, Nancy Wallach; Ruth Kaufmann; Kimsooja Studio, Graham McNamara, Amanda Parmer, and Allie Rex; Knoll Textiles, Kathryn Gray; Krannert Art Museum, Jenifer Dapper, and Kathleen Jones; Le musée Jean Lurçat et de la tapisserie contemporaine d'Angers, Françoise de Loisy; Les arts décoratifs, Véronique Belloir, Rachel Brishoual, and Caroline Pinon; Los Angeles County Museum of Art, Diana Folsom, Delfin Magpantay, Renee Montgomery, and Bobbye Tigerman; Memorial Art Gallery of the University of Rochester, Lu Harper; Memorial Union—Iowa State University, Kathy Svec; Magdalena Abakanowicz Studio, Magda Grabowska; Metropolitan Museum of Art, Jane Adlin, Geanna Barlaam, Jared Goss, and Linda Seckelson; Milwaukee Art Museum, Heather L. Winter; Minneapolis Institute of Arts, Dawn Fahlstrom and Patricia Martinson; Musée

départemental de la tapisserie, Michèle Giffault; Musées d'Angers, Laurence Ritouet and Dominique Sauvegrain; Musée des Augustins, Christelle Molinié; Musée des beaux-arts de Montréal, Danielle Blanchette and Marie-Claude Saiaa; Museum Bellerive, Kristin Haefele; Museum für Gestaltung Zürich, Kunstgewerbesammlung, Sonja Gutknecht; Museum of Art, Rhode Island School of Design, Tara Emsley and Kate Irvin; Museum of Arts and Design, David Revere McFadden and Laura Stern; Museum of Decorative Arts, Prague, Helena Koenigsmarková; Museum of Fine Arts, Boston, Jennifer Marsh; The Museum of Modern Art, New York, Sheelagh Bevan, Paul Galloway, and Thomas D. Grischkowsky; Museum of Nebraska Art, Jean Jacobson; National Gallery of Art, Washington, Peter Hustis and Barbara C. G. Wood; Nelson-Atkins Museum of Art, Holly Wright; North Dakota Museum of Art, Greg Vettel; Oakland Museum of California, Lisa Silberstein; Oliver Wendell Holmes Library, Phillips Academy, Susan Alovisetti and Tim Sprattler; Park Avenue Armory, Nina Gray; Passage de Retz, Jacqueline Klugman Friedman; Robert S. Peabody Museum of Archaeology, Phillips Academy, Malinda Blustain, Bonnie Sousa, and Marla Taylor; Philadelphia Museum of Art, Elisabeth Agro, Dilys Blum, Stephanie Pereira Feaster, Holly Frisbee, Timothy Rub, and Sara Reiter; Philadelphia Redevelopment Authority, Julia Guerrero; Portland Art Museum, Oregon, Debra Royer; Proventus, Daniel Sachs; Racine Art Museum, Dave Zaleski.

In addition, the following have been generous with their assistance: The Renwick Gallery of The Smithsonian American Art Museum, Nicholas Bell, Carol Rossi, and Shannon Schuler; Rochester Institute of Technology, Becky Simmons; Saint Louis Art Museum, Lauri Kramer, Natalie C. Musser, Ella Rothgangel, Janeen Turk, and Patricia Woods; San Francisco Museum of Modern Art, Barbara Rominski and Layna White; Cynthia Schira; Stephanie Schumann; SD26, Tony and Marissa May; Seattle Art Museum, Sarah M. Berman; Madalyn Shaw; Smithsonian American Art Museum, Riche Sorensen; Smithsonian Institution Archives, Tad Bennicoff; SOFA, Erinn M. Cox; Somerhill Gallery, Joe Rowand; Soprintendenza alla Galleria nazionale d'arte modernae contemporanea, Claudia Palma; Springfield Art Museums, Julia Courtney; Sprüth Magers, Friederike Schuler; Lotus Stack; Stedelijk Museum, Marjan Boot, Leontine Coelewij, Geurt Imanse, Margreeth Soeting, Monique Splinter, Eva Vonk, and Hetty Wessels; Christa Mayer Thurman; Toledo Museum, Michael Ryan; Um leckopr myslové museum v Praze, Konstantina Hlava ková and Lucie Zadražilová; University of Iowa Museum of Art; Vancouver Art Gallery, Cheryl Siegel; Vignelli Associates, Beatriz Cifuentes; Wadsworth Atheneum Museum of Art, Ann Brandwein, Adria Patterson, and Stephen Persing; Whitney Museum of American Art, Monica Shenkerman; and Yale University Art Gallery, Jock Reynolds.

At the Addison special acknowledgment is due to the many members of our talented staff. The registrarial team of Denise Johnson and James Sousa has handled all detailed requirements for loans, shipping, and travel. The Addison's preparators, Leslie Maloney, Brian Coleman, and Jason Roy, have once again coupled their expert handling and protection of works of art with sensitive design skills to ensure the elegance of this exhibition. Research Associate Susan J. Montgomery brought her meticulous skills to the exhibition history and bibliography. Jaime DeSimone, the Charles H. Sawyer Curatorial Fellow, compiled lists, checked information, explored tenuous links, unearthed missing information, and gathered photographic materials. Her efforts have kept the many balls in the air until they landed in perfect arrangement in the finished book and exhibition.

We are pleased to have had the considerable skills and knowledge of Purtill Family Business, Philadelphia, who designed this elegant volume; Joseph N. Newland, Q.E.D., who once again has gracefully content edited the text; and our colleagues at Yale University Press, Patricia Fidler, Jeffrey Schier, Sarah Henry, and Lindsay Toland, whose graciousness and enthusiasm have been much appreciated.

Finally, it is a pleasure to acknowledge the gracious donors who have encouraged our efforts to celebrate this exemplary artist. Mark Rudkin, Phillips Academy class of 1947, was an early champion and benefactor of this project. His generous support was augmented by grants from The Coby Foundation, Saundra B. Lane, The Poss Family Foundation, Nancy B. Tieken, Able Trust, Target Corporation, The Friends of Fiber Arts International, Dirk and Lee Born, and several anonymous donors. We offer our sincere gratitude to them all.

BRIAN T. ALLEN
The Mary Stripp & R. Crosby Kemper Director

Muñeca 1957

Wool; 11¾ × 4¾ in / 29.9 × 12 см

Collection of Itaka Martignoni

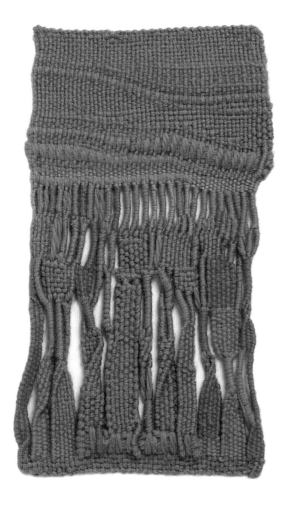

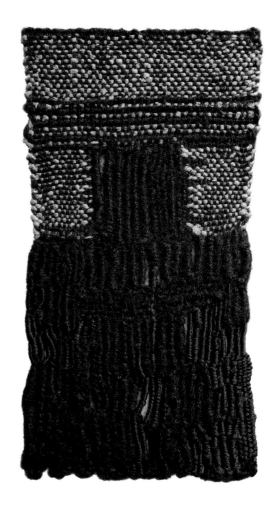

Zapallar 1957–58
Wool; 9¼ × 4¾ in / 23.5 × 12 cm
Private collection

Chonchi, Chiloe 1958
Alpaca, cotton; 9⅝ × 5¼ in / 24.5 × 13.3 cm
Private collection

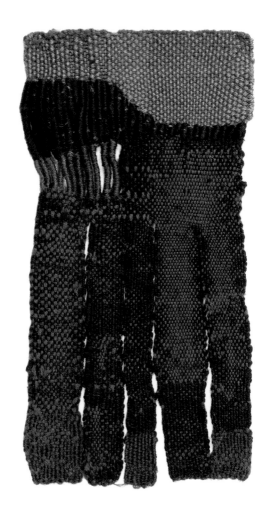

Rallo 1957

Wool; 9⁷⁄₁₆ × 5⅛ IN / 24 × 13 CM

Cooper-Hewitt, National Design Museum, Smithsonian Institution (Museum purchase from General Acquisitions Endowment Fund, 2006-13-2)

Blue Letter 1959

Hand-woven wool; 17¾ × 17 in / 45.1 × 43.2 cm

Museum of Modern Art, New York, N.Y., U.S.A. (Philip Johnson Fund, 338.1960)

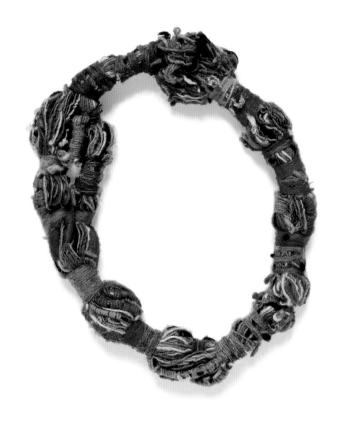

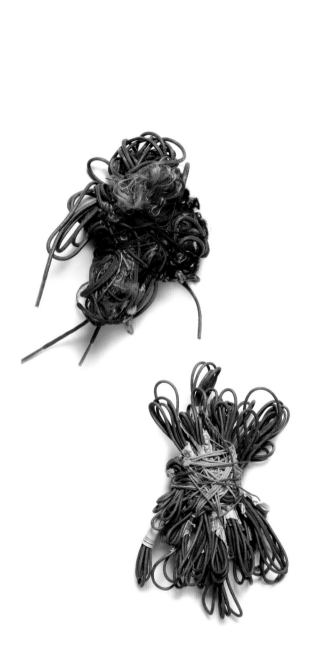

Clignancourt 1960
Leather shoelaces, silk, cotton; 3 X 3 IN / 7.6 X 7.6 CM
Collection of Suzy Langlois

Dimanche 1960
Leather shoelaces; 3½ X 5 IN / 8.9 X 12.7 CM
Private collection

Redondo 1960
Wool; 6 X 6 IN / 15.2 X 15.2 CM
Private collection

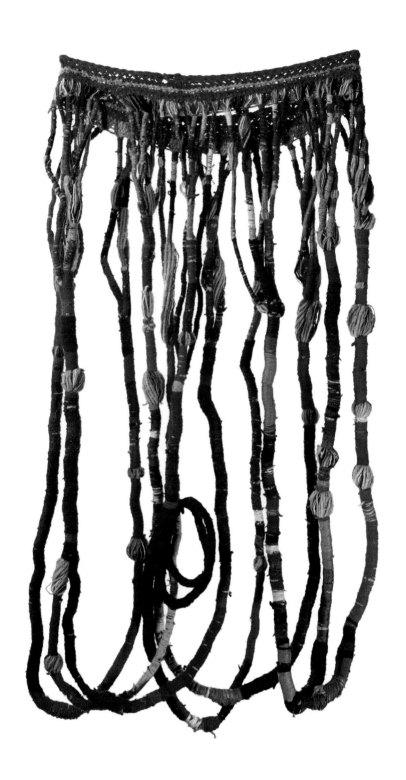

Falda 1960
Wool; 27½ × 15 in / 69.9 × 38.1 cm
Private collection

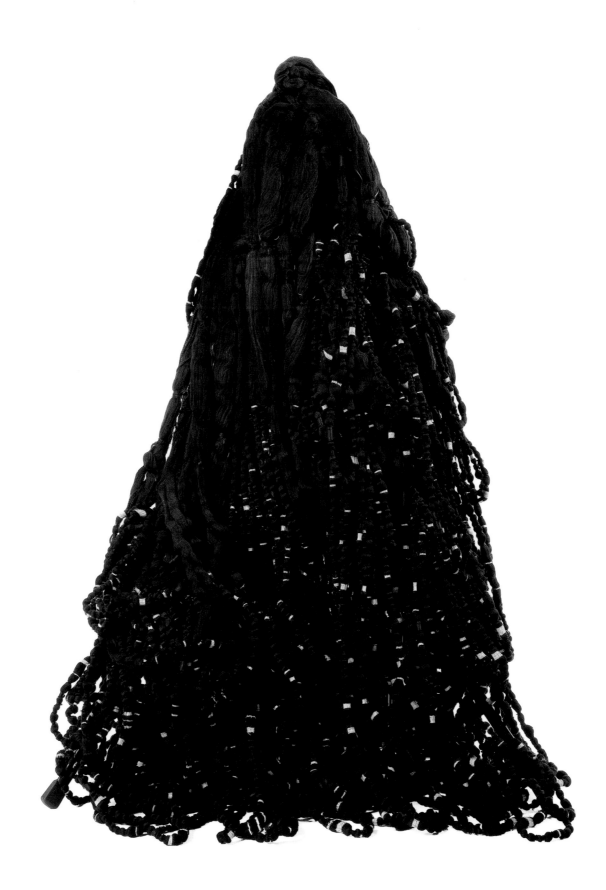

Tenancingo 1960
Cotton; dimensions variable, 35 7/16 × 17 11/16 × 17 11/16 IN / 90 × 45 × 45 CM as photographed

Private collection

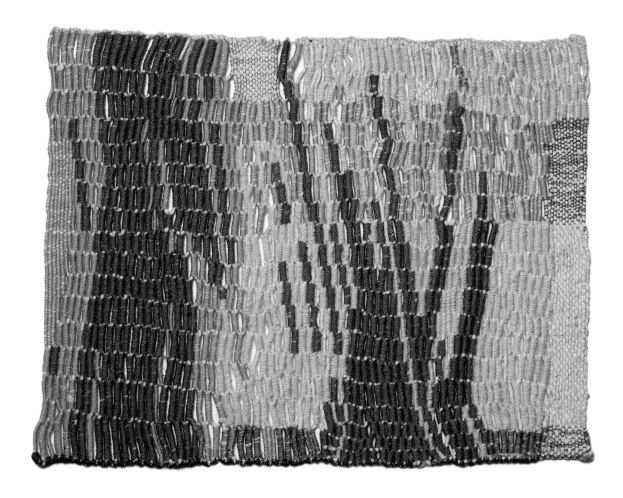

Willow 1960

Cotton, wool; 11⅝ × 15¹⁵⁄₁₆ IN / 29.5 × 40.5 CM

Cooper-Hewitt, National Design Museum, Smithsonian Institution (Gift of Anonymous Donor, 2006-14-5)

Escribiendo con Textura 1960

Unbleached cotton; $10^{7/16} \times 13$ IN / 26.5×33 CM

Cooper-Hewitt, National Design Museum, Smithsonian Institution (Gift of Anonymous Donor, 2006-14-4)

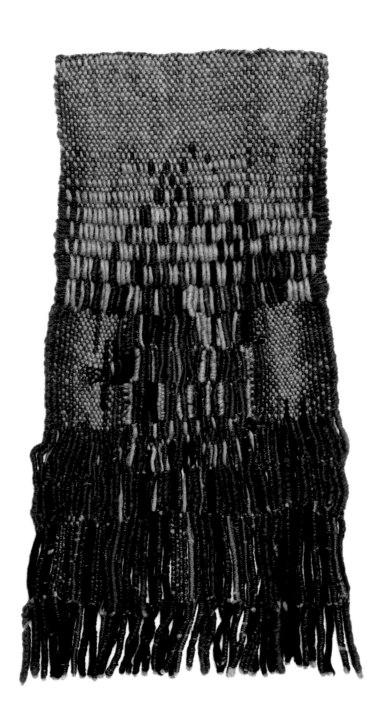

Plegaria 1960
Wool; 16¾ × 8¾ in / 42.6 × 22.2 cm
Collection of Cristobal Zañartu and Rebecca Clark

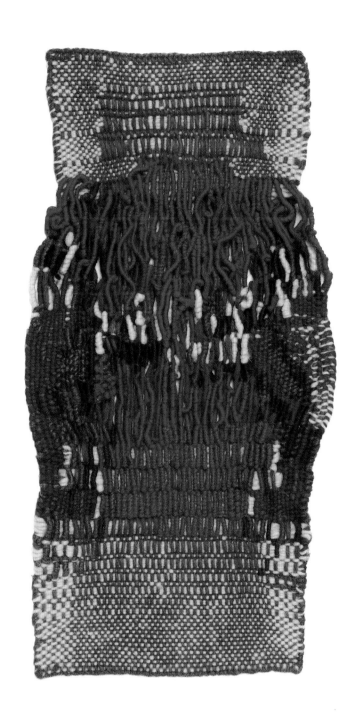

Solferino Tacubaya 1960

Wool; 15¾ × 8¼ in / 40 × 21 см

Collection of Cristobal Zañartu and Rebecca Clark

Quadrado Obscuro-Menos Obscuro c. 1961

Hand-spun wool diptych; 11 × 11⅜ in / 28 × 29 cm each panel

Private collection

White Letter 1962

Hand-spun wool; 46½ × 38 in / 118.1 × 96.5 cm

Museum of Modern Art, New York, N.Y., U.S.A. (Gift of Knoll Associates, 430.1964)

He 1965
Wool; 8⅞ × 5½ in / 22.5 × 14 cm
Collection of Jenelle Porter and Conny Purtill

She 1965
Wool; 9 × 5 in / 22.9 × 12.7 cm
Collection of Jenelle Porter and Conny Purtill

Squiggle c. 1963
Silk; 11 × 9½ ɪɴ / 27.9 × 24.1 ᴄᴍ
Private collection

Knoll Vidal, Black-Gray-Blue 1964–65

Wool; 20½ × 23 in / 52 × 58.4 cm

Private collection

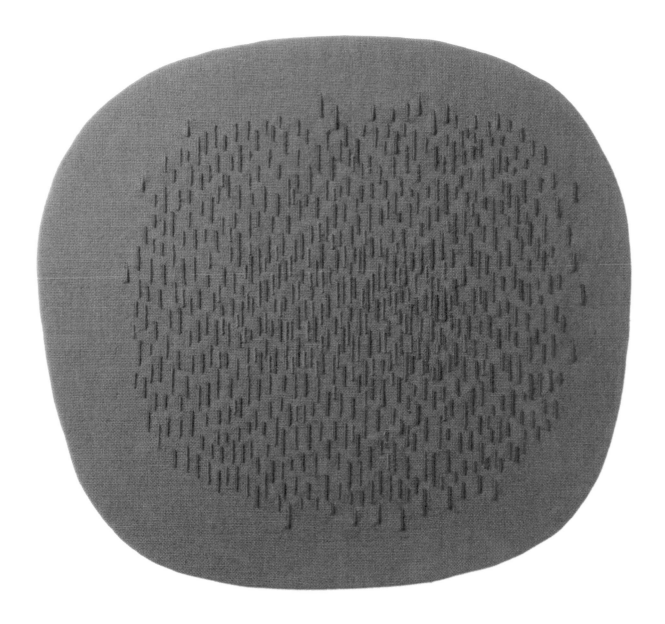

Knoll Vidal, Green-Mustard 1964–65

Wool; 20½ × 23 in / 52 × 58.4 cm

Private collection

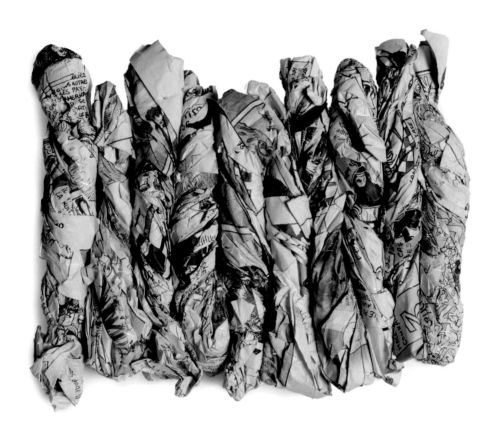

Serpent à Sonnette 1965
Printed paper; 8½ × 6¾ in / 21.6 × 17.2 cm
Private collection

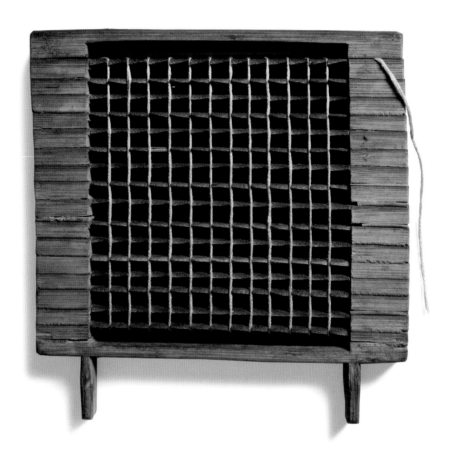

Gingembre 1965–67
Bamboo, cotton; 5½ × 5½ IN / 14 × 14 CM
Private collection

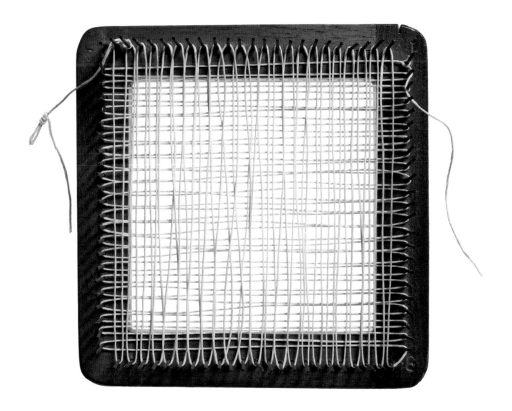

Les Clous 1965–67

Wood, linen, nails; 4¾ × 4¾ × 1¼ in / 12.1 × 12.1 × 3.2 cm

Private collection

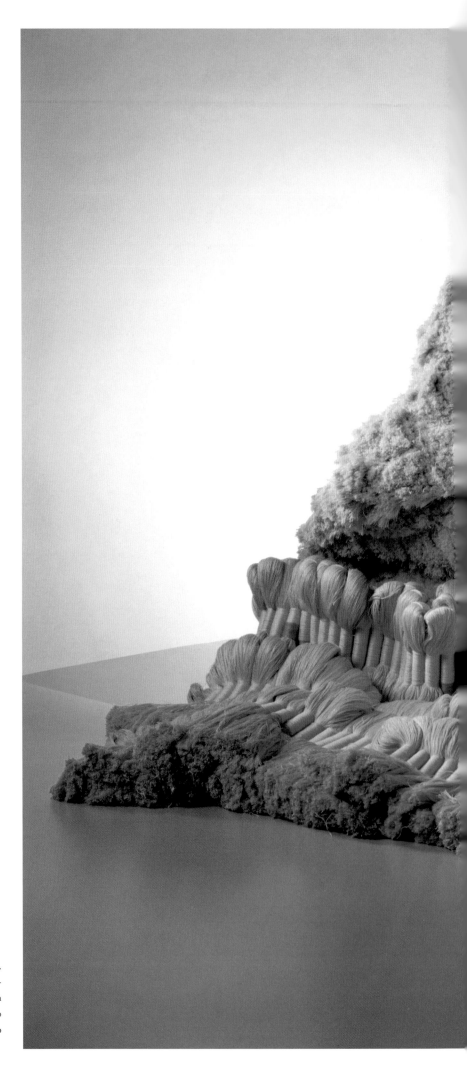

Banisteriopsis 1965–66

Linen, wool; dimensions variable, height 62½ IN / 158 CM as photographed

The Montreal Museum of Fine Arts (Liliane and David M. Stewart Collection)

Hicks's free-standing sculptures, reliant on gravity without the assistance of armatures, have components of compacted linen in the shape of ponytails, stacked in varying formations. These works have been exhibited in different shapes. "Banisteriopsis" refers to a hallucinatory plant extract from the upper Amazon. The Banisteriopsis series (see also pp. 60–61) is related to *The Evolving Tapestry: He/She* (pp. 58–59). Its components are also related to the bas-relief *Linen Lean-to* (p. 65) and *Lion's Lair* (pp. 66–67).

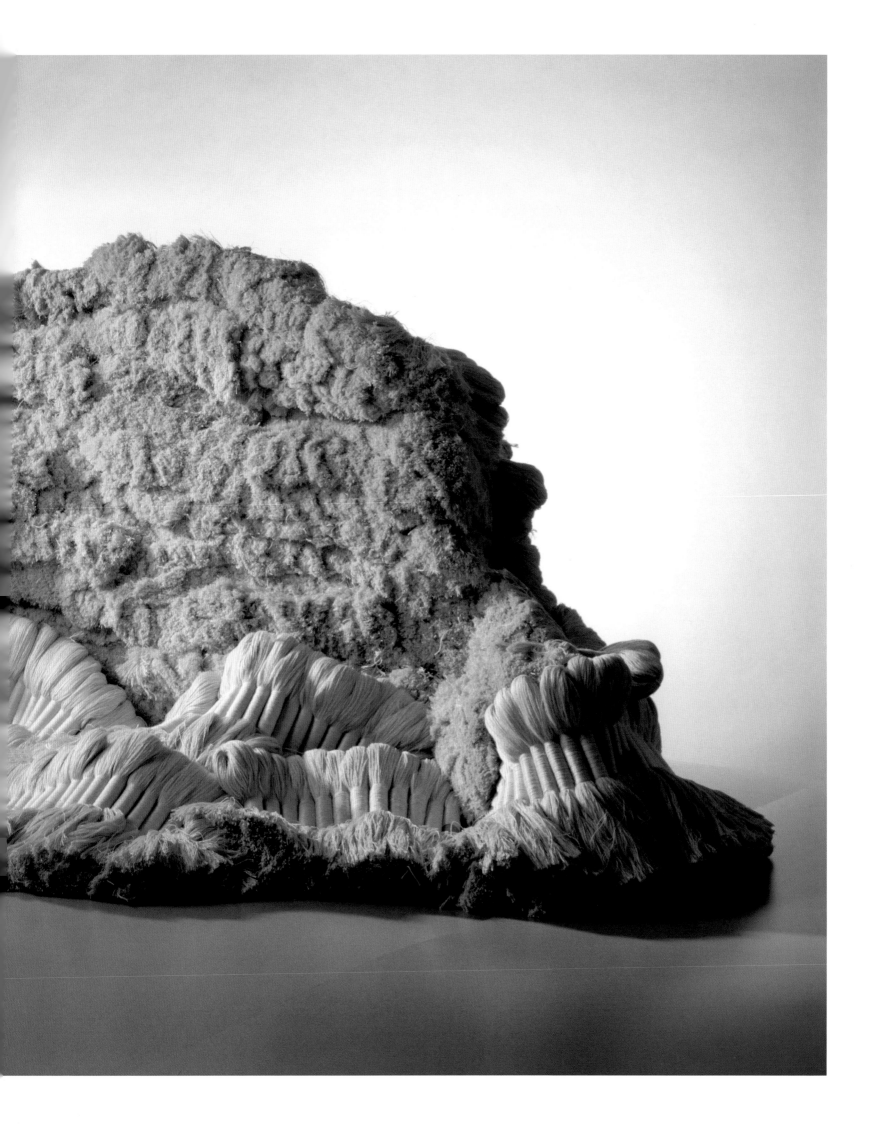

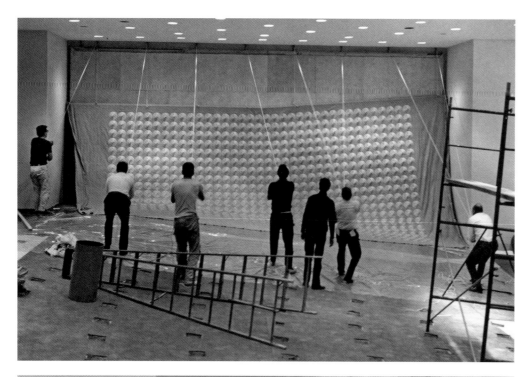

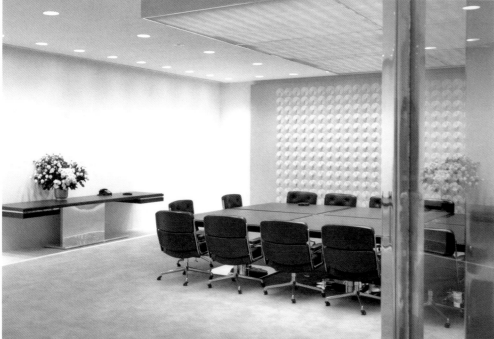

Commissions for the Ford Foundation Building, New York 1966–67

Two wall-sized tapestry bas-reliefs

Architect: Kevin Roche, John Dinkeloo and Associates; Interior Designer: Warren Platner

top
Auditorium Tapestry

32 × 13 �́ᴛ / 9.8 × 3.9 ᴍ

The bas-relief tapestry being hoisted into place in the auditorium. The architect Henri Tronquoy, who engineered the fabrication of the works in the artist's Paris studio, devised a way
by which the two panels of embroidered medallions (see sample at right) could be shipped from Paris to New York for the installation.

bottom
Conference Room Tapestry

40 × 10 ᴛ / 12.2 × 3.1 ᴍ

right
Maquette for Ford Foundation commissions 1966–67

Linen, silk, anodized aluminum; 30 × 24 ɪɴ / 76.2 × 61 ᴄᴍ

Private collection

The wall panels for the conference room and auditorium were each constructed in one piece, without seams, and the embroidered medallions were held in tension by anodized aluminum
discs. The maquette is on natural linen base cloth, with silk embroidery.

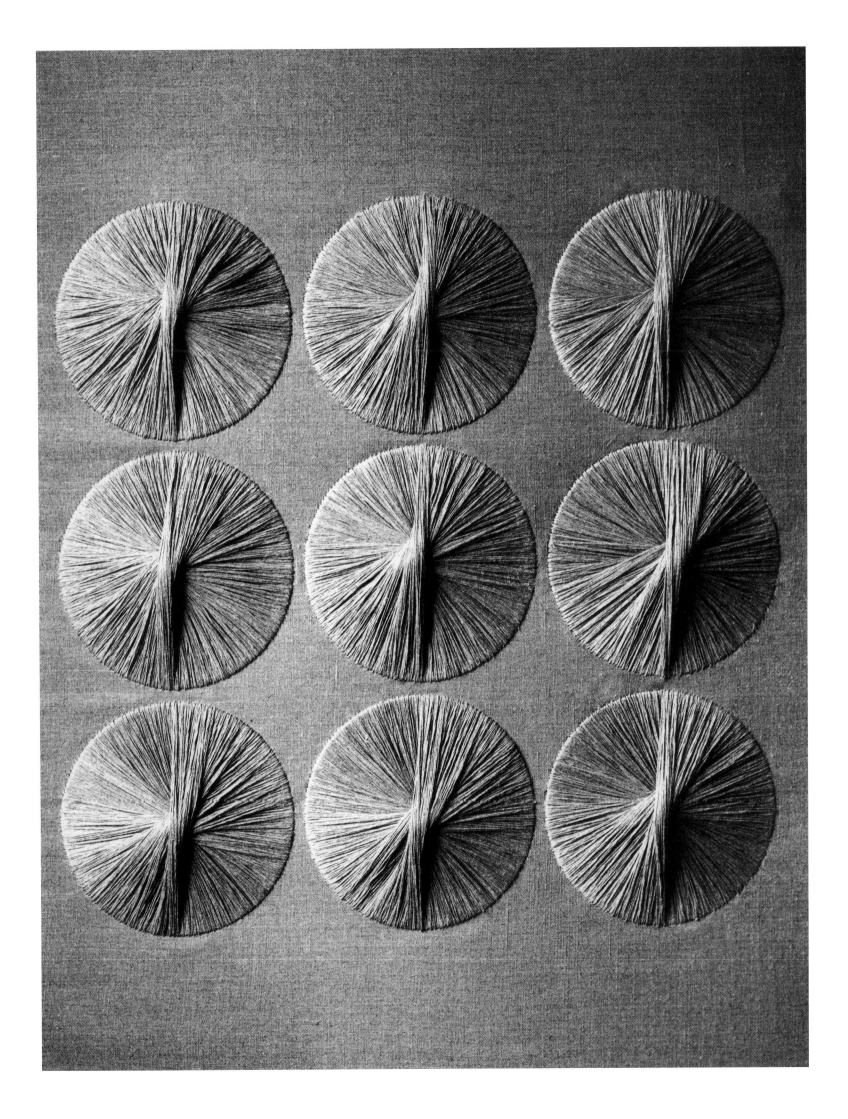

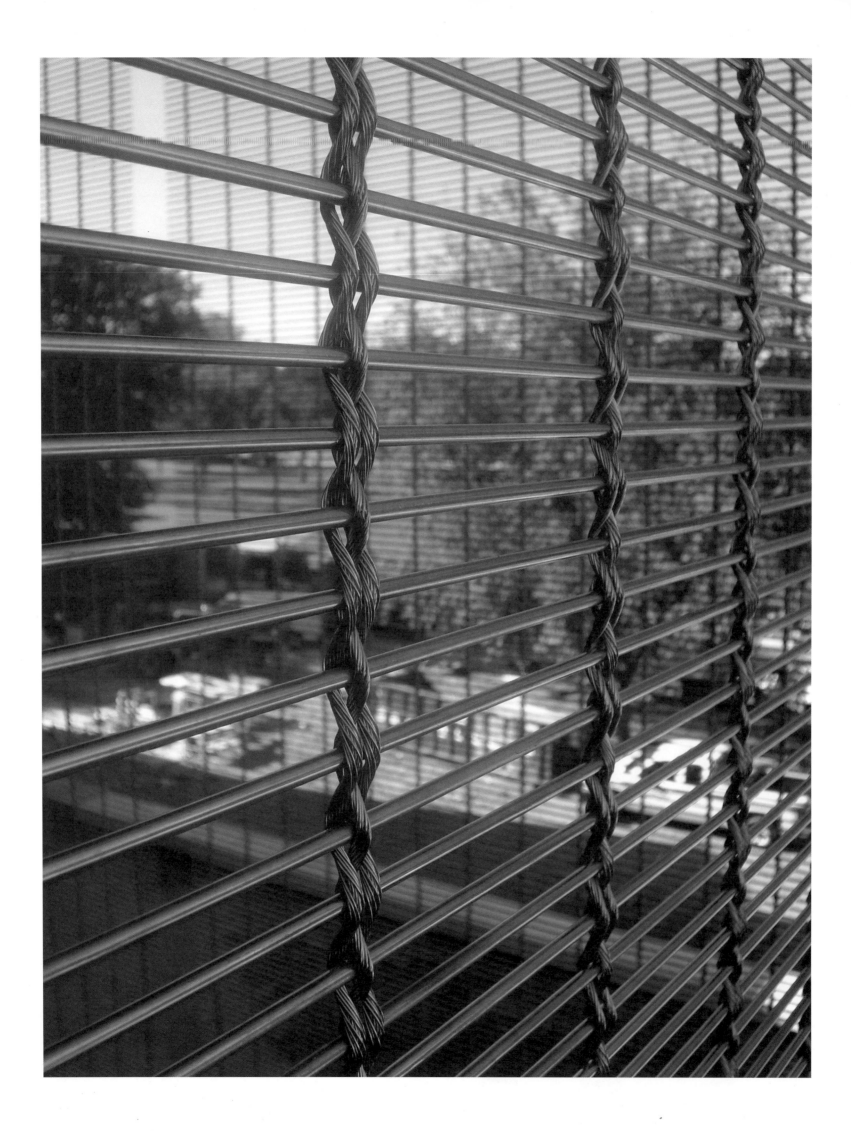

SUSAN C. FAXON

Twined Thoughts

twine |twīn|:

• *(noun)*: strong thread or string consisting of two or more strands of hemp, cotton, or nylon twisted together.

• *(verb [trans.])*: cause to wind or spiral round something: *she twined her arms around his neck.*

• *(verb [intrans.])*: (of a plant) grow so as to spiral around a support: *runner beans twined around canes.*

• *(verb [trans.])*: interlace: *a spray of jasmine was twined in her hair.*

In September 2009, the remarkable discovery of thirty-thousand-year-old wild flax fibers in the foothills of the Republic of Georgia filled stories in the popular press. These spun, twisted, and knotted fibers, found preserved in clay deposits in caves inhabited in the Upper Paleolithic period, suggest that prehistoric hunter-gatherers were fabricating fiber cords

for use in tool- and basket-making. A number of the fibers had been dyed with natural pigments, indicating that the makers might have been producing colorful textiles. This extraordinary discovery is the earliest evidence yet found of spinning, dying, and weaving.[1]

In the same month as the announcement about the discovery of these earliest known fibers, the Addison Gallery of American Art hung a transparent skin of mesh screens around the glass face of the new addition that was rising adjacent to its 1931 neoclassical museum building. Made of panels of woven stainless steel, the screening is a contemporary method of providing shading and preventing heat absorption, a system more frequently used on European buildings (fig. 1). While performing its shading function, this new material adds a shimmering, softening enclosure to the new structure. A perfectly twenty-first-century material used in a contemporary application, this

Fig. 1. Detail of stainless-steel mesh screen installed on newly constructed addition to Addison Gallery of American Art, 2009.

metal "fabric" is actually constructed by twining, heir to an ancient hand method of interlacing horizontal strands in and out around vertical strands that "often is considered the ancestor of true weaving."[2]

The discovery of prehistoric fibers and the installation of modern woven steel speak from opposite ends of the continuum that spans the enduring human activity of weaving. That these events occurred at the very moment of a meeting between the Addison's curatorial staff and Sheila Hicks to discuss an exhibition of work by this artist who has long been inspired by both historical textiles and new technologies tied these otherwise disparate events into meaningful connection.

The story of this exhibition and publication project is filled with similar confluences and intertwining coincidences.

Sheila Hicks's artistic awareness, amply described in this volume, began with her mother, who introduced her to sewing; her grandmother, who showed her embroidering and knitting; and her great aunt, who taught her painting. As a result, claims Hicks, she was always "thread conscious."[3] Encouraging grade-school and high-school art teachers recognized her promise; local museums and libraries whetted her appetite for the art of past civilizations. Upon graduation from high school, an independent streak and an urge to make art prompted her to enroll at Syracuse University, a pioneer in university fine-art programs.[4] After two years, fate in the determined hand of a close friend led Hicks to transfer to Yale University's art school.[5] In New Haven in the fall of 1954, she found herself immersed in a full program of art classes in the Department of Design—drawing,

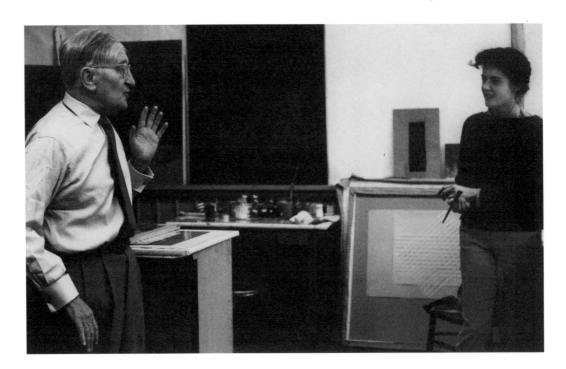

Fig. 2. Josef Albers and Sheila Hicks in Street Hall, Yale School of Art, 1958. The miniature weaving at far right, *Muñeca* (see p. 9), was woven by Hicks in Chile. The Color Crossed panel below is one of a series of studies the artist made based on color exercises assigned by professor Sewell Sillman for Albers's course "Interaction of Color." Today Hicks continues to work along these lines in her weaves and also in works on paper. Color Crossed studies are used in this book for chapter dividers and the endpapers.

painting, sculpture, the history of Eastern art, and Art 11, the "Interaction of Color," taught by the head of the school, Josef Albers (fig. 2).

Hicks began her undergraduate studies in fine arts at Yale the same year that another young student, who had attended Cooper Union in New York, enrolled at Yale for graduate studies in sculpture. After receiving his MFA degree in sculpture in 1957, Gerry Shertzer was destined to move to Andover to teach in the growing art program that was housed in the basement of the Addison Gallery.

Studio art at Andover originated under the Addison's first director, Charles H. Sawyer. Within the first years after the 1931 opening of the museum, with its gallery spaces filled with the very best of American art, Sawyer took money out of his own pocket to hire an art teacher. He believed that Phillips Academy students' appreciation of art would come as much from learning about its making in practical studio classes as it would through exposure to the historical art treasures of the museum. Seeing and doing in concert became the foundation of Andover's art teaching, and so it has remained for the ensuing eighty years.

Sawyer left the Addison nine years later to head the Worcester Art Museum. In a coincidence important to this story, his next move, in 1949, was to Yale University, where he was installed as the dean of the School of the Fine Arts, and director of the Division of the Arts. One of his earliest moves was to bring Josef Albers to New Haven to head the Department of Design. Thus, it was through the actions of Sawyer that Hicks and Shertzer came in contact with and studied under the inestimable Albers, absorbing the energetic and individual art instruction that Albers had honed at the Bauhaus in the 1920s and further refined at Black Mountain College in North Carolina from 1933 to 1949.

Charles Sawyer's inclusive attitude toward art and art history had been refined in the development of the formative art course he taught at Andover. In spite of Sawyer's own traditional academic training at Andover and Yale, his approach at both schools was to emphasize the integration of arts, architecture, and design. Sawyer's interest in this Bauhaus-inspired approach was exemplified by the four exhibitions that included Albers's work at the Addison between 1935 and 1941.[6] The commitment to Albers as an artist was also reinforced by the Addison's enthusiastic acquisitions of his work.

Fig. 3. Josef Albers, *Bent Black (A)*, 1940. Screenprinted oil on Masonite, 37 1/2 x 27 3/4 in. (95.3 x 70.5 cm). Addison Gallery of American Art, Phillips Academy, Andover, Massachusetts (Gift of Mrs. Frederick E. Donaldson, 1944.11)

The bonds between Yale's art program, the Addison Gallery, and Josef Albers were tight and remained so. Albers's importance to Andover was cemented in the late fifties by the development of a completely revamped curriculum for the school's art program. Bartlett Hayes, who was both the Addison's second director and the chair of the art department, put the program's new design in the hands of the Albers-trained Shertzer and art teacher Gordon (Diz) Bensley, a photographer and Yale graduate in philosophy who had been teaching students to make photograms in the museum's basement. Between the Addison's dedication to the work of Albers and the training of the school's young instructors, it is not surprising that the department devised a program based strongly on Bauhaus tenets.

By the time that the Phillips Academy art curriculum was being rewritten in 1958, Albers was coming to the end of his career at Yale. His influence on art education endured. As historian Frederick Horowitz has written, "From the 1950s to the 1990s one could walk into any class in basic design and trace many of the exercises directly to Albers."[7] Shertzer melded his own educational experiences into a comprehensive program that built on the basic Albers design. As he explained, "I drew heavily on the strong four-year program I had enjoyed at the High School of Music and Art [in Manhattan]; the concept of a multi-disciplined foundation course that was the hallmark of Cooper Union; and the carefully constructed sequence of drawing and color exercises that I learned at the feet of Jose[f] Albers." Although he was adapting a graduate-level curriculum for high-school students, Shertzer "was convinced my approach would work if I emphasized basic seeing and thinking, and believed the intellectual and technical growth would follow. I'm still convinced seeing is the talent, and the artwork a logical material representation of it."[8]

Fig. 4. Josef Albers (1888–1976), *Formulation: Articulation I, Folder 24*, 1972. Screenprint on heavy-weight wove paper, 15 x 40 in. (38.1 x 101.6 cm). Addison Gallery of American Art, Phillips Academy, Andover, Massachusetts (Gift of The Josef Albers Foundation, 1975.41.24)

Shertzer's statement resonates with Albers's conviction that it was the teacher's task to "awaken the student's intellects and nourish their growth."[9] How closely these ideas match Albers's commitment to developing in students the "capacity to perceive clearly and acutely. What do we actually see? How well do we see it?"[10] The role of teaching, Albers wrote, is to "make the result of teaching a feeling of growing."[11]

The commitment to the essential exercise of training the eyes to see and the mind to understand that was common to Albers and the Andover faculty was reinforced by the hiring in 1962 of Robert Lloyd, an architect and furniture designer who had studied at Harvard's Graduate School of Design and had worked with Albers's former colleague Molly Gregory at Black Mountain. A passionate advocate for the significance of the arts in general education, Lloyd asserted that of the two qualities to instill in students, creativity and imagination, it was the latter that was more important. Continuing, he championed the exercises of "'seeing,' both as a perceptual capacity and as it directly relates to and controls thinking, and 'making something happen' as a basic human discipline. Both of these are quintessentially intellectual, and perhaps more important than math."[12]

The connections and coincidences that link Sheila Hicks with Yale, Yale with Andover, and ultimately Hicks to Andover give resonance to the project on which the Addison and the artist embarked. Adding yet another serendipitous aspect to the mix is the presence of the Peabody Museum of Archaeology on the Andover campus. Like the Addison a highly unusual institution to be associated with a high school, the Peabody presides over a treasure trove of archaeological and ethnographic artifacts that serve as teaching tools for the academy. It was among these collections, on her September 2009

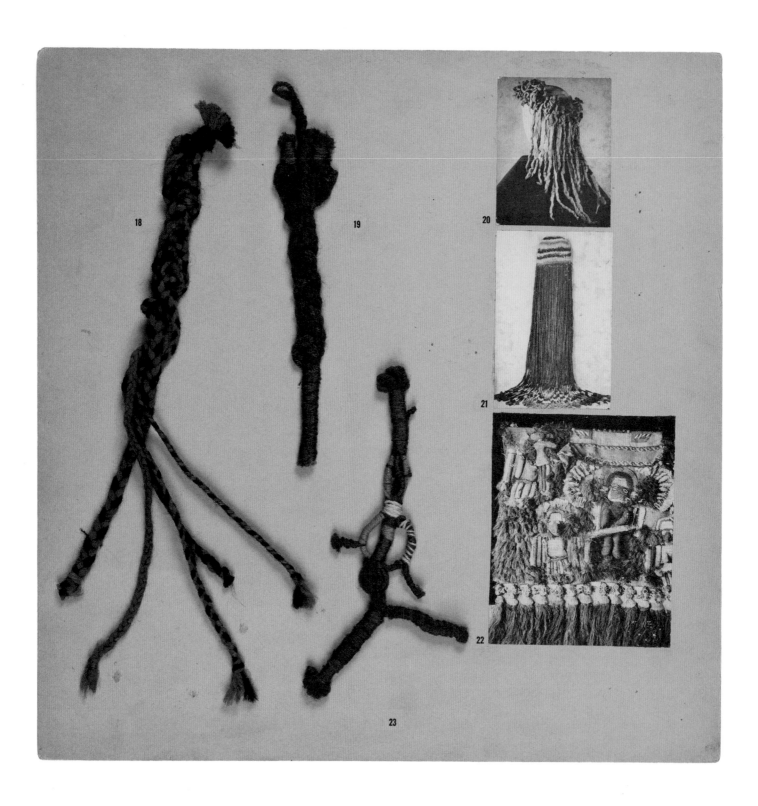

Sheet from Yale Thesis: "Andean Textile Art" 1957

Unbound book; 11½ × 8¼ in / 29.2 × 20.9 cm each

Private collection

Three plaited and wrapped wool studies by Hicks (at left), inspired by Pre-Columbian three-dimensional ceremonial head-gear
and a bas-relief with small, stuffed figures and fringes (illustrated at right).

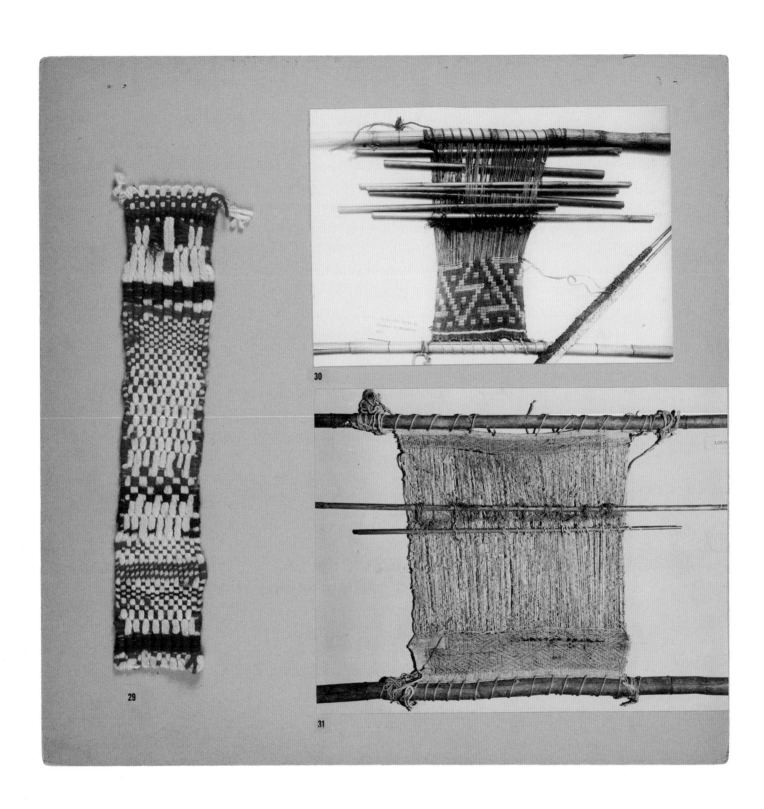

Sheet from Yale Thesis: "Andean Textile Art" 1957

Unbound book; 11½ × 8¼ in / 29.2 × 20.9 cm each

Private collection

Small band of exploratory weaving techniques in cotton (at left), made by Hicks on a frame after studying weavings made on
Andean backstrap looms, illustrations of which accompanied archeological excavation texts (at right).

visit, that Hicks and the Peabody curators unearthed stunning basketry and woven frag-
ments to include in the Addison's exhibition, as they speak directly to the artist's own
interests and studies (figs. 6, 7).

 In these moments in the storerooms of the Peabody, it was once again clear
that Hicks's own education is an amazing amalgamation of multiple influences and
explorations. While her academic experiences at Yale under Albers's guidance instilled
in her a solid core of Bauhaus-based art training, this is far from the whole story.
In fact, Hicks characterizes her introduction to Andean art in George Kubler's Yale
course on the art of Latin America as her most pivotal academic experience. It was her
thesis adviser, the debonair Junius Bird, an archaeologist in the Department of South
American Archaeology at the American Museum of Natural History in New York, who
opened her eyes to the study of ancient Peruvian textiles. Moreover, Hicks's continuing
engagement with architecture was sparked by the dynamic lectures of Yale's preeminent
architectural historian, Vincent Scully, as well as those of architect Louis Kahn, who
had just finished designing the Yale University Art Gallery next door to the university's
studio building.

 During Hicks's last two semesters at Yale, the artist Rico Lebrun was invited to
teach in the Department of Design. From Lebrun, whom Hicks described as a teacher
who "opened our eyes to humanity," she learned a more exuberant approach to paint-
ing and art-making, so different from the logic and clarity of the Albers methodology. As
she has explained, the inability of these two, characterized by Hicks as "strong artists
and convincing teachers," to get along forced her to think about the choices she would
need to make in pursuing her art. Deciding not to be a teacher, she explained, "I became
determined to make art and to live in an atmosphere in which
art can be produced."[13]

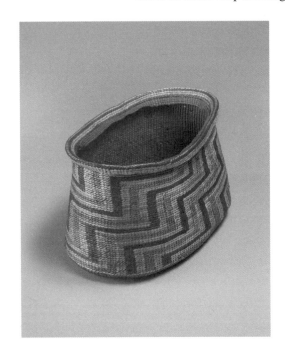

 After graduation, Hicks began working and travel-
ing, and following her own path. She put her intense interest
in architecture and photography to active use in Mexico to
document the work of Spanish architect Félix Candela. She
traveled to Paris on a fellowship to study painting, and there
she met Raoul d'Harcourt, whose book *Les textiles ancient du
Perou et leur techniques* had been the basis for her research.
Back in Mexico, she forged close relationships with German-
born sculptor Mathias Goeritz and Mexican architect Luis
Barragán, both of whom encouraged her to develop her weav-
ing. She formed bonds with indigenous artisans and worked
with them in reinterpreting and producing textiles based on
their local techniques and traditions. Her European connec-
tions expanded as she came in contact with the energetic

Fig. 6. Berry basket, 19th century, Tlingit/Alaska. Warps, stationary and simple twined wefts, basket selvage: cedar; wrapped wefts: plain and dyed
beargrass. Robert S. Peabody Museum of Archaeology, Phillips Academy, Andover, Massachusetts

international art circles of Paris, where she settled permanently in 1964. Throughout the more than forty years that Hicks has been in Paris, the renowned anthropologist Claude Lévi-Strauss and textile historian Monique Lévi-Strauss have been primary influences and close friends. In addition, both have been supporters of and have written about Hicks's work.

Throughout her life, Hicks's insatiable curiosity and her insistence on learning through direct examination of the tangible evidence of indigenous weaving practices in the countries of their origin have led her to five continents. In nearly every place she has traveled for her work, starting with Mexico, then continuing through stints in France, Morocco, India, Chile, Sweden, Israel, Saudi Arabia, Japan, and South Africa, she has developed close and productive relationships with designers, artisans, industrialists, architects, politicians, and cultural leaders. Who she is today is the confluence of a life-time of these commitments and experiences.

Her method of interacting with students, interns, and new learners is built on the premise that all can find themselves in the act of creating and that the materials of learning are pervasive in everyday life. The interns who have joined her studio in Paris over the years have been given remunerative assignments and have become full-fledged participants in the world of making art and honoring deadlines.

In 1984 Hicks was invited to teach a winter-term course at Middlebury College in Vermont. Much of the studying took place out of the classroom: she led the students down to the town bakery at 6 a.m., into the local courthouse for trial hearings, and into the newspaper's pressroom. The idea was to register the invisible, functional underpinnings and systems of everyday lives in their familiar environment. Seemingly commonplace materials, ordinary ideas were turned on their head—with the goal of forcing students to see anew or see through previously assumed ideas. In much the same way that Albers quizzed his own students—What is the primary characteristic of a sheet of paper? Can folding or crimping the flat sheet give the paper new properties, new form? Can we confound our preconceptions about the paperness of paper?—Hicks similarly asked the Middlebury students: Can we understand the craft of the baker, the obligations of the newspaperman? Can we recognize a world that exists beyond our own experiences? Can we learn by seeing? Can we learn by doing? As an attendee in her Middlebury class affirmed, it was "not a class at all, it's a way of life!"[14]

For Hicks, art *is* a way of life and life is a form of art. Several years ago, on a trip to Paris to plan this exhibition, two members of the Addison staff gathered one morning at

Fig. 7. Square-bottom basket, 20th century, Athabascan/Yukon Territory. Birchbark. Robert S. Peabody Museum of Archaeology, Phillips Academy, Andover, Massachusetts

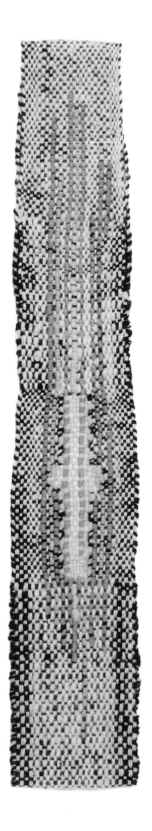

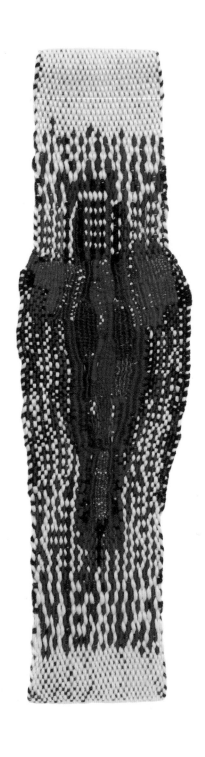

Faja II (detail) 1956
Cotton, wool; 21 X 5 IN / 53.3 X 12.7 CM
Private collection

Faja III (detail) 1956
Cotton, wool; 21 X 5 IN / 53.3 X 12.7 CM
Private collection

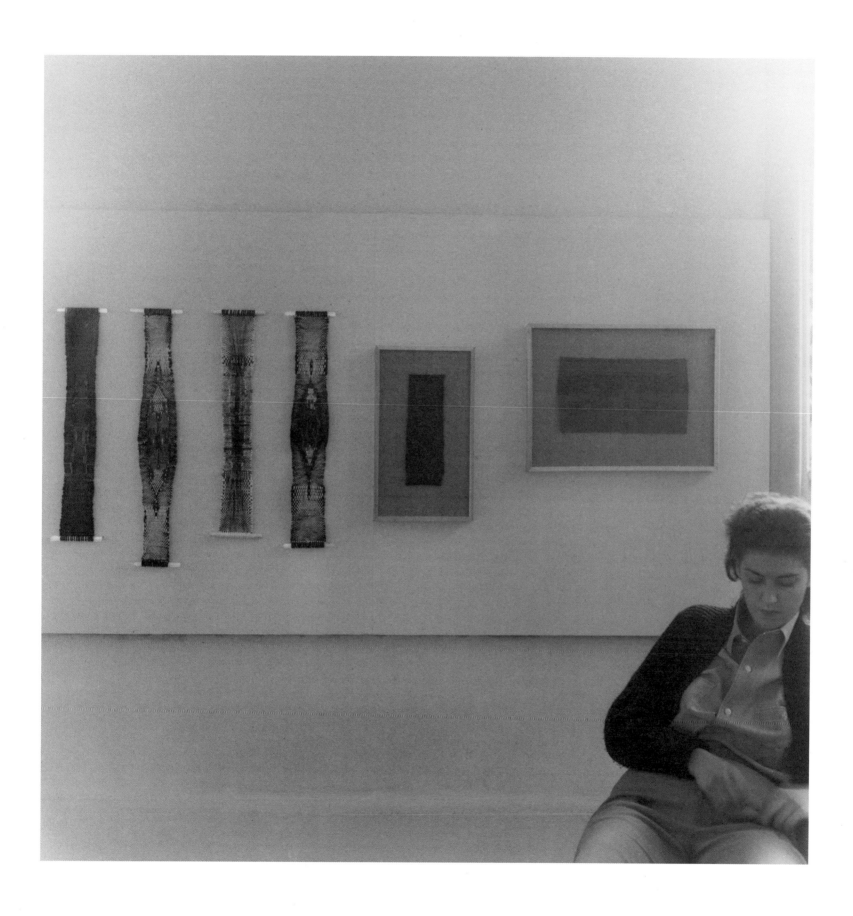

Fig. 8. Ernest Boyer, photograph of Sheila Hicks in her MFA show at Yale, May 1959, which included paintings and weavings.
Second from right is *Muñeca* (see p. 9).

Fig. 9. Phillips Academy studio art teacher and photographer Gordon (Diz) Bensley, a Yale graduate in philosophy, with his class tin the basement of the Addison Gallery of American Art, c. 1950–51. Addison Gallery Archives

Fig. 10. Sheila Hicks, Edward E. Elson Artist-in-Residence, reviewing work made in Therese Zemlin's Phillips Academy class, "Woven Structures and Fabric" (ART-314), May 2010.

her studio in the historic cour de Rohan. But before getting down to work, Hicks suggested a morning stroll through the nearby Luxembourg Gardens. The group wandered along benches filled with sunning Parisians, past children playing on the grass, by lavishly planted flower beds, and down paths to an intriguing outdoor art installation, admiring statues of French notables along the way, before ending up at a tearoom. The visitors were confused. Time was passing and there was barely enough of it to accomplish all there was to do. On another visit there was another walk, this time including a stop at a favorite architectural bookstore to browse the elegantly designed, freshly minted volumes of pristinely photographed buildings before setting off for the park. A platter of freshly opened oysters started dinner at a small bistro that evening. Yet another time, the driver of the taxi transporting the group to a meeting in the countryside was directed to make a couple of detours, once so the visitors could see the cobblestone entrance of Versailles and again on the return trip to admire sparkling Paris at night.

Why these detours with so much to accomplish? Was this for pleasure? Was Hicks revealing her beloved city-home? Certainly. But was there something else going on? Of course: it was both a test and an exploration. What kind of visual thinkers were these Addison people? How observant? How attuned to the world? How attuned to the way this artist thinks? Would there be common threads to bind artist and museum, common impressions, common points of view, common ideas?

The answer, it turns out, is that there were numerous twinings, many connections—devotion to education, passion for art in all its forms, appreciation for the act of making, and commitment to the interrelationships between seeing, doing, and learning, as well as to common histories not yet discovered.

NOTES

1. Eliso Kvavadze, Ofer Bar-Yosef, Anna Belfer-Cohen, Elisabetta Boaretto, Nino Jakeli, Zinovi Matskevich, and Tengiz Meshveliani, "30,000-Year-Old Wild Flax Fibers," *Science* 325, no. 5946:1359.

2. S. J. Doyon-Bernard, "From Twining to Triple Cloth: Experimentation and Innovation in Ancient Peruvian Weaving (ca. 5000–400 B.C.)," *American Antiquity* 55, no. 1 (January 1990): 69.

3. Monique Lévi-Strauss, *Sheila Hicks* (New York: Van Nostrand Reinhold, 1974), 11.

4. In 1874, Syracuse University became the first institution to offer a bachelor of fine arts degree. Yale University, where Hicks was to transfer, had instituted a BFA degree in 1891, and in evidence of its commitment to the teaching of women from the start of its School of the Fine Arts, Yale's first BFA was earned by the painter Josephine Miles Lewis. See Judith Ann Schiff, "The First Female Students at Yale," *Yale Alumni Magazine* 73, no. 1 (September–October 2009), http://www.yalealumnimagazine.com/issues/2009_09/oldyale024.html.

5. Six years after Sawyer's arrival, the name was changed to School of Architecture and Design. For a more complete history of the school's name changes see Frederick A. Horowitz and Brenda Danilowitz, *Josef Albers: To Open Eyes, The Bauhaus, Black Mountain College, and Yale* (London and New York: Phaidon, 2006), 257 n 189.

6. The 1935 exhibition, *Woodcuts by Professor Josef Albers*, was the first American exhibition devoted to Albers's work. See "Exhibition Chronology," in *American Abstraction at the Addison* (Andover, MA: Addison Gallery of American Art, 1991); also see Avis Berman, "Creating a Tradition: The Addison and the Artist," in Susan Faxon, Avis Berman, and Jock Reynolds, *Addison Gallery of American Art: 65 Years* (Andover, MA: Addison Gallery of American Art, 1996), 128–29; 130–31.

7. Frederick A. Horowitz, "Albers's Teaching Legacy," in Horowitz and Danilowitz, *Josef Albers*, 252.

8. Gerald Shertzer, "Self-Evaluation May 1987," Gerald Shertzer File, Andover MA, Phillips Academy Archives.

9. Horowitz, "Albers the Teacher," in Horowitz and Danilowitz, *Josef Albers*, 74.

10. Ibid., 72.

11. Ibid., 96.

12. Robert A. Lloyd to Lance R. Odden, 2 November 1977, Robert Lloyd File, Andover MA, Phillips Academy Archives.

13. Hicks quoted in Horowitz, "Albers the Teacher," in Horowitz and Danilowitz, *Josef Albers*, 68.

14. Christine Rae, "SEE/SAW: The Fine Art of Teaching," *American Fabrics and Fashions*, no. 119 (Spring 1980): 77.

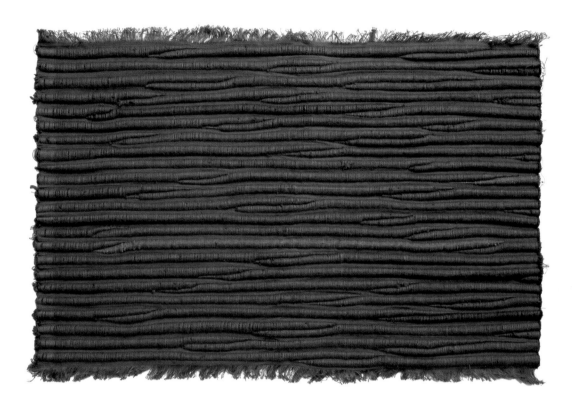

Badagara Blue (detail) 1966

Hand-woven cotton; 8 × 8¾ IN / 20 × 22 CM

Cutting from hand-woven cloth 52 inches wide and 30 yards long

Private collection

In 1965 Hicks began designing textiles for the Commonwealth Trust in Calicut, Kerala, India, the largest and oldest continually functioning hand-weaving workshop in the world.

Badagara, woven by Dravidian artisans, has been in continuous production for more than forty-five years. See another example, *Badagara White*, p. 104.

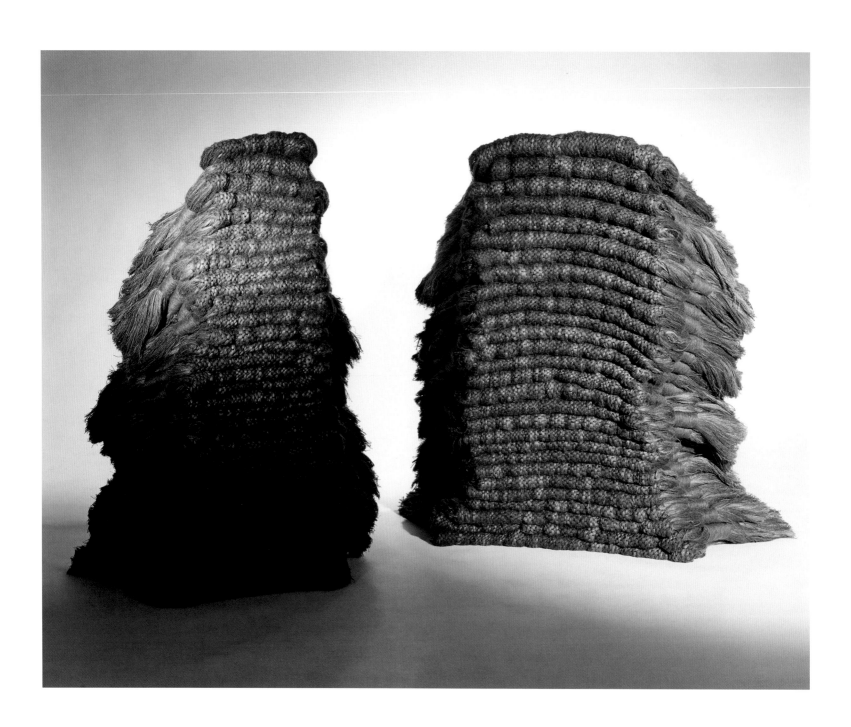

The Evolving Tapestry: He/She 1967–68

Linen, silk; dimensions variable

Museum of Modern Art, New York, N.Y., U.S.A. (Given in Memory of Arthur Drexler by Sheila Hicks, Jack Lenor Larsen, and Henry and Alison Kates; and Department Purchase Funds, 452.1987.a-vvv)

When exhibited in the Museum of Modern Art's 1969 *Wall Hangings* show, the work was installed in two vertical stacks (p. 58). At a later date, the museum presented it as one unified volume (p. 59). The artist's concept for the work is that the components can be structured in different permutations and the form can continue to evolve. It has been exhibited in various other configurations.

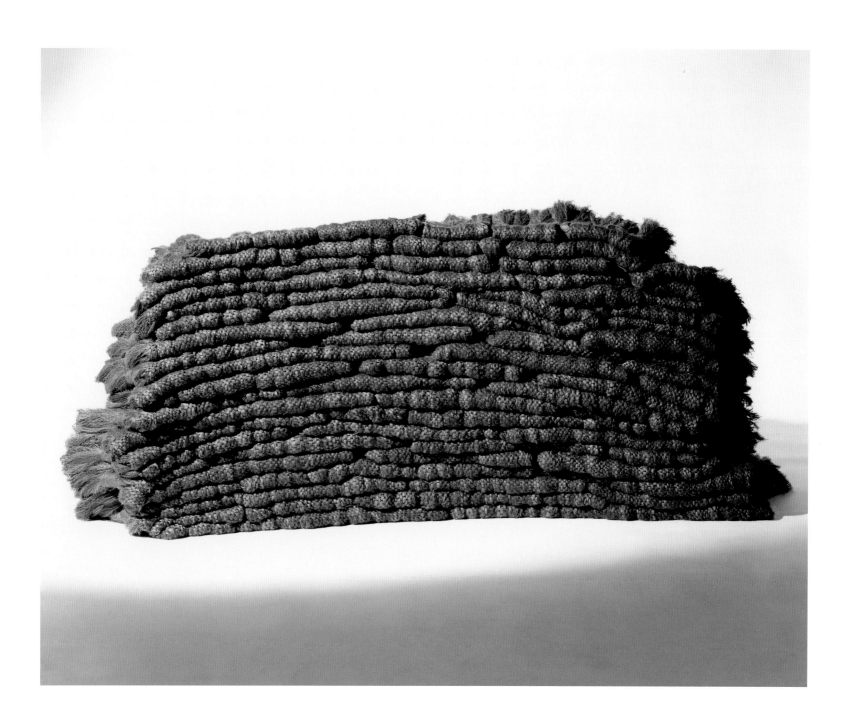

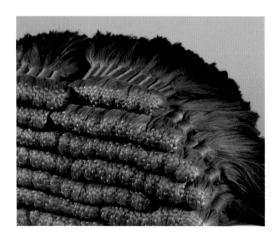

Banisteriopsis—Dark Ink 1968/1994
Linen, wool, synthetic raffia; 42 pieces, each 18 × 19 in / 45.7 × 48.2 cm
Philadelphia Museum of Art (Gift of the artist 1995)

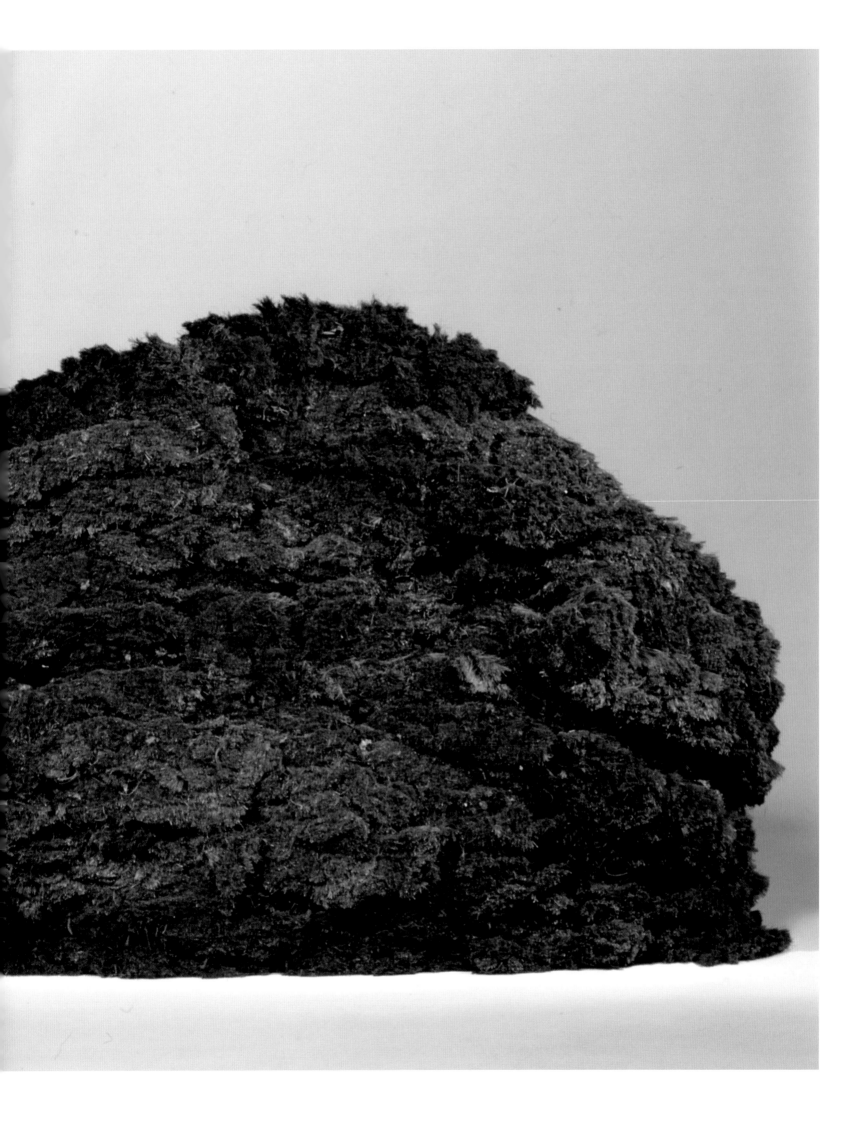

right

Grand Prayer Rug 1966

Wool, cotton; 144 × 60 IN / 365.8 × 152.4 CM

Philadelphia Museum of Art (Gift of the Women's Committee of the Philadelphia Museum of Art, 1994-80-1)

above

Grand Prayer Rug as originally installed at the CBS Building.

The work was commissioned by CBS and placed in the ground floor restaurant of its corporate headquarters, designed by Eero Saarinen, at 51 West 52nd Street, New York.

The building is known as "Black Rock" for its dark granite cladding, and the restaurant initially had granite walls as well.

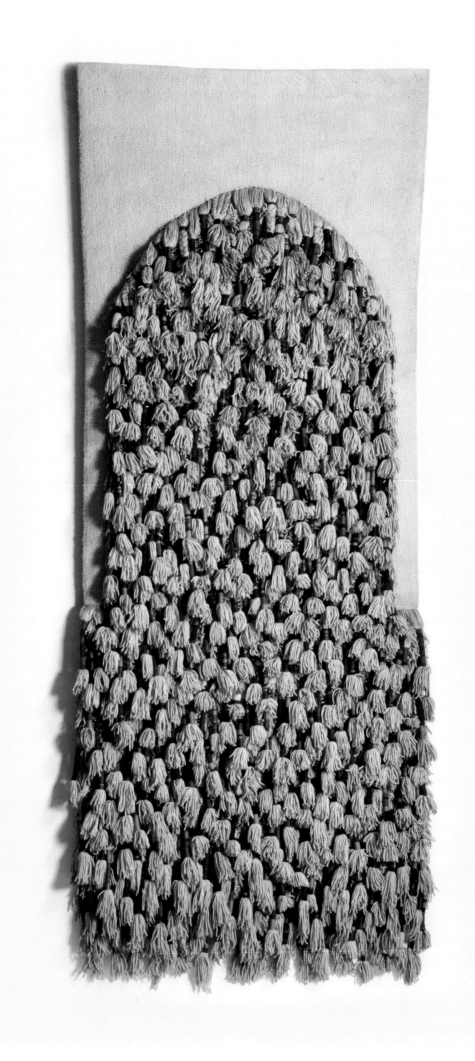

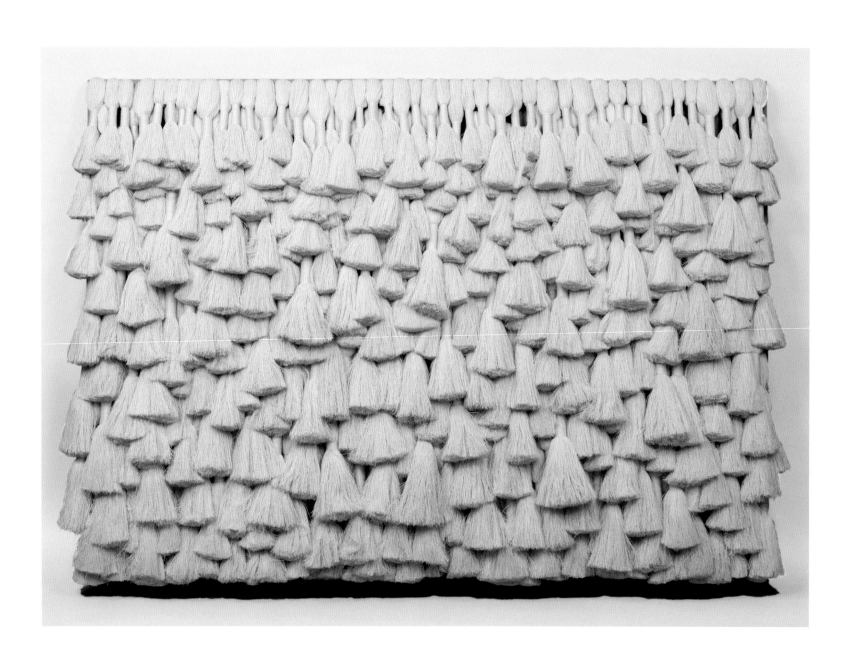

Linen Lean-to 1967–68
Linen; 59⅛ × 82¾ × 6 IN / 150 × 210 × 15.2 CM
The Metropolitan Museum of Art, New York, N.Y. (Purchase, Anonymous Gift, 1986; 1986.7)

following
Lion's Lair 1968
Linen; 9 × 19 FT / 27 × 6 M
One of three commissions for the Georg Jensen Center for Advanced Design, New York
Interior designer Warren Platner created the environments of furniture and objects.

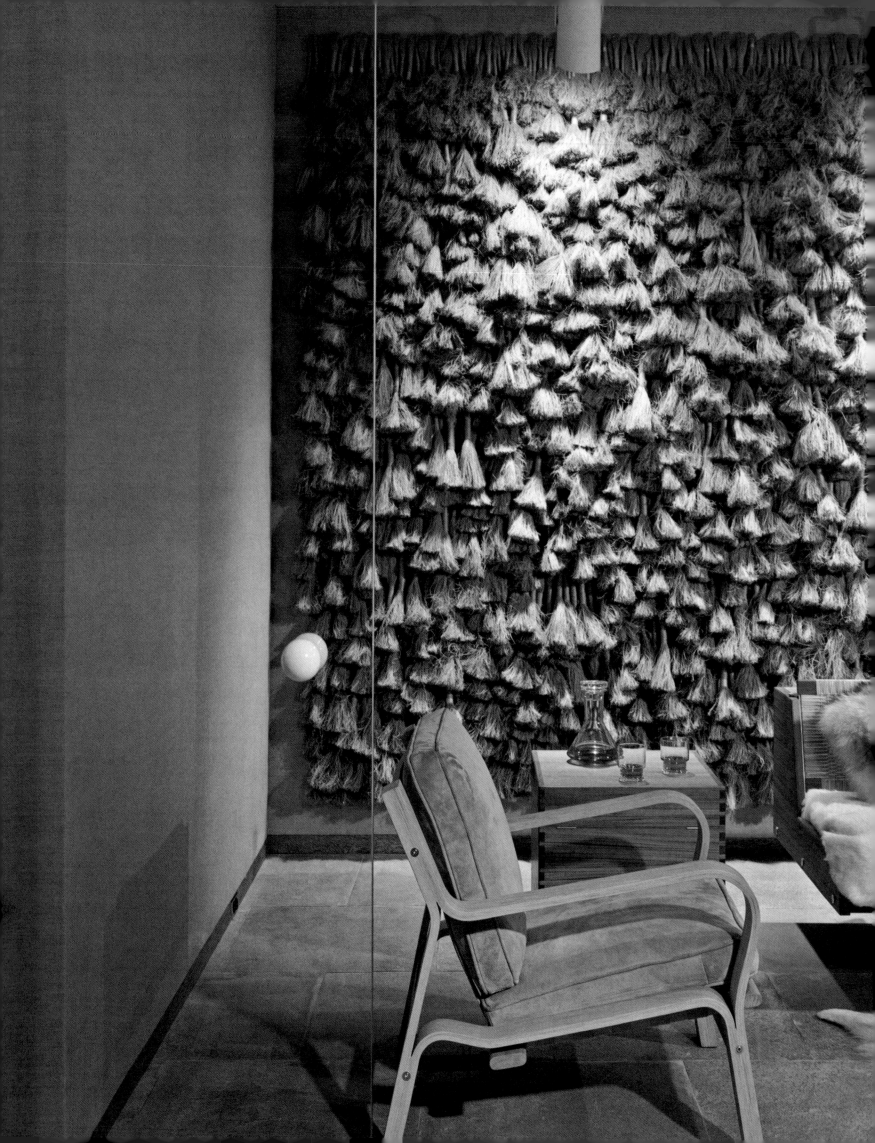

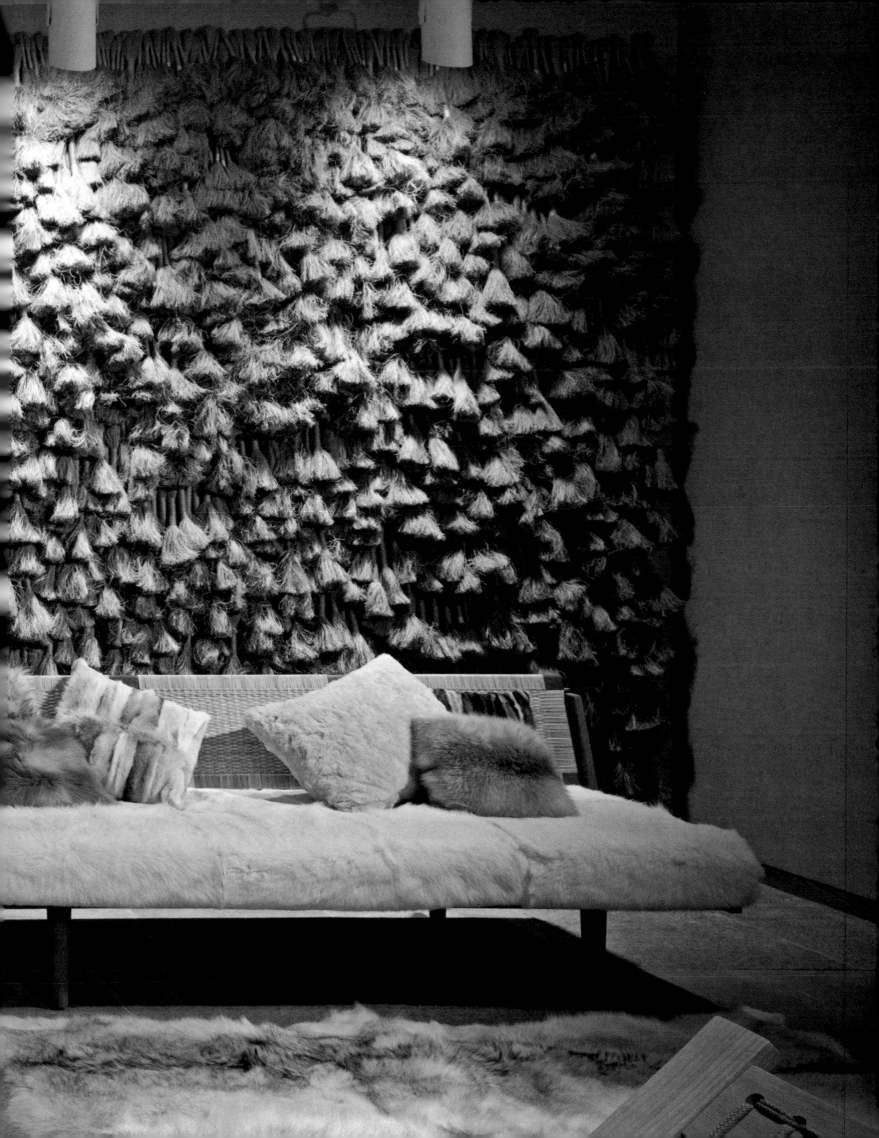

Bamian (Banyan) 1968/2001
Wool, wool twisted with acrylic; dimensions variable
Private collection

As installed in a former horse stable with white-washed slate walls, in *Soie & Ardoise, Sheila Hicks, Petites Pièces*, Trélaze, France, 2005

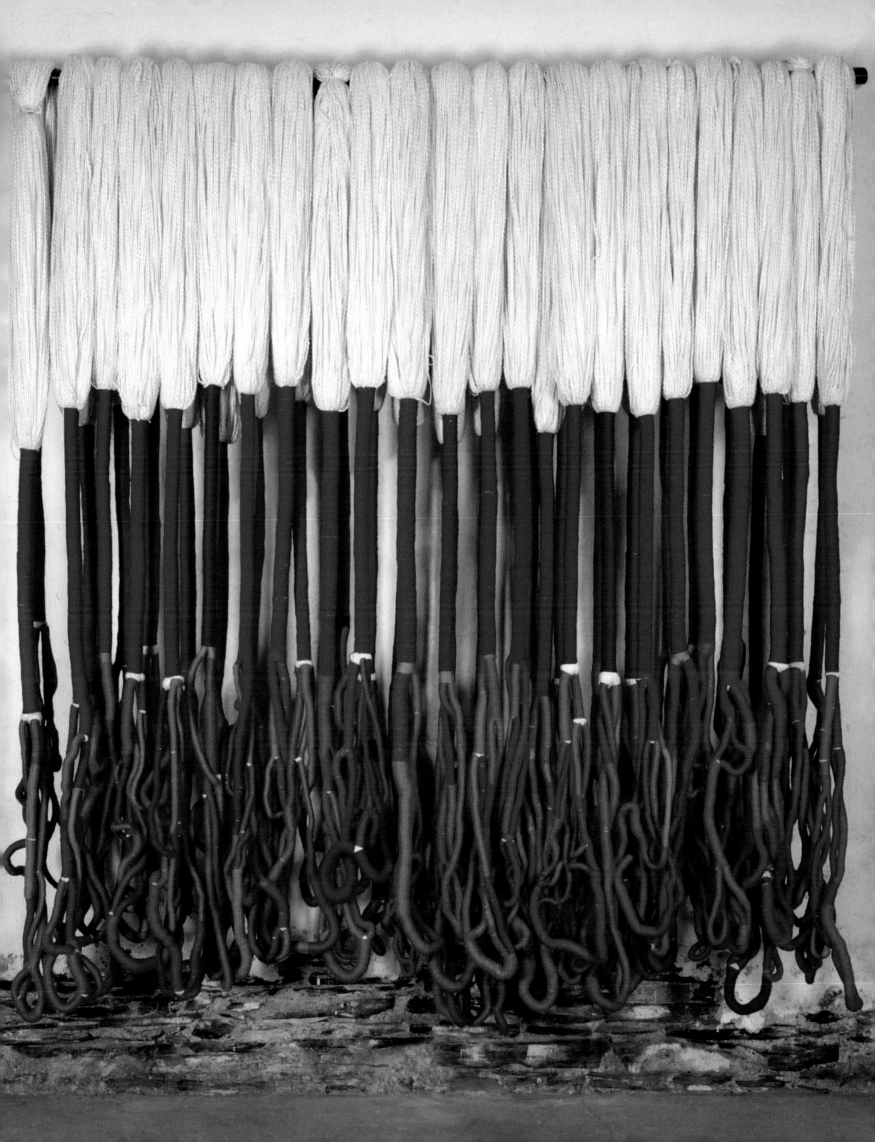

Cicatrices 1968
Silk, mohair; 8¼ × 4¾ IN / 21 × 12 CM
Cooper-Hewitt, National Design Museum, Smithsonian Institution (Gift of Anonymous Donor, 2006-14-2)

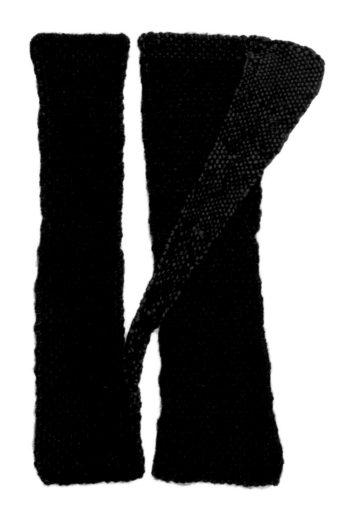

Cross Over 1968
Wool; 8¼ × 5½ in / 21 × 14 cm
Private collection

The Principal Wife 1968

Linen, rayon, acrylic yarns; 100 × 80 × 8 in / 254 × 203.2 × 20.3 cm

Museum of Art, Rhode Island School of Design, Providence (Gift in memory of Mary Josephine Cutting Blair, 2005.42)

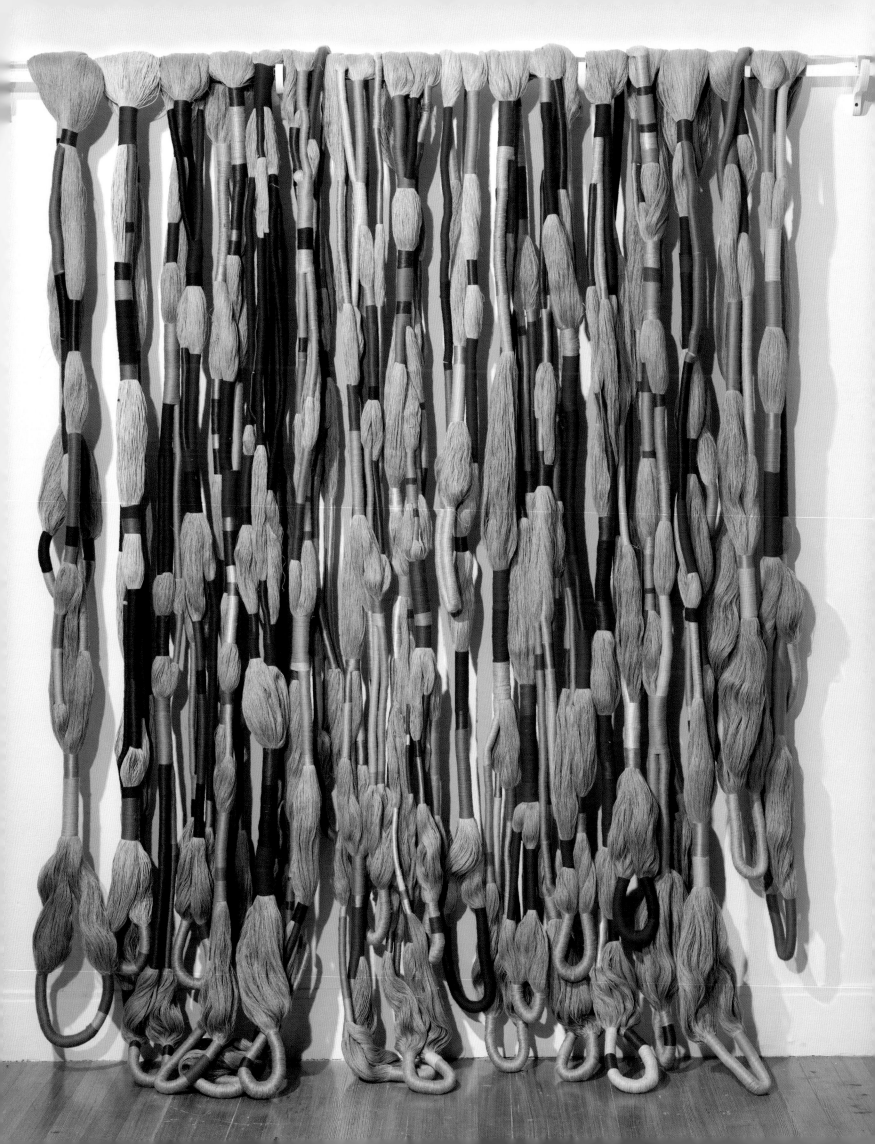

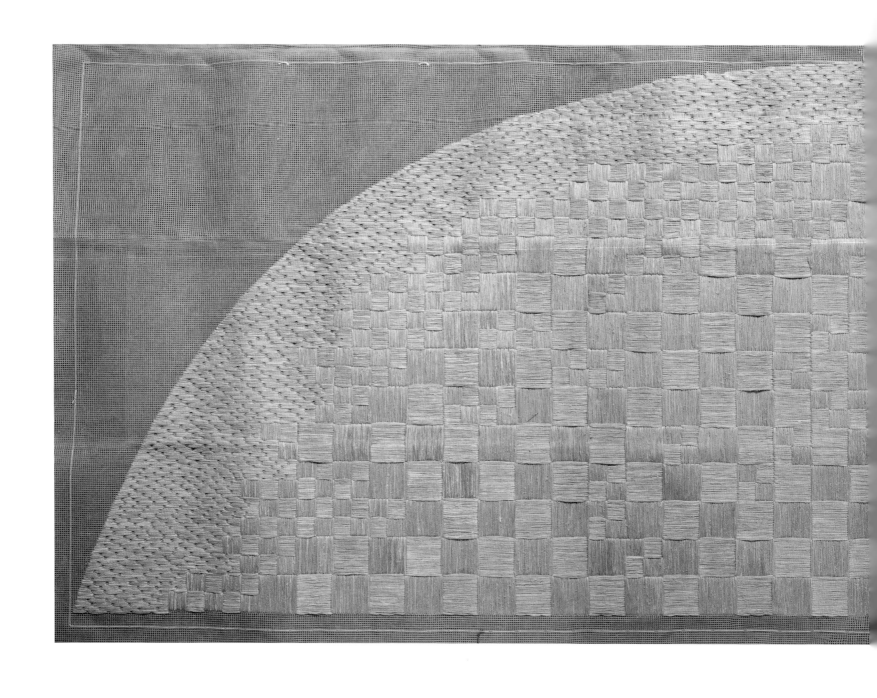

Bas-relief for interior of Boeing 747 aircraft, Air France 1969–77
One of eighteen works
Silk on petit-point grid; 53⅛ × 157½ in / 135 × 400 cm
Private collection

images at right

Left: Detail of one of the bas-reliefs in progress. Center: Hicks working on a bas-relief in her Passage Dauphine studio, Paris. Right: An example installed in the first-class lounge on the upper deck of a two-level cabin in one of Air France's first fleet of 747 jets. The demi-lune shaped panel followed the curve of the aircraft.

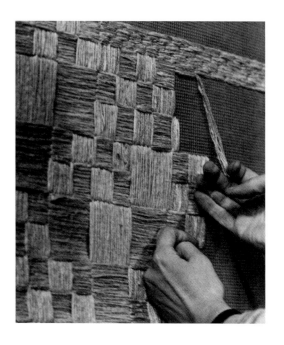

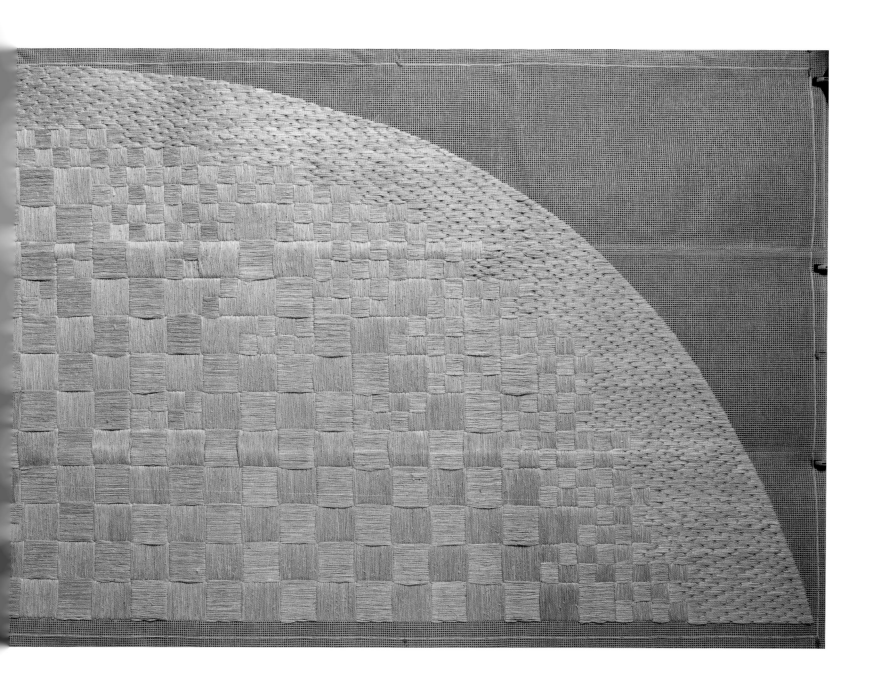

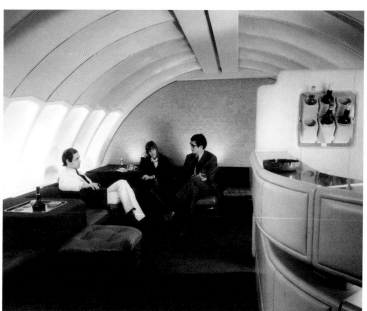

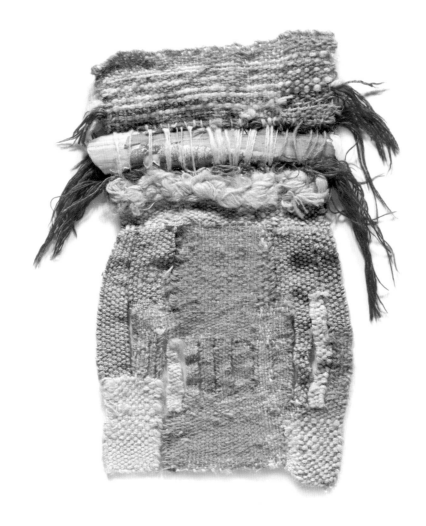

M'hamid 1970
Silk, vicuña, razor clam shell; 9¼ × 7 ɪɴ / 23.5 × 17.8 ᴄᴍ
Cleveland Museum of Art (Gift of Mildred Constantine, 1992.358)

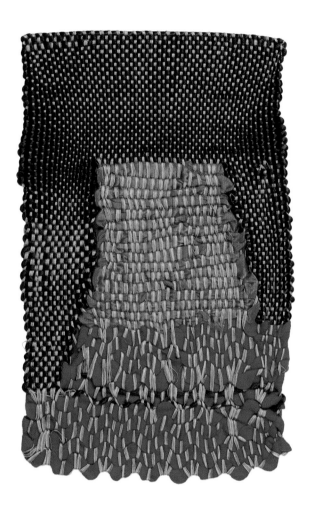

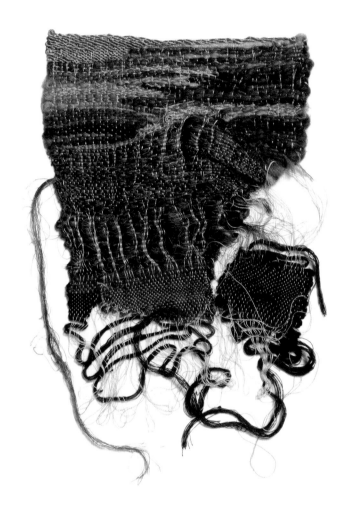

Move Over c. 1970

Cotton, nylon, ricrac; 8⅞ × 5½ in / 22.5 × 14 cm

Private collection

Dégringolade 1971

Cotton, wool, silk; 8⅝ × 6¾ in / 21.9 × 17.2 cm

Private collection (courtesy of Cristina Grajales Gallery)

Trapèze de Cristobal 1971
Wool, linen, cotton; 129 15/16 × 78 3/4 IN / 330 × 200 CM
Stedelijk Museum, Amsterdam

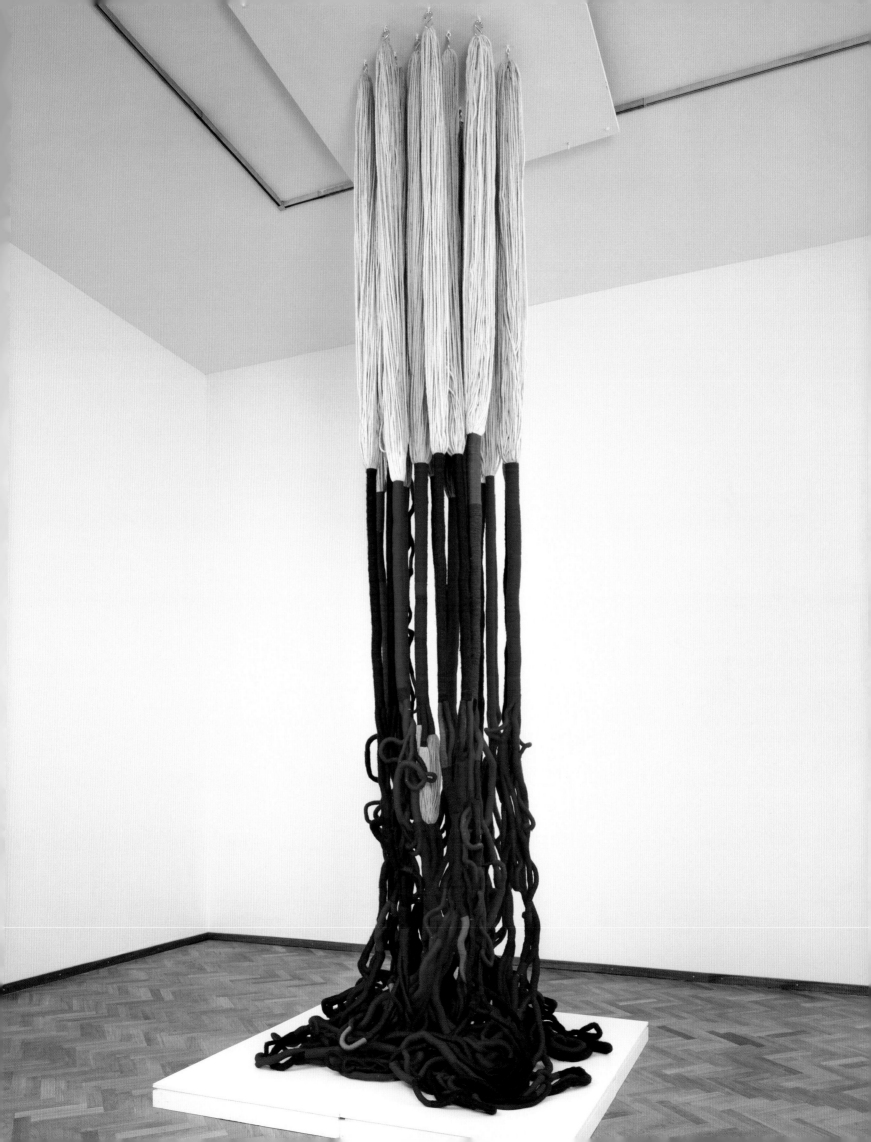

Palacio Iturbide 1972
Commission for Banco de Mexico Headquarters, Mexico, D.F.
Architect: Francisco Guerrero-Torres
Restoration and interior architect: Ricardo Legorreta, 1972
Wool; 196⅞ × 137¹³⁄₁₆ in / 500 × 350 cm

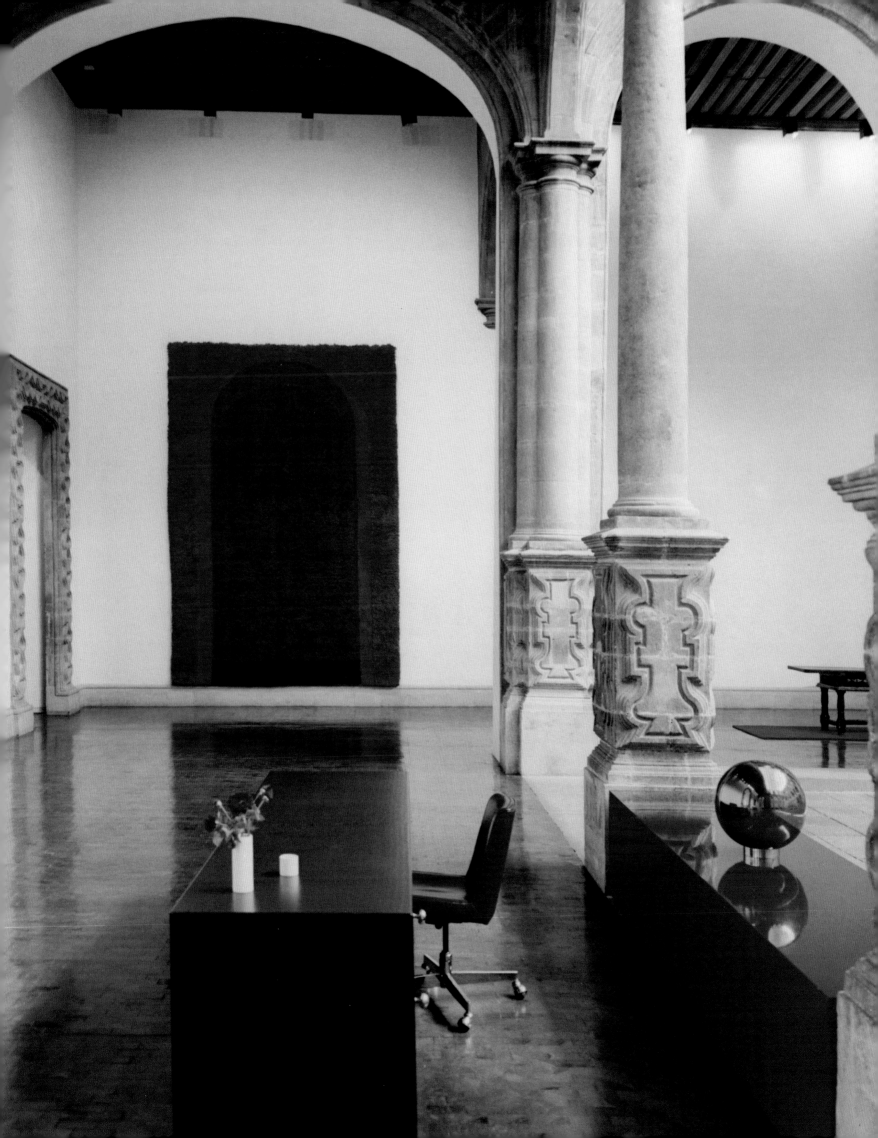

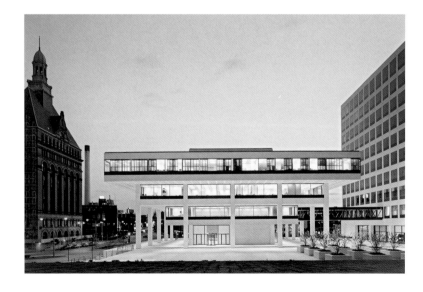

Commissions for MGIC Investment Corporation Headquarters (formerly Morgan Guaranty Insurance Company), Milwaukee 1972–73
Architects: Skidmore, Owings & Merrill
Interior designer: Warren Platner

Installation views of reception areas, board room, and conference rooms
Wool bas-relief (p. 83); linen, gold, silver thread (p. 84 top); silk, linen (p. 84 bottom); silk, linen (p. 85 top); gold thread, cork (p. 85 bottom)

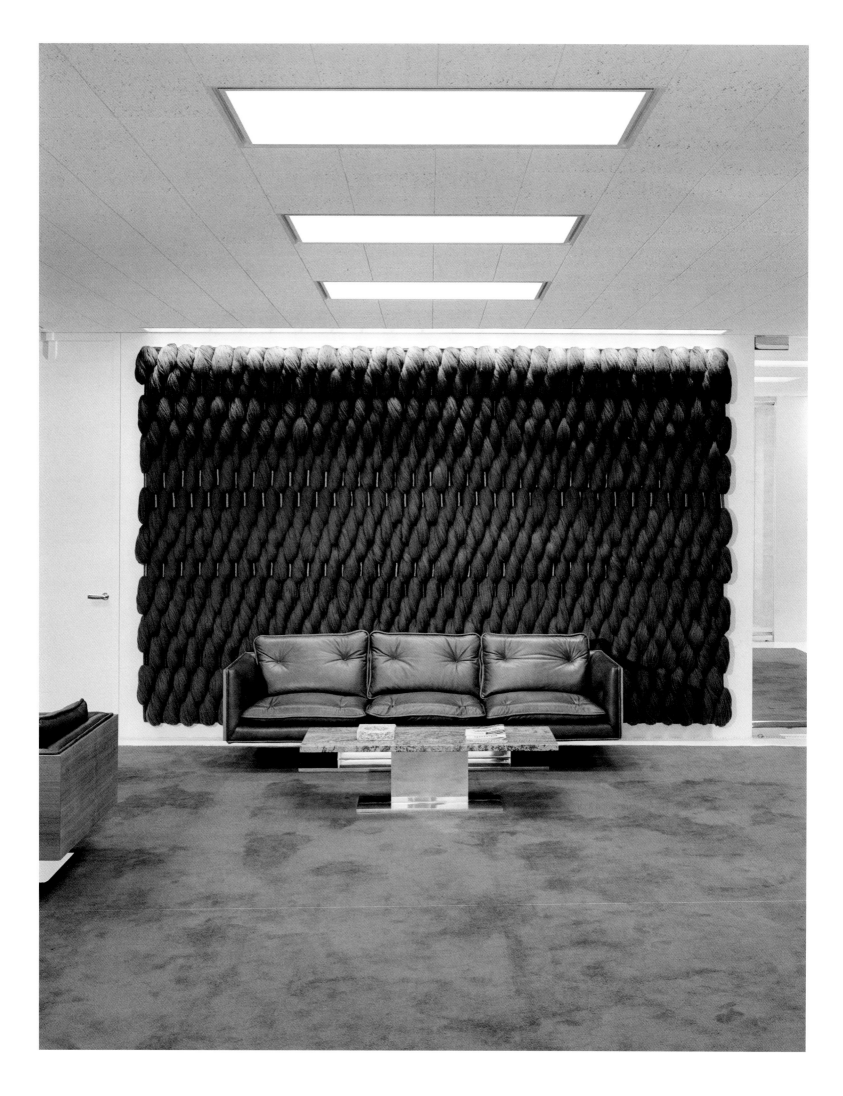

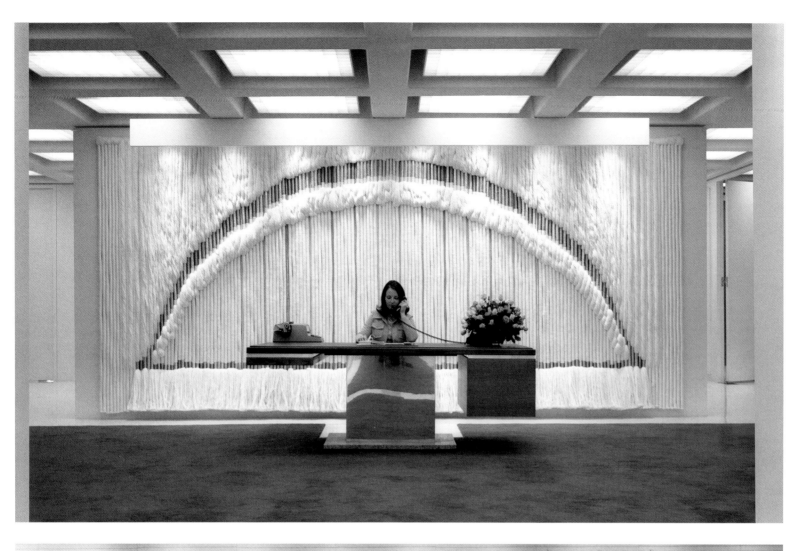

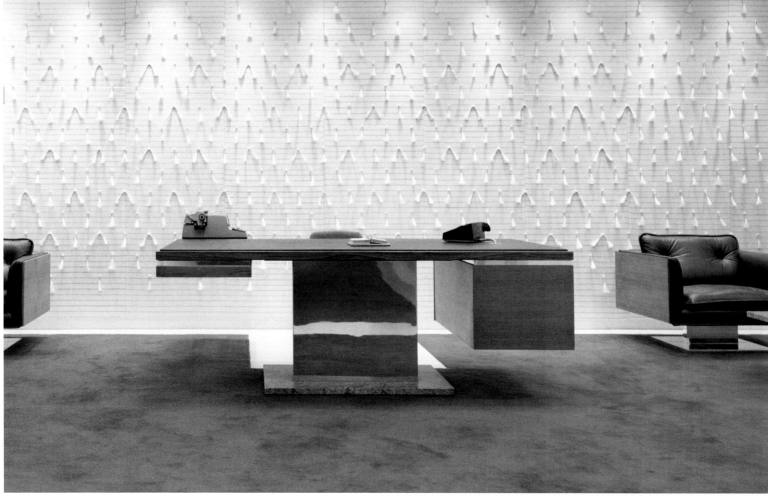

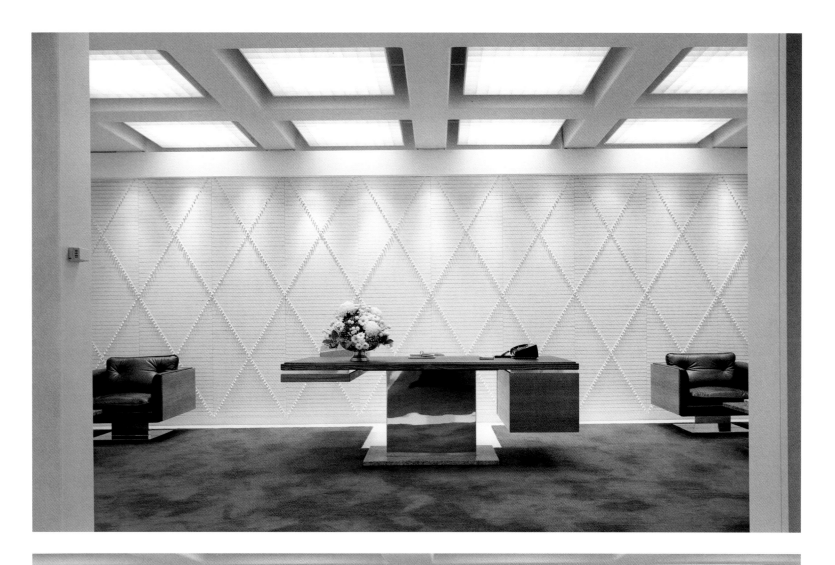

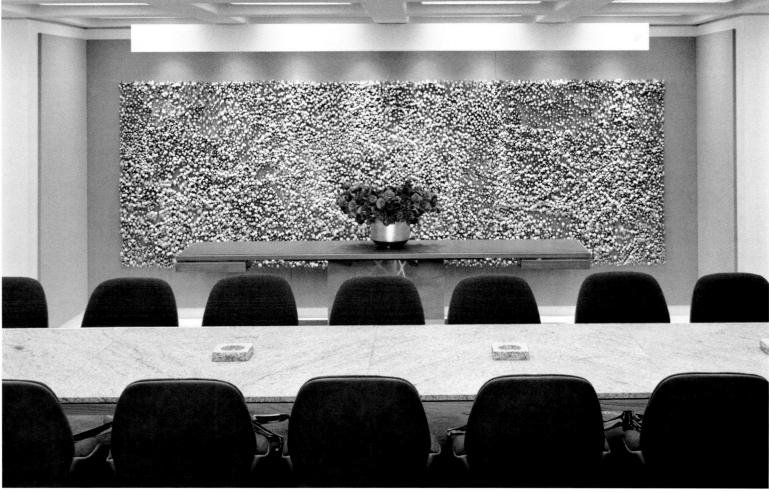

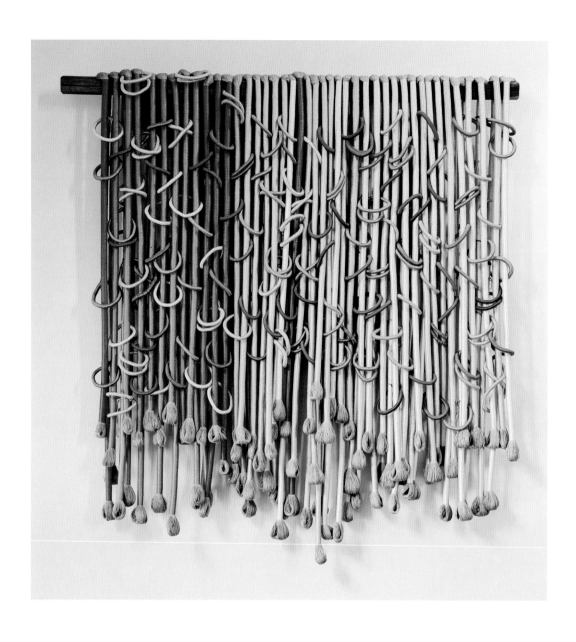

opposite
La Mémoire 1972
Commission for IBM Headquarters, La Defense, Paris, France
Interior Designer: Michael DePotestad
Linen, silk, wool, synthetic fibers; 120 × 176 IN / 304.8 × 447 CM

The work was deconstructed in 2001, and later reconstructed as two projects: shown above is the one in the collection of The Lawrenceville School (Gift of Bob and Lynn Johnston), where it is installed in the library. The remaining cords, in the collection of Bob and Lynn Johnston, have been reconfigured by the artist for this exhibition.

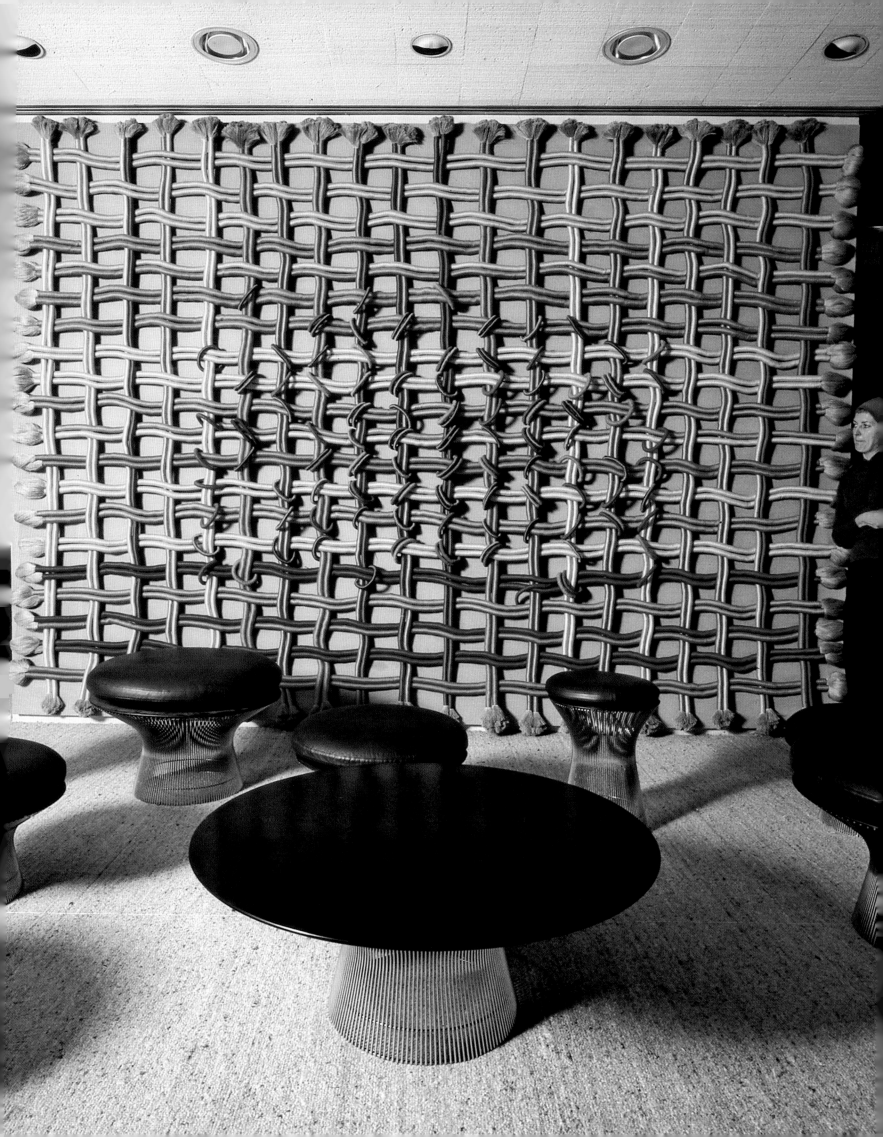

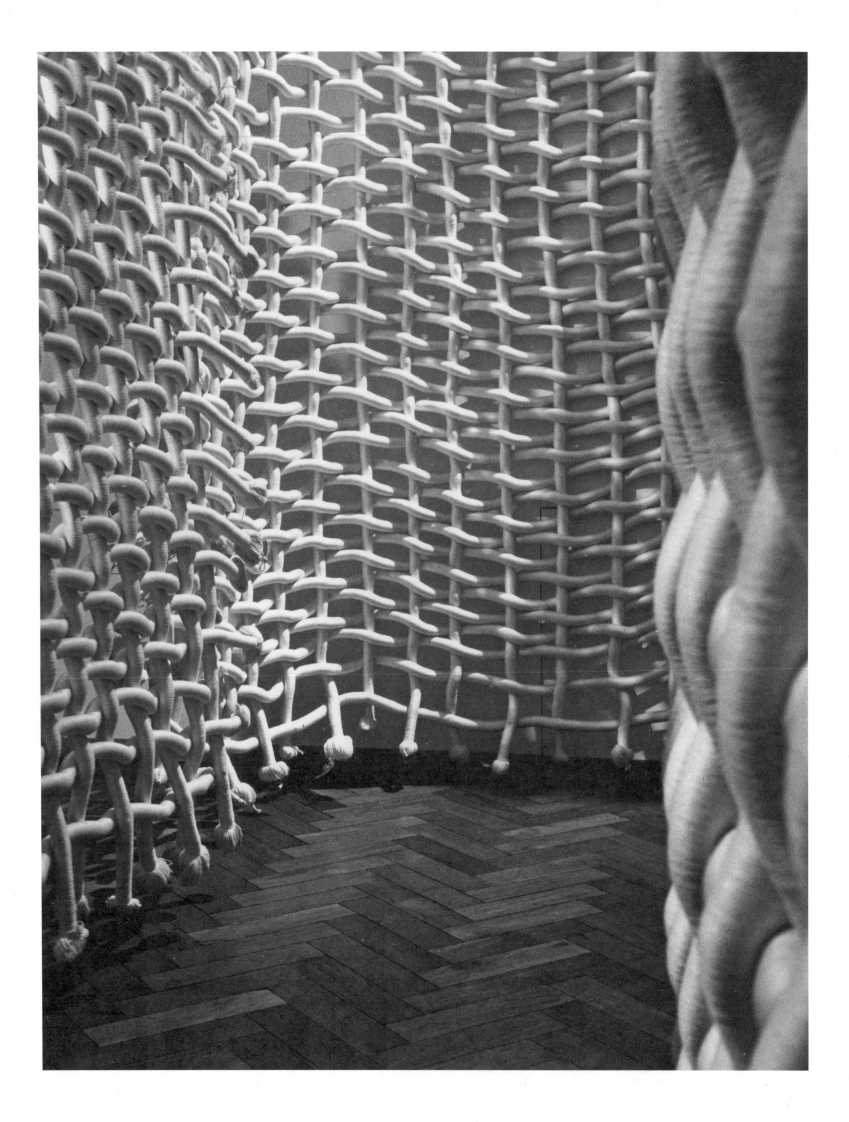

JOAN SIMON

Unbiased Weaves

For the past fifty years, the practice of artist Sheila Hicks has been characterized by a process of continual exploration that is grounded in attention paid. She herself proceeds with the counsel she has long given others—to say yes before saying no, to seek and include rather than to ignore and exclude, and to always carry a pencil, paper, and camera—as the condition for creating "things" that question categories of art and design, of design and craft, as they also question the relations between individual and collective makings, the unique and multiple versions of an object, the signed and anonymous. She has worked in her studio and in the studios of others; with artisanal workshops and for industry; in collaboration with architects for site-specific commissions; and with artists, performers, and museum curators on temporary, ephemeral projects.

The works of Sheila Hicks are abstractions constructed of color, usually but not always beginning with a single line. Typically, this line is a single strand of yarn. Her works often reference the history of textiles and their structures, and they not infrequently also have the notational quality of text. They may take form in two dimensions or three, in small format or at a grand architectural scale. To describe what she does and how she thinks, Hicks has charted her process as "channels of investigation" and her makings as "unbiased weaves."[1] Thinking with line—whether on the page for her Color Crossed studies, or animated in space—is critical in the artist's conceptual approach.

The breadth of her references, her ways of recording details observed and of analyzing structure, meaning, and context, may be seen in the daybooks[2] she has kept since 1957, when she first traveled in South America during a gap year, so to speak, on a Fulbright grant to paint in Chile between her BFA and MFA studies at the Yale School of Art and Architecture in New Haven. There she had studied painting and the "interaction of color" with Josef Albers, sculpture with José de Rivera, printmaking with Gabor

Fig. 11. Sheila Hicks, *Labyrinth*, 1972. Linen, cotton, dimensions variable. As installed at the Stedelijk Museum, Amsterdam, 1974. The work, originally consisting of seven panels, was deconstructed, and the elements were later reconstructed in New York, Lund, Sweden, and Paris, at times as free-standing rolled panels, sometimes hanging from the ceiling, and at other times leaning against the walls or on the floor (see fig. 83).

Peterdi, typography with Norman Ives, photography with Herbert Matter; she audited
Louis Kahn's architecture crits and, critically, attended among her art history courses
George Kubler's "Art of Latin America."

Kubler opened his paradigm-shifting book *The Shape of Time: Remarks on the
History of Things* with the proposition "Let us suppose that the idea of art can be expanded
to embrace the whole of human-made things, including all tools and writing in addition
to the useless, beautiful, and poetic things of the world."[3] After his book's publication in
1962, Kubler's approach influenced a generation of artists in the 1960s—especially those
loosely grouped either as minimalists, process artists, or conceptualists—but the effect
on Hicks of his thinking and approach to the continuum of things across space and time
began to influence the course of her art-making when she was a student watching his
projected slides in 1956. In his class Hicks became fascinated with the interactive colors
and intricate structures of Pre-Incaic textiles and began to analyze their complexity by
attempting to remake them herself. Although she was untrained as a weaver and at the
time was a painting major, these studies would constitute the basis for her 1957 thesis,
"Andean Textile Art." As she set about experimenting with string, twine, and various
yarns in what she refers to as her "painting stall in the dilapidated Street Hall" at Yale,
Hicks came to the realization: "If my paintings at the time were meshes of color, why not
interlace colored lines of thread?"

While the young artist equated the different mediums, this was far from the case
in much of the rest of the art world, either in the immediate context of art school or in
galleries and museums. Such processes as weaving, ceramics, or glass-making were not
taught at Yale, as they had been at the Bauhaus, and a bias against craft also would have
placed these mediums in an arena of ambition other than fine art. Working artists of
Hicks's generation typically would keep their ways of supporting their studio work apart
from what issued from the studio itself.[4] Hicks, though, as early as her student years, and
throughout her career, was free of such bias, and in describing her works as "unbiased
weaves," addresses multiple issues.

In economy, forthrightness, and knowing wordplay, the pairing of "unbiased" and
"weaves" signals a simplicity that belies the complexity of the artist's conceptual approach.
While it is a statement of how Hicks's sculptures, bas-reliefs, drawings, and weaves, as
well as her designs for production fabrics, at once honor and depart from textile-making
tradition, the two words also flag the classifications that have, more often than not in the
past century, isolated weaving as a territory, as a class of objects apart from and often
subordinate to other techniques and materials for art-making. Hicks's use of "weaves" as
a noun declares the interlacing on which her pieces rely (inclusive of the found objects
made of woven cloth, whether linens or clothing, she readily employs). "Unbiased" states
a point of view free of prejudice of many sorts. Such an unbiased regard allows certain of
her objects to accumulate in repetitions of similar forms that might align them with process

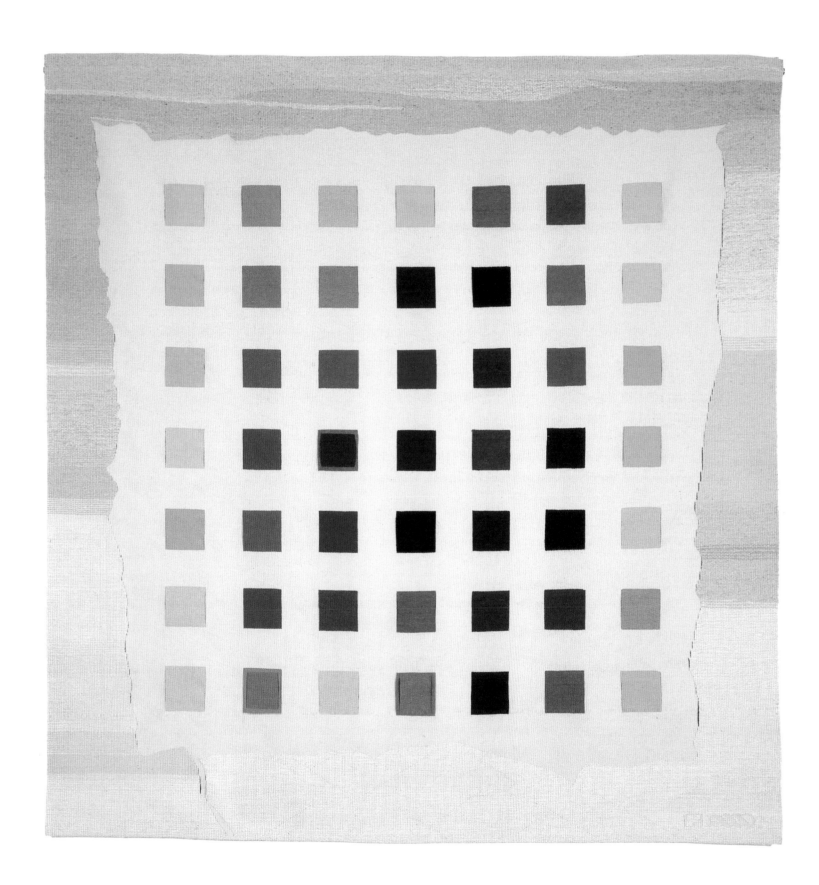

Color Alphabet II/VI 1988
Wool, silk; 74¹³⁄₁₆ × 72¹³⁄₁₆ ɪɴ / 190 × 185 ᴄᴍ
Collection of Itaka Martignoni

and minimal art in contemporary art-critical terms; at the same time it includes those works that look most like and are in fact weavings, the miniatures. These are structured with verticals (warp) interlaced with horizontals (weft), and are made on a tool devised by the artist from a painting's stretcher bars, with nails inserted into the top and bottom edges of the frame to hold the initial armature of warp in tension and to break from the expected right-angled regularity generally associated with the construction of cloth. Many of these works, in fact, turn the stasis of the grid and embody the extension of fluidity from working "on the bias" (pp. 202, 203). Critically for Hicks, this is not gained by reorienting the resulting plane but rather by her initial passes within the primary structure itself. At a size alluding to that of a page, and with a kinship to improvisatory line drawings as well as to painterly passages of watercolor and the tradition of small paintings known as miniatures, these "minimes"—the word the artist herself uses for her small works, and which serve as a laboratory for all others—invoke her multitude of references.

Just as Hicks addresses fundamental questions of construction and deconstruction in her unbiased weaves, so has she remade the form of a biographical chronology (fig. 60). Thinking on paper, she reveals the flow of a life's events as she details important moments by lines that swoop and link influences in her process of picturing and analyzing the relations between key markers, rather than simply recording an unremitting sense of forward progress. Borrowing this form of relational overview seems useful in understanding how her diverse works in distinctly different domains interrelate, and in exploring the objects themselves in the passages below I will locate the discussion in a similar way.

Such an approach is intended to recognize the frameworks and contexts in which her works are viewed and collected and at the same time to offer understandings of her overall project that account for differences as well as continuities among works throughout her oeuvre, whether they were made as studio investigations or as public commissions; whether they were crafted by her own hand or under her direction; and whether they take up the space of sculpture or, as she says, "flow by the kilometer" at mills or artisan workshops. It also allows a reconnection of themes, ideas, and techniques in works separated by the departmental divisions under which they have been acquired by museums: textiles, decorative arts, craft, architecture and design, and contemporary art, to name a few.

To look at Hicks's practice in this way further allows an understanding of how and why her works have also been divided by critical terminologies that, intending to highlight new approaches, have proved less useful over time, or were inapplicable, in fact, at the outset. In Europe in the 1960s, for example, though Hicks's works were shown under the rubric "the new tapestry," echoing revisions of a long-standing tradition there, they were never tapestries at all (about which more later). The 1960s was a particularly fertile time for naming the apparently "new," and just as the initial use of "video art" has been losing its qualifier as that technological medium is becoming another tool in an artist's toolbox, the contemporaneous use of "fiber art" (and the related framing of a "fiber revolution") have

also come to seem overdetermined. Whether they choose to continue to define their work primarily through its material qualities or not, several generations of artists over the past four decades have incorporated a variety of what then were categorized as "craft" materials in diverse works, created with different conceptual underpinnings, at a wide variety of scales, and for different sites and situations, as Hicks has done from the outset.[5] Though Hicks never felt the need to decide between the techniques of textile fabrication and other ways of constructing artworks, Sarat Maharaj, in her essay "Textile Art—Who Are You?" illuminates the question when she offers the concept of "an undecidable—as Derrida puts it, something that seems to belong to one genre but overshoots its border and seems no less at home in another. Belongs to both, we might say, by not belonging to either."[6]

Using the word "pioneering" to describe Hicks's practice is not limited to her focus on fiber as material or to the ways she conjoined medium and concept. It also relates to how she developed a singular atelier in Paris; how she fostered collaborative production incubators in Mexico, Germany, India, Morocco, Chile, and South Africa; how working in interrelated domains cross-pollinate her channels of investigation through different modes of patronage, production, and distribution; and, above all, how her vision, informed by historical reference as well as contemporary technologies, is embodied in her "unbiased weaves."

HOW DOES ONE CARRY FOUR GEESE ON A TRAIN?

Before taking up residence in Santiago, Chile, in September 1957, where, in addition to painting in accordance with her Fulbright, she also taught her version of Albers's "Interaction of Color" course, in Spanish, at the Faculty of Architecture of the Universidad Católica (1957–58), Hicks traveled down the west coast of South America. At this time she began to write and draw in her daybooks and to photograph. "When I was doing this my purpose was just to keep myself on track. I never thought the information might become useful. Later it became useful, but back then I just entertained myself; almost like writing a comic book of what was happening every day."[7] In an entry made during the last week of February 1958, Hicks recorded something of an oddity, a bulbous shape with emerging heads of birds. It is, in fact, a sketch of something she had observed

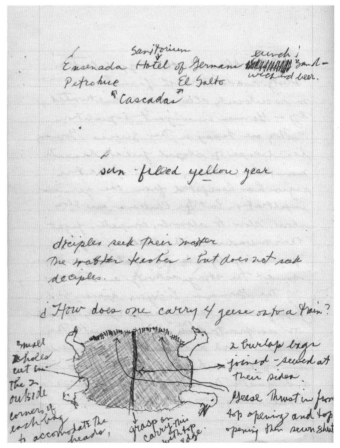

Fig. 12. Page with notes and drawing in Sheila Hicks's daybook, 1958. "How does one carry 4 geese on a train?"

on a train to Puerto Montt, in the southern part of Chile: a hand-woven bag that a man was carrying over his shoulder, on top of his poncho, and in which there were four live geese (fig. 12). For Hicks it was something both "ordinary and astute." It "was smart," she recalls, a design problem "intuitively solved with attention to economy and of course practicality—how to carry four live creatures to market." Her analysis of structure reveals also her sense of humor, indeed joy, in these observations. It was "a hand-woven potato sack converted to portable housing by unsewing the four corners, and, in allowing the openings to be as important as the cloth, the geese could poke their heads out and breathe, while the sack contained the rest of what was going on. The whole point of the thing was to get them to market alive and not mess up the train en route. While their noisy quacking couldn't be hidden, their shitting could." Another of her daybook drawings, overtly a figure sketch, records her observation of materials and forms from someone's head to toe, noting felt hat, waist-cinching *faja* (a belt or a strap), and rope shoes (which she similarly records in her photographs). In other entries of the same period, Hicks details the components of a four-post loom—which she would learn to use by sitting on the ground and working with two weavers on the island of Chonchi, Chiloe, Chile—and analyzes the method for weaving a poncho, whose bowing edges would be echoed in her

own weaves (pp. 21, 29), and she almost obliterates a black-bordered typewritten page (notes for a report to the Fulbright office accounting her whereabouts) with a crayon drawing of an abstracted landscape (fig. 13), which has much in common with a photograph she took near Punta Arenas, Chile, in 1957 (fig. 14), where, as she says, "Light, shadow, sky, earth, water meet in the southern hemisphere, in the Magellan Straits … inspiration for painting and drawing[.]" The crayon drawing itself resembles as well the paintings she had made while at Yale (fig. 15).

Re-viewed as a cluster of related works, one sees at this early stage Hicks's bold palette and color interactions, her ways of playing figure off ground, and her self-taught approach to a variety of tools, materials, and the structure of both. The vocabulary she would explore for the next fifty years is evident: her approach to building form of color, her fascination with deconstructions and reparations of cloth—her introduction of slits to puncture surfaces to allow light to permeate or

Fig. 13. Page with drawing and notes in Sheila Hicks's daybook, 1958. Abstracted landscape drawn on typewritten notes to the Fulbright office about her painting fellowship in Chile.

seemingly emit from her works—and her abstracting from the observed, whether nature's forms or culture's artifacts.

In addition to her work as both student painter and teacher during this year (for which she later received course credit toward her MFA), this period also marks the importance of research to her own art practice. For Junius Bird, a curator at New York's Museum of Natural History, she photographed artifacts and sites such as Machu Picchu (fig. 32), and through him she met archeologist Grete Mostny, who showed Hicks "mummy bundles"—mummified corpses wrapped in layers of textiles secured with *fajas*—which led Hicks to further investigate ancient textiles and the ways they were made.[8] Her photographs reveal consistencies in point of view, compositional strategies, and motifs (such as mounds or *fajas*) with her weavings and sculpture.

To focus on such a liminal period when she was both painting and weaving—her first exhibition of paintings was at the Museo Nacional de Bellas Artes in April 1958[9]—introduces a vocabulary that would be confirmed in her first mature works and in the productive start of her career as both artist and designer, in Mexico, in 1959. (See Whitney Chadwick's essay for a detailed discussion of Hicks's work developing at a cross-cultural hub of European modernism and indigenous traditions in Mexico, 1959–63.) Hicks had earlier spent a summer studying painting in Taxco, Mexico, in 1954, and even as a high school student sought to explore other cultures, when she considered becoming an exchange student in Brazil. But her exploratory and itinerant practice would be firmly seeded in this in-between year of 1957–58 in South America. That Hicks inscribes one of her notebook pages with the words "sun-filled yellow year" (fig. 12)[10] summarizes her pleasure in a time that was both catalyst and grounding for her work to follow. Hicks claims that her observations during this South America trip animate her later works, which, she says, are "flashbacks" to discoveries she made at that time.

LINES SQUARED, IDEAS BUNDLED

Hicks returned to Yale in the fall of 1958, and by the next spring had completed her MFA work in painting. With a Fribourg grant in hand to study in France in fall 1959, she

Fig. 14. Sheila Hicks, photograph of Punta Arenas, Chile, 1957. 7 1/4 x 7 1/2 in. (18.4 x 19.1 cm). "Light, shadow, sky, earth, water meet in the southern hemisphere, in the Magellan straits," notes Hicks. "This beach near the extreme southern city of Punta Arenas was inspiration for painting and drawing." Fig. 15. Sheila Hicks, *Red-Blue Painting*, 1956. Dry pigment with polymer on Masonite, 36 x 48 in. (91.4 x 121.9 cm). Collection of the artist

nevertheless headed first to Mexico after graduation, moving that summer to Mexico City, and later to Taxco el Viejo, where she married and lived on a beekeeping ranch (to which she returned after her stay in France). Hicks's initial idea for work in Mexico was a plan she had conceived before leaving Yale, which was to make a film about Félix Candela's experimental hyperbolic paraboloid constructions (a film never completed). In preparation for the film she photographed his architectural sites under construction,[11] at times turning her focus to related forms, capturing, for example, in one shot the soaring elegance of the wimples worn by nuns visiting the construction site of their future chapel (fig. 16). Once again Hicks taught (in Spanish) a basic design and color course to architecture students, in Mexico City at the Universidad Nacional Autónoma de Mexico, and she found encouragement for her weaving experimentation from artist Mathias Goeritz and architects Luis Barragán and Ricardo Legorreta. She continued weaving not only "for my own amusement but for other people too, increasing to a larger scale. I began working with [American weaver] Polly Rodriguez, who had a workshop in Taxco and with [Mexican weaver] Rufino Reyes who was from Mitla, near Oaxaca, but who would come up [to Guerrero] and sell his wares. Together we [started] working out new designs that he would help me make."[12]

Within the next two years, Hicks's work would enter New York's Museum of Modern Art (MoMA) with the acquisition in 1960 of the monochrome wool *Blue Letter*, 1959 (p. 13); she would have her first solo show—a survey of her small woven works of the past five years—at Mexico City's Antonio Souza Gallery (1961), an event that would engender her first exhibition review (by Ida Rodriguez in *Novedades*);[13] and she also exhibited her work for the first time at the Knoll showroom in Mexico City (1961). If the same types of works were exhibited in each of these three venues, the contexts and publics differed. Even more important were the venues that allowed for the presentation of Hicks's art in juxtaposition with other things, both historical and contemporary, things that otherwise would have been classified differently. In June 1963 at the Chicago Merchandise Mart's Knoll showroom, Hicks's small woven works were in dialogue with the furniture of Eero Saarinen (fig. 73). That fall and into the winter of 1964, Hicks exhibited again in Chicago, at the Art Institute, where in her first solo museum show in the United States her work was seen in galleries that also exhibited historical textiles (fig. 74).[14]

The paradigms of the showroom and the storeroom, the design showcase and the museum frame, would prove over the next decades to be more conducive than the isolated gallery exhibition to Hicks's practice. Though in some ways separate universes, Knoll and MoMA intersected in 1962 when the company gave to the museum Hicks's *White Letter* (p. 23), which was also the year of its making. But even more critical in the long run for the development of Hicks's practice would be a relationship with Knoll that contributed to her independence to be able to live and work as she chose; at Florence

Fig. 16. Sheila Hicks, photographs of Félix Candela's hyperbolic paraboloid forms for the Chapel San Vicente de Paul, with one showing nuns visiting the site of their future chapel (1959, Colonia Coyoacan, Mexico D.F., Enrique de la Mora, architect)

Opposite: fig. 17. Sheila Hicks, photograph of architect-engineer Félix Candela's forms for a chapel on a hilltop in Cuernavaca, Mexico

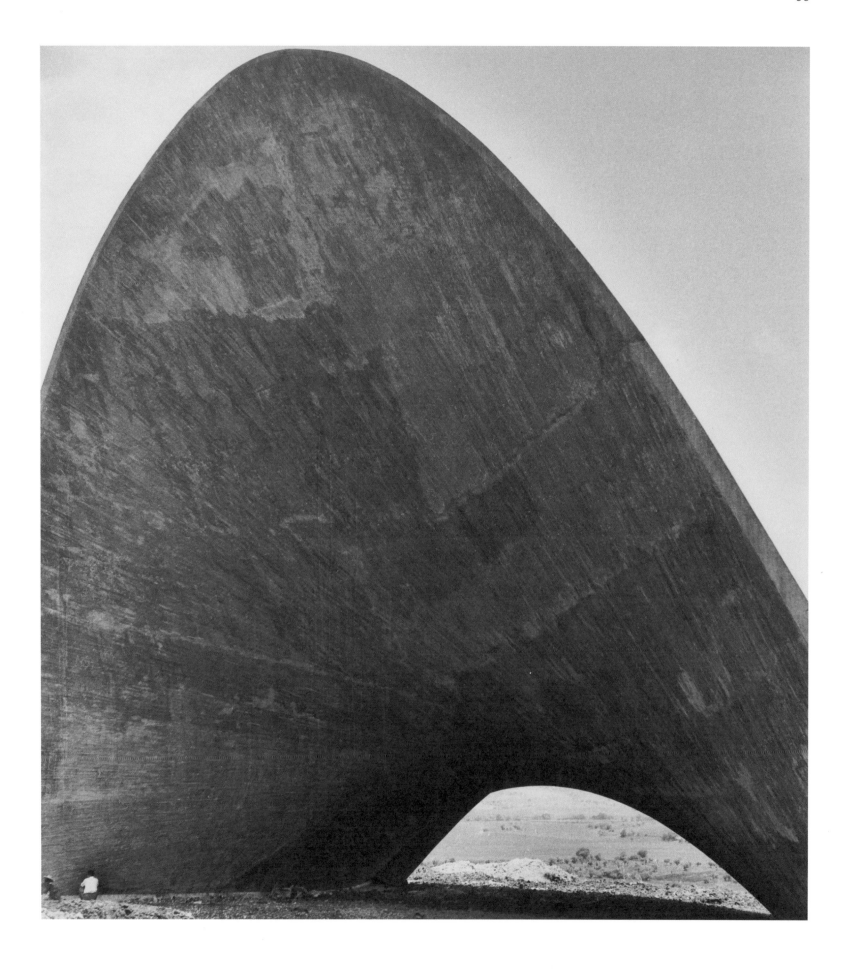

Knoll's insistence she was given a contract in January 1964 for textile design and con-
sulting on color and materials. Another cluster of Hicks's works, related to her decisive
meeting with Florence Knoll, reveals her thinking and her ways of making.

In South America Hicks had woven a piece of cloth that was inspired by an illus-
tration—*Tissus à carreaux (armature de toile) 2*—in Raoul d'Harcourt's 1934 *Les textiles
anciens du Pérou et leur techniques* (fig. 18),[15] a book that played a part in her acquaintance
with Anni Albers in New Haven, as both wanted to borrow it from the library for their
investigations of ancient textiles. To look at this illustration in detail leads us backward
and forward in time and helps in understanding the development of Hicks's work. She
reimagined its pattern of alternating squares and sequenced them within the overall field
almost self-referentially to the two-part structure of cloth: one square isolating vertical
lines, as if to declare a warp's existence, and within the next square a flow of horizontal
lines, to establish a weft's existence. Hicks used the cloth to make a suit, which she wore
to her interview with Florence Knoll (fig. 19). The pattern became one of her Knoll-
produced fabrics, *Inca* (fig. 18). She had earlier employed the structure for one of her
sample weavings in her 1957 Yale thesis, and she would also return to the motif some
forty years later for her miniature *Inca Chinchero*, 2007 (p. 208).

While Hicks would deconstruct the pattern of a grid for the embroidered seat covers
she would also make for Knoll France (pp. 30, 31)—to be used with Saarinen chairs—she
would later design and weave the multiplied square in an actual slit tapestry, *Color Alphabet*,
1988 (p. 93), which arrays its color increments like a paint company's sample chart. Seen
as a group, these reveal Hicks's consistent eye, hand, and conceptual approach over time,
attentive to but not focused primarily on an end use of what she was making.

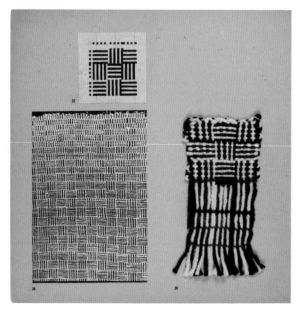 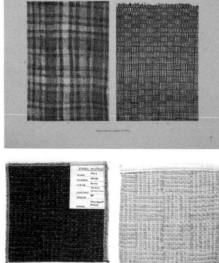

Fig. 18. The diagrammatic illustration at upper right, *"Tissus à carreaux (armature de toile),"* published in Raoul d'Harcourt's 1934 *Les textiles anciens du
Pérou et leur techniques*, inspired Hicks to develop many variations over time. She first wove it to analyze the structure for her 1957 Yale thesis (page at left);
seven months later she used the pattern to weave a textile of llama wool (far lower right).
Subsequently the artist designed *Inca* (lower center) for Knoll Associates, based on this pattern, whose subtle structure continues to be explored by Hicks;
see the miniature *Inca Chinchero*, 2007 (p. 208).
Opposite: fig. 19. Suit designed by Sheila Hicks of her hand-woven wool textile based on the square pattern of an ancient Andean textile; it was worn to her
first meeting with Florence Knoll in New York.

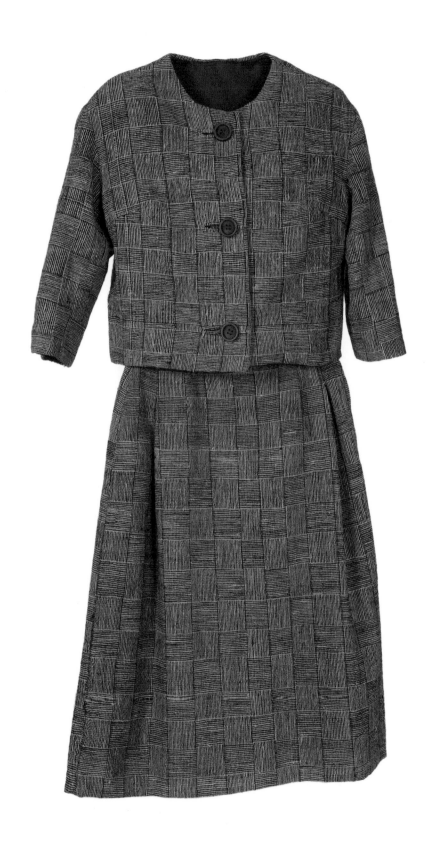

Hicks's focus on the constructed grid of textiles is seen also in various of her deconstructions: by magnifying a weave to colossal size the negative forms of the square were emphasized in *Labyrinth* (fig. 11) in an object that was at once screen, floating wall, and temporary sculpture (it was undone after its installation at the Stedelijk). For the miniature *Les Clous*, 1965–67 (p. 35), Hicks employed a found object as part of the work: a small frame used for weaving elements for a patchwork (resembling her own improvised "loom") was left in place to frame and structure the loose interlacings of a single line of linen that transforms from warp to weft, and the whole of which remains affixed to its armature, confounding, in fact, the made and the found. In yet another iteration of Hicks's addressing a found object as a base for, and to highlight, the geometries of her "weaves," in the contemporaneous *Gingembre* (p. 33) Hicks used the bamboo slats of the square form of a Japanese ginger grater as an armature through which her cotton weaves. In recent works such as *Fenêtre I*, *II*, *III*, and *IV*, all 2009 (pp. 219, 216, 217, 111), Hicks has returned again to accentuating the potential of the grid, leaving lengths of warps evident within each as contrast to the woven top and bottom edges, and giving primacy of place to a nonintervention, a technique she explored in her earliest Mexican weavings in a series titled Ventana and in *Squiggle*, c. 1963 (p. 29). In the new works, the central area is a site that exaggeratedly emphasizes both line and light, for these employ neither traditional slit-weave construction nor are they geometric forms that abstract and highlight with color the positive and negative passages of horizontals and verticals. (Compare, for example, *Vanishing Yellow*, 1964/2004 [p. 103] which is also animated with a single slit weave.) Hicks continues to address in newly complicated ways the conceptual and material force of her deconstructions as constructed form.

In this cluster of images, one can see how Hicks teases out lines of thought and particular references, with different permutations in each action, which correspond to her thoughts at each moment of return to her question, not unlike the way Kubler summarized his researches of forms over time when he used the image of a bundle: "We can imagine the flow of time as assuming the shapes of fibrous bundles ..., with each fiber corresponding to a need upon a particular theater of action, and the solution to its problems. The cultural bundles therefore consist of variegated fibrous lengths of happening, mostly long, and many brief."[16]

Hicks would also periodically and literally use the form of the bundle itself, derived from the mummy bundles and wigs (*pelucas*) she had seen and photographed in South America. She would use them as building units—some three thousand of them—for her stacked and variable repetitions that constitute *The Evolving Tapestry: He/She*, 1967–68, and several versions of *Banisteriopsis*, dating from 1965–66 to 1994; similar bundles (that she herself calls "ponytails") were included in works such as the incremental marks in a bas-relief for her first public commission in New York, *Grand Prayer Rug*, for Eero Saarinen's 1966 CBS headquarters, and for the similarly structured *Lion's Lair*, 1968

Vanishing Yellow 1964/2004

Cotton; 9½ × 8¼ IN / 24.1 × 21 CM

Private Collection

(pp. 66–67), displayed at the Georg Jensen design center in New York, later reconstructed and now in the collection of the Saint Louis Art Museum.

Hicks also has quite literally massed "variegated fibrous lengths," inspired by the strands or bundles of plaited and knotted warp ends, for the compacted lines of *Tenancingo*, 1960 (p. 17). She has wrapped the bundled fibers themselves to create long cords suspended from the ceiling and falling into the grand spill of *Trapèze de Cristobal*, 1971 (p. 79), and in a 2009 commission the horizontal flow of enveloped cords constituted bas-reliefs for the Massimo Vignelli–designed restaurant SD26 at the north end of Madison Square Park in New York (p. 220).

In 1964, from her new base in Paris, Hicks would continue to exhibit and to make her studio work as well as design projects, and she began to teach (in French). Her design work for manufacturers such as Vorwerk in Wuppertal, Germany, consisted of creating bas-reliefs using semimechanized carpet-production techniques. In association with artisan workshops, such as those of the Commonwealth Trust in the state of Kerala, India, she

Fig. 20. Sheila Hicks, *Badagara White* (detail), 1966.
Opposite: fig. 21. Sheila Hicks, photograph, Santiago, Chile, c. 1975. The undulating surface of corrugated metal of this roll-down security façade anticipates her Badagara series of cotton high-relief textiles hand-woven on the Malabar Coast in Kerala, India, from 1965 to the present.

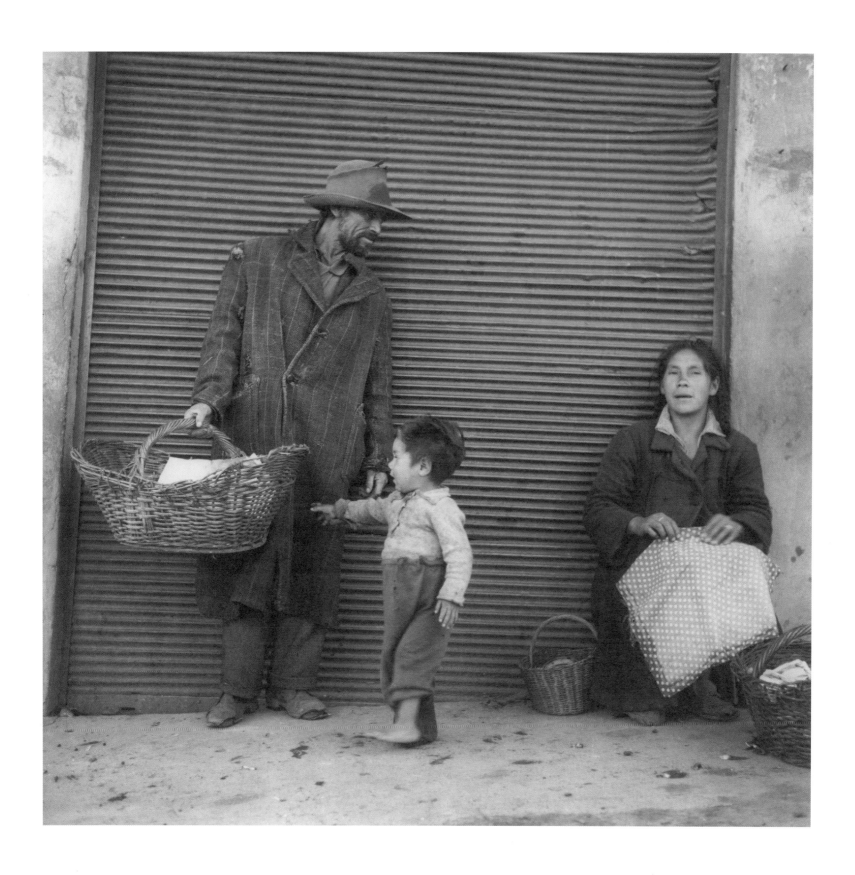

would develop hand-woven designs such as her Badagara (fig. 20) and Palghat series, in which multiple, loosely spun weft inserts created a densely rippling surface that had much in common imagistically with the corrugated steel doors she had photographed earlier (fig. 21). In constrained living quarters in Paris and working in different countries, Hicks has used her "minimes" as a laboratory for her ideas and almost as daily meditation.

MIGRATIONS: EAST FIFTY-THIRD STREET, NEW YORK, AND BEYOND

Hicks has said that her art has at various times migrated to architecture and design, and nowhere has this been more evident—and the relationships between all three more critical—than on one block of New York's East Fifty-Third Street, where at mid-block on the north side of the street is the Museum of Modern Art (MoMA), and on the south side at its western edge a new CBS headquarters was built in the 1960s. (Her work also migrated to another building on the block, to the Museum of Contemporary Crafts, when MoMA lent works from their collection to an exhibition at this neighbor.)[17] Hicks's *Grand Prayer Rug* would be hung at CBS, while its prototype, indeed catalyst, *Prayer Rug*, would enter the collection of MoMA.[18]

A lunch between MoMA's director, René d'Harnoncourt, and one of its trustees, CBS president William Paley, who asked advice for an artwork for the granite walls of the ground floor of the new building, was the genesis of the CBS commission. D'Harnoncourt sought the counsel of MoMA's Architecture and Design Department, and Mildred Constantine recommended Sheila Hicks and brought *Prayer Rug* for review, as it was then at MoMA awaiting photography for the catalog and the preview invitation of

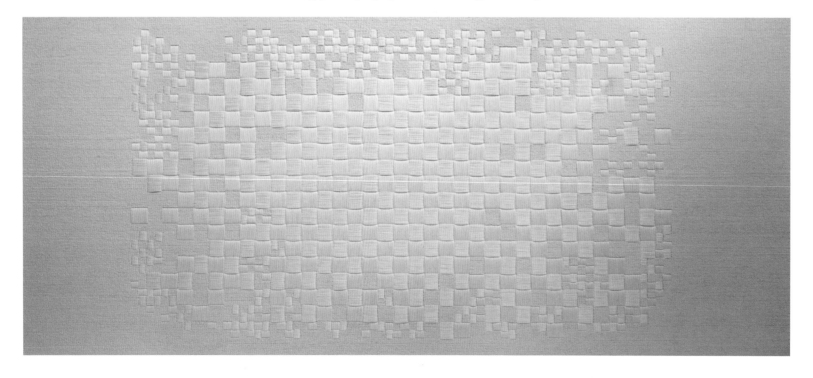

Fig. 22. Sheila Hicks, *Grand Hieroglyph*, 1967. Wool, cotton, latex, 9 x 24 ft. (274.3 x 731.5 cm). Installed on the seventh floor, George Eastman Building, Rochester Institute of Technology.

the upcoming *Wall Hangings* exhibition. Though the interior designer for the CBS build-ing, Warren Platner, had not been consulted about the Hicks commission, he was pleased with the result, which led to other collaborations, notably for the Ford Foundation (pp. 38, 39), the Georg Jensen design center (pp. 66–67), the TWA terminal at John F. Kennedy Airport, the MGIC corporate headquarters in Milwaukee (pp. 82–85),[19] and the Rochester Institute of Technology (fig. 22). These set out Hicks's lexicon for creating walls and entire rooms, not just material to be hung on a wall or in the window but rather material to create a range of varying inflections that charge their surfaces as well.

Each of these commissions enabled Hicks to explore new methods and processes, and they offered a supply of raw materials for her own studio works; there is a flow back and forth between her private investigations and the commissions. The rigor of each and the relation between them was noted by Hicks in her comment "If you're a soloist and you practice every day and experiment, when someone invites you to become part of an opera or an orchestra, you don't lose your personal voice."[20] To create large-scale works, Hicks created yet another kind of ensemble, her own atelier in Paris, where, with the help of assistants (and at times renting extra space to accommodate even grander scale), she could fabricate the components of site-specific projects. In opening a studio, first on quai des Grands Augustins, then in the Passage Dauphine and rue des Bourdonnais, and later in the cour de Rohan, Hicks began to formulate a way of working with colleagues who, like her, had young children and whose family and school schedules could be balanced with the requirements of the studio. To help facilitate Hicks's intermittent teaching and designing in such artisan workshops as the Commonwealth Trust hand-weaving center in India, she trained her interns and apprentices in the atelier to adhere to her professional standards and to meet the requirements of the studio without compromise. At the same time, she insisted that they be paid rather than work for free. Many who began working for her more than forty years ago have continued until retirement. Eva Zeibekis, who joined the atelier in 1967, for example, continues to play an important role in the daily life of the studio.

Commissioned site-works can be subject to the vagaries of taste, the ongoing life of a building, and possible transfer of ownership. At some point, Hicks's *Grand Prayer Rug* was no longer on display at the CBS building, as its ground floor spaces were occupied by different tenants, and it ended up at an obscure auction, where a bidder recognized it as a work by Hicks, and an important one in her oeuvre (pp. 62, 63). It was subsequently acquired by the Philadelphia Museum of Art, where now it is not in isolation but rather is contextualized by other works, similar to the way its prototype is now displayed at the Museum of Modern Art. Likewise, Hicks's commission for Amsterdam's Schiphol Airport was de-installed when the international lounge expanded and is now part of the collec-tion of the Stedelijk Museum; her bas-relief for the entrance of IBM building at Paris's La Grand Arche lives on beyond its original site, part of it now installed in the library of Lawrenceville School in Princeton, New Jersey (p. 86); and her AT&T commission has

been reconfigured in two new versions, at the Institute for Advanced Studies in Princeton and the Smithsonian's Renwick Gallery in Washington, D.C. (pp. 122–23). Hicks's works for the Ford Foundation have had a fate congruent with their original commissions, as the building's interior as well as its exterior have been designated as historic landmarks. Other works have been reutilized by the artist for reasons of her own. Early on, she could afford neither to store her works if they were unsold after exhibition, nor to replenish her supply of materials continually. In recuperating her own materials, she could, as she says, "carry on the process of investigation and expand and transform them while exploring their potential."

Hicks first showed in the *Biennale Internationale de la Tapisserie* in Lausanne in 1967. As she recalls, the biennale's director, Pierre Pauli, paid her an unannounced visit at her rue de Seine studio and invited her to exhibit. When she accepted, Hicks notes, it "was a bit like putting my finger in the dike and being unable to get it out afterwards, because I became absorbed into the story of what is a tapestry, what is not a tapestry, what is the new tapestry, what is the tapestry that leaves the wall and jumps into space—three-dimensional. And I became a pioneer in the new tapestry movement.… I was confronted by Madame [Marie] Cuttoli at the biennale, who was a patron of tapestry and who actually caused many cartoons of artists like Picasso and Léger to be woven into tapestries, and I remember she approached me at the opening ceremony and said to me, 'I hear you are exhibiting a tapestry'—in French. And I answered, 'Oui, Madame. Voilà. Voici ma tapisserie.' And she said, 'I, I do not see a tapestry.'[21]

Hicks's entry in the sixth Lausanne biennale in 1973, *L'Epouse préférée occupe ses nuits (The Preferred Wife Occupies Her Nights)*, 1972, has yet another story (fig. 54). It was a bas-relief (four hundred centimeters in diameter) with an element that spilled into the gallery space, and while it was a sculpture created of textile materials, and the main part was positioned on the wall where it occupied the space of tapestry, it was not "a tapestry." Yet, it was widely published and appeared in the 1996 edition of the *Encyclopaedia Universalis* in the "Tapestry" entry as the only example of the "new tapestry" of the 1960s and '70s.[22] Nonetheless, this work, fixed in time in the *Encyclopaedia*, no longer exists, for it was long ago taken apart by Hicks, who used its materials to create several other works.[23] Then, in the 1977 biennale, Hicks exhibited tons of laundry borrowed from the Lausanne Hospital, which also caused a controversy, but a later

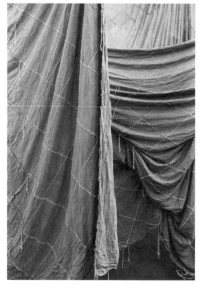

Fig. 23. Sheila Hicks, *Le Démeloir* (detail), 1977. Linen. As installed in *Sheila Hicks: Tons and Masses*, Lunds Konstall, Lund, Sweden, 1978

Fig. 24. The catalog accompanying *Sheila Hicks: Tons and Masses*, Lunds Konstall, 1978, designed by John Melin. The catalog's long narrow paper bands are literally bound. The strips are rolled and then wrapped and tied with a newborn's cotton "birth girdle" or "belly" band, which were also used in one of Hicks's installations for the exhibition.

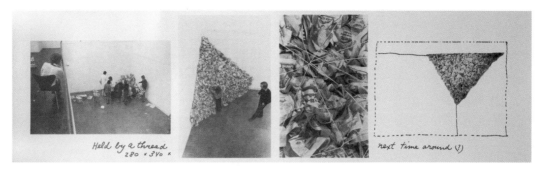

biennale catalog called it "a turning point,"[24] and she herself continued to use masses of appropriated laundry and clothing on the ground or in suspension for temporary installations (as she also used stacks of bundled and crumpled newsprint (fig. 25).

As part of her practice and to continue to expand ideas over time, Hicks has made works in various versions, just as she did with *L'Epouse préférée occupe ses nuits*. By twisting long skeins of linen and flax in "S" and "Z" directions and anchoring them on a firm background, she has explored light and shadow in single-panel works, in multiple panels, and, in 1992–93, in a nine-foot-high by 338-foot-wide frieze at the Fuji City Cultural Center in Japan, where it spans multiple entrances to the theater (pp. 140, 141. She has accommodated architects when they redesign a space in which one of her works is installed, preferring another version of hers to a work by a different designer, and she has made variations for specific sites over the course of many years, such as her raw silk bas-relief panels for the interiors of eighteen Air France 747 aircraft (pp. 74, 75).

ARTISTE/ARTISANE?

In 1977, the Musée des Arts Décoratifs in Paris mounted an exhibition that employed a question as its title: *Artiste/Artisane?* The show and its catalog focused on debate itself in order to widen the terrain of made things about which this debate might be played out. In the opening essay Georges Duby, a professor at the Collège de France, used the tympanum of the Autun Cathedral by Gislebertus (c. 1125), arguably the oldest of signed sculptures in European art, as the jumping-off point: "Had he worked with his mind or his hands? Is this a work of hands *and* mind? Hands alone? Not one such distinction is at the base of the hierarchy we establish unconsciously when we choose between these two words: artisan, artist?"[25]

Works by Alexander Calder, Christo, Sheila Hicks, Jacqueline Monnier, Jean-Paul Riopelle, Antoni Tapiés, and Claude Viallat, among others, were presented in the exhibition along with a selection of anonymous works or works signed before 1900. These came from various collections of industrial design and the collections of the Musée des Arts Décoratifs and were placed in correspondence with minerals and fossils to create "des jeux de mirroirs et d'interferences." Popular arts, including toys as well as sculpted canes and personal crucifixes, were included within the category *Oeuvres de tendresse et de souvenir* (objects of tenderness and memory). Within the grouping *Oeuvres de patience* were a *Tablier indéfiniment reprisé par une grand-mère* (an apron endlessly repaired by

Fig. 25. A page from the 1978 Lund catalog *Sheila Hicks: Tons and Masses*, showing the installation *Held by a Thread*, 1978, of twine and crumpled newsprint, installed in a corner of the Lunds Konsthall.

a grandmother), and *Paire de chaussettes reprisés par une Carmélite* and *Drap reprisé par une Carmélite* (respectively, a pair of socks and a sheet, mended by a Carmelite). The latter two were lent to the exhibition by Sheila Hicks, but rather than presented as isolated examples they were offered as found objects reclaimed—and part of the oeuvre of the artist. These were exhibited along with Hicks's hand-twisted skeins of cotton and linen for *75 mouchoirs (75 Handkerchiefs)*, 1976, and *150 mouchoirs (150 Handkerchiefs)*, 1976.

Just as wool and cotton were widely available in Mexico, linen was abundant in France, and so Hicks began to use this material when she moved there in 1964. In France she also began to incorporate found objects such as shoelaces, collars, and hat bands into her work (pp. 14, 27), and she visited flea markets and *brocantes*, where she found such stray materials. They were complemented by found objects particularly notable for their reparation. Hicks's offerings of mended things in *Artiste/Artisane?* in fact, confirm and in some ways also confound the exhibition's premises. For though these were artisanal works, her conceptual reclamation of these objects into the realm of artwork signaled that the exhibition's fundamental question was not the neat binary choice between artist or artisan—rather, that the history of twentieth-century art had widened the territory to incorporate one kind of thing into the field of another.

In the tradition of naming, claiming, and reorienting found objects, her darned socks and sheets fall in some sense within the conceptual art tradition of Duchamp's bottle rack and bicycle wheel but differ from those "nonoptical" choices, as they are not industrially fabricated and Hicks has chosen these things as much for their incidents and marks as for their overall forms. Further, it is something far different to resite a thing that once wrapped body parts. This gives the Carmelite objects the kind of detail in construction that Hicks has always sought and also the kind of surface incident that bears a strong relation to the *tachisme* of French abstraction and the interruptions and improvisatory yet structural facts of her own miniatures. In placing a pair of socks in isolation as one of her miniatures, Hicks used doubling to highlight their reclamation and, at the same time, offered a riposte to the very notion of compare-and-contrast art history lessons.

Hicks's use of recuperated materials is the basis of many of her works and often the subject of her workshops, such as the UNESCO design workshop she led in Capetown, South Africa. Among the objects made by the participants were:

> *toys, receptacles, and textiles. We set the goal that the things we fabricated had to serve a purpose and while they could be fanciful they needed to be useful and functional. Tourist markets were not the primary target. They might come into play eventually but only after we were satisfied that the creations met with their own high standards. Often we used modest materials (classified, by some, as waste) and with them invented imaginative and original designs: newsprint—crushed and coiled—became baskets; string, rags and vines intertwined became carrying devices; seeds, pods, dried roots became jewelry and adornment; tinfoil and tin cans, nails, staples, and wire became*

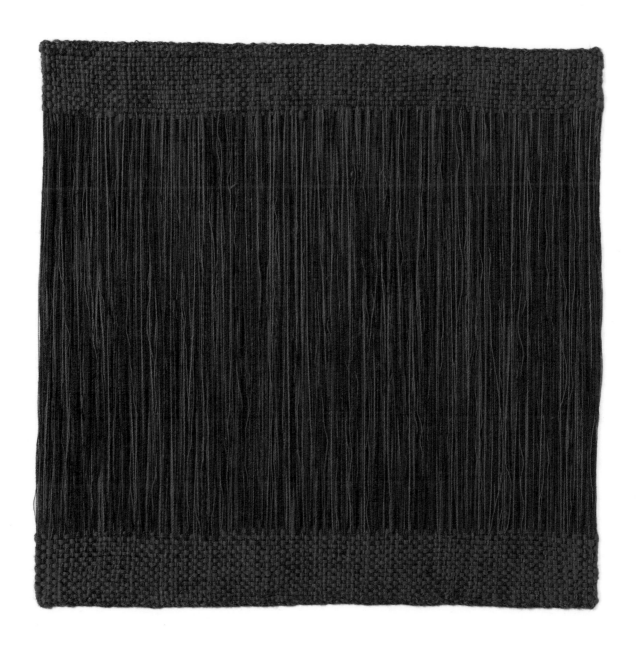

Fenêtre IV 2009
Wool; 11 × 11¼ IN / 27.9 × 28.6 CM
Private collection

*door, roof, and window panels; husks, and worn out clothes were refashioned and
filled with grain, beans or sand to become dolls and toys. In a city like Cape Town
we could scavenge and recycle dozens of materials—all free. And color was also free.
We invented tools to work with the different "finds" and sometimes the improvised
tools, in themselves, were curious forms and shapes. I have always been fascinated
with the way repaired and mended goods show ingenuity, and the workshop in South
Africa opened my eyes to ways of exploring that I continue to plumb.*[26]

MATERIALS AND MAKERS

For her miniatures Hicks has employed materials as diverse as transparent noodles, pieces
of slate, razor clam shells, shirt collars, collected sample skeins of embroidery threads,
rubber bands, shoelaces, and Carmelite-darned socks (pp. 76, 131, 14, 126), while her
temporary installations have incorporated thousands of hospital "girdles"—birth bands
for newborns (p. 125)—baby shirts, blue nurses' blouses, and khaki army shirts (fig. 27),
as well the wool sheets darned by Carmelite nuns (figs. 53, 57). In these, Hicks's found
objects embed a memory of use, by unnamed but multiple individuals, and invoke the
use of textiles historically from birth until death: the bands that bind the infant, healing
its separation from its mother; the uniform of a soldier, implying a soldier possibly felled;
the sheet used in a hospital that supports the living and that could be a shroud in waiting,
a potential wrap for the dead. These too may be seen as "objects of patience," not only
in their reclamation and in some cases their reparation, but also as Hicks re-tends them
in their construction as artworks, whether displayed in the Konsthall of Lund, Sweden;
a window of a department store in Amsterdam; or an art gallery in Paris (fig. 26). These
works embed the secrets of their initial use, and for Hicks they are everyday treasures
that are re-valued as they are seen anew.

Hicks has titled an ongoing series *Trésors et Secrets*. Around a core of something

found—a piece of clothing or other object—she has
wrapped still other layers of cloth and repetitively cir-
cumscribed and bound it with threads to form things
that are as tangible as rocks (she has also called these
"soft stones") and as mysterious as Man Ray's *Enigma
of Isidore Ducasse*, 1920, in which he supposedly
secreted a sewing machine under a blanket and tied
the bundle with string. Some of these small sculp-
tures, as groupings of multiple parts, are in the col-
lections of the Museum of Fine Arts, Boston, the Mint
Museum in Charlotte, the Stedelijk Museum, New
York's Museum of Art and Design, the Minneapolis
Institute of Art, and the Philadelphia Museum; they

Fig. 26. Sheila Hicks, *Baby Time Again*. Installation of readymade baby shirts at Galerie Suzy Langlois, boulevard Saint Germain, Paris, France, May–June,
1978, 157 1/2 x 275 5/8 x 157 1/2 in. (400 x 700 x 400 cm).
opposite: Fig. 27. Sheila Hicks, *Back from the Front*, 1980. Khaki soldier's cotton shirts. Installation at the Israel Museum, Jerusalem, 1980. The shirts were
returned to the army at the end of the exhibition.

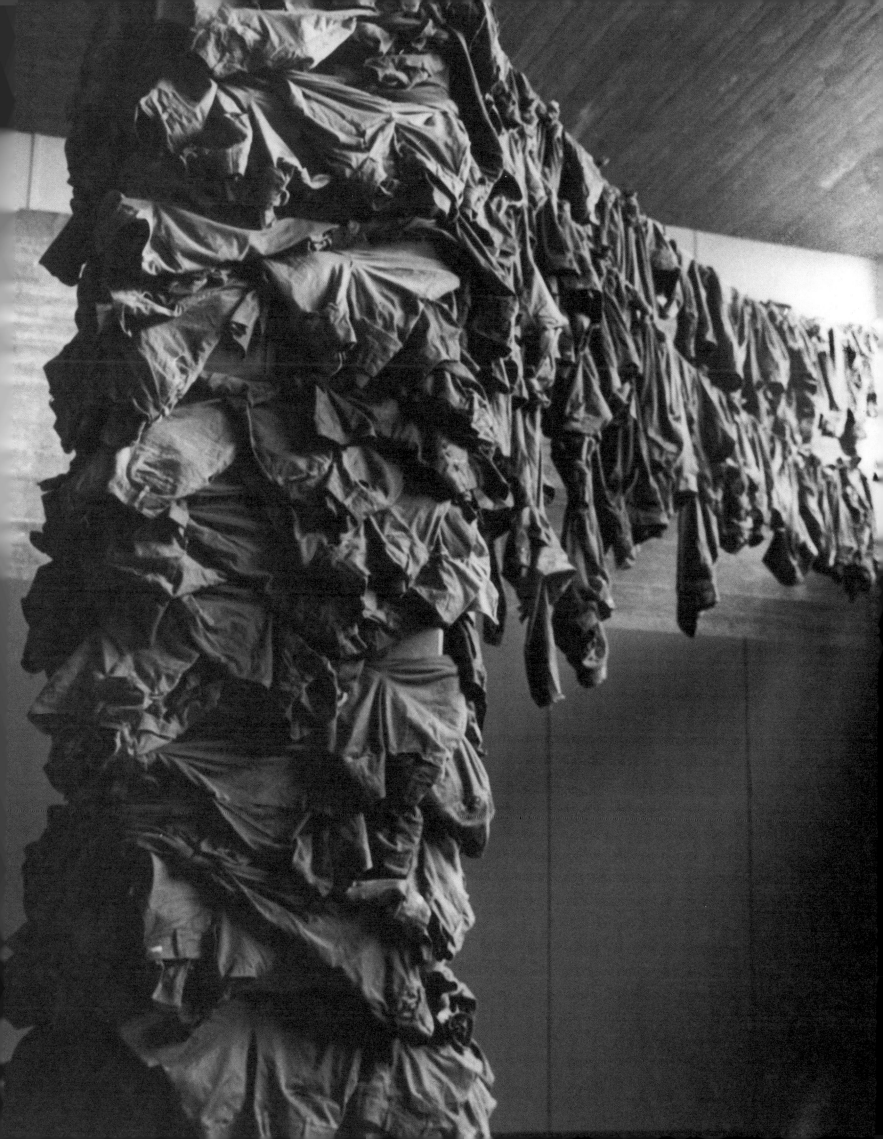

also served as the prototypes for the large-scale sculpture *Eight Sumo Balls*, 2009, which is suspended from the ceiling for her commission at the restaurant SD26 (fig. 28; p. 221), and as a prototype for a functional hassock.

Among the many issues raised in the exhibition and catalog essays for *Artiste/ Artisane?* are those of a signature or anonymity; of a multiple or unique piece; of how orientation may change the understanding of an object. Except for her drawings and photographs, Hicks has rarely signed one of her works. Further, her commercial textiles, like those produced by the Commonwealth Trust workshop, such as the Badagara or Kerala series, are issued anonymously (and have in fact led to other widely circulated anonymous works by other makers, such as the Badagara-like textile that served as upholstery in the Metroliner train between Boston and Washington, D.C.). That some Hicks works are made as unique objects while others appear in multiple variations (and in reconstructions of earlier works) means that her practice manifests issues of equivalence and not hierarchy dependent on number.

Related are the variations in presentation of Hicks's works that depend on "the bundle" as a construction unit and/or the repetition of overall forms, in works such as the *Banisteriopsis* pieces and *The Evolving Tapestry: He/She*, which can be reconfigured for each installation. Another critical point addressed in the *Artiste/Artisane?* exhibition concerned the reorientation of a form from its original plane of presentation in altering its perception apart from its techniques of making. Jean-Marie Lhôte focused on the radical difference achieved when a plate, for example, is reoriented from its plane of tabletop to the plane of a wall—opening yet another statement/ question: "It is the same object! Is it the same object?"[27] These questions have been a part of Hicks's work since the 1960s. In reorienting a rug to a wall, as she did with her Prayer Rug series, the resulting bas-relief echoes its original inspiration and making but now embodies a larger history (and possible prior uses) as part of its content. The darned soles of *Footprints (Rose)*, 1978 (p. 126), no longer flat to the ground and hidden inside *sabots* (wooden clogs), are now hung vertically on the wall, directly confronting the spectator in the gallery.

Fig. 28. Sheila Hicks among elements of *Eight Sumo Balls*, 2009. Linen, cotton, synthetic raffia, metallic fiber, diameter of each sculpture from 33 1/2 in. (85 cm) to 41 5/16 in. (105 cm), installation dimensions variable. Commissioned by Vignelli Associates for SD26 Restaurant & Wine Bar, New York (see p. 221)

TRANSNATIONAL

The 1980s was a challenging decade for Hicks. It witnessed few museum and gallery exhibitions relative to the years preceding or following, but it was a period that allows one to see the artist's great range in making public her ideas and her artworks, now at times independently of each other. She would work in publishing in New York, plan and create artworks for the campus of the King Saud University in Riyadh, Saudi Arabia, and, at the end of the decade, after an accident that left her temporarily wheelchair-bound, she would travel to yet another place, Japan, where she would receive architectural commissions executed during the next decade.

At the beginning of the 1980s, from her base in Paris, Hicks took on the jobs of publisher and editor of *American Fabrics and Fashions* (*AFF*, fig. 86), a textile-industry trade publication to which she had contributed since the 1960s, and she began a regular commute to New York as a result. The work would also extend her explorations of techniques and materials, and help cross-pollinate information offered to manufacturers with texts by anthropologists, poets, and others whom Hicks found inspiring, innovative, or just plain curious. (See, for example, "Kwakiutl Indian Potlatch and Museum Opening," or "A History of Men's Underwear: State of the Art.")[28] And while this may seem a divergence from her studio art-making or architectural commissions, it involved creating a publication from many elements informed by the same interests: particularly her dialogue with historians and anthropologists, such as George Kubler, Claude Lévi-Strauss (who wrote an early text on her woven works),[29] and William C. Sturtevant (with whom she planned an exhibition of historical textiles drawn from the collections of the Smithsonian). Her background as photographer, researcher, and writer came to the fore, as did her early studies of typography and design. In *AFF* she would include actual samples that went beyond swatches, including a linen sock or braided copper tape, for example. But publishing and especially the materials of publishing had long been parts of her practice, whether writing for architecture journals from Mexico; using recycled book pages, as in the early miniature *Serpent à Sonnette*, 1965 (p. 32); or recuperating newsprint in her work, as well as the stacks of newspapers in her installation *Tons and Masses* at the Lunds Konsthall, and the coiled baskets made from twisted sheets of newsprint.

By the mid-1980s Hicks would take on a project that would occupy her for three years and take her away from her New York publishing endeavor. In working as the consultant on art projects for the new King Saud University (fig. 90), Hicks returned to her earliest interest in architecture and at the same time built monumental textile works, including woven tapestries, based on her photographs and drawings for *Palm* and *Sandscape*, for which she painted full-scale cartoons.

It was, in fact, Hicks's understanding of and attraction to architecture that set the conditions for her large-scale commissions: an understanding of the language of architecture and architects, and a willingness to take part in those conversations over long

periods of time. One could say that this also goes back to her studies at Yale and to her South American travels in 1957–58, when she discovered architecture commissions by Alexander Calder, Jean Arp, and Fernand Léger at the then-new university in Caracas. She recalls that this "was the first time I'd seen contemporary architecture [with] monumental artworks. The auditorium was by [Alexander] Calder with all kinds of acoustical baffles in curvilinear shapes and bright colors. They were attached to the walls and the ceiling. That was a big eye-opener."[30] There was also her role as a teacher, initially of design to young architects in Chile and Mexico and later of design workshops in Fontainebleau, Morocco, and South Africa.

Key to Hicks's many architectural commissions is an engagement with space and the way her work might animate and focus it, and with working with materials and symbols that, while international in scope, are both personal and local. For her collaboration with Ricardo Legorreta in Yucatan, Mexico, for the Hotel Camino Real in 1975, Hicks used the local cactus material *henquén* to create three hundred wall hangings. For *Doncho* (stage curtain) in Kiryu, Japan (pp. 150–51), Hicks worked with the newest technologies for materials that would dazzle and entice an audience as well as define the separation of space, as she had earlier done with the bas-relief lush golden "embroideries" that illuminated the Ford Foundation walls. A sense of dynamic serenity, to use an oxymoron, is at the essence of these public spaces, whether she is making them for a room of an AIDS hospice on Rivington Street in downtown Manhattan, the federal courtrooms in New York City's Foley Square, or the grand public space that is Target's corporate headquarters in Minneapolis.

For Target's *May I Have This Dance?* 2002–3, Hicks's sources were a small brass knot that had been a paperweight on her father's desk (fig. 29), an exuberant Breton circle dance captured on a postcard (fig. 30), and an idea of circling developed from pastel drawings to create inviting, animated forms that would energize such a vast space—a signal of Hicks's way of working not only to "surprise and awaken curiosity" but also "to startle."[31] Other works take on different tenors appropriate to the spaces, whether a courthouse or a hospice, "as a background and to accompany the theater of life, in a way—to enrich it and to give a fallback, almost secure, position for people who find themselves in frightening, traumatic situations."[32]

WIDENING THE GATE

Color is the basis for all of Hicks's works—even when white—and while her sources might be the light on the Pont Neuf at night, the resulting colors could be those forged by intense heat for a new steel fiber she helped to invent with textile designer Junichi Arai for the Bridgestone Tire Company in Japan. The resulting colored stainless steel fiber has a wide range of uses and qualities. As the artist says, "Soft, strong, and pliable, it could be used outdoors as well as indoors. I am always looking for new materials and to push

their logic to try to make them do miraculous things."[33] That these could be used at large scale, for situations requiring fireproofing, was part of its potential; that it also could be used in Hicks's miniatures, where it changes "the hand" of the woven cloth itself, is also part of its marvel (p. 148).

To say that Hicks has worked across several domains is an understatement yet necessary to recognizing the radical expansion of the domains for art-making that have occurred in the course of her career. At the end of the 1950s, when the artist and the studio as an arena of action were privileged above all other places of art-making, Hicks's commissioned work led her to new experiments with materials and forms, and also, in a circular fashion, back to the studio. For the next two decades, when for many artists commercial endeavors were seen as a sideline, or mere support (and an invisible one, at that), for the real artwork going on in the studio, Hicks, in concert with architects and interior designers, completed commissions that, for her, were equivalent to the sculptural masses and ephemeral installations she exhibited in art galleries and museums in the expressing of her vision.

Figs. 29, 30. Sources of inspiration for Hicks's sculpture *May I Have This Dance?* 2002–3 (following), a knotted brass paperweight and a postcard of a traditional Breton dance performance (Danses Gwenedour)

Fig. 31: Installation of Hicks's *May I Have This Dance?* 2002–3, commissioned by Target Corporation for its headquarters in Minneapolis. See also the dustjacket, which illustrates the commission's components as viewed in the courtyard of the artist's studio in the cour de Rohan, Paris, 2004. The work was de-installed in 2010 in consultation with the artist when the client redesigned the space. In an ongoing partnership with Target, Hicks reconfigures the elements enabling the work to be exhibited differently in various contexts.

Whether orchestrating a publication or the artworks for an entire university, making public projects for concert halls or hotels, or creating sculptural forms that hug the floor or extend from the wall; whether weaving on an upside-down table in her garden in Mexico or stitching marks for works on paper; whether organizing a design school in a former prison in South Africa or working with schoolchildren in Milwaukee or design students at the Rhode Island School of Design; whether exhibiting her works in the *vitrines* of Hermes in Paris or Tokyo, in the showrooms of Knoll in Chicago or Mexico City, or in museums and galleries on every continent but Antarctica—in each of the domains in which she works, and whichever of her channels of investigation are examined, Sheila Hicks has drawn on the history of things seen, including a range of historical and quotidian textiles, and her own reimaginings of their possibilities.

This process is consistent with Kubler's ideas, notably his understanding of "widening the gate" in regard to "the durability of forms over time" and "the fullness of things." In particular, he wrote of a strategy that "requires the widening of the gate until more messages can enter. The gate is bounded by our means of perception, and these, as we have seen through the history of art, can be enlarged repeatedly by the successive modes of sensing which artists devise for us."[34] Hicks, in her innovations in many domains, has chosen to perpetually widen the gate, and in so doing has illuminated the many forms an artist's attention may take and the diverse places in which they may be seen.

NOTES

1. Hicks's "channels of investigation" drawing appeared first in a publication accompanying her exhibition at Modern Master Tapestries, New York, in 1974. She later translated it into French. For this exhibition she has drawn it anew, again beginning c. 1973–74 and updating to the present. Sheila Hicks characterized her works as "unbiased weaves," in conversation with this catalog's contributors and publisher in 2009, leading to its use for this essay's title. Unattributed quotes come from my conversations with the artist.
2. Sheila Hicks's daybooks at times appear more journal-like, at others more sketchbook-like. They are also amended with postcards, newspaper clippings, and bits of sample materials.
3. George Kubler, *The Shape of Time: Remarks on the History of Things* (New Haven: Yale University Press, 1962), 1.
4. Linda Norden argues that in Eva Hesse's textile designs for Boris Kroll between January and spring 1960—and the materials for designing and producing them (the grid for plotting design and the card and string system for working Jacquard looms)—one can see many of the motifs and materials that she would use in her later sculptural works. But, as Norden writes, "to my knowledge, she never subsequently alluded to the job, or to any aspect of what she might have learned from it. Her descriptions of the tensions she experienced—competition with fellow-employees, as well as fear of not producing adequate work—indicate that she dismissed this job as 'work,' part of supporting herself, but not part of her art." The references in her journal to the Kroll firm, "known for its arts-and-crafts-quality upholstery, drapery, and tapestry," were cryptic, and it was Sheila Hicks who deciphered them for Norden. Linda Norden, "Getting to Ick," in *Eva Hesse: A Retrospective*, ed. Helen Cooper (New Haven: Yale University Art Gallery and Yale University Press, 1992), 61–62 and n36. Both Hesse and Hicks were transfer students studying painting at the Yale School of Art, and both were students of Rico Lebrun and favored students of Josef Albers. Hesse later found the twine, rope, and other materials for her breakthrough bas-relief sculptures while working at a studio in a former textile factory in Germany. Hicks would later find the techniques and materials for what would be her signature bas-reliefs at the Vorwerk-Arterior plant in Germany, a maker of carpets.
5. Sculptor Fred Sandback (1943–2003) worked exclusively with strands of yarn to define his architectonic installations. Those drawing on "craft" materials as well as those associated with decorative arts and furnishings include Liza Lou (b. 1969), who beads her environments, and Robert Gober (b. 1954), who, for individual sculptures or for elements of his installations, has created a woven basket, printed fabrics for a cushion and slipcover, and a wedding

dress, as well as furniture and bedding.

6. Sarat Maharaj, "Textile Art—Who Are You?" in *Reinventing Textiles: Gender and Identity*, Vol. 2, ed. Janis Jefferies (Winchester, UK: Telos Art, 2001), 7.

7. Sheila Hicks, interview with Monique Lévi-Strauss, February 3, 2004, Archives of American Art, Smithsonian Institution, www.aaa.si.edu/collections/oralhistories/transcripts/hicks04feb.htm.

8. In 1957, a recently discovered frozen mummy of a young girl was a subject of wide discussion in Chile, and its publication in the bulletin of the Natural History Museum enabled Hicks to further investigate ancient textiles and the ways they were made. *La momia del cerro el plomo*, Apartado del Boletin del Museo Nacional de Historia Natural, Tomo XXVII. Sheila Hicks Archives, Paris.

9. The Museo de Bellas Artes exhibition was in fact constituted of two simultaneous solo shows, installed in concert with each other. Hicks's paintings were based on things she had observed, especially landscapes, and Sergio Larrain's large photographs, as Hicks notes, were of "rocks, seaweed, and algae [and other] things we'd seen in Chiloe—wooden houses built on stilts in the water, and when the water was down we'd walk under the houses and see the shells and debris washing up making incredible designs." Larrain enlarged the images to sizes as large as Hicks's paintings. "When I saw how large they were—they were probably 70 inches high—we didn't hang the paintings or the photos on the walls, but I think that's what people liked about the show. We made . . . little braces that we could attach to the bottoms to each side of the panels. That way they were freestanding. The paintings and photographs danced in the room, facing each other at angles." Hicks interview with M. Lévi-Strauss.

10. Entry (undated) made during the last week of February 1958. Sheila Hicks Archives, Paris.

11. Sheila Hicks published her architectural photos in New York–based magazines. Her article on Candela's church of San Antonio de las Huertas in Mexico City, "Wizard of the Shells," was published in *Architectural Forum*, November 1959. She also published in *Horizons*, *Architectural Record*, and *Progressive Architecture*.

12. Hicks interview with M. Lévi-Strauss.

13. Ida [Chacha] Rodriguez, "La magia del arte textile," in *Mexico en la Cultura, Novedades*, March 26, 1961.

14. *The Textiles of Sheila Hicks*, at the Art Institute of Chicago, November 26, 1963–January 5, 1964, was curated by Allen Wardwell, acting curator of decorative arts and primitive art at the Art Institute. Press release; Sheila Hicks Archives, Paris.

15. Raoul d'Harcourt, *Les textiles anciens du Pérou et leurs techniques* (Paris: Editions d'art et d'histoire, 1934). Republished with an introduction by Sheila Hicks and Sophie Desrosiers (Paris: Flammarion and Musée du Quai Branley, 2008).

16. Kubler, *The Shape of Time*, 122.

17. Though Hicks initially had not wanted to participate in a show grouping her work under "crafts," and declined to participate in the exhibition *Woven Forms*, which was organized by the Museum of Contemporary Crafts, a work of hers in the Museum of Modern Art's collection was lent. Visiting the show toward the end of its run (March 22–May 12, 1963), Hicks discovered the works of Lenore Tawney and Claire Zeisler and would meet both artists and show with them over subsequent years.

18. *Prayer Rug*, fabricated at Vorwerk, a carpet maker with whom Hicks also had a design contract, was made, as the artist notes, "by using a power driven hand-gun to shoot heavy wool yarn through a tough cotton duck cloth support and then irregularly hand cutting the resulting projections of material, before spot wrapping it into clusters to vary the surface."

19. The Chicago firm of Skidmore, Owings & Merrill designed the MGIC headquarters (formerly Morgan Guaranty Insurance Company, now MGIC Investment Corporation).

20. Hicks interview with M. Lévi-Strauss.

21. Hicks interview with M. Lévi-Strauss.

22. *Encyclopaedia Universalis* (Paris: Encyclopaedia Universalis Editeur Paris, 1996), s.v. "Tapis." According to the artist, the original *L'Epouse préférée occupe ses nuits* illustrated in the *Encyclopaedia* was initially shown at the Grand Palais in Paris in 1972 prior to being exhibited in the 1973 Lausanne biennale.

23. Two other versions of *L'Epouse préférée occupe ses nuits* were made. In addition, a fragment of the original appeared in Paris's Clignancourt flea market, c. 2006–7, and was acquired by a California collector. When Hicks was at the Getty Conservation Institute giving a lecture, the collector asked Hicks to authenticate it and restore it, which she did. As part of her practice, Hicks has emphasized ongoing forms and their various embodiments, so that an idea continues even though any one particular manifestation may not. She has recognized surviving elements from original objects as works in their own right, not as fragments, and has reconfigured the elements of some works into two or more objects, emphasizing the modular concept of their making.

24. See catalog for the *16e Biennale Internationale de la Tapisserie de Lausanne*, 1995 (commissioners Christian Bernard, Alanna Heiss, Toni Stooss).

25. Georges Duby, "D'une ségrégation venue du fond des âges," in *Artiste/Artisane?* (Paris: Musée des Art Décoratifs, 1977), 7.

26. Hicks interview with M. Lévi-Strauss.

27. Jean-Marie Lhôte, "Signatures," in *Artiste/Artisane?*, 50.

28. William C. Sturtevant and Peter Macnair, "Kwakiutl Indian Potlatch and Museum Opening," *American Fabrics and Fashions*, no. 122 (Spring 1981): 80–82; Helen Benedict, "A History of Men's Underwear, State of the Art," *American Fabrics and Fashions*, nos. 124/125 (January-February-March 1982): 89–94.

29. Claude Lévi-Strauss contributed articles to *Le Tapis mural* (Rabat, 1974) and *Douze ans d'art contemporain en France* (Paris, 1972).

30. Hicks interview with M. Lévi-Strauss.

31. Hicks interview with M. Lévi-Strauss.

32. Hicks interview with M. Lévi-Strauss.

33. Hicks interview with M. Lévi-Strauss.

34. Kubler, *The Shape of Time*, 124.

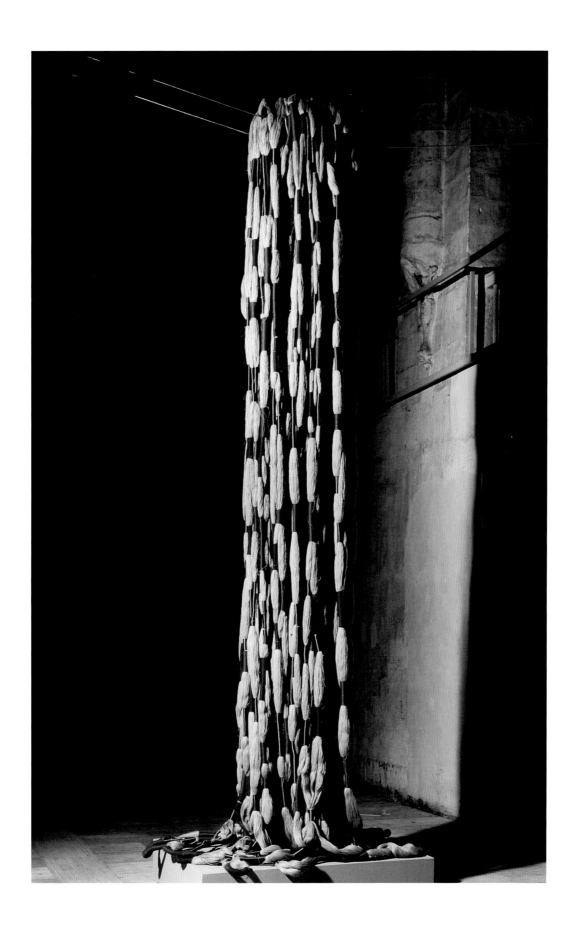

Lianes Nantaises 1973
Linen, wool, silk, synthetic raffia; 120 × 70 ɪɴ / 304.8 × 177.8 ᴄᴍ
Musée Jean Lurçat et de la Tapisserie Contemporaine, dépôt du Château des Ducs de Bretagne

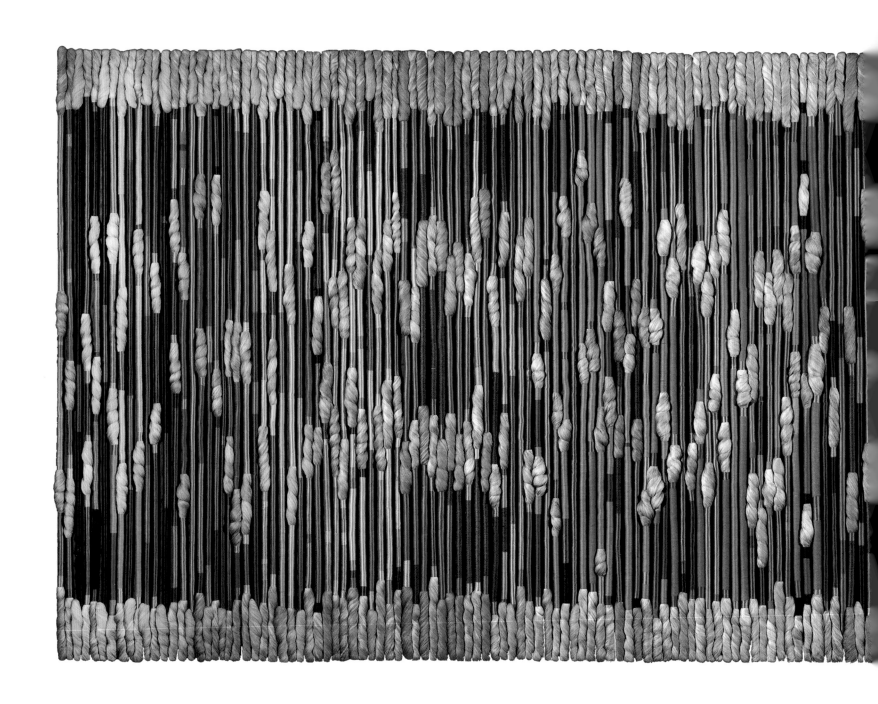

The Silk Rainforest c. 1975

Silk, linen, cotton; 96 × 270 × 3 in / 243.8 × 685.8 × 7.6 cm

Renwick Gallery of The Smithsonian American Art Museum (Gift of Bob and Lynn Johnston through Educational Ventures, Inc.)

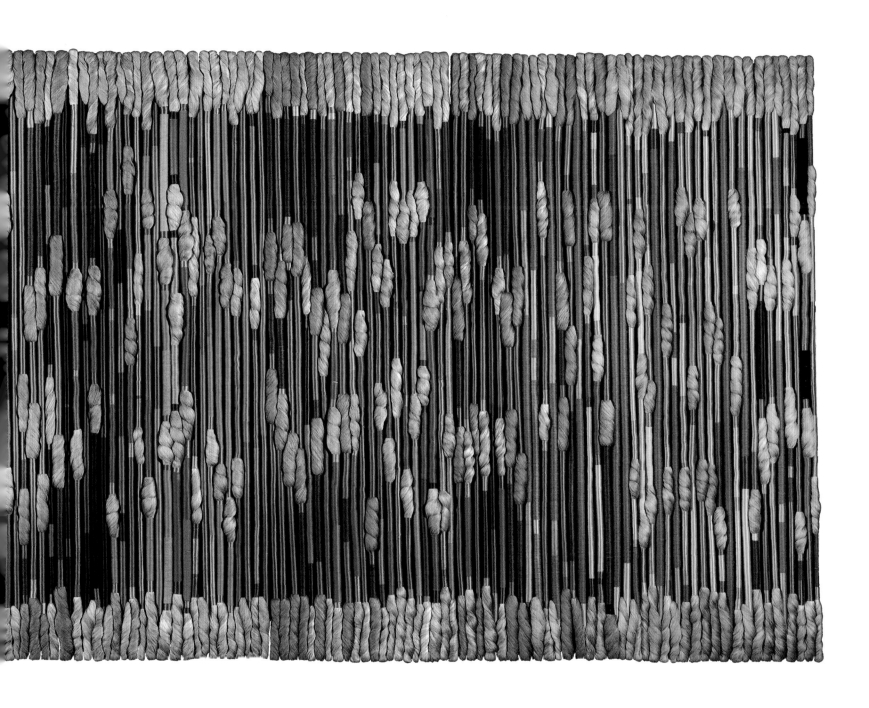

Raining Baby Bands 1978
Cotton; dimensions variable
Private collection

As installed in *Sheila Hicks: Flag Art*, Gallery/Gallery, Kyoto, 1982.

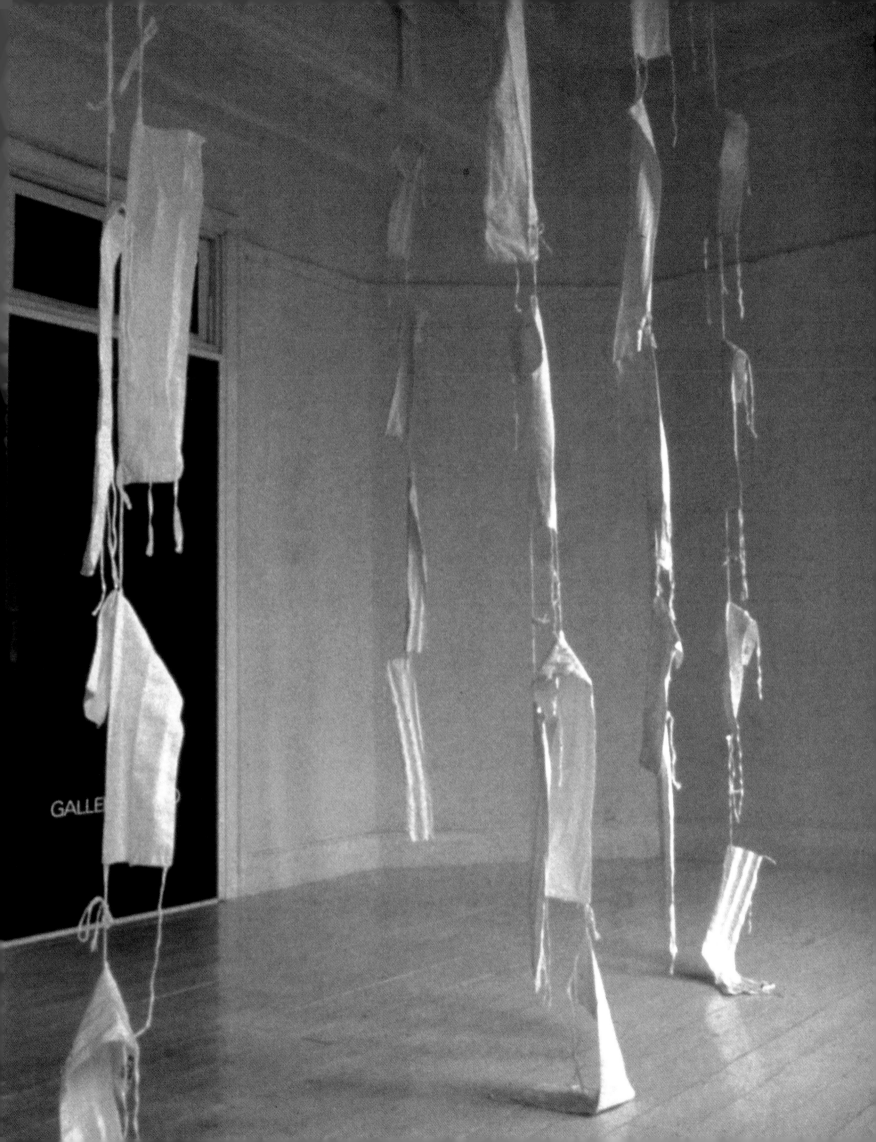

Footprints (Rose) 1978
Linen, cotton; 8 × 3½ in / 20.3 × 8.9 cm
Private collection

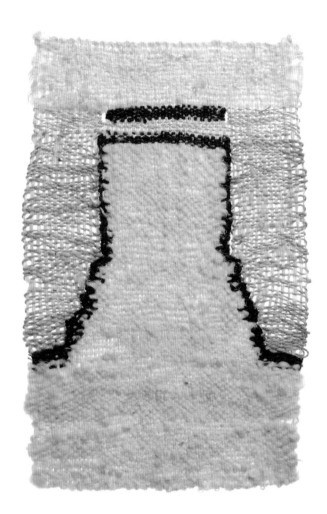

Le Phare de l'Iroise 1978

Wool, linen; 9⅝ × 6¼ IN / 24.5 × 15.9 CM

Collection of Caroline and Roger Ford

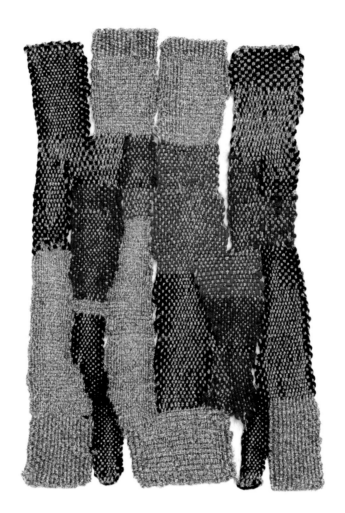

Olympic Bravery 1979

Synthetic metallic fiber, wool; 9 1/16 × 5 7/8 IN / 23 × 15 CM

Cooper-Hewitt, National Design Museum, Smithsonian Institution (Museum purchase from General Acquisitions Endowment Fund, 2006-13-3)

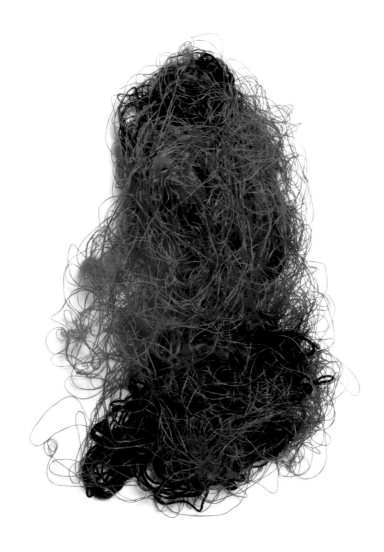

The Silk Invitation 1983

Silk, cotton; 10¼ × 7¾ IN / 26 × 19.7 CM

Private collection (courtesy of Cristina Grajales Gallery)

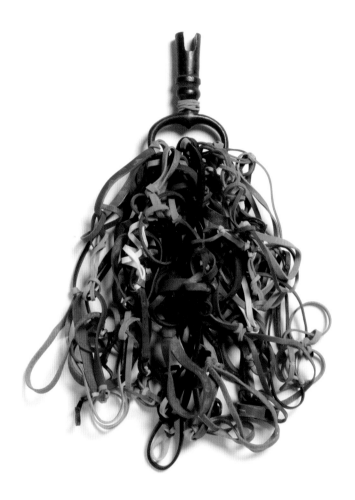

La Clef 1988
Rubber bands, metal key; 9½ × 6 in / 24.1 × 15.2 cm
Private collection

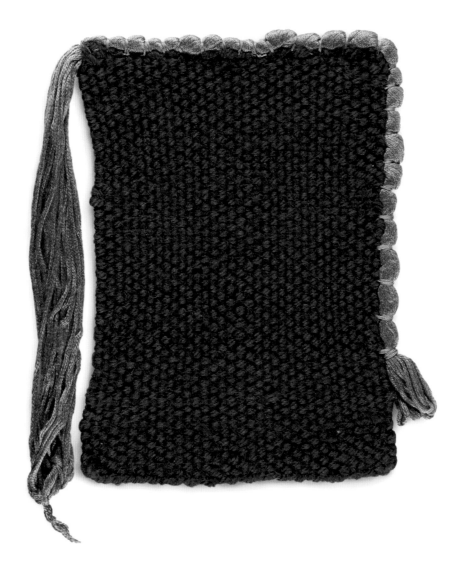

Self-Portrait on a Blue Day (Miniatuurweefsel [Miniature Textile]) 1987
Wool, silk; 7 1/16 × 5 1/8 in / 18 × 13 cm
Stedelijk Museum, Amsterdam

Isadora 1988
Linen; 9 × 6 in / 22.9 × 15.2 cm
Private collection

Les Etoiles 1989
Handmade paper; diptych
Private collection

Nuage 1990

Choma; 8 1/16 × 6 11/16 IN / 20.5 × 17 см

Cooper-Hewitt, National Design Museum, Smithsonian Institution (Gift of Anonymous Donor, 2006-14-9)

Loosely Speaking 1988

Linen; 10 × 6 in / 25.4 × 15.2 cm

Private collection

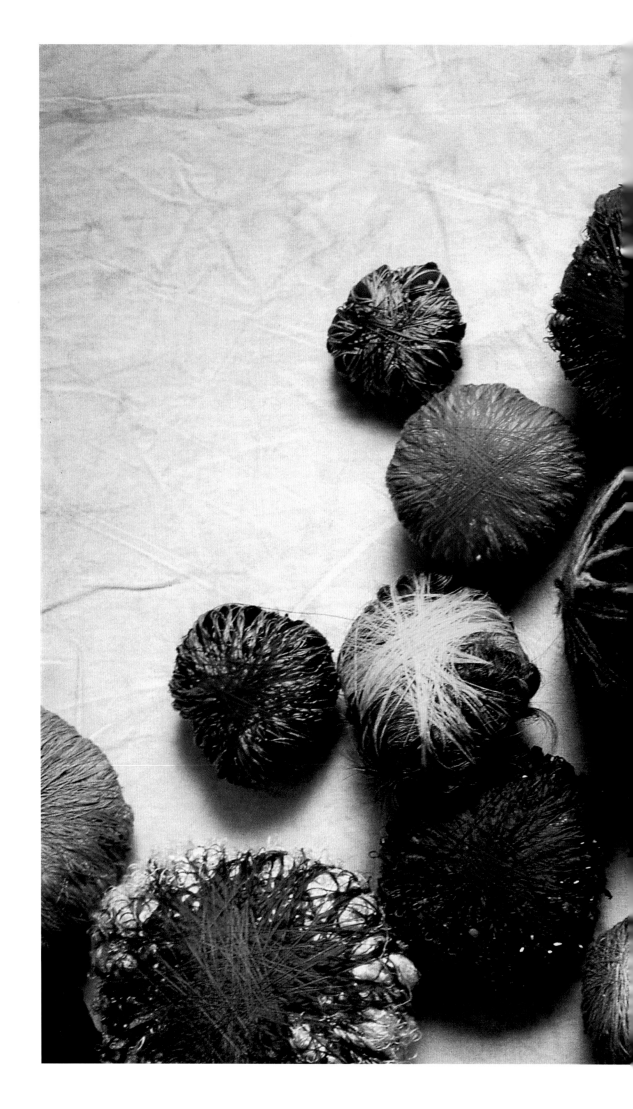

Trésors et Secrets 1990–95
Found materials; dimensions variable
Private collection

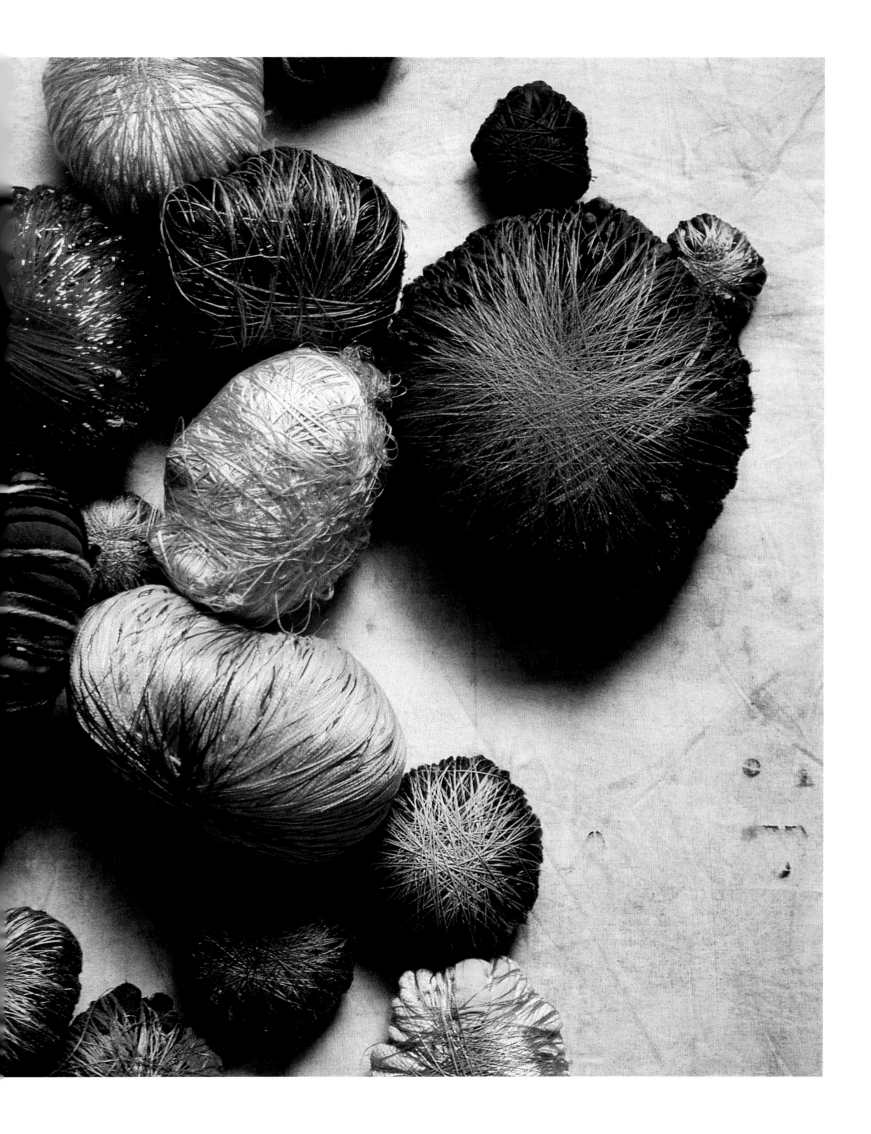

Four Seasons of Mount Fuji 1992–93
Commission for Fuji City Cultural Center, Japan
Linen; 102⅜ IN X 338 FT / 260 CM X 103 M

Components for work laid out in cour de Rohan, Paris.

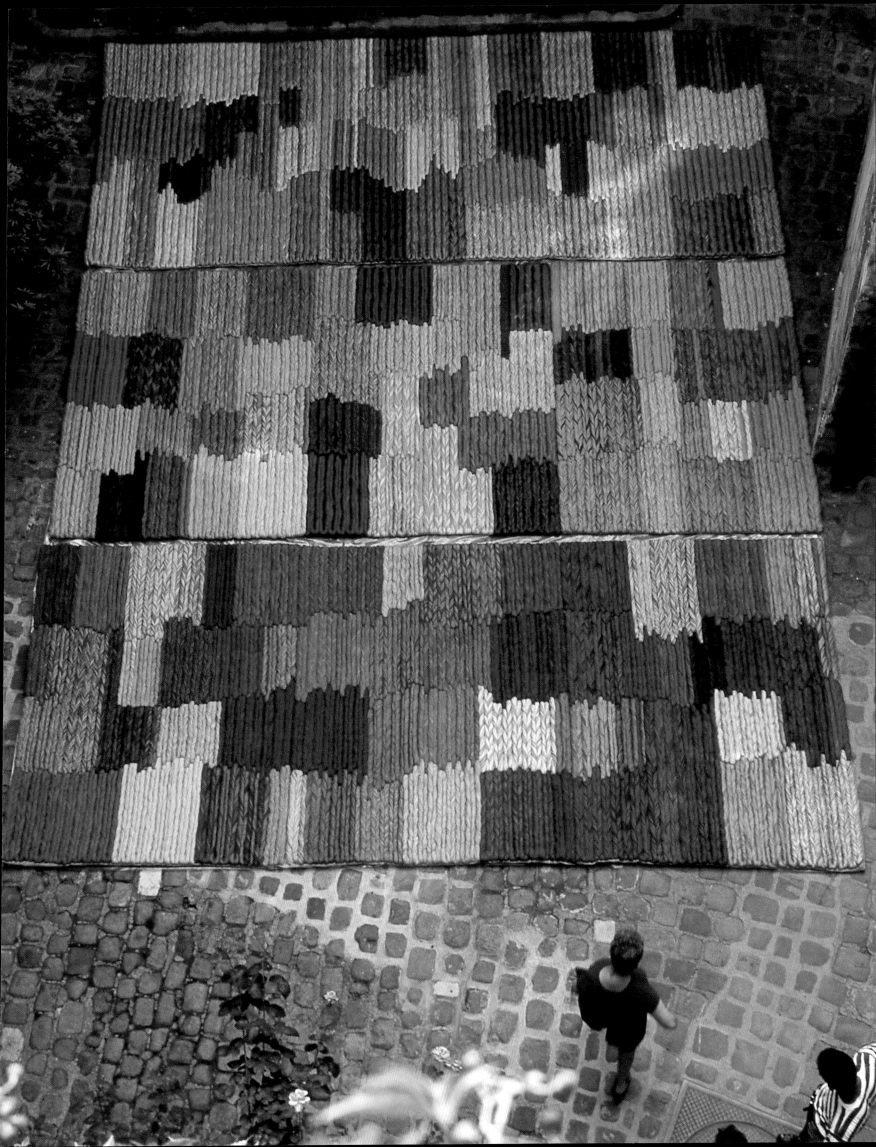

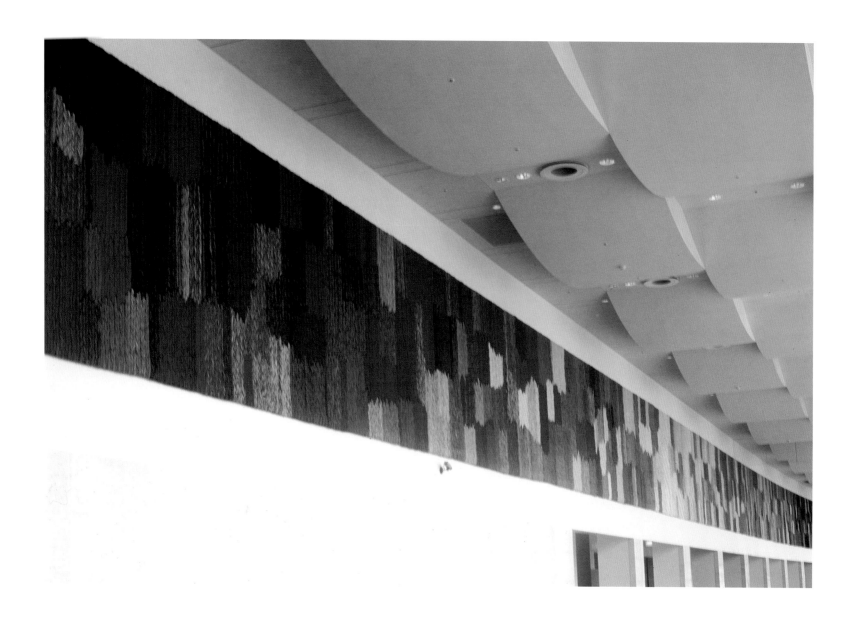

Views of the installation, above the theater doors

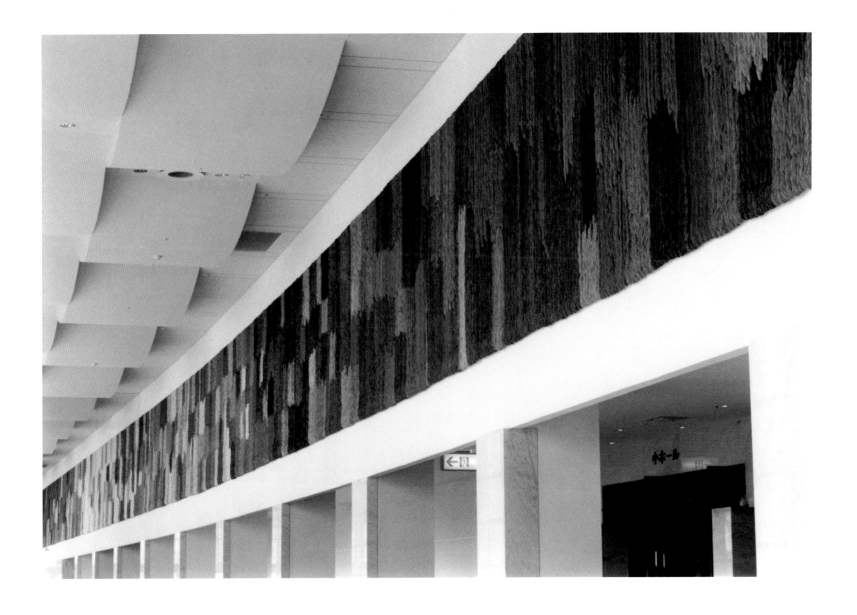

Battle of Kearney 1993

Paper, linen; 14⁹⁄₁₆ × 19⁵⁄₁₆ IN / 37 × 49 см

Private collection

Battle of Lexington 1993

Paper, linen; 14⁹⁄₁₆ × 19⁵⁄₁₆ IN / 37 × 49 см

Private collection

Battle of Lincoln 1993

Paper, linen; 14⁹⁄₁₆ × 19⁵⁄₁₆ ɪɴ / 37 × 49 ᴄᴍ

Private collection

Battle of Omaha 1993

Paper, linen; 14⁹⁄₁₆ × 19⁵⁄₁₆ ɪɴ / 37 × 49 ᴄᴍ

Private collection

Study for Convergence, Hermes 1996

Linen; 41¾ × 41¾ in / 106 × 106 см

Private collection

Cooper-Hewitt, National Design Museum, Smithsonian Institution (Museum purchase
from General Acquisitions Endowment Fund, 2006-13-9-a,b)

opposite

Installation view of *Menhir*, 1998–2004 (foreground), and two untitled drawings,
2001, in *Entrelacs de Sheila Hicks*, Passage de Retz, Paris, 2007

Rapprochement 1998
Stainless steel fiber; 9½ × 5¾ IN / 24.1 × 14.6 CM each

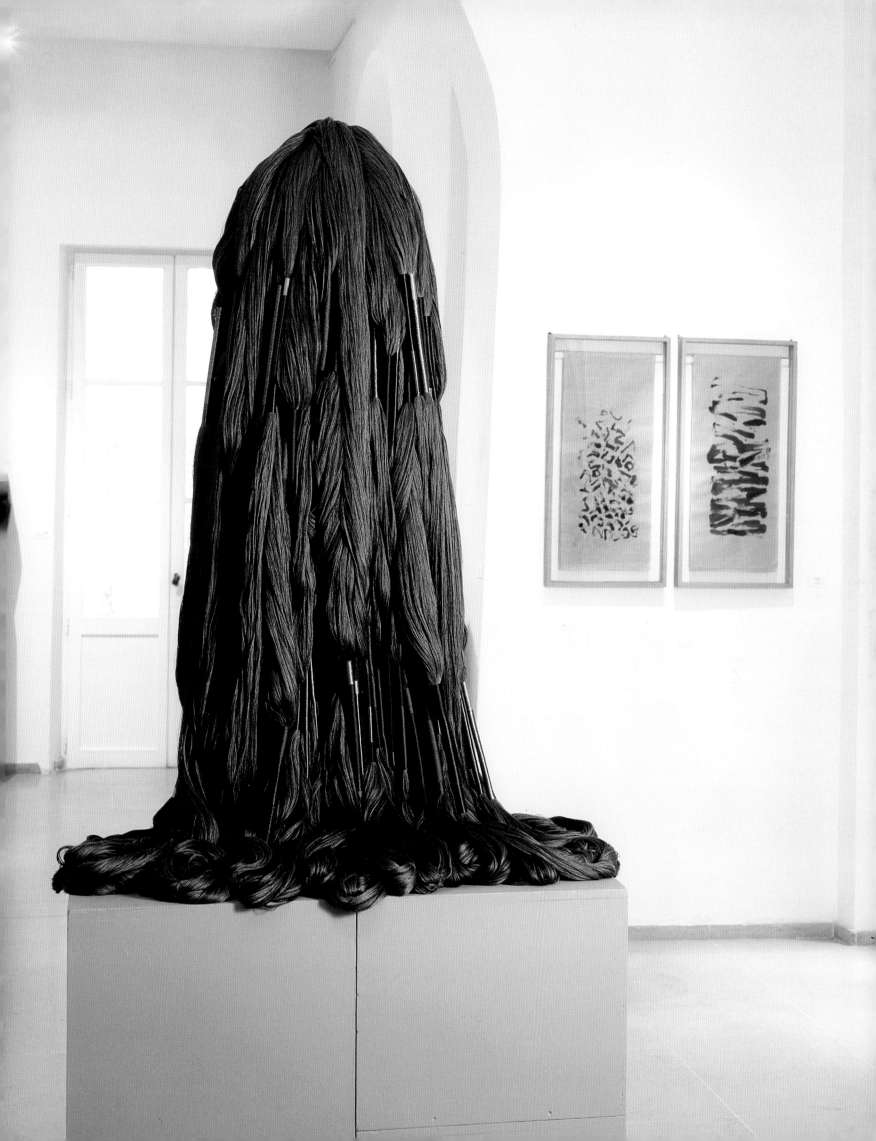

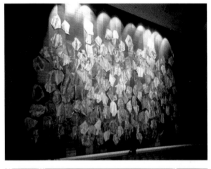

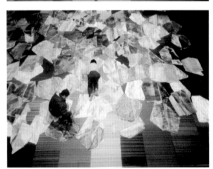

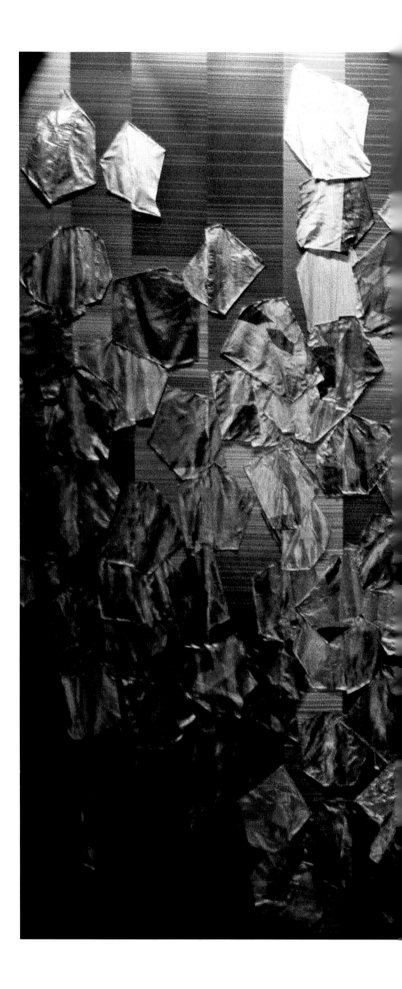

Doncho (stage curtain) 2001
Commission for Kiryu Cultural Center, Gunma, Japan
Architects: Sakakura Associates, Tokyo
Technical advisor: Junichi Arai; technical assistant: Taeko Baba
Polyester; 37 FT 8¾ IN × 68 FT 10¾ IN, / 11.5 × 21 M

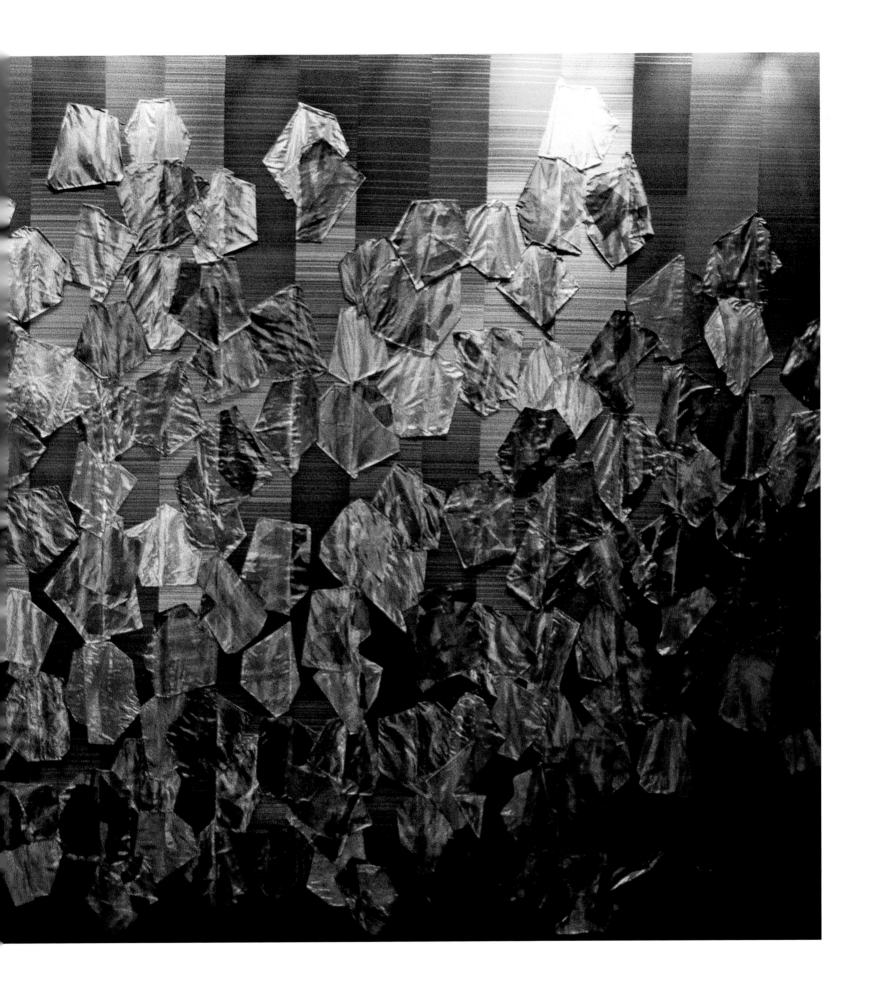

WHITNEY CHADWICK

Ancient Lines and Modernist Cubes

Flying from North Africa to Paris, Sheila Hicks posed a question to herself. "What is my work?" she asked in a journal entry. "It is not easy to explain because I invent as I go along.... I have studied painting, sculpture, photography and drawing, but my strongest attraction is to textiles. I make a kind of textile art. I develop environments, fabricate thread objects, weave textiles, build up soft sculptures, bas-reliefs, and I design and make functional things from thread. I often make a statement about my feelings regarding the world using textiles as my language."[1]

Hicks has characterized her artistic trajectory as one of "connecting the dots."[2] In her case the dots mark the adventurous spirit and passionate curiosity that propelled her into a global odyssey well before the term "transnational" gained art world currency. At Yale in the 1950s, Hicks studied painting with Josef Albers, whose disciplined Bauhaus-based methodology dispatched the core of Cézanne's modernism to a generation of post–World War II American artists that included Robert Rauschenberg, Joseph Rafael, Kenneth Noland, Irving Petlin, and Eva Hesse, among others.[3] Hicks's works honor the rich history of ancient textile cultures and that of twentieth-century modernist art and architecture with their vanguard spirit and embrace of industrial progress, rapid change, and the language of abstraction. Combining the rigor of European constructivism with a profoundly sensuous response to forms and materials, Hick's works are both optical and tactile. They reiterate weaving's pliability and a temporality that is emphatically embedded in repetition. Even as her works draw on modernism's legacy, they challenge its cultural exclusiveness and its privileging of painting, sculpture, and the nonrelational object over media identified with the corporeal and artisanal traditions. Engaging with art-critical discourses centered on the roles of the grid and the two-dimensional plane in abstract art—whether drawn, painted, sculpted, or woven—they defy categorization.

Opposite: fig. 32. Sheila Hicks, photograph, Chonchi, Chiloe, Chile, 1957. "By looking through the viewfinder of a reflex camera to change perspective, I not only found a point of view within my photographs but also the approach I took to form-making. By looking upward through the supporting wood stilts I worked with diminishing perspective, and later carried this into the descending tubular cords that are assembled to form works such as *Bamian* (p. 69), *The Principal Wife* (p. 73), and *Trapèze de Cristobal* (p. 79)."

And they erode boundaries that structure western European and North American histori-
cal assumptions about relationships between modernism, contemporary art, craft, and
non-European visual cultures.[4]

LINEAR EXCURSIONS AND UNBIASED WEAVES: 1957–64

Sheila Hicks was two years out of art school when her solo exhibition *Tejidos* opened
in September 1961 at the Galeria Antonio Souza in Mexico City. Unframed and tacked
directly to the gallery's white walls singly and in small groups, her weavings and wrapped
objects articulated a clear relationship between the structural complexity of their pre-
Incaic influences and the contemporary integration of form and color that underlay
Albers's Bauhaus teaching. A comparison of photographs of her 1958 painting exhibition
in Chile and her 1959 MFA exhibition of paintings and weavings (fig. 8) with the Souza
exhibition two years later reveals the importance of her shift from painting, in which
the brushstrokes optically "wove" color, to weaving's structural integration of color and
texture physically embedded within the material and gesture (p. 22).[5]

Blue Letter, 1959 (p. 13), is one of a series of early monochromatic weavings in
which a single continuous strand of yarn, used as both warp and weft, results in a double-
sided weave with four finished selvages. Each filament is inserted by hand, a process that
Hicks has related to writing a sentence word by word, with the raised cipherlike glyphs
floating above the flatness of the planar grid while at the same time replicating it as a
visual field. This work, along with related early weavings, originated in the young art-
ist's curiosity about how the Mesoamerican textiles she first saw in art historian George
Kubler's slide lectures had been made.[6] A subsequent period of research, analysis, and
experimentation proved instrumental in fostering the close relationship between the ten-
sion of the weave and the movements of hand and body that remain central to Hicks's
artistic practice. "I have a project related to linguistics," she later observed. "The idea is
to take a single pliable element—in this case, of course, a single thread, comparable to a
thread of language—and to demonstrate, as you might weave ideas around a theme, the
most that can be done with it from both the constructed and the sensuous sense. Because
this is a medium where you can be both intellectual and sensuous at the same time."[7]

If art for Albers stemmed from "the discrepancy between physical fact and psy-
chic effect," Hicks instead thought of herself as pushing "the boundaries of the material
through the exercise of technique without losing sight of the structural principles of both."[8]
Albers's teaching has often been characterized in terms of a rigid application of Bauhaus
principles. Yet the exercises he assigned his students consistently challenged them to rei-
magine the boundaries of a material's properties (standing a sheet of paper on its edge
rather than laying it flat, for example), or subjecting the grid to "rearrangement" exercises
in which structural and spatial changes are made by cutting and bending wire screening
to introduce spatial effects that respect the material's flatness (fig. 34). He also liberated

Opposite: fig. 33. Sheila Hicks, photographs from Machu Picchu, Peru. Left: carved steps in Machu Picchu, 1958. Right: Huayna Picchu visible across the valley
from Machu Picchu, 1957. Hicks's standing, linen pile-up sculpture is based on the shapes of the mountains in this region.

 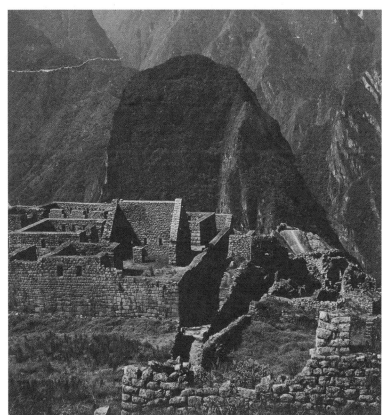

abstraction from painting and sculpture, continually reinforcing Walter Gropius's insistence that "there is no essential difference between the artist and the craftsman."[9]

Hicks's interest in a "semantics" of weaving was stimulated by art historian George Kubler's lectures on Mesoamerica. In them he mapped the argument that would appear in *The Shape of Time: Remarks on the History of Things*, published in 1962. Kubler's rejection of historicism and formal sequencing, along with his stress on material culture rather than "fine arts" objects, led him to an investigation of classes of objects in order to emphasize the structures and taxonomies of historical change.[10] This radical reformulation of the familiar paradigms of Enlightenment history would have a significant impact on a number of American artists—from Robert Smithson and Donald Judd to Hicks—all of whom sought ways to break free of developmental style–based thinking during the 1960s. Hicks has credited Kubler as a major influence on her thinking about material culture, and his thought played a significant role in what she calls an "ongoing methodology in my form-making." The system of classification that results, with its focus on structural relationships rather than on artistic progressions such as early, middle, and late, centers around categories ("closed," "open," "blocked," and "ephemeral" compositions) and series (Hieroglyph, Cord, Slit, Cascade, Mound, Laundry, Tapestry, etc.).

Yale, with its emphasis on research and analysis, encouraged Hicks to clarify and articulate her ideas. Albers's design exercises, Kubler's art history, and Louis Kahn's mastery of the relationship between materials, structure, and texture in architecture provided a rich ground on which she would continue to draw.[11] But Yale also gave her, as she later said, "everything to fight against." Anxious to escape New Haven's gray winters, and determined to renegotiate the fine line between academic learning and indoctrination, she left for South America with a Fulbright grant to Chile.[12]

Left: fig. 34. Josef Albers (1888–1976), *Structural Constellation*, 1953. Incised Bakelite, 17 1/8 x 22 5/8 in. (43.5 x 57.5 cm). Addison Gallery of American Art, Phillips Academy, Andover, Massachusetts (Gift of Mr. and Mrs. Charles H. Sawyer, 1991.161).
Right: fig. 35. Gego (1912–1994), Untitled, 1960. Ink on paper, 18 15/64 x 16 7/64 in. (46.3 x 40.9 cm).
Opposite: fig. 36. Ferdinand Bosch, photograph of Sheila Hicks working on *Solferino Tacubaya* (p. 21) in Taxco el Viejo, Guerrero, Mexico, 1960–61. On the wall are two sweaters she knitted for her daughter. At upper left is one of her "Letter" weavings; below it are several wrapped cord works.

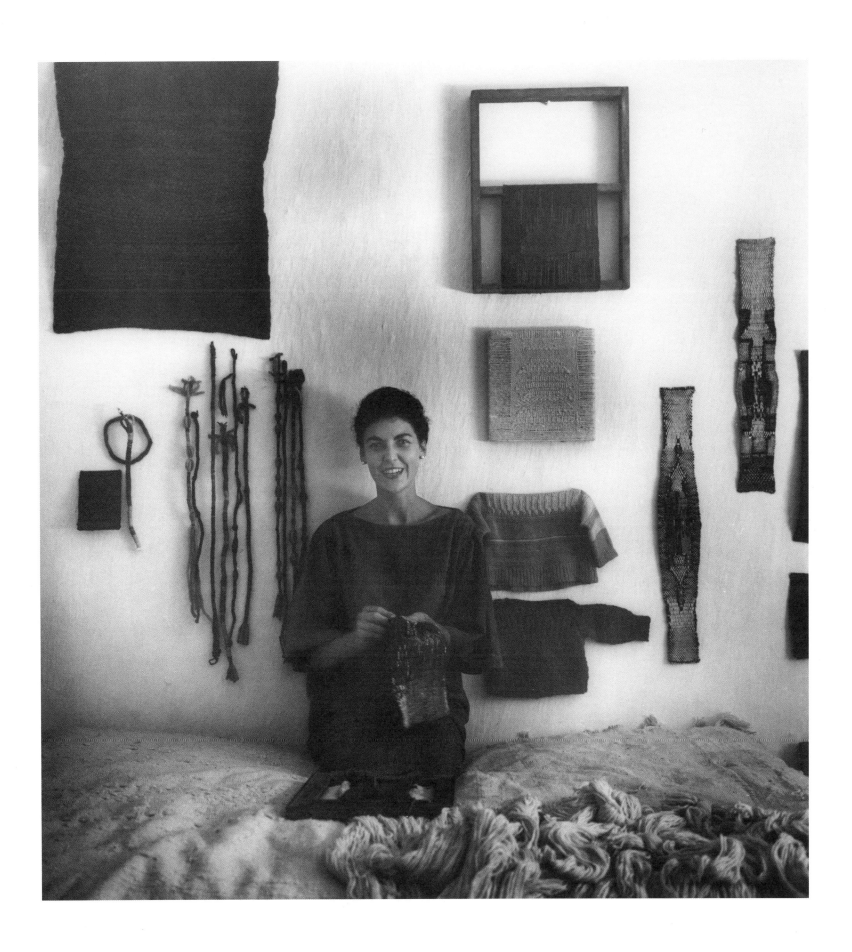

Traveling through Venezuela, Columbia, Ecuador, Peru, and Bolivia on local buses, trains, and small planes, Hicks recorded her impressions with camera, pen, and notebook. In Venezuela she met the artists Gego (Gertrude Goldschmidt), Jesús Rafael Soto, and Alejandro Otero. Gego, trained as an architect, had turned to drawing and sculpture in the 1950s. Adapting the geometric grid, she had begun producing weblike or linear configurations in which classical and romantic impulses mingled in ways that Hicks found engaging (fig. 35). In Santiago Hicks "found an empty store, bought a bed, put nails in the walls and hung up my clothes."[13] A meeting with the photographer Sergio Larrain led to another journey, this one through southern Chile, where she photographed weavers, remote landscapes and villages, and ancient forests and glaciers.[14] The photographs and drawings that resulted reveal a careful attention to relationships between volume, plane, and surface texture across a wide spectrum of materials and forms (fig. 33). All would inform the compositions and structure of the paintings, weavings, and wrapped objects that followed.

Hicks returned to Yale in the fall of 1958 and received her MFA in painting after two semesters in residence. Requesting that her diploma be forwarded to Mexico, she left immediately to work on a documentary film on the Spanish architect Félix Candela. Although the film was never completed, her photographs of Candela's soaring parabolic domes under construction were later published in architecture journals. These photographs, ranging in subject from the meshlike grids erected by construction workers (she has since referred to their forms as "three-dimensional weavings in space") to the intricate constructions in the beehives on the ranch in Guerrero, Mexico, where she lived with her apiculturist husband, document Hicks's investigation of architectonic structures.

In Guerrero Hicks expanded her exploration of woven form, making rugs and household furnishings using an improvised four-post loom and available materials. Among the works in Hicks's 1961 exhibition (fig. 37) was *Muro Blanco*, 1960, a small (9 1/2 x 8 5/8 inches) weaving in handspun wool that, finished front and back (unlike painting), reveals a worked surface that shifts between gossamer filaments and husky passages. She later described it as "weft floats in measured repetition to form squares, rectangles, and trailing lines. Texture builds cumulatively, like white-washed adobe slabs."[15] In a review of that exhibition in *Novedades*, writer-critic and art historian Ida Rodriguez Prampolini pointed to Hicks's work's fusion of Albers's constructivism and the "automatism" of the Abstract Expressionists, and situated it within the complex of ancient and contemporary influences that attracted her at this time.[16]

The location of the exhibition at the Galleria Antonio Souza on the prominent Paseo de la Reforma was itself significant. By 1961 the gallery had become an important site for the display of work by artists determined to redefine modernist abstraction rather than pursuing the more nationalistic and figurative strain of contemporary Mexican art exemplified in the works of Rivera, Kahlo, Tamayo, and others. The sculptor Mathias

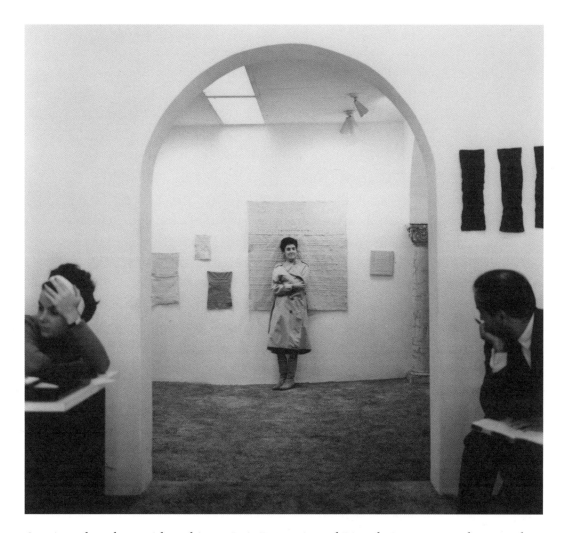

Goeritz, who, along with architects Luis Barragán and Ricardo Legoretta and Prampolini, formed the core of Hicks's intellectual and artistic circle in Mexico, encouraged her to pursue both her painting and fiber-based endeavors. Goeritz, who embraced abstraction as a syntax rooted both in modernity *and* in vernacular and historical traditions, had exhibited abstract sculptures at Antonio Souza in 1960. Hicks's own 1961 exhibition was followed by a show of works by a group calling themselves the "Los Hartos," or "The Fed-up Ones," a loose coalition of artists, architects, and photographers who viewed Goeritz as a kind of Duchampian figure and mentor.[17]

Hicks's move away from the flatness of the woven surface and toward a stronger interplay of surface, light, color, and personal expression was reinforced by her ongoing dialogue with Goeritz and Barragán in Mexico (fig. 38). Goeritz's major sculptural and architectural projects of his early years in Mexico included the 1953 *Museo Experimental El Eco*, in which abstract and expressionist spaces and large minimal sculptural forms encouraged creative and collaborative interactions and the "towers" of Satellite City, which he designed with Barragán. The collection of soaring sculptures resembling towers

Fig. 37. Sheila Hicks at her first solo gallery exhibition, *Tejidos—Sheila Hicks*. Galeria Antonio Souza, Mexico City, Mexico, D.F., September–October 1961.

sited at the southern entrance to Mexico City, was conceived as a challenge to the extreme rationality of functionalist architecture and nationalist valorizations of indigenous traditions.[18] Poised at the boundary between architecture and sculpture, the towers resonated with the architects' shared belief in spiritual striving. In 1958–59, Goeritz also produced a series of bas-reliefs using iron pierced with nails.[19] Within architecture circles, Goeritz and Barragán were recognized as visionary figures. Their insistence on "emotionalism or sensualism" was intended as a corrective to an excessive reliance on the rigid geometries, stripped-down modular forms, and endless curtain walls identified with the spread of the International Style.[20]

Goeritz encouraged Hicks sometime around 1961 to visit Greta Daniel, the curator of architecture and design at the Museum of Modern Art (MoMA) in New York, and the contact led to the museum's first purchases of Hicks's work, including *Blue Letter*. Daniel encouraged Hicks to expand the scale of her research in ways that reinforced the museum's interest in design that aligned with the parameters of high modernism. Hicks's own commitment to the abstract expression of complex surface tensions in the Letters and Hieroglyphs series is clear in the letters she exchanged with Daniel, as well as in her notebook entries. On March 30, 1961, she observed; "I have been working on some new textiles along the idea suggested in the conversations of last November. Recently I finished a comparatively large one of crude, hand-spun white wool [*White Letter*, 1962; p. 23]. It seems architectural with small wrapped columns of threads supporting heavily textured areas."[21]

During this period Hicks benefited from a rich and fruitful dialogue about color with Barragán. The intense saturated colors of *Plegaria* and *Solferino Tacubaya*, both 1960 (pp. 20, 21), are among the many works from this period that translate local colors and textures into deeply personal expressions. *Solferino Tacubaya's solferino* (magenta) wrappings of the white warp contribute to the work's spatial depth, while the title alludes to both the magenta hue worshipped in Mexico (Barragán's favorite color) and the address of his house. It was there that the two spent long afternoons discussing color and its range of permutations, including yellow—chrome, zinc, cadmium, Naples, the acid yellow-green of Mexico—and red—vermilion, scarlet, crimson, carmine, terra-cotta, copper, *solferino*.

Hicks's growing interest in the wall as a marker of architectonic scale, the use of intense color for expressive purposes, and the literal penetration of the surface, can be seen in the weavings that she executed for the Chapel of Las Madres Capuccines Sacramentarias, 1960 (fig. 40), on which, along with the restoration of the existing convent in Tlalpan on the southern edge of Mexico City, Barragán had been working since 1953. Barragán's own spiritual and mystical inclinations coincided with those of the resident nuns and were incorporated into the design of the chapel. Goeritz was enlisted to create gold-leafed panels that glowed with flickering candlelight, and Hicks designed panels

Opposite: fig. 38. Sheila Hicks, photograph of the architect Luis Barragán and the artist Mathias Goeritz in Barragán's house on Calle Francisco Ramirez, Tacubaya, Mexico, c. 1962–63.

that "floated" gently, rather than being rigidly fixed on a wall. As light filtered through their ascending vertical slits, the contemplative panels recalled both the slit weaving of pre-Incaic textiles and the *tagli* (slit surfaces) of the contemporary artist Lucio Fontana, whose works she had seen in Rome.

As a result of meeting the Italian postwar neo-avant-garde painter Piero Dorazio and seeing his work in Milan in 1960, Hicks was "thunderstruck" by his canvases with their interwoven grids of thinly painted colored lines creating meshlike dense and vibrating surfaces that reminded her of "the structures of honeycombs."[22] In Rome the two artists visited a major exhibition of the paintings of Mark Rothko, whose large scale "murals" and use of color had long moved Hicks. Lucio Fontana's *Concetto Spaziales* (e.g., fig. 39), in which the earlier *tagli* (cuts made in the canvas surface with a knife) are transformed into complex orchestrations of spatial movement that, while literally penetrating the canvas plane, also function illusionistically, registered immediately with Hicks. "I found it [Fontana's painting] marvelous but aggressive—to cut the cloth (picture plane) with a blade was so audacious and introduced shadows physically. By contrast my tedious approach of slit weaving (like Kilims) is gentle and allows light to filter through the woven plane from behind."[23]

The significance of Hicks's years in Mexico for the formation of her mature artistic vision cannot be overemphasized. The radical shift from New Haven to South and Latin America challenged her to plot a course that was restricted by neither the material culture of indigenous peoples nor European modernism. She would later summon up the importance of Mexico in a letter written to Mildred Constantine, associate curator in MoMA's Department of Architecture and Design, after seeing a work inspired by that period in Constantine's house: "I am still thinking about the first shock when I stood in your piano salon and realized that the *Red Hieroglyph* was on the wall behind me—when

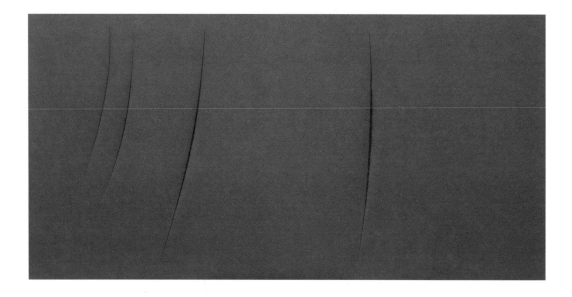

Fig. 39. Lucio Fontana (1899–1968), *Concetto spaziale, Attese*, 1959. Water-based paint on canvas, 49 3/16 x 98 3/4 in. (125.0 x 250.8 cm), Solomon R. Guggenheim Museum, New York (Gift, Mrs. Teresita Fontana, Milan, 1977, 77.2322)

Opposite: fig. 40. Sheila Hicks, *Ascension*, 1960. Slit-weave tapestry, hand-spun wool, 44 x 34 in. (111.8 x 86.4 cm). This tapestry model was created for Luis Barragán's Chapel of Las Madres Capuccines Sacramentarias, on which he had been working since 1953.

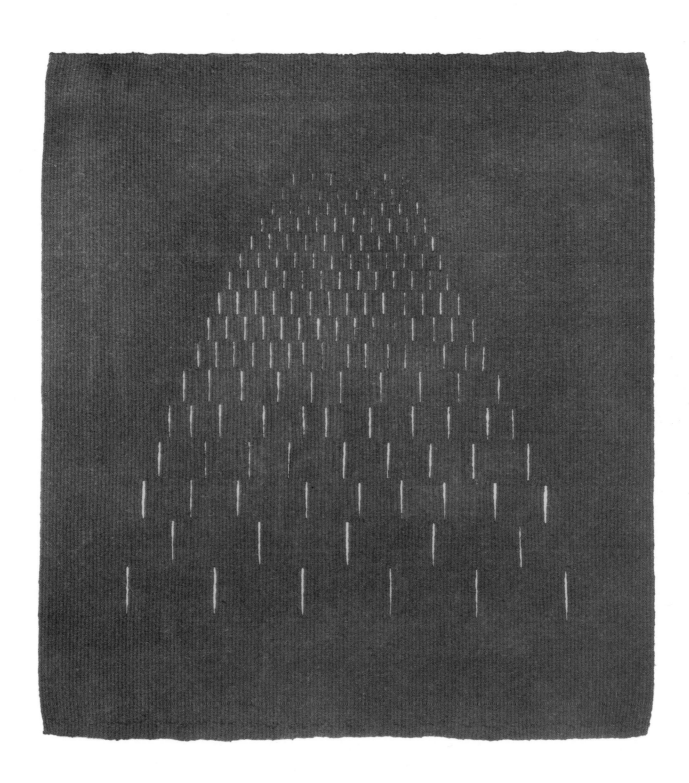

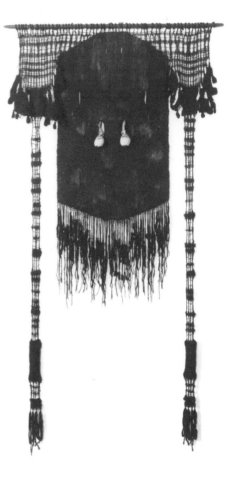

I turned to look at it—I looked *into* it and all of a sudden the blocks or gaps fell away; I thought of Mexico, of wool, of the first wool writing I tried to do, of PoPo [Popocatépetl volcano], the snow on top, the valleys between Taxco and Iguala, the Amate [sacred pre-Hispanic paper] and Casahuate trees, Mathias, gold leaf and Barragán and solid wood cubes. Then I remembered all the wool letters I had tried to structure and read and the hieroglyphs as they appeared to me in chiseled facades."[24]

PLIABLE PLANES AND SOFT WALLS

Between 1963, when MoMA loaned *Blue Letter* to the exhibition *Woven Forms* at the Museum of Contemporary Crafts in New York, and 1974, the date of Hicks's first retrospective at Amsterdam's Stedelijk Museum, her work would play an important role in defining weaving and fiber as contemporary media. Living in Paris and working internationally, she developed a diverse but interrelated set of practices that ranged from private to public, and from intimate scale to monumental architectural installations.

Woven Forms, which foregrounded the work of five North American artists who had moved away from traditional loom-based approaches and were using hemp, sisal, linen, rough-spun wool, and synthetic fibers in relation to contemporary developments in collage, sculpture, and assemblage, is often cited as the formal acknowledgment of new developments in fiber work as a medium for artistic expression in the United States, and the moment when such work began to be acquired seriously by private collectors and public institutions in this country.[25]

The exhibition opened a year after the landmark first *Biennale Internationale de la Tapisserie* in Lausanne focused attention on the revival of the European tradition of tapestry, and less than a decade after MoMA's *Textiles U.S.A.*, curated by Greta Daniel and Arthur Drexler, which had introduced the work of the "artist-craftsman" into an exhibition otherwise devoted to commercially produced textiles. All three exhibitions raised significant questions about terminology and identity that would persist well into the 1970s.[26]

Woven Forms included objects that ranged in scale from Lenore Tawney's monumental free-hanging totemic "personages" in black, white, or natural linen linking sculptural form and knotting techniques inspired by Peruvian warp ends, to Claire Zeisler's geometrically patterned silk wall hangings (fig. 41), to Alice Adams's and Dorian Zachai's freestanding sculptures, to Hicks's small works in handspun wool. In addition to weaving, the works included a range of sizes and techniques, from twining, knotting, and netting to plaiting, and included found objects.

Fig. 41. Claire Zeisler (1903–1991), *Black Ritual*, 1961. Black silk, 50 x 20 in. (127.0 x 50.8 cm). Museum Bellerive, Sammlung des Kunstgewerbemuseums, Zurich, Switzerland.

Opposite: fig. 42. Sheila Hicks, *Rufino*, 1961. Hand-spun wool, 16 x 16 in. (40.0 x 40.0 cm). Location unknown. *Rufino* was exhibited at the Art Institute of Chicago, Antonio Souza Gallery, and Kunstgewerbemuseum, Zurich, Switzerland.

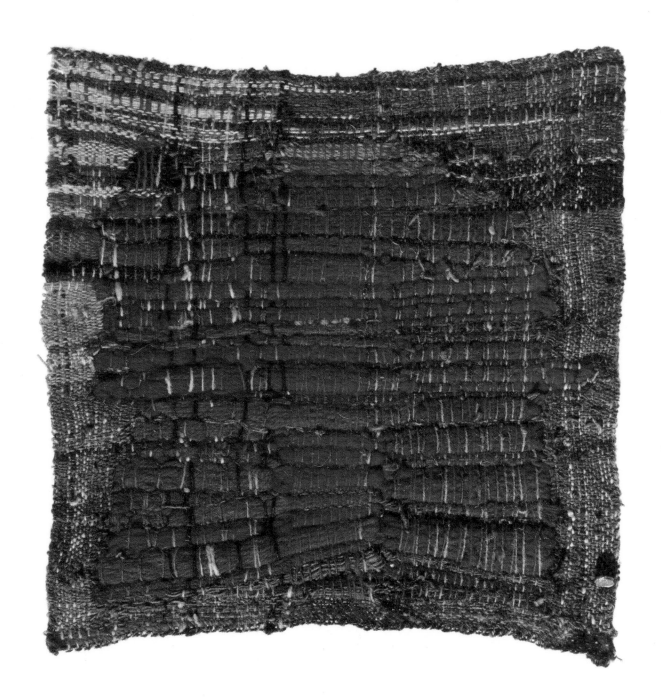

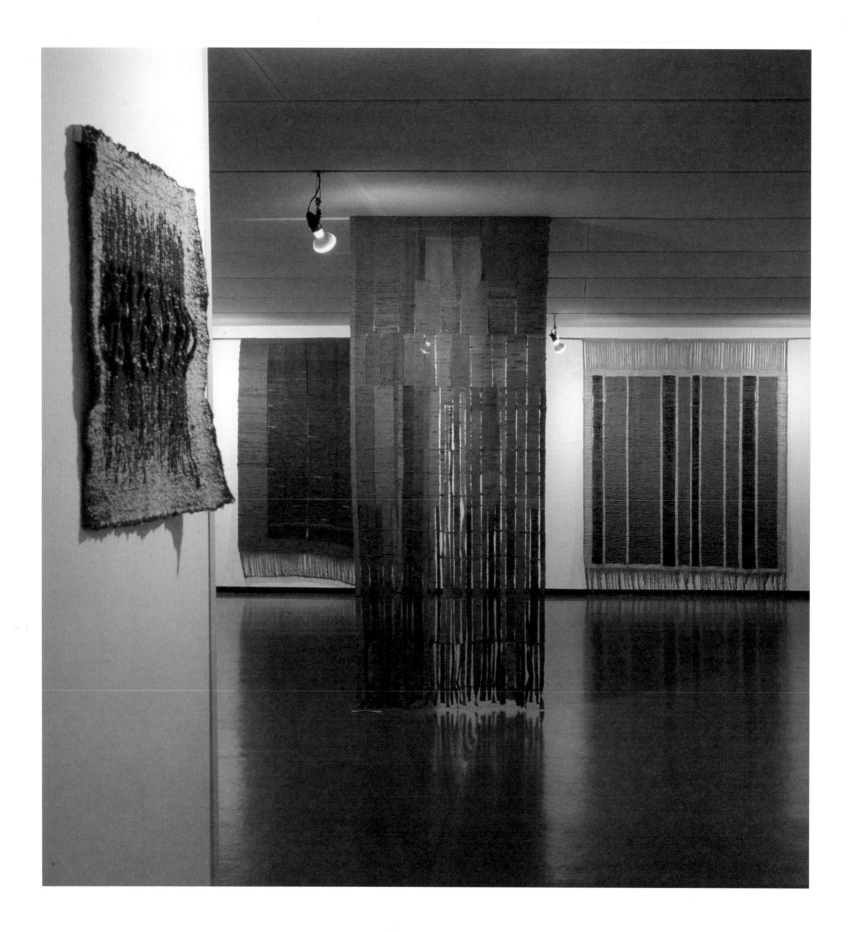

Hicks, viewing much of this work for the first time, perceived a strong element of humor and playfulness in the diverse approaches to structure and material. The juxtaposition of her woven bas-relief and brightly colored slit-woven panel with three-dimensional works pointed to her current play between flat weaves and sculptural forms. Fusing material, structure, and personal meaning in fields of intense color and texture, *Greta Weaving (no. 55)*, at 9 inches by 5 3/4 inches, packs a powerful punch into a format the size of a hand (fig. 44). Combining wrapping with an eccentric tapestry weave in which the weft departs from a strict right-angle relationship to the warp, Hicks orchestrated an exuberant play of intense hues—orange, rose, cinnabar—to create a commemorative portrait of MoMA curator Greta Daniel.

A year later Erika Billeter chose the same title for a new exhibition at the Kunstgewerbemuseum in Zurich. *Gewebte Formen: Sheila Hicks, Lenore Tawney, Claire Zeisler* reframed the previous year's exhibition to focus on only three American artists (fig. 43). In addition to *Greta*, the catalog lists another of Hicks's "miniatures" along with two larger panels. As a showcase for "innovative three-dimensional fiber construction," *Gewebte Formen* also marked the moment when Hicks's work began to circulate widely in Europe through exhibitions, commissions, and community-based projects.[27]

The textured surfaces and open centers of the Ventana series point to new relationships between wall and plane in Hicks's work of the 1960s. The openings recall the role of window grates and bars in breaking through a plane. They also suggest the boundary between public and private domains, as do the *misrabi* in the architecture of countries influenced by Islamic culture, including Spain, Mexico, and North Africa. "Ventana," literally "window," is also related to the Spanish word *ventaneo*, a flirtation conducted through a window.

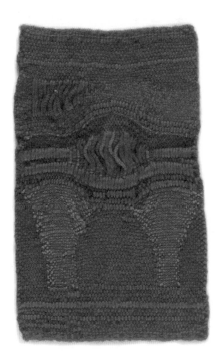

In these works, mottled surfaces woven of roughly handspun wool evoke the dry adobe of Mexican vernacular architecture. The relationship between these works and their architectural sources can be seen in Hicks's photographs of Mexican architectural sites that articulate the precision of her ongoing interrogation of the wall as structural support, visual plane, and metaphoric sign.

Hicks's interest in the Moorish-inspired forms of Mexican Colonial architecture intensified in the later 1960s and '70s. The elegant pen lines of her drawings from North Africa hover between descriptive and subjective responses to form. With these journal notations, drawing expands to encompass both the investigative and the expressive. By the

Opposite: fig. 43. Installation view of *Gewebte Formen: Sheila Hicks, Lenore Tawney, Claire Zeisler*, held at the Kunstgewerbemuseum, Zurich, Switzerland, March–May, 1964.
Fig. 44. Sheila Hicks, *Greta Weaving (no. 55)*, 1961. Wool, 9 x 5 3/4 in. (22.9 x 14.6 cm). Museum of Modern Art, New York, N.Y., U.S.A. (Gift in memory of Greta Daniel and Greta Design Fund, 259.1962)

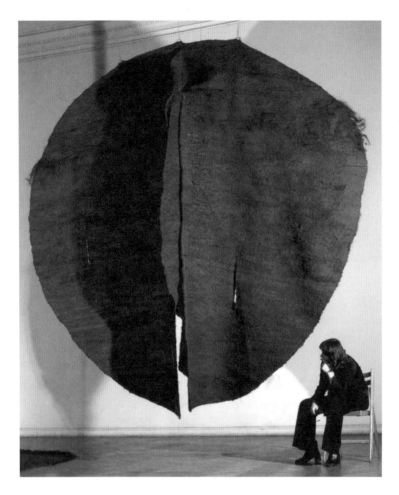

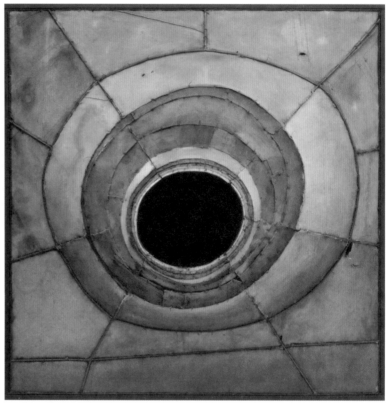

Fig. 45. Magdalena Abakanowicz (born 1930), *Abakan Red*, 1969. Sisal on metal support, 118 1/8 x 118 1/8 x 137 51/64 in. (300.0 x 300.0 x 350.0 cm). Tate (Presented anonymously 2009, T12979)

Fig. 46. Lee Bontecou (born 1931), Untitled, 1962. Welded iron, canvas, wire, black paint, 54 x 55 x 15 in. (137.2 x 139.7 x 38.1 cm). National Gallery of Art, Washington (Gift of the Collectors Committee)

Fig. 47. Eva Hesse (1936–1970), *Legs of a Walking Ball*, 1965. Varnish, tempera, enamel, cord, metal, papier-caché, unknown modeling, compound, particle board, wood, 17 3/4 x 26 3/8 x 5 1/4 in. (45.1 x 67.0 x 13.3 cm). Leeum, Samsung Museum of Modern Art, Seoul (2005)

mid-1960s Hicks's wall hangings were also showing a strong Moorish influence. Drawn to the affinity between the rectangular plane of the prayer rug and Moorish arched structures, she combined the two in the series of Prayer Rugs (pp. 62, 63), and in other new bas-reliefs. In contrast to the Ventana series with its opening up of internal space, these bas-reliefs leave the flat wall behind and "explode" into space. Contrasting hand-scissor-cut sections of tufting with cascades of layered clusters of fibers, Hicks created the dynamic tension between the stability of the plane and its extension into space that would underlie her subsequent site-specific architectural commissions.

Hicks's move to a more dramatic intervention in shaping three-dimensional space and a larger scale also reflected her awareness of current developments in wall hanging and sculpture. These ranged from the increasingly monumental scale of works in fiber by eastern European artists Magdalena Abakanowicz (fig. 45), Jagoda Buic, and others to the radical reshaping of planes and the environmental implications of current work by Lee Bontecou (fig. 46) and Louise Nevelson. As her works increased in scale Hicks adapted their surface treatments to the broader expanse of the wall, as well as to the even broader context of an entire room.[28]

Hicks's use of knotting and weaving expanded the sculptural and semantic implications of the Hieroglyph series in works such as *Rufino* (fig. 42), with its raised texture in deep red, magenta, emerald, turquoise, and saffron yellow, and its warp of discontinuous, knotted yarns woven so that it reads both as surface color and structure, and *Manga*, also 1961, a freestanding Indian red and purple tubular form from which wrapped and braided elements explode (fig. 48). In the latter, the knotting recalls the ancient Andean *quipu*, where knots were used by the Inca as mnemonic devices, graphic language, and codes through which to record the data necessary to the organization of an empire of ten million subjects. The knots carry personal and cultural meaning, organizing and translating sensations through material so that they register in time and space. "It's the knots which interest me the most," Hicks wrote in a journal entry, "where one thread becomes attached to another. Joined together, overlapping and twisting actively. The thread flows on and when turning eases over and under another, disappearing, re-appearing, transversing or binding together, attaching one network of fibers to other harp-like series. ... Weaving ... Twining ... Netting, looping in a long continuous thread through itself or knitting, crocheting, sewing embroidery—each with its multiple variations and then, all combined together to form a textile, a pliable plane, a double sided surface or a many faced solid but often soft object constructed of threads—a wig, a ball, or a bundle."[29]

During the later 1960s and '70s these contrasts—wall and plane, soft and rigid, miniature and monumental, fixed and freestanding—expanded the artist's formal vocabulary. Hicks's work circulated within architecture and design contexts, as well as within those identified with fine-arts and craft traditions. As media-based classification yielded to more conceptual frameworks, she would be variously identified as an artist, designer,

weaver, fiber-artist, sculptor, writer, and photographer, as her work drew the attention of critics, historians, curators, and artists seeking to renegotiate or, in some cases, to shore up the walls of earlier assumptions about art, craft, and design. As traditional sculptural materials (marble, bronze, wood) gave way to steel, lead, neon, and resin and expanded to include felt, feathers, fur, rope, string, thread-waste, and dust, it became more difficult to discuss Hicks's masses of piled mounds and bound cords, Tawney's see-through grids, and Zeisler's totemic spills without reference to Hesse's rope-and-string sculptures, Agnes Martin's gridded paintings and drawings (fig. 52), and Fontana's slit surfaces.[30]

Eva Hesse's transition from painting and drawing to sculpture began in the mid-1960s in an abandoned textile factory in the Ruhr Valley, where she produced a series of machine-part drawings and assemblages. Fashioned from paint, cord, papier-mâché, and metal, works like *Legs of a Walking Ball*, 1965 (fig. 47), share a dialogue with Hicks's work that arises not from any direct influence between the artists, but from related attitudes toward materials, two- and three-dimensional space, and the use of the wall to reinforce planarity. Cord or string effects the transition from two- to three-dimensional space in *Legs of a Walking Ball* as similar structures would in Hicks's "soft" walls and her later sculptural works, including *The Preferred Wife Occupies Her Nights (L'Epous préféré occupe ses nuits)*, 1972.

While it is not surprising that these two former Albers students would contribute to transforming his principles centered in the plane and the grid, their paths diverge in significant ways. As Hesse's work became inseparable from the discourse of materials and processes that would define postminimalism in the later 1960s, Hicks worked in a wide range of contexts that crossed fields—from weaving to sculpture, design to architecture, and handwork to production. Many of these productions circulated well beyond the art gallery and the museum, the primary sites in the validation of vanguard art practices.

For Hicks, as for other students of Albers over the years—from Ruth Asawa and Robert Rauschenberg at Black Mountain College to Hesse and Robert Mangold at Yale—Albers's exercises took root in a range of practices: weaving in wire (Asawa), structuring surfaces with found textiles (Rauschenberg), recuperating fiber, rope, and string as sculptural materials (Hesse). The grid remained central to Albers's pedagogy, and its "rearrangement" would reappear in Hesse's elaboration of the drawn line as if it were thread, and in Hicks's attention to linear surface permutations of new relationships between structure and illusion.[31] If we set aside received wisdom about what distinguishes painting from sculpture, and art from craft, and give a nod to Rauschenberg's observation in 1959 that "a pair of socks is no less suitable to make a painting with than wood, nails, turpentine, oil and fabric," and to Hicks's later incorporation of articles of clothing into her works, it becomes easier to accept the complex relationship that has existed throughout the twentieth century between textiles, painting, and weaving, and their interactions within modernist ideologies.[32] Addressing the distinction between the

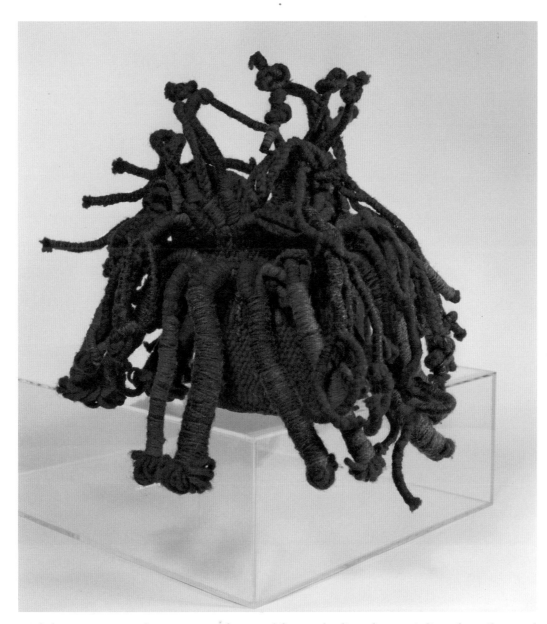

grid that structures the woven surface and forms the literal materiality of textiles, and the grid that secures both the visual scaffold and the opticality of much twentieth-century abstract painting, Hicks has commented: "The grid is a concept, a way of thinking, but it is rarely applicable to materials."[33]

Debates about material, form, attitude, and concept that played out across a period of social and cultural upheaval in North America and Europe in the second half of the 1960s were often directed against what were perceived as the constraints of minimalism. In the United States, the Civil Rights and Black Power movements, a growing anti–Vietnam War movement, and a period of intense social activism that coincided with the contemporary Women's movement combined to raise significant challenges to

Fig. 48. Sheila Hicks, *Manga*, 1961. Hand-spun wool, 8 x 5 in. (20.3 x 12.7 cm). Private collection

orthodoxies of all stripes. In western Europe leftist challenges to a period of postwar stability escalated into social unrest in France, Germany, and Italy and the so-called Prague Spring in Czechoslovakia.

Despite Clement Greenberg's commitment to maintaining painting's privileged status in relation to modernist design, the period in the later 1960s marked by the transition from the rigorous geometries of postpainterly abstraction and minimalist sculpture to conceptual, process, and "anti-form" exploitations of nontraditional art materials, and scattered, dispersed, site-specific, and transitory works, corresponded both to the introduction of overt forms of political content into art, and to the period of woven forms' rejection of the restrictions in size and rectangularity imposed by the loom. These new directions were tracked in major exhibitions. Among them were the Jewish Museum's *Primary Structures* in 1966, with its focus on geometric form, industrial fabrication, and

Fig. 49. Sheila Hicks, photograph of the *Micalvi*, a supply ship between Punta Arenas and Isla Navarino, 1958. "I retained the memory of this aerial view with its open hatch and the assembled and patched tarpaulins on the deck of the ship and used it frequently in my installations of found laundry and linen—including darned sheets and unseamed nurses blouses."
Opposite: fig. 50. Sheila Hicks, *Nuage*, 1986. An installation of four suspended panels—"patchworks of disassembled nurses blouses" in the exhibition, *Man Ray—Sheila Hicks*, Lunds Konstall, Lund, Sweden, 1986.

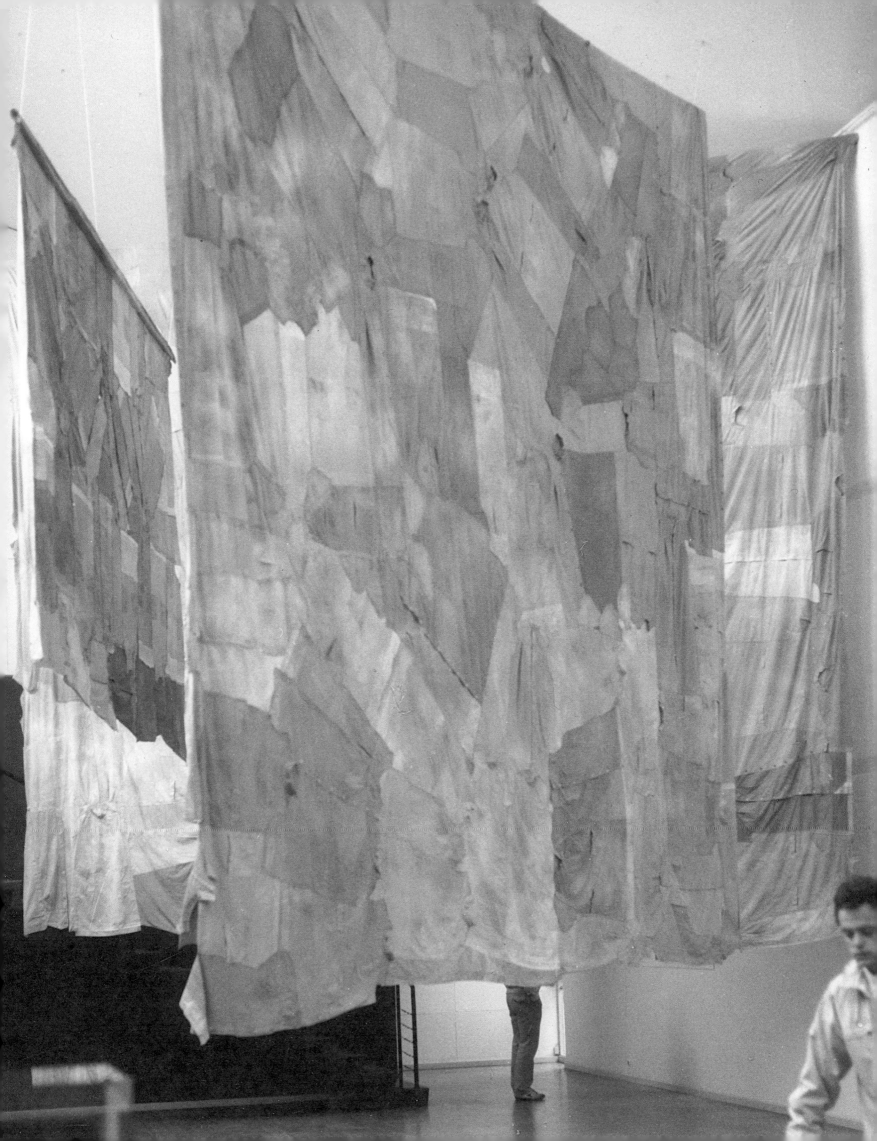

new conceptual approaches among sculptors, and MoMA's *Wall Hangings* in 1969, its first major exhibition devoted to contemporary work constructed of fiber and the first to be installed outside the architecture and design galleries.[34] Lucy Lippard's groundbreaking exhibition *Eccentric Abstraction* at the Fischbach Gallery in 1966 elicited David Antin's observation in *Artforum* that the exhibition's only evident shared interest was to be seen in "a kind of unexpected use of materials."[35]

While the majority of the artists in *Eccentric Abstraction* were already identified with contemporary vanguard art practices in New York, Alice Adams was the only artist included in both *Eccentric Abstraction* and *Wall Hangings*. An untitled work of 1966 by her pointed to the ways that even as new materials proliferated, attitudes toward their use often revealed significant differences among artists. Consisting of two floor pieces that resembled ravaged chairs, and incorporating coils of steel cable disguised as hemp under dots of red or brown paint, Adams's piece suggested a lack of interest in asserting the integrity of material that aligned her work with that of many contemporary sculptors who viewed material as secondary to concept.

For Hicks and Zeisler, among others, material continued to matter, even as the forms it might assume remained open to renegotiation. Zeisler, while recognizing what she called her "affinities" with sculptors like Hesse and Robert Morris in the 1960s, carefully differentiated her use of materials from theirs: "In a certain way I feel closer to these artists [Hesse and Morris] than to craftsmen.... Eva Hesse ... used a wide variety of existing materials and stretched them to the utmost to fit the ideas that she wanted to execute.... For me, fiber still comes first ... and that's why some people still categorize my work as craft."[36] Louise Bourgeois, who came from a family of tapestry restorers in Aubusson and who would increasingly use fabric, lace, and embroidery in her works after 1990, took a different position when she embraced the primacy of concept over material: "The wish to say something antedates the material; the material is completely secondary," she observed.[37] For Hicks, however, "concept and material are inextricable."

Exhibitions like *When Attitudes Become Form* at the Kunsthalle Bern in 1967 and the Whitney Museum's *Anti-Illusion: Procedures/Materials* two years later signaled a new embrace of impermanence and process. Materials like hemp, thread, rubber, felt, and string, many of which represented the residue of industrial processing, were now increasingly evident in the work of artists from Morris (felt) and Reiner Ruthenbeck (netting/cloth) to Fred Sandback (yarn) and Richard Tuttle (canvas and thread) (fig. 55), but they seldom elicited serious dialogue about the shifting parameters of mainstream art and its exclusions. "Consumed as they were with classification," Elissa Auther argues, "neither champions nor detractors [of breaking down media-based distinctions] considered the categories 'art' and 'craft' as discursive constructions reflecting an unequal distribution of power, status and prestige in the art world."[38] Although Hicks chose a different nomenclature when she exhibited at the *Troisième Biennale Internationale de*

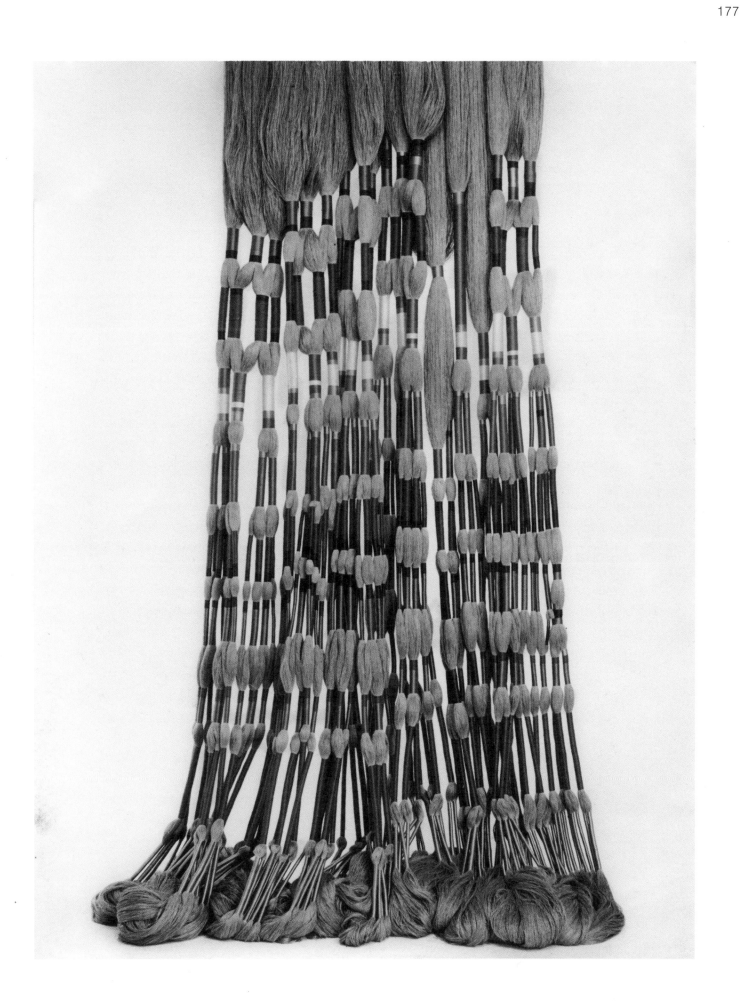

la Tapisserie in 1967, *Huaquen*, a tall vertical fall of wrapped linen cords that belonged to a class of objects she called "open compositions," hovered between abstract sculpture and ceremonial regalia (fig. 51).[39]

In Europe new links between materials and artisanal traditions had emerged in the first *Arte Povera* exhibition in 1967.[40] Its twelve artists assumed an antitechnological stance in opposition to American minimalism and called for the incorporation of reproductive technologies, a renewed emphasis on the artisanal, and a broader embrace of new materials and processes of production. *Arte Povera* was one of a range of international exhibitions in these years that focused on postminimalism, conceptual art, land and environmental art, and performance. Their mix of attitudes and styles, often linked intellectually and conceptually rather than formally, formed the subject of what would come to be known in Europe as the "new art." These scattered events represented much more than a background for artistic and critical debate. They would prove central to demands for social activism and cultural transformation; and they would challenge cultural hegemonies. Their emphasis on context, situation, ephemera, and process would resonate a few years later as many artists, including Hicks, moved into more transitory and environmental installation work. At the same time, in Europe the existence of a strong art-tapestry tradition encouraged large-scale public architectural commissions.

One of the first and most unexpected Hicks commissions came from the British architect Theo Crosby for the conference center he designed in Mecca, Saudi Arabia. Upon seeing Hicks's Prayer Rug wall hanging series, he asked her to make seven versions to be hung in the assembly hall.[41] In 1967 architect Warren Platner, a former associate of Eero Saarinen and now in charge of interiors for the architectural firm of Kevin Roche John Dinkeloo and Associates, invited Hicks to design and make tapestry panels for two walls in the boardroom and auditorium of the new Ford Foundation headquarters in

New York. Uninterested in what he termed "decoration," Platner had been drawn to Hicks's rigorous design aesthetic and sensual use of material when he saw *Grand Prayer Rug*, 1964, installed on the ground floor in Saarinen's new CBS headquarters in New York (pp. 62, 63). "Thread is not to be used as an ornament," the architect wrote to Hicks, "but a construction material, complementary to the others and, in a certain sense, superior to the others, because of being more visible. The combination of thread and surrounding elements must give rise to a harmonious dialogue."[42]

The Ford Foundation building, originally welcomed as "a remarkably prescient piece of architecture," provided a different challenge as an iconic example of a restrained International Style modernism.[43] The building's

Fig. 52. Agnes Martin (1912–2004), Untitled, 1960. Ink, watercolor, and graphite on paper, 11 3/4 x 11 15/16 in. (29.9 x 30.3 cm). Addison Gallery of American Art, Phillips Academy, Andover, MA (Gift of Frank Stella [PA 1954], Addison Art Drive, 1991.46)

twelve-story glass atrium (applauded by *New York Times* critic Ada Louise Huxtable as "probably one of the most romantic environments ever devised by corporate man") included a major tapestry project by Hicks (pp. 38, 39).[44] Working with a team of skilled artisans in her Paris workshop, Hicks stretched the thirteen-foot, nine-inch linen base cloth on a gigantic sewing frame endowed with two moving cylinders. The cloth unwound from one cylinder and, once it was embroidered, rewound on the other. Embroiderers worked in pairs on both sides of the stretched cloth as they stitched medallions of honey-colored silk thread over supports of anodized aluminum disks to make a shape like that of a propeller in relief.[45] The commission also represented a culmination of Hicks's growing conceptualization of the rigid wall plane as a soft form. "I think it was the first time that someone conceived of a contemporary textile tapestry as an entire wall—not as a tapestry hung on the wall," she later remarked. "This was a real breakthrough ... a pliable plane that was then brought into tension and became the actual wall."[46]

Hicks has traced the origins of her interest in the relatedness of the structural wall and its aesthetic "doubling" to her long interest in architectural space, as well as to her desire to interact with its geometric solidity by placing on it a substantial soft surface that both replicates the planar support and humanizes it. Yet in no way do Hicks's "soft walls" represent a simple application of Bauhaus design. Indeed they are equally informed by Barragán's use of color to alter visual perceptions of the architectural plane, as well as by the lessons of Fontana, Dorazio, Rothko, and other painters whose use of color and notions of abstract constructivism developed around relationships between the literal and optical manipulation of two-dimensional space in abstract painting.

By 1968 Hicks's soft walls had shifted from a planar orientation to become, in her words, "open compositions" that increasingly depended on additive processes of stacking, piling, and/or hanging. *The Evolving Tapestry: He/She* (p. 59) was formed by the uprising of May 1968 in Paris, when the streets of the Left Bank ignited in protests between students, workers, and police. To protect her studio, which had large windows at street level, as well as the small children who were also in residence there, Hicks stacked large bundles of linen in front of her windows.[47] *The Evolving Tapestry*, its piles of bound elements held in place by gravity, would prove adaptable to a variety of situations as she remade it for various sites and contexts by adding or replacing new serial elements in a process that both repeated and renewed the work within successive iterations.

Fig. 53. Sheila Hicks, *Les Draps Carmelite* (detail), c. 1978 (see p. 185).

When *Wall Hangings*, curated by Mildred Constantine and Jack Lenor Larsen, opened at the Museum of Modern Art in December after a lengthy tour of the United States, it showcased the work of an international group of artists. By 1969 the move to challenge hierarchies of vanguard art that relied on maintaining the distinction between "art" and "craft" had found a powerful champion in Constantine. At her insistence, *Wall Hangings* was installed in the museum's first-floor special exhibitions galleries rather than in those dedicated to architecture and design. This strategy of incorporation was underscored in the catalog when the curators noted that "the weavers from eight countries represented in this catalogue are not part of the fabric industry, but of the world of art."[48] In fact, as Hicks observed, many of the participants in the exhibition were not even weavers.

Hicks's works included *White Letter*, 1962, among the first of her woven Hieroglyphs; a large *Prayer Rug* in white wool; *The Principal Wife*, 1968 (p. 73), and another version of *The Evolving Tapestry*. In their catalog essay, Constantine and Larsen noted: "Of particular interest is Sheila Hicks's Evolving Tapestry comprising over three thousand similar elements, which she describes as 'pony tails.' These modular elements are made up of thread—a linear element—but rather than being intermeshed to produce a plane they are massed to create a volume."[49]

By 1969, when *Wall Hangings* opened, discussions around weaving, fiber-based work, and craft traditions had taken on a distinctly political cast as feminist artists, art historians, and critics began to consistently interrogate the terms of a debate that not only linked decoration, textiles, and weaving to femininity, but increasingly argued that their depreciation reflected a deeply embedded sexual politics.[50] In the early 1970s pattern and decoration artists would mobilize the "decorative" as a challenge to Greenberg's devaluing of the term. At the same time women artists from Miriam Schapiro and Elaine Reichek to Harmony Hammond and Judy Chicago, among others, would draw on feminism's valorization of textile traditions and its critique of the gendering of certain materials as "feminine." At the same time artists such as Faith Ringgold, Miriam Schapiro, Betye Saar, and Barbara Chase-Riboud were drawing on textile traditions of various cultures as inspiration and, at times, forms of critique. For Hicks and Chase-Riboud, who had met at Yale in 1959 before settling in Paris, crossing borders and working transculturally was already familiar territory.

The blurring of the lines between genres and the materials historically associated with them, not to mention issues of class, race, ethnicity, and the exclusion of women from major institutions of art world power and privilege, encouraged some to see classification and hierarchical orderings as arbitrary and subject to "re-writing." As critics have noted, settling on abstraction as the privileged language for articulating the experience of modernity has carried with it a denial of historical reality.[51] It was that denial that originally motivated Hicks's travels to South America and Mexico in the 1950s. If in 1969 *The Evolving Tapestry* pointed to her awareness of the social conflicts that would define the

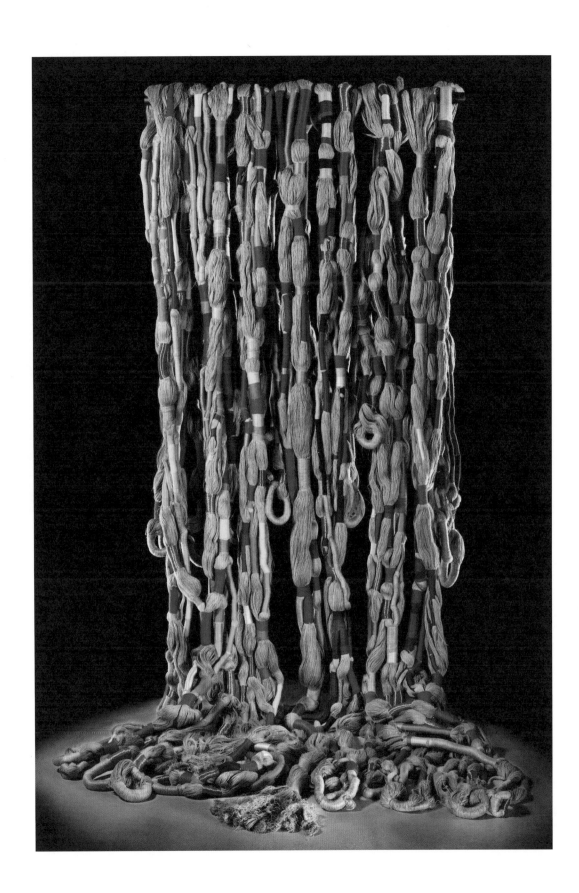

The Principal Wife Goes On 1969

Linen, silk, wool, synthetic fibers; dimensions approximately 186 × 69 × 4 IN; 472.5 × 175 × 10 CM

Renwick Gallery of The Smithsonian American Art Museum (Gift of S. C. Johnson & Son, Inc.)

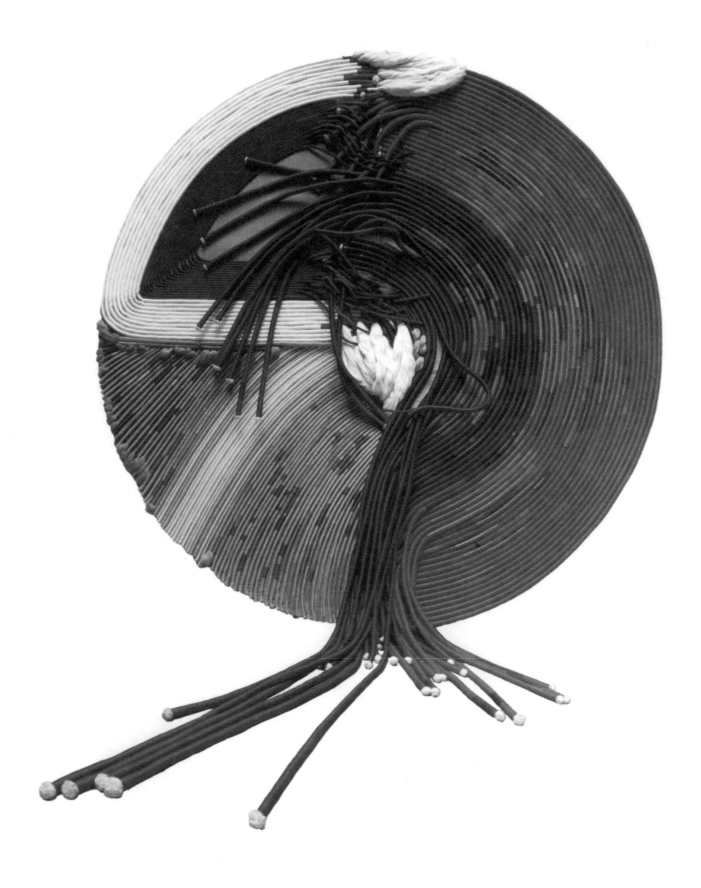

next decade, it also articulated her growing interest in more fully realizing not just the sculptural implications of fiber, and the structural resonance of its materiality in relation to the two-dimensional plane, but also its environmental and social potential.

MOVABLE WALLS: FIBER AS INSTALLATION

Douze ans d'art contemporain en France opened at the Grand Palais in Paris in 1972. For Hicks, being included in a major exhibition of contemporary art in France marked a significant turning point. Originally proposed by Georges Pompidou to the minister of culture, Jacques Duhamel, the president of the Republic requested that a selection of works by the principal painters and sculptors then working in France be included in an important exhibition.[52] When François Mathey visited Hicks's studio to select work for the exhibition, a playful banter between curator and artist resulted in a title for one of the two works exhibited.[53] *The Preferred Wife Occupies Her Nights*, 1972 (fig. 54), an assembly of wrapped elements, is a fixed, or, in Hicks's taxonomy of forms, a "closed," composition of opposing forces. Its large circular panel consists of multiple cords of thick cotton core wrapped with nylon, silk, gold, and linen threads and stitched onto a linen canvas base.

Although the exhibition opened at a moment when women on both sides of the Atlantic were challenging the lack of representation of women in major museum exhibitions, there is little evidence that its organizers had taken sexual politics into account in their selection process. Not until the following year would women artists' groups in France—from Spirale, founded in 1973 to study *la création étouffée*, to Musidora, an association of feminist actresses and filmmakers founded the same year—attract significant public awareness. The *Douze ans* exhibition's only two women artists—Niki de Saint Phalle and Hicks—both enjoyed international reputations. Saint Phalle was the creator (working in collaboration with Jean Tinguely and Per Olof Ultvedt) of the wildly successful monumental sculptural installation *Hon* (She) in Stockholm in 1966 and the series of inflatable Nanas that followed. Both Saint Phalle and Hicks were active in expanded media and collaborative activities that crossed from painting and sculpture to fiber, textiles, theater, design, and fashion. Both, like many women of their generation for whom professional achievement and personal emancipation occurred long before there was a contemporary feminist movement, resisted feminism as a label and often refused to participate in exhibitions devoted exclusively to women. Yet the fact that Hicks in particular worked with materials and processes that in the early 1970s became inextricably bound up with feminism's desire to recuperate devalued areas of female creativity and productivity calls for closer attention—to both the ways her work intervened in, and reinforced (without stating), the goals of contemporary feminism, and the ways that her attitudes toward materials and history intersect with, and differ from, much of what is often thought of as "feminist art" in the 1970s.[54]

From Hicks's perspective the skills of needlework and sewing that she had

Opposite: fig. 54. Sheila Hicks, *L'Epouse préférée occupe ses nuits (The Preferred Wife Occupies Her Nights)*, 1972. Cotton, linen, silk, nylon, metallic fiber, 157 1/2 in. diameter (400.0 cm), no longer extant. Exhibited at the Grand Palais, Paris, 1972, and at the *6e Biennale Internationale de la Tapisserie*, Lausanne, in 1973.

acquired as a child, combined with her training and research in the ancient histories of weaving and fabric, had encouraged her to see textiles as part of an unbroken historical trajectory that was unique neither to women nor to western Europe and North America. At Yale she had absorbed Kubler's expansive view of the interconnectedness of all material culture. His methodology provided the tools that subsequently encouraged her to synthesize European modernist traditions and ancient abstract languages in works that also enabled her to earn a living and raise a family.

Hicks's Stedelijk retrospective would both affirm the direction her work took during the later 1960s and early 1970s and intersect with an expanding range of attitudes toward materials and processes. Visiting the Stedelijk Museum in 1973 to begin planning the installation of her work there, she experienced the galleries' large spaces through the sounds and movement of an exhibition of Jean Tinguely's kinetic sculptures. The encounter both challenged her to rethink the relationship between static object and exhibition space, and pushed her toward thinking more environmentally about her museum installations. Increasingly after the Stedelijk retrospective, Hicks would explore the use of found garments in installations in which her "soft walls" were freed from any fixed relationship to the wall as support in order to become "pliable" planes that moved in space.

In 1977 Hicks exhibited darned wool sheets that she recuperated from the Carmelite Convent in Boulogne-Billancourt as a temporary free-hanging installation for the exhibition *Artiste/Artisane?* at the Musée des Arts Décoratifs in Paris. She then borrowed freshly washed and ironed nurses' blouses from a Swiss hospital for an installation at the *Huitième Biennale Internationale de la Tapisserie* in Lausanne and neatly piled up several tons of the material into the form of a glacier on a podium. Displayed as sculpture for six months,

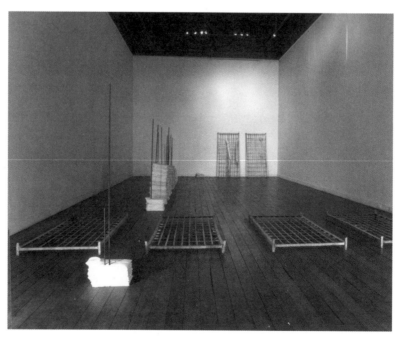

Fig. 55. Richard Tuttle (born 1941), *4th Summer Wood Piece*, 1974. Cloth, wood, 30 x 20 x 1 in. (76.2 x 50.8 x 2.5 cm). National Gallery of Art, Washington (Dorothy and Herbert Vogel Collection, gift of Dorothy and Herbert Vogel, Trustees)
Fig. 56. Doris Salcedo (born 1958) installation: Untitled, 1990; background, right: Untitled, 1989–90. Steel, animal fiber, 78 3/4 x 35 7/16 x 3 9/16 in. (200 x 90 x 8 cm each). Galeria Garcés-Velàsquez, Bogotá, Columbia
Opposite: fig. 57. Sheila Hicks, *Les Draps Carmelite*, c. 1978. Wool, 92 x 46 in. (236 x 117 cm). Private collection. One of four wool sheets darned by nuns in the Carmelite Convent of Boulogne Billancourt, France.

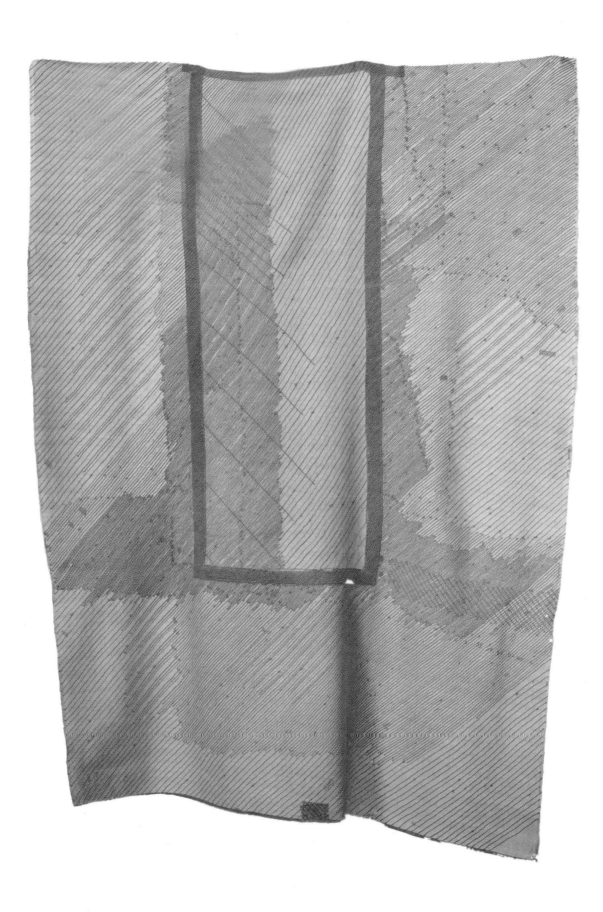

the nurses' smocks were later washed and returned to the hospital for further use. The recycling of materials, with its roots in historical traditions in which precious woven fiber was continually incorporated into new objects, had long attracted Hicks, as had the social dimensions of cloth production, many of which related to historical communities—from indigenous peoples to charitable, religious, and healing institutions.

A year later, newborn-baby shirts, surgical gowns, hospital bedcovers, and nurses' blouses found their way into her new installations in Lund, Sweden, and Montreuil, France. In *Tons and Masses* at the Lunds Konsthall, Hicks combined the stability of a glass wall and the fluidity of floating cotton garments in a poetic moving surface that invoked departed bodies along with healing and caring. Using a few "tons" of newsprint and "masses" of bedsheets, shirts, blouses, and baby birth bands, her sculptural forms approached architecture (p. 124; fig. 59).

Hicks's incorporation of a growing range of new materials into environmental installations coincided with a period in the later 1970s when new materials and new attitudes toward installation were being institutionalized in exhibitions from New York to Europe. In New York, the 1975 Whitney Biennial reflected the freewheeling spirit of inclusiveness that often accompanied the liberationist politics and antiestablishment attitudes that had begun in the 1960s. In addition to pointing to an expanded vocabulary of postminimalist recuperation of salvaged materials, the exhibition also represented a shift to attitudes toward sculpture that focused on linking sculptural conceptions based on tactility and the literal properties of medium to an antiformalist dissolution of the object that stressed dispersion, desubstantiation, agglomeration, scattering, and piling.[55] Working primarily in Europe, Hicks continued to pursue a similar direction, always working within the parameters that she associated with cloth and textiles as an inherent and significant part of material culture.

The generation of artists that came of age in a period often associated with a "post-"modernism built on a self-conscious challenging of modernist assumptions. If

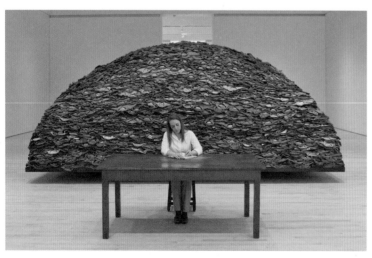

the recuperation of neglected, "feminized," and/or critically devalued materials underlay many feminist-based investigations in the 1970s, succeeding generations of artists, both male and female, brought an ironic perspective to their choice of such "loaded" materials (Rosemary Trockel, Robert Gober) or, in a number of cases, degraded them (Mike Kelley, Tracy Emin, Kiki Smith).[56]

Fig. 58. Ann Hamilton (born 1956), *indigo blue* (detail), 1991/2007. Cotton clothing, wood and steel platform, wood table and stool, book, eraser. Dimensions variable. San Francisco Museum of Modern Art (Accessions Committee Fund purchase)
Opposite: fig. 59. Sheila Hicks, installation of Swiss nurses' blouses in the exhibition *Sheila Hicks: Fil*, Centre d'Expositions, Montreuil, 1979.
"I worked with the community and led 'animations,' interactive performances, and lectures for the duration of the show."

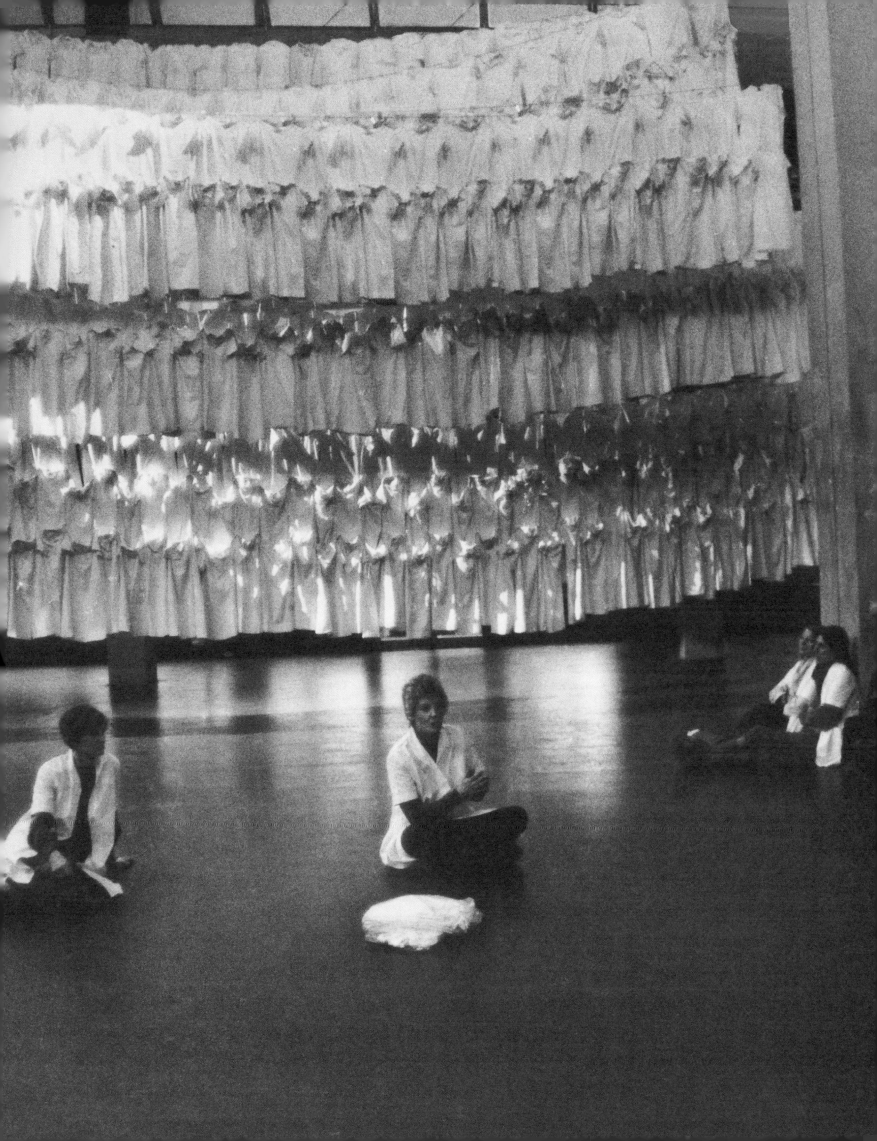

Recent critical writing on the work of artists like Smith, Mona Hatoum, Trockel, Gober, Doris Salcedo (fig. 56), Ann Hamilton (fig. 58), Kelly, and others has drawn attention to the 1980s as a historical moment, not unlike the later 1960s and early 1970s, that witnessed renewed challenges to hierarchies of material and meaning: from Anselm Kiefer's straw to Ann Hamilton's indigo shirts. As a result of earlier challenges to the devaluation of materials historically linked to domestic traditions, the postmodern embrace of appropriation and pastiche, and a kind of anything-goes scavenging of materials and images mingled with a renewed respect for textile and artisanal traditions. As younger artists felt less constrained by labels, from "modernist" to "feminist," the era of "post-" took root. By the early 1990s, installations incorporating clothing, many of them specific to non-European cultural traditions, had become common. Many artists working transnationally drew on a range of indigenous traditions in which cloth played major historical and cultural roles.

In 1992 at the Seoul Art Centre, Hicks, who unexpectedly had been given more space than she anticipated in the museum, filled three immense rooms with 180-foot-long fishnets that "flowed" from one area to another, casting shadows which inscribed the patterns of the filaments on the walls. She invited visitors to draw the shadows directly on the walls, in effect inscribing a line that was also a filament or, in her words, a "trace of a thread." "It was the memory of an object," Hicks recalled, equating the action with the ways that material objects convey cultural and historical meaning, "the trace of a language, the reminder of a common experience."

During the later 1990s and early 2000s Hicks continued to expand the vocabulary of a single thread extended in space in a series of major installations, several of them in Japan. In 1992–93, she dyed five tons of linen thread in more than ninety colors and created a 338-foot-long (103 meters) bas-relief at the Fuji City Cultural Center (pp. 142, 143). And in 2001 she completed a stage curtain, *Doncho* (pp. 150–51), for the new Kiryu City Performing Arts Center in Gunma Prefecture, Japan, using a number of innovative new fiber technologies that she pursued with local engineers and factories.

From wool to cotton, and from linen to rubber and steel, pliable filaments have served Hicks as the medium of expression through which she has woven/twisted/knotted/plaited the connective tissue of her life since the day she first pounded nails into stretcher bars and pulled a thread across the open space between them. The thread that she has followed since that day has led her through materials, processes, and conceptual frameworks, all of which carry with them complex histories. Within those histories, her work forms its own connective "thread," linking far-flung cultures and modern expressions, and drawing together many twentieth-century radical tendencies.

NOTES

1. Excerpts from Hicks's journal were published in *Free Fall: Sheila Hicks* at the Israel Museum, Jerusalem, 1980; the original source has been edited by the artist for clarity. I want to thank Sheila Hicks for her patience and generosity, her willingness to share her vast knowledge of textiles, and her assistance in elucidating and clarifying the history covered in this essay; any remaining errors are solely my responsibility. My thanks to Joan Simon and Susan Faxon, whose patient commitment to the exhibition has facilitated its progress at every step, and whose careful readings of the text and generous suggestions proved invaluable. A number of individuals assisted in tracking down specific works and providing illustrations; special thanks to Jill Bloomer at Cooper-Hewitt, National Design Museum, Bridget Donahue at Gladstone Gallery, Barbara Rominski, and the San Francisco Museum of Modern Art library staff. Thanks also to Jaime DeSimone, Moira Roth, Elissa Auther, Judith Bettelheim, Mildred Constantine, and Monique Lévi-Strauss for their assistance, to Richard Overstreet, Diane Johnson, and John Murray for hospitality and support in Paris, and to friends and family for their encouragement throughout.

2. Quotations from the artist otherwise not attributed derive from conversations with Hicks that took place in her Paris studio and in New York between January 2006 and June 2009.

3. For an expanded discussion of the influence of Albers's teaching on New York artists in the late 1950s and 1960s, see Carl Goldstein, "Teaching Modernism: What Albers Learned in the Bauhaus and Taught to Rauschenberg, Noland, and Hesse," *Arts Magazine* 54, no. 4 (December 1979): 108–16.

4. The formation of this classification system, challenges to it, and its perpetuation are the subject of Elissa Auther's "Classification and Its Consequences: The Case of 'Fiber Art,'" *American Art* 16, no. 3 (Autumn 2002): 2–9. "Consumed as they were with classification," Auther argues, "neither champions nor detractors [of breaking down media-based distinctions] considered the categories 'art' and 'craft' as discursive constructions reflecting an unequal distribution of power, status and prestige in the art world." In *String, Felt, Thread: The Hierarchy of Art and Craft in American Art* (Minneapolis: University of Minnesota Press, 2009) she takes up these issues in an expanded form. For a discussion of the relationship between Hicks's miniatures and tendencies in American art of the 1960s, see my "When Is a Grid Not a Grid: A Tale of Two Works and Multiple Histories," in *Contemporary Feminist Studies and Its Relation to Art History and Visual Studies* (Gothenburg: Acta Universitatis Gothenburgensis, University of Gothenburg Press, 2010), 12–31.

5. The sources of these early paintings range widely: from Paul Klee and Mark Rothko to Joan Mitchell and Philip Guston.

6. Hicks also met Anni Albers in 1956 or 1957 through Josef. Anni's response to Hicks's first weavings appears to have been somewhat ambivalent, and Hicks resisted the experienced weaver's suggestion that she align the edges of the weave in order to reinforce the grid's geometry. Although Anni, who was not on the Yale faculty, would serve as an informal adviser on Hicks's thesis, she was not, as has sometimes been asserted, either a teacher or a mentor. The sources of Hicks's deployment of the raised surface, as well as her understanding of terms like "concept," "material," and "technique" can be traced to Anni Albers's writings, to her use of a so-called floating weft in her weavings, and to Josef Albers's design principles. Equally important, however, was Hicks's work with Kubler, her intensive research into ancient weaving traditions, and her growing belief in a close relationship between woven form and human expression as an integral aspect of material culture; see note 10 below.

7. Sheila Hicks in conversation with Eleanor Munro, in Munro, *Originals: American Women Artists* (New York: Simon and Schuster, 1979), 368.

8. See Josef Albers, *Search Versus Re-search: Three Lectures by Josef Albers at Trinity College, April 1965* (Hartford, CT: Trinity College Press, 1969), 20.

9. Goldstein, "Teaching Modernism," 109; see note 3 above. Hicks is also on record as saying that "the point, of course, is to break the barrier between artisanry and art. Albers made no such distinction. Bauhaus theory made no distinction"; in Munro, *Originals*, 368.

10. The fullest expression of Kubler's ideas can be found in *The Shape of Time: Remarks on the History of Things* (New Haven: Yale University Press, 1962). Kubler's influence on artists is the subject of Pamela M. Lee, "'Ultramoderne'; Or, How George Kubler Stole the Time in Sixties Art," *Grey Room* 2 (Winter 2001): 46–77.

11. Although she never formally enrolled in architecture classes at Yale, Hicks often attended Kahn's critiques, and she credits him with shaping her understanding of architectural scale; she subsequently embarked for South America in the company of his talented student Joaquin Rallo.

12. Hicks had accepted Albers's offer to teach his new course in art and design at the Catholic University in Santiago after completing her BFA in 1957.

13. Munro, *Originals*, 367.

14. Larrain, later a Magnum photographer, was the son of the distinguished architect and dean of the Architecture School at the Catholic University, Sergio Larrain Garcia-Moreno.

15. Nina Strizler-Levine, ed., *Sheila Hicks: Weaving as Metaphor*, (New Haven: Yale University Press, 2006), 94. Hicks was not alone among North American artists in drawing on Mexico's rich cultural heritage in the first half of the twentieth century. Between 1933 and the 1960s the Alberses made some fifteen visits of varying duration to Mexico. Josef Albers's 1941 series Graphic Tectonics includes the lithograph *To Monte Alban*, and the clean modernist lines and crisp shadows of his photographs of adobe walls acknowledge his familiarity with Edward Weston's photographs of Mexican vernacular architecture. Anni Albers's first wall hangings executed after moving to the United States include *Ancient Writing* and *Monte Alban*, both 1936, and they incorporate the parallels she saw between De Stijl and ancient Andean textiles. Neal Benczra has traced Josef

Albers's approach to art and architecture as a fusing of Bauhaus thought and the example of pre-Columbian architectural sculpture; *The Murals and Sculpture of Josef Albers* (New York and London: Garland, 1985), 35 and passim. See also *Anni and Josef Albers: Latin American Journeys* (Madrid: Museo Nacional Centro de Arte Reina Sofía and the Josef and Anni Albers Foundation), 2007.

16. "La magie del arte textil," *Novedades*, March 26, 1961.

17. The group included prominent members of the expatriate European community of surrealists, including photographer Kati Horna. Hicks's friendships with the surrealist painters Leonora Carrington and Alice Rahon in Mexico also point to her awareness of the activities of the exiled European surrealist community in Mexico at this time; see Francisco Reyes Palma, "La exposición de Los Hartos," in *Los ecos de Mathias Goeritz* (Mexico City: Antiguo Colegio de San Ildefonso, 1997), 169–79.

18. Goeritz's "museum," controversial from the beginning (its spaces were compared to the sets of Fritz Lang's Expressionist film *The Cabinet of Dr. Caligari*), was vigorously attacked by Diego Rivera. The ensuing public debate stimulated Goeritz to produce a "Manifesto of Emotional Architecture," in which he laid out his intention of putting the language of abstraction in architecture and sculpture into the service of organic, social, and spiritual values; for a fuller discussion of Goeritz's theories, see *Mathias Goeritz, Architectural Sculpture* (Jerusalem: Israel Museum, 1980). If Goeritz's form language remained decidedly modernist, his emphasis on the emotional and spiritual content of sculpture contributed mightily to his marginalization in New York's minimalist circles in the 1960s, despite clear formal similarities between his objects and those of Robert Morris, Donald Judd, Ronald Bladen, and others; see Gregory Battcock, ed., *Minimal Art: A Critical Anthology* (Berkeley and Los Angeles: University of California Press, 1995; originally published by Dutton Signet in 1968), 19–20.

19. Olivia Zuñiga, *Mathias Goeritz* (Mexico: Editorial Intercontinental, 1963), 41; examples of these works were included in the exhibition of Los Hartos in 1961.

20. While not widespread at the time, the new approach was applauded by some; see, e.g., Thomas Creighton, "The New Sensualism," *Progressive Architecture* 40, no. 2 (September 1959): 141–47. Two years later the journal positioned Goeritz's "emotional architecture" at the center of a wider tendency characterized as the "new sensualism" that had arisen in the 1950s. See also Mathias Goeritz, Introduction to Hans Beacham, *The Architecture of Mexico: Yesterday and Today* (New York: Architectural Book Publishing, 1969), 7–11.

21. Hicks's letter to Daniel was consulted in the Sheila Hicks archives. Hicks's relationship with the museum was further strengthened when Mildred Constantine, a pioneering supporter of contemporary work in fiber who had studied art history in Mexico, succeeded Daniel and became a strong advocate of Hicks's work.

22. Hicks was drawn to Dorazio's search for sculptural definition, architectonic structure, and "plasticity," an untranslatable and elusive melding of materiality and optical sensation that was shaped by twentieth-century European modern movements from Russian formalism and the Bauhaus to Forma I in Italy and the pure abstraction of Robert and Sonia Delaunay; Edward Fry, "Piero Dorazio and the Crisis of European Values," in *Piero Dorazio: A Retrospective* (Buffalo, NY: Albright-Knox Art Gallery, 1979), 11.

23. E-mail from Sheila Hicks to the author, March 17, 2008.

24. The letter was consulted in the Sheila Hicks archives. Constantine was assistant curator in the Department of Architecture and Design from 1948 to 1953, and associate curator 1953–70.

25. The exhibition grew out of Billeter's initial interest in exhibiting Hicks's work from Mexico in a solo show and expanded to include the work of Lenore Tawney, Claire Zeisler, Alice Adams, and Dorian Zachai. The title derived from the term Tawney had given to her first sculptural objects, open-warp weavings with areas of plain weave and/or exposed warp thread that began in 1955. Although categories and designations, from "craft/craftsperson/weaver" to "art/artist," used in discussing work in nontraditional "fine arts" media would remain contested throughout the 1960s and '70s, I have chosen to use the term "artist" in speaking of work that engages in genres associated with contemporary art such as collage, assemblage, installation, etc., regardless of the media employed. The history of this terminology is the subject of Elissa Auther's *String, Felt, Thread*, cited in note 4. The term "tapestry" is used to distinguish a flat weave from cloth in that the weft does not travel from selvage to selvage, but breaks its progress in order to produce the colored areas and patterns that build the images of the historical tapestry. As Auther notes, during the 1960s and '70s, "an extraordinary number of artists beyond the so-called fiber artists…, including Eva Hesse, Robert Morris, Keith Sonnier, Lucas Samaras, Miriam Schapiro, Faith Ringgold, and Judy Chicago, to name only the most well-known, experimented with or adopted the medium" (*String, Felt, Thread*, xii).

The artists included in *Woven Forms* represented neither a "school" nor a "movement," and they came from different geographic regions and had no direct influence on each other at this time. Tawney, who had begun her career as a sculptor, had turned to weaving in the early 1950s; Hicks and Adams had both started out as painters, with the latter moving on to study sculpture and, later, tapestry at Aubusson in France. Curator Paul Smith's positioning of their objects as somewhere between "historical weaving techniques," "traditional conceptions of form," and "objects of a radically new nature" points to the growing effort to differentiate the new work in fiber both from traditional weaving/craft *and* from sculpture/"fine" art without allowing one to absorb the other and, at least implicitly, negate real differences in many artists' attitudes toward the relationship between material, form, and concept. The fact that the exhibition took place in a museum already closely identified with histories of craft in the United States, however, may have contributed to reinscribing its contents as craft; Smith, Introduction to *Woven Form*, unpaginated; see also Auther, *String, Felt, Thread*, 3–4, 30–31, and passim.

26. Curators Greta Daniel and Arthur Drexler justified their use of the term "artist-craftsman" on the grounds that "individual craftsmen [sic] still excel in the attention to detail that provides one kind of quality in textiles"; see Greta Daniel, Introduction to Textiles U.S.A. (New York: Museum of Modern Art, 1956), 6. For a discussion of terminology and identity at a moment when definitions of design and craft were unstable, see Nina Stritzler-Levine, "A Design Identity," in Sheila Hicks: Weaving as Metaphor, 346–51. Like many artists who came of age in a period when identity politics were beginning to articulate sexual and cultural identities through hyphenation ("woman-artist," "African-American," "fiber-artist," etc.), Hicks shared Anni Albers's view that, "ancient craftsmen were artists, no hyphen needed," and she continues to avoid classifications that she feels restrict, rather than enhance, meaning; the Anni Albers quote is in "Conversations with Artists," in Anni Albers: Selected Writings on Design, ed. Brenda Danilowitz (Middletown, CT: Wesleyan University Press, 2000), 52. The term "woman artist," feminist art historian Griselda Pollock later cautioned, differentiates the history of art along the lines of "artists" and "women artists." "We invite ourselves to assume a difference," she added, "which all too easily makes us presume that we know what it is" (Differencing the Canon: Feminist Desire and the Writings of Art's Histories [New York: Routledge, 1999], 33).

27. The exhibition situated Hicks's work within innovative new developments in fiber and led to invitations to teach a workshop at the Bath Academy in England and to work in German and Irish textile and carpet mills. Within the next few years Hicks would exhibit in Italy, Germany, Finland, Sweden, and England, among other European countries.

28. The earliest example of a new relationship between wall and floor was developed in the carpets and wall panels Hicks executed for the Rancho Chorillo in Taxco, Mexico, around 1960.

29. Document consulted in the Sheila Hicks archives.

30. Martin herself saw the origins of the grid in her work not in relation to Greenberg's search for irreducible flatness and an opticality shorn of referential meaning, but as a way of linking pure form and meaning that recalled Mondrian's philosophy; see Anna Chave, "Agnes Martin: 'Humility; The Beautiful Daughter ... All of Her Ways Are Empty,'" in Barbara Haskell, Agnes Martin, with essays by Barbara Haskell, Anna C. Chave, and Rosalind Krauss (New York: Whitney Museum of American Art, 1992), 136. The inclusion of Martin's paintings in signal exhibitions of geometric abstraction in the 1960s, including the Guggenheim Museum's 1966 exhibition Systemic Painting, contextualized her grids in relation to the work of artists like Frank Stella and Donald Judd, and may have shifted attention away from the fact that she was never exclusively interested in issues of pure form. Her mark-making, its variations and texture evident, bears the hallmarks of a personal handwriting in a way similar to that of Hicks's Letters and Hieroglyphs.

Although coincidental, it is significant that Erika Billeter's 1964 exhibition Gewebte Formen (Zurich: Kunstgewerbemuseum) and Clement Greenberg's Post-Painterly Abstraction (Los Angeles County Museum of Art) opened the same year. Although Gewebte Formen and Post-Painterly Abstraction were directed toward different audiences, both sought to reconceptualize histories of twentieth-century abstract painting and woven form.

31. See note 3 above.

32. Rauschenberg quoted in Calvin Tompkins, Off The Wall (Garden City, NJ: Doubleday, 1980), 182.

33. Sheila Hicks in conversation with the author, Paris, March 28, 2007.

34. The year 1966 also marked Eva Hesse's first exhibition of wrapped and soft objects fashioned by hand from cloth, fiber, wire, and rubber, and her participation in major exhibitions including Stuffed Expressionism at the Graham Gallery and Lucy Lippard's Eccentric Abstraction at the Fischbach Gallery, both in New York City.

35. David Antin, "Another Category: Eccentric Abstraction," Artforum 5, no. 3 (November 1966): 57. The trajectory from geometric form to organic reference was addressed by Grace Glueck in a review that covered a range of current New York exhibitions, including Eccentric Abstraction. See her "ABC to Erotic," Art in America 54, no. 5 (September–October 1966): 105–8.

36. J. Patrice Marandel, "An Interview with Clair Zeisler," Arts Magazine 54, no. 1 (September 1979): 152.

37. Frances Morris, ed., Louise Bourgeois (London: Tate Modern, 2007), 174.

38. Auther, "Classification and Its Consequences," 8. Artists like Sandback and Tuttle also challenged both minimalism's reliance on industrial materials and its valorization of heroic scale. The small scale, modesty, and ephemeral materials that emerged in Tuttle's merging of painting and sculpture in his "constructed paintings" around 1965 elicited a set of critical responses that culminated in Hilton Kramer's dismissal of his 1975 Whitney Museum retrospective. Failing to recognize the works' radical challenge to modernist imperatives, Kramer fell back on a Greenbergian rhetoric that dismissed modesty and small scale as attributes of the so-called minor arts (a category that included fiber and textiles); Hilton Kramer, "Tuttle's Art on Display at Whitney," New York Times, September 12, 1975.

39. The work's title referenced the weaving and craft workshop that Hicks, working with Catalan artist Juame Xifra and Jean Paul Beranger from Paris, founded in Chile in 1968 to provide employment for workers during a drought that decimated the country's sheep herds.

40. See Germano Celant, Arte Povera (New York: Praeger, 1969; originally published by Gabriele Mazzotta Publishers, Milan); and Germano Celant, "Arte Povera," in Arte Povera in Collezione (Milan: Castello di Rivoli Museum d'Arte Contemporanea, 2000).

41. This led to multiple commissions, including work for King Saud University in Riyadh, designed by architect Gio Obata in the 1980s.

42. Cited in Monique Lévi-Strauss, Sheila Hicks (New York: Van Nostrand, 1974), 26.

43. Mason Currey, "Rediscovered Masterpiece: The Ford Foundation," *Metropolis: Architecture/Culture/Design* 28, no. 5 (December 2008): 90–103; the quote is on 90.

44. Ibid., 96. The tapestry project consisted of "two walls": one in the auditorium (9.80 m x 4.07 m; 32 ft., 2 in. x 13 ft., 4 in.) and the other in the conference room (12.23 m x 3.04 m; 40 ft., 2 in. x 10 ft.), both visible through glass doors from a common entrance.

45. For a more complete description of the work, see Lévi-Strauss, *Sheila Hicks*, 26–29.

46. Hicks, cited in Currey, "Rediscovered Masterpiece," 100. The multiple sources of Hicks's "soft walls" include Bauhaus design principles as well as Anni Albers's insistence on the importance of the flexible plane in the use of fiber in contemporary architecture. In "The Pliable Plane, Textiles in Architecture," *Perspecta 4; The Yale Architectural Journal* (1957): 36–41, Albers drew on the Bauhaus notion of the flexible, or "pliable," plane in arguing for a new role for textiles in modern architecture. Tracing the history of textiles in the production of transportable and lightweight dwellings with walls of nonrigid, nonsupporting material that are related to textiles, even if not literally derived from woven fiber, she argued that the structural principles relating built and woven forms have the potential to generate a new relationship between the architect and the inventive weaver. Fabric must become an "integral architectural element, a counterpart to solid walls," she concluded (41).

47. For a review of the work when it was exhibited, see Jack Lenor Larsen, "The New Weaving," *Craft Horizons* 29 (March/April 1969): 22–30.

48. Mildred Constantine and Jack Lenor Larsen, *Wall Hangings* (New York: Museum of Modern Art, 1969), unpaginated. Unlike contemporary exhibitions that plotted the course of postminimalism in the United States and "fiber art" in Europe, *Wall Hangings* was largely ignored by New York critics. The sole art review, written by sculptor Louise Bourgeois and published in the journal *Craft Horizons*, offered qualified approval amid some reservations (she had, after all, turned away from her family's work as tapestry restorers in becoming a sculptor, and although she would later reincorporate textiles into her work she had not yet begun to do so to any significant degree); see Louise Bourgeois, "The Fabric of Construction," *Craft Horizons* (March 1969): 31–35.

49. Constantine and Larsen, *Wall Hangings*, unpaginated.

50. See Auther, "Fiber Art and the Hierarchy of Art And Craft, 1960–1980," *Journal of Modern Craft* 1 (March 2008): 13–34.

51. See, for example, Johanna Drucker's useful discussion in *Theorizing Modernism: Visual Art and the Critical Tradition* (New York: Columbia University Press, 1994), 9–17 and passim.

52. Documents relating to the exhibition and its critical reception were consulted at the Sheila Hicks archives.

53. Mathey, responding to Hicks's question "Why has it taken so long for you to cross the river," replied with the words *"Je savais que, si je venais un jour, j'y passerais mes nuits"* (I knew that if I came one day, I would pass the nights), a phrase which soon became the title of another Hicks work.

54. Hicks and Saint Phalle were both aware of the cultural differences toward issues of gender and sexuality in France and the United States in the 1970s that would shape subsequent writing, though neither focused on them. See, for example, Elaine Marks and Isabelle de Courtivron, "Introduction III: Contexts of the New French Feminism," in *New French Feminisms*, ed. Marks and de Courtivron (New York: Schocken, 1981), 28–38; and Roger Célestin, Eliane Dal-Molin, and Isabelle de Courtivron, eds., *Beyond French Feminisms: Debates on Women, Politics, and Culture in France, 1981–2001* (New York: Palgrave Macmillan, 2003), 1–14.

55. For an extended discussion of this phenomenon in the context of the 1960s and early 1970s, see Alex Potts, "Tactility: The Interrogation of Medium in Art of the 1960s," *Art History* 27 (April 2004): 283–304.

56. I am indebted to Elissa Auther for her characterizations of the attitudinal differences of artists maturing in the 1970s, 1980s, and 1990s.

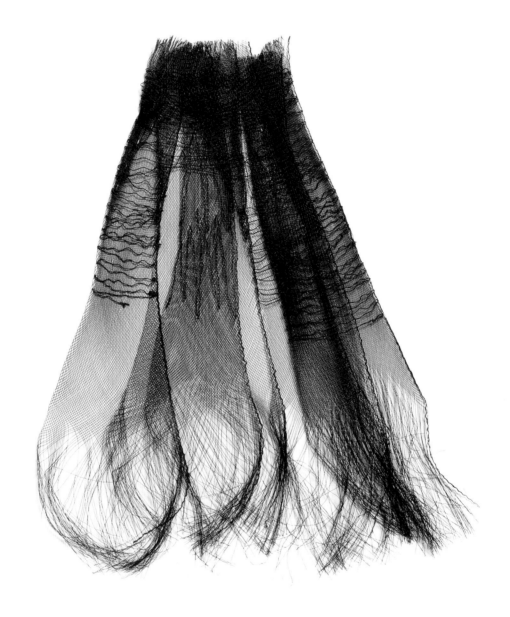

Forêt Bleue 2002

Cotton, synthetic hat bands; 13 13/16 × 9 7/8 IN / 35 × 25 CM

Private collection

194

Manoli 2001–2
Cotton, synthetic fiber, leather; 9 × 5½ in / 22.9 × 14 cm
Collection of James Stacey and Elizabeth Murphy

Vagues de Phare 2003

Cotton, hand-spun wool; 8⅝ × 5¼ ɪɴ / 21.9 × 13.3 ᴄᴍ

Collection of Caroline and Roger Ford

Phare d'Acier 2003

Linen, cotton, stainless steel; 9⅝ × 5¾ ɪɴ / 24.5 × 14.6 ᴄᴍ

Private collection

Droite Gauche 2003

Linen, razor clam shell; 9 1/16 × 5 7/8 IN / 23 × 15 CM

Cooper-Hewitt, National Design Museum, Smithsonian Institution (Gift of Anonymous Donor, 2006-31-1)

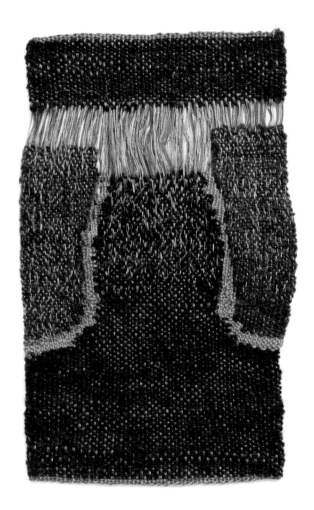

Phare Ouvert 2003

Cotton, hand-cut wool; 9 × 6 in / 22.9 × 15.2 cm

Collection of Caroline and Roger Ford

Les Escargots 2003–4

Cork, linen; dimensions variable

Collection of Target Corporation and the artist

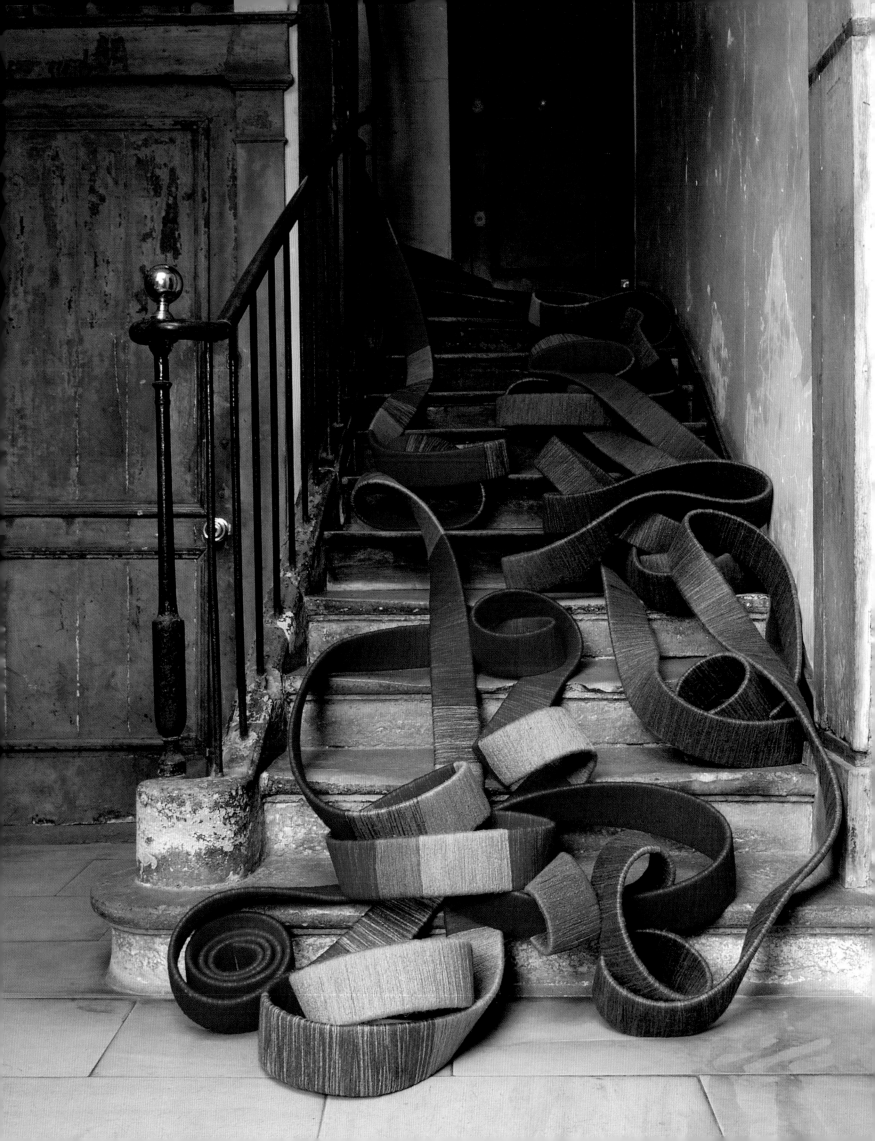

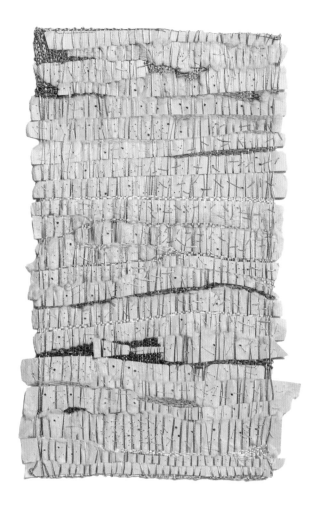

La Lettre de Rupture 2004
Cotton, handmade paper, linen; 9⅞ × 6 in / 25 × 15.2 cm
Private collection

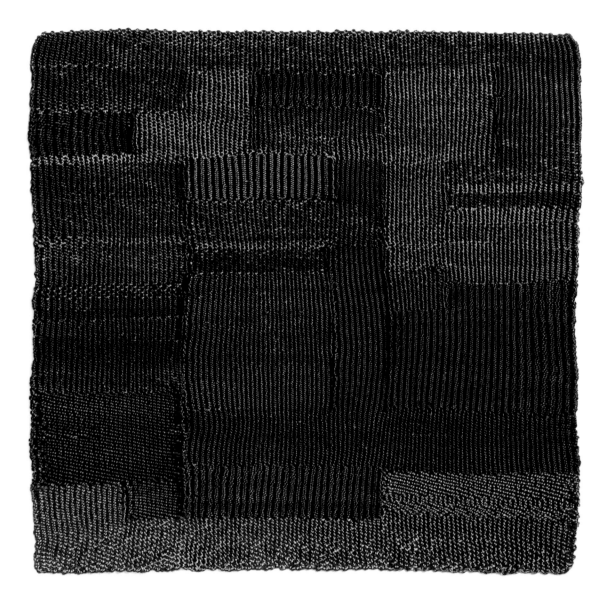

Moudang 2004

Stainless steel; 11 × 11¹³⁄₁₆ ᴉɴ / 28 × 30 ᴄᴍ

Cooper-Hewitt, National Design Museum, Smithsonian Institution (Museum purchase from General Acquisitions Endowment Fund, 2006-13-4)

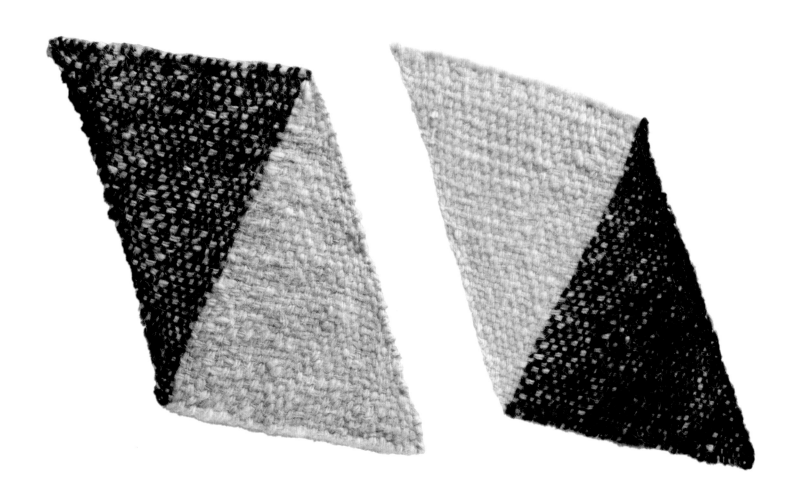

Diagonal I 2005
Hand-spun wool; 17¼ × 16½ in / 43.8 × 41.9 cm
Collection of Caroline Baumann

Diagonal III 2005
Hand-spun wool; 17¼ × 16½ in / 43.8 × 41.9 cm
Collection of Caroline Baumann

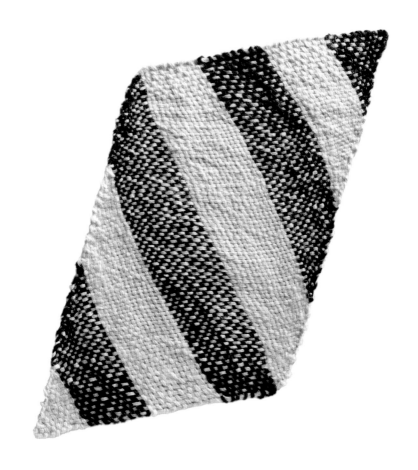

Lino Diagonal 2005

Linen; 14½ × 12¾ in / 36.8 × 32.4 cm

Private collection

Effondrement 2005

Synthetic silk, slate; 9¹³⁄₁₆ × 5¹¹⁄₁₆ IN / 25 × 14.5 см

Cooper-Hewitt, National Design Museum, Smithsonian Institution (Gift of Anonymous Donor, 2006-14-6)

Niña, Niña 2005

Cotton, wool; 9⅞ × 5½ in / 25 × 14 cm

Collection of Ali Stritzler-Levine

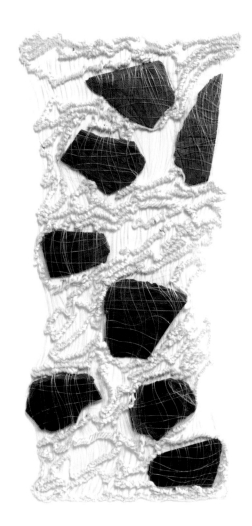

Ardoise 2006
Linen, slate, monofilament; 8½ × 4⅛ in / 21.6 × 10.5 cm
Private collection

Mozambique 2006
Linen, synthetic fibers; 10 × 8 in / 25.4 × 20.3 cm
Private collection

208

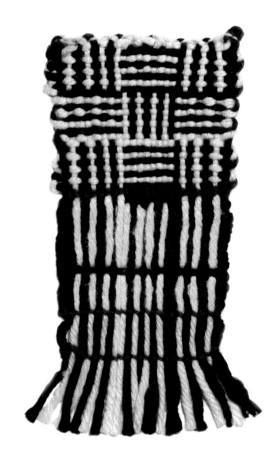

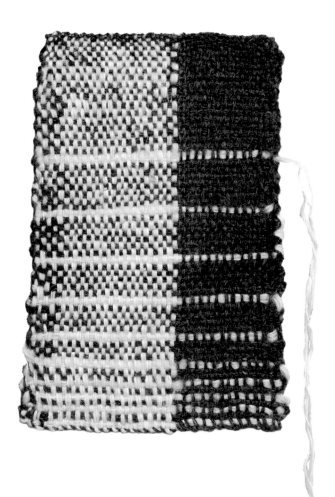

Inca Chinchero 2007

Cotton; 9 3/16 × 5 3/8 IN / 23.3 × 13.7 CM

Private collection

Embedded Voyage 2008

Alpaca, wool; 8 1/2 × 5 1/2 IN / 21.6 × 14 CM

Private collection

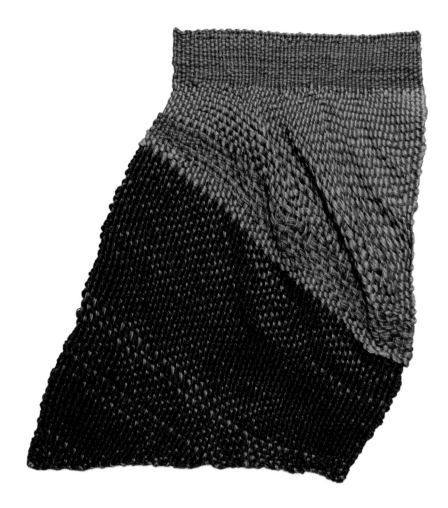

Déménageur 2008
Silk; 9⅛ × 8⅛ in / 23.2 × 20.6 cm
Private collection

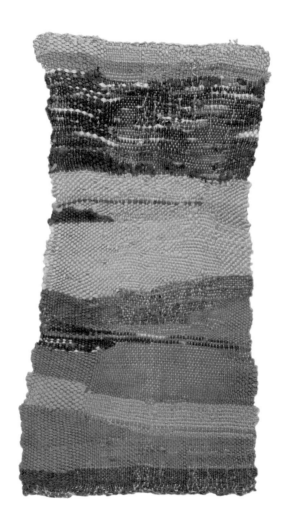

Bonsai Tapestry c. 1986

Cotton, rayon; 9½ × 5⅛ in / 24.1 × 13 cm

The Metropolitan Museum of Art, New York, N.Y. (Gift of Edward Merrin, 1990, 1990.271)

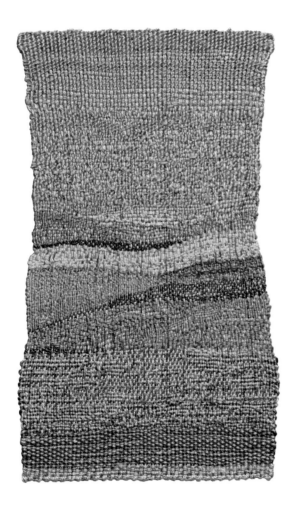

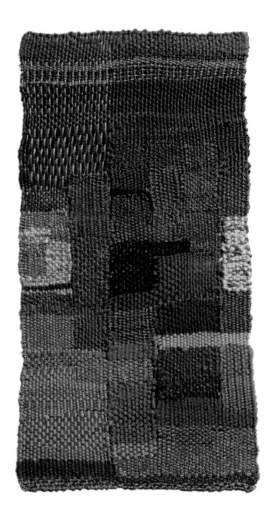

A Certain Distance 2008
Cotton, silk; 9⅜ × 5½ in / 23.8 × 13.9 cm
Private collection

Cluny II 2008
Metallic; 10 × 6 in / 25.4 × 15.2 cm
Collection of Itaka Martignoni

Prophecy from Constantinople 2008–10
Linen, wool; 236¼ × 70⅞ IN / 600 × 180 CM
Private collection

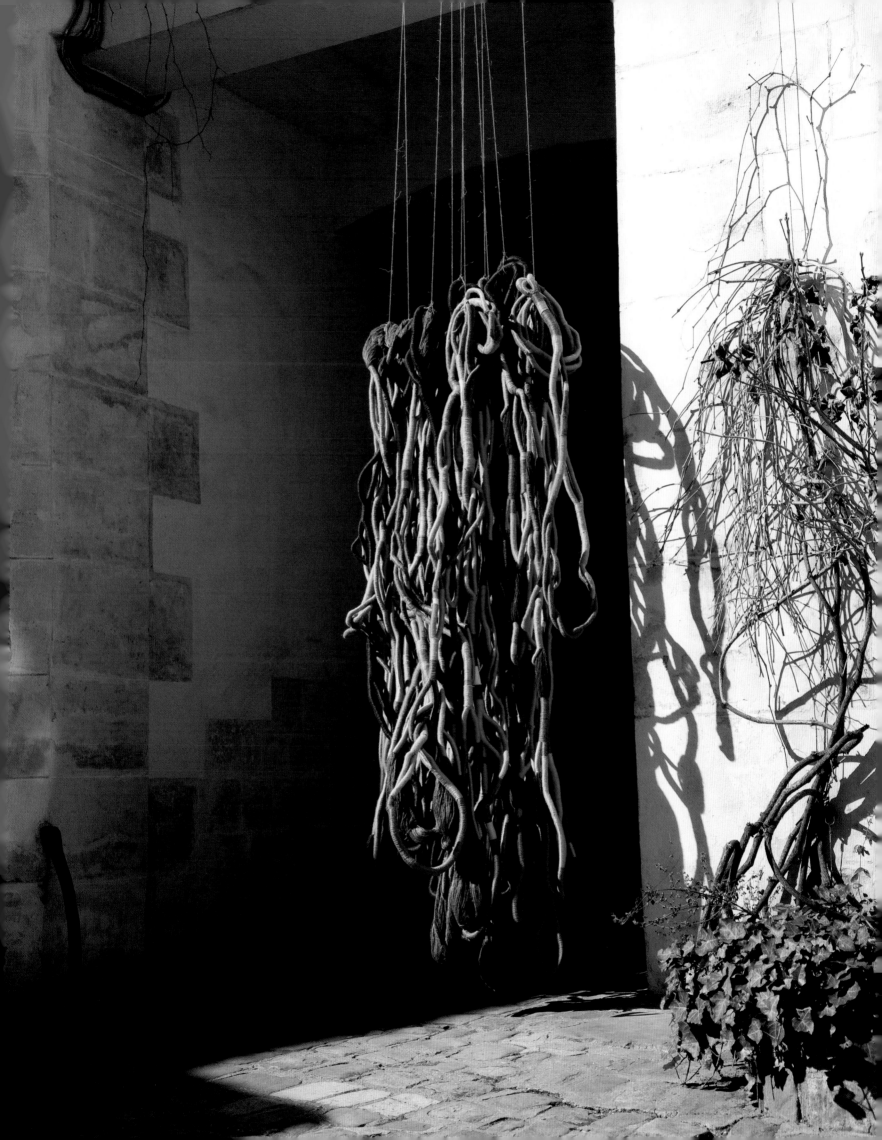

Blessed Hand 2009

Cotton, bamboo; 9½ × 5¾ in / 24.1 × 14.6 cm

Private collection (courtesy of Cristina Grajales Gallery)

Etiquette 2009 (two views)

Bamboo, cotton, paper; 9½ × 5¾ in / 24.1 × 14.6 cm

Private collection (courtesy of Cristina Grajales Gallery)

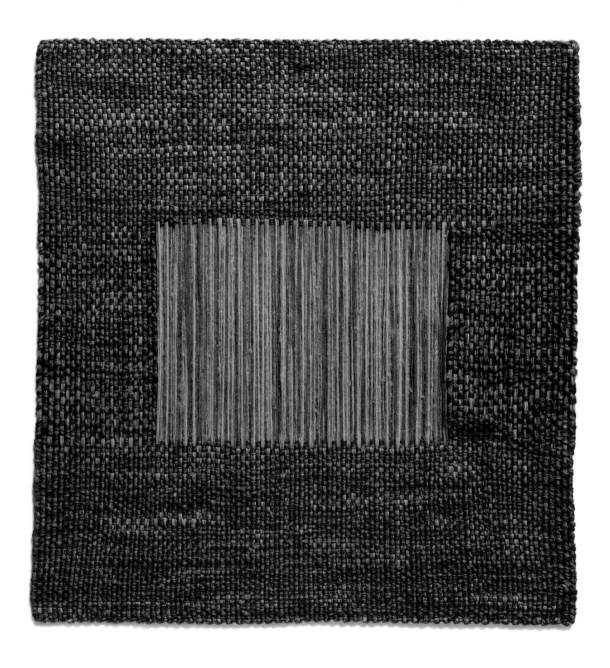

Fenêtre II 2009
Cotton, bamboo, linen, silk; 10¾ × 10¼ in / 27.3 × 26 cm
Private collection

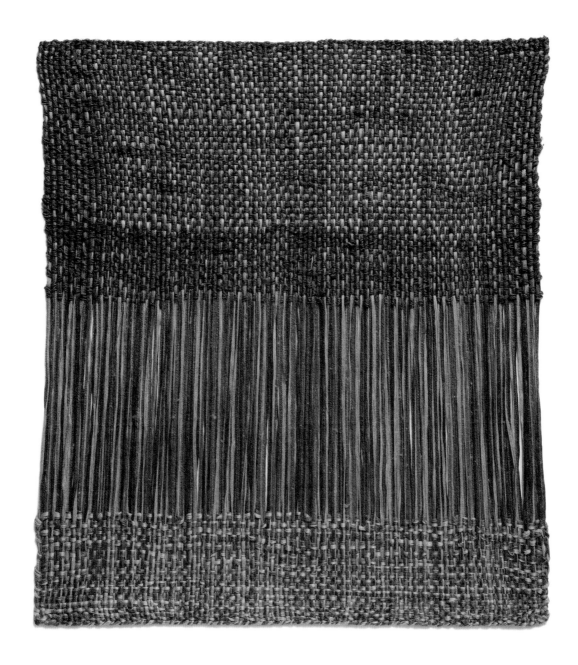

Fenêtre III 2009

Cotton, bamboo, linen, silk; 10¾ × 9¾ in / 27.3 × 24.8 cm

Private collection

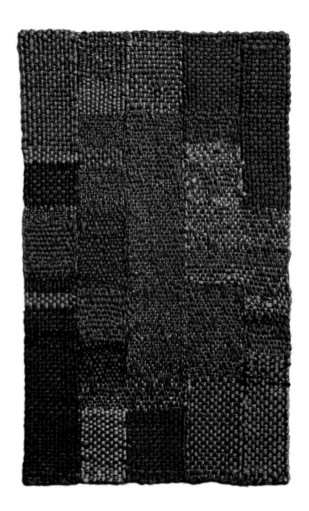

Scarlet Byways 2009

Bamboo, cotton, silk; 9½ × 6 in / 24.1 × 15.2 cm

Private collection (courtesy of Cristina Grajales Gallery)

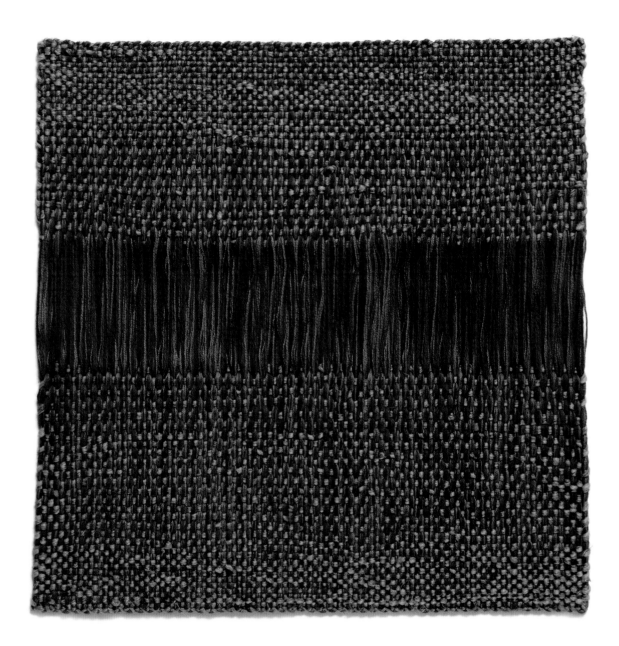

Fenêtre I 2009
Cotton, bamboo, linen, silk; 10½ × 10½ in / 26.7 × 26.7 cm
Private collection

Installation, SD26 Restaurant & Wine Bar, New York 2009
Dimensions variable
Designer: Vignelli Associates, Massimo Vignelli

Wrapped and Coiled Traveler 2009
Bamboo, cotton, wool, silk; 8⅞ × 5¼ IN / 22.5 × 13.3 cm
Private collection (courtesy of Cristina Grajales Gallery)

226

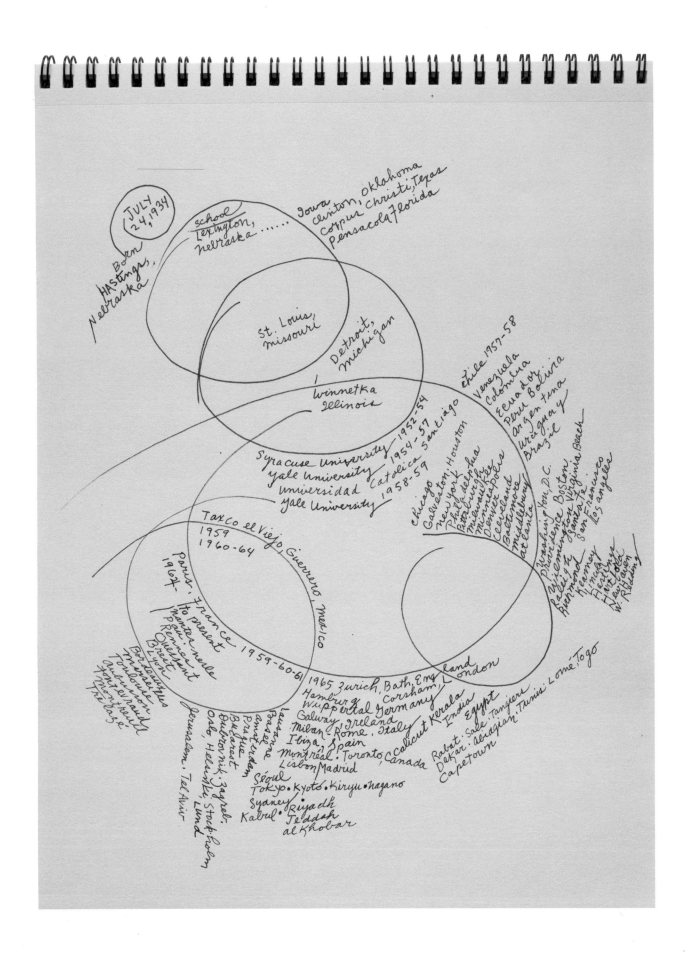

Fig. 60. Sheila Hicks, *Chronology*, 2010. Ink on paper, 14 x 11 in. (35.6 x 27.9 cm), Collection the artist.

Chronology

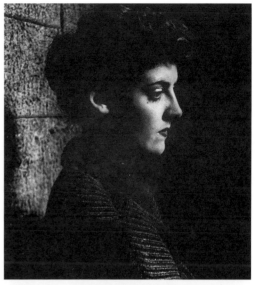

1934

Born July 24 in Hastings, Nebraska, to Frances Barbara Weingart (1912–1993) and Ray Eugene Hicks (1913–1993).

•

1941–54

Attends grade school in Lexington, Nebraska and, from age seven, in Detroit, where she completes elementary school and intermediate school studies. Takes Saturday art classes at the Detroit Institute of Art. Enrolls at Cass Technical High School and studies geometry and two-dimensional design. Family moves to Winnetka, Illinois (1949). Hicks attends New Trier High School, graduating in 1952, and attends summer school at the Art Institute of Chicago, where she studies draping and pattern-making, before entering Syracuse University in the fall to study art. Studies painting and printmaking. Among Hicks's teachers at Syracuse University are John Davies, Jim Dwyer, and Douglas Wilson. In spring 1954 is accepted as a transfer student at Yale University School of Art and Architecture, New Haven, Connecticut. Spends the summer (1954) painting in Taxco, Mexico. Enters Yale in the fall.

•

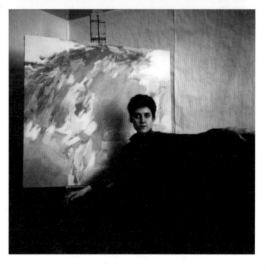

Fig. 63. Ernest Boyer, photograph of Sheila Hicks, 1957.

Fig. 64. Sheila Hicks's "painting stall," Street Hall, Yale University, 1958. On the chair is a Bolivian hand-woven alpaca carrying sack that Hicks converted into her winter coat. On the wall above is a photograph by Sergio Larrain. On the easel is a Color Crossed work on paper, from a series the artist continues to make today. Above and to the right of the easel is one of Hicks's abstract paintings of powdered pigment with polymer on canvas.

Fig. 65. Ernest Boyer, photograph of Hicks with a painting in progress, Street Hall, 1958.

Fig. 62. Sheila Hicks, *Taxco-Iguala*, painted in July 1954 in Taxco el Viejo, Mexico. Oil on canvas, 12 x 16 in. (30.5 x 42 cm).

Fig. 61. Sheila Ann Hicks, age 3.

228

1954–57

At Yale studies painting, sculpture, printmaking, photography, typography, art history, and architecture history. Among her teachers at Yale are Josef Albers, Bernard Chaet, Sewell Sillman, Herbert Matter, Norman Ives, George Heard Hamilton, George Kubler, and Vincent Scully. Attends architecture crits of Louis Kahn; independent study of weaving after school with Anni Albers (1956); independent study of ancient Andean textiles with archeologist Junius Bird. Works hand-setting type in a small printing house. Awarded a Fulbright grant to study painting in Chile (1957–58). Receives BFA in painting (1957).

•

1957–58

Travels to Venezuela, Columbia, Ecuador, Peru, Bolivia, and Chile (figs. 14, 32, 33). Photographs Andean weavers and archeological sites including Machu Picchu. Teaches in Spanish basic design and color to architecture students at the Universidad Católica, Santiago. First museum exhibition of weavings at Museo de Historia Natural, Santiago (1957). First museum exhibition of paintings at Museo Nacional de Bellas Artes, Santiago (April 1958). Exhibits paintings with photographs by Sergio Larrain at Galeria Galatea in Buenos Aires, Argentina (June 1958). Visits Brazil. Returns to Yale (September).

•

Fig. 69. Luis Barragán, photograph of Sheila Hicks and Antonio Souza, at her first gallery exhibition, Antonio Souza Gallery, Mexico, D.F., 1961 (taken with Hicks's Rolleicord camera).

Fig. 70. Faith Stern, photograph of Sheila Hicks weaving on a back-strap loom attached to a banyan tree, Mitla, Oaxaca, Mexico, 1960.

Fig. 71. Ferdinand Bosch, photograph of Sheila Hicks weaving using a small stretcher-bar frame as a loom, Taxco el Viejo, Mexico, 1960. On the wall behind are two of her *faja* works. Her dress is of her own design, in hand-woven cotton manta.

Fig. 66. Josef Albers with students drawing a kraft paper "Baroque scroll" on the wall, 1955–56. Courtesy of The Josef and Anni Albers Foundation, Bethany, CT.

Fig. 67. Marc Riboud, photograph of Sheila Hicks, Rancho Chorillo Acuaduct, Taxco, Mexico, 1964.

Fig. 68. Sergio Larrain, photograph of Sheila Hicks on the balcony of her house and studio on Calle Merced, Santiago, Chile, 1958, during her Fulbright fellowship stay.

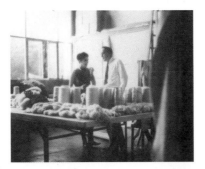

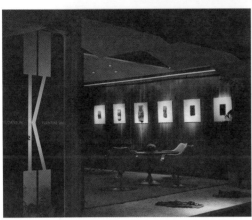

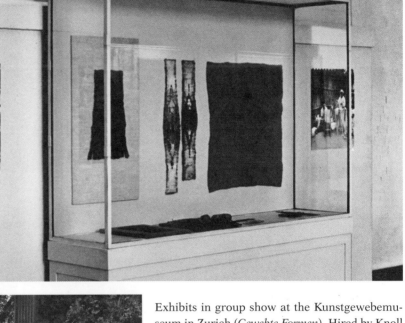

1959–65

Studies with Josef Albers and Rico Lebrun. Receives MFA in painting at Yale School of Art and Architecture (1959). Awarded Fribourg grant to paint in France, beginning fall 1959 to spring 1960. Prior to studying in France moves to Mexico, photographs and films architecture by Félix Candela. Meets Mathias Goeritz, Luis Barragán, and Ricardo Legorreta. Returns to Mexico (1960), teaches basic design and color in the architecture department at the Universidad Nacional Autónoma. Exhibits two- and three-dimensional works in wool at Galeria Antonio Souza, Mexico City, in her first solo gallery show (1961). Opens workshop and weaves cotton and wool in architectural scale. The Museum of Modern Art, New York acquires work by the artist (*Blue Letter*, 1959), first of her works to enter a museum collection (1960). Exhibits in group shows, among them at the Museum of Modern Art (*New Acquisitions*, 1960), the Museum of American Craft (*Woven Forms*, 1963, which travels under the title *Formas Tejidas*), and Milan Triennial (1964). Exhibits at Knoll Associates showrooms in Mexico City and Chicago (1963) (fig. 73). First solo exhibition in American museum at the Art Institute of Chicago (1963–64; fig. 74), and first solo gallery exhibition in the United States at La Piña Gallery, La Jolla, California (1963) (fig. 76).

>

Exhibits in group show at the Kunstgewebemuseum in Zurich (*Gewebte Formen*). Hired by Knoll Associates (1964) to develop textile designs and act as a consultant on color and materials; moves to Paris that year. Teaches first workshop at the Bath Academy in England (November 1964). Designs for the carpet mill Vorwerk-Arterior in Wuppertal, Germany. Completes her first public commission, for Eero Saarinen's new CBS (Columbia Broadcasting System) building on Fifty-Second Street in New York City; Warren Platner interior designer (1964).

•

Fig. 72. Sheila Hicks with architect Warren Platner at Vorwerk-Arterior factory, Wuppertal, Germany, 1962.

Fig. 73. Sheila Hicks's exhibition at the Knoll Associates showroom, Merchandise Mart, Chicago, 1963.

Fig. 74. Installation photograph of Sheila Hicks's first solo museum exhibition in an American museum, *Textiles by Sheila Hicks*, 1963, Art Institute of Chicago—included her photographs and weavings. The photograph of Sheila Hicks with backstrap loom by Faith Stern is at left.

Fig. 75. Marc Riboud, photograph of Sheila Hicks and artist Barbara Chase-Riboud, with David Riboud and Pia Zañartu, Normandy, France, July 1965.

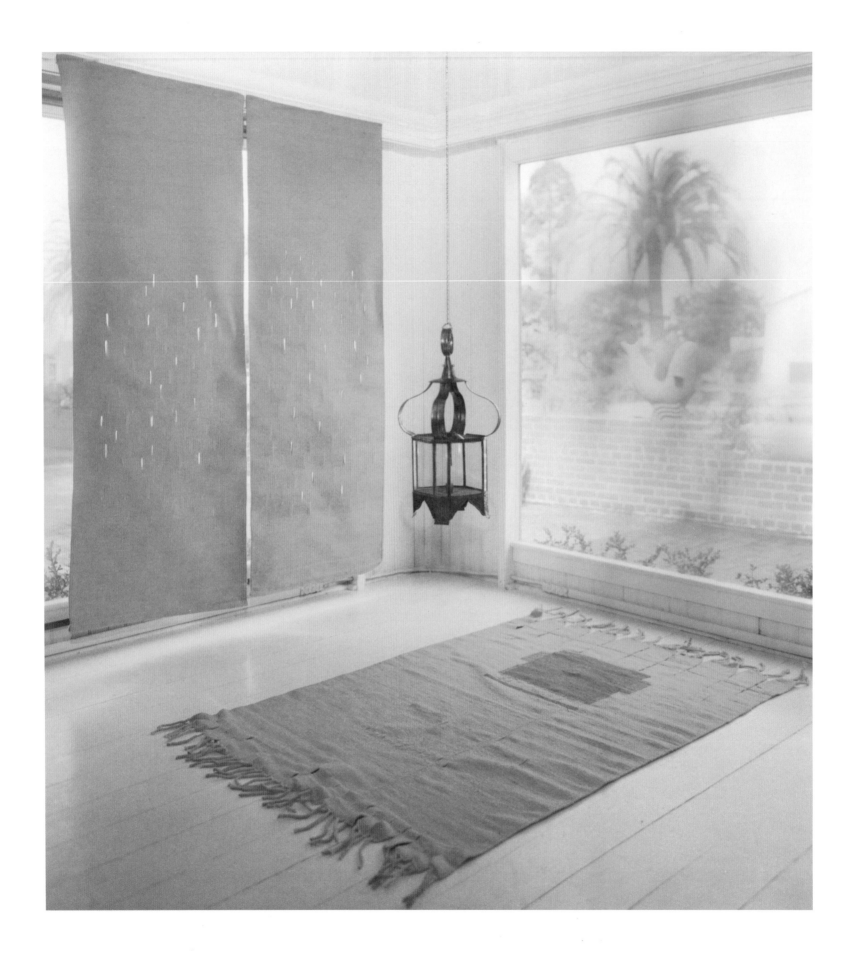

Fig. 76. Sheila Hicks's first solo gallery exhibition in the United States, *Exhibiting Wool—Sheila Hicks*, La Piña Gallery, La Jolla, California, 1963.

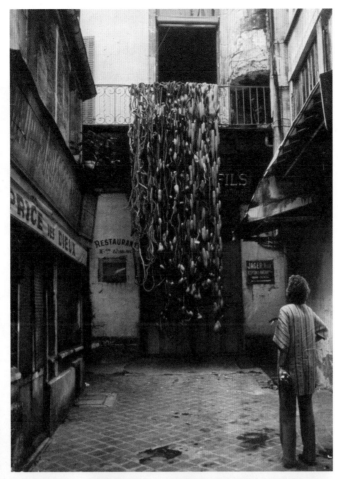

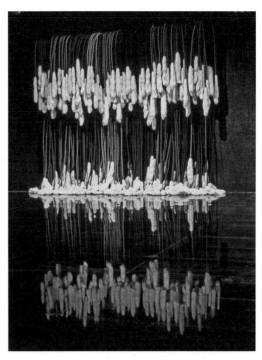

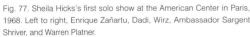

1965–74

Exhibits in London and Oldenburg, Germany (1965). Knoll launches their most successful woven upholstery fabric, Inca, designed by Hicks and based on an ancient Andean textile (fig. 18). V'Soske produces her designs for wall hangings in Galway, Ireland, and she works in India to create cotton textiles for a hand-weaving workshop, Commonwealth Trust, in Calicut, Kerala; her Badagara textile is in continuous production to this day. Opens studio in Paris on the quai des Grands Augustins with architect Henri Tronquoy to fabricate a large commission for the Ford Foundation.

>

Moves studio to the passage Dauphine, Paris, and creates works for the Ford Foundation and Georg Jensen Center for Advanced Design in New York, Air France, TWA terminal at JFK airport in New York, Rochester Institute of Technology, and, in Paris, the Banque Rothschild, Francis Bouygues, IBM, Kodak, and Fiat Tower. Establishes workshop in Hacienda Huaquen, Chile (1968), and Taller de los Bravos in Mexico. Consultant to Moroccan government for design of hand-knotted carpets. Exhibits in Paris, Helsinki, Stockholm, London, Prague, Amsterdam, Rabat, Dakar, Tunis, Belgrade, Skopje, Bucarest, Lausanne, New York, Madrid, Barcelona, Munich, Marseille, Toulouse, Bourdeaux, and Los Angeles.

>

Her works are included in the exhibition *Objects: U.S.A.—The Johnson Collection of Contemporary Crafts* (1969), which travels in the United States through 1971, and internationally through 1974, and in the groundbreaking exhibitions *Wall Hangings*, Museum of Modern Art, New York (1969), and *Perspectief in Textiel*, Stedelijk Museum, Amsterdam, Holland.

Participates for the first time in *3ème Biennale Internationale de la Tapisserie de Lausanne* (1967), invited by Pierre Pauli (also exhibits in 4ème Biennale [1969], 5ème Biennale [1971], 6ème Biennale [1973], 7ème Biennale [1975], 8ème Biennale [1977], and 16ème Biennale [1995]). Hicks and Niki de Saint-Phalle are the only women whose works are included in the large survey exhibition *Douze ans d'art contemporain en France* at the Grand Palais, Paris (1972). First museum retrospective, at the Stedelijk Museum, Amsterdam (1974). Opens an additional studio, Atelier Bourdonnais, near Les Halles, Paris, (fig. 80) to create works for MGIC (formerly Morgan Guaranty Insurance Company, now MGIC Investment Corporation) commission in Milwaukee. Exhibits monumental hand-knotted carpets as wall hangings in solo show at Galerie Bab Rouah, Rabat, Morocco (1971), and later exhibits one of them, on the floor, at the Galerie Suzy Langlois, Paris (1974–75).

•

Fig. 77. Sheila Hicks's first solo show at the American Center in Paris, 1968. Left to right, Enrique Zañartu, Dadi, Wirz, Ambassador Sargent Shriver, and Warren Platner.

Fig. 78. Sheila Hicks's son Cristobal Zañartu and daughter Itaka Schlubach in their grandparents' garden in Northfield, Illinois, with elasticized synthetic cords that were the model of Hicks's commission for the Hyatt Hotel, O'Hare Airport, 1969.

Fig. 79. Marc Riboud, photograph of party celebrating Hicks's exhibition *Le Tapis Mural de Sheila Hicks*, in Rabat, Morocco, 1971. At upper right is Mildred Constantine, curator at Museum of Modern Art, New York, and cocurator with Jack Lenor Larsen of the museum's pioneering *Wall Hangings* exhibition (1969); the two also coauthored *The Art Fabric* (1981).

Fig. 80. Image used on cover of the catalogue designed by Wim Crouwel for Hicks's first retrospective exhibition, Stedelijk Museum, Amsterdam, 1974. Photograph by David Housez, at the entrance the artist's studio on rue de Bourdonnais, Paris.

Fig. 81. Martine Franck, photograph of Sheila Hicks with two of the nuns at the Carmelite Convent at Boulogne Billancourt who helped embroider some of the 18 panels for Hicks's Air France commission (see pp. 74, 75).

Fig. 82. Sheila Hicks's installation in 1972 at the Grand Palais, *Je savais que si j'y venais un jour j'y passerais mes nuits*, 1972. Linen, silk, nylon, 186 x 294 in. (465 x 750 cm). Photograph by David Housez.

1975–85

Named Fellow of the Kunst Akademie, The Hague, Holland, 1975. Awarded Gold Medal, American Institute of Architects, 1975. Teaches at the Ecole des Beaux Arts de Fontainebleau, France. Participates in *Artiste/Artisane?* Musée des Arts Décoratifs, Paris (1977). Collaborates with film director Stanley Kubrick and set designer Jan Schlubach for the film *The Shining* (1977). Relocates her studio to cour de Rohan, Paris, where she continues to work today (named "Pas de Mule" in 2006). Creates installations using readymade items, including newspapers and clothing lent by local hospitals, in *Shelia Hicks: Vikt och Volymer (Tons and Masses)*, Lunds Konsthall, Lund, Sweden (1978) (figs. 24, 25). Named Janson Distinguished Visiting Professor of Art at Middlebury College (1980). Serves as publisher and editor of *American Fabrics and Fashion (AFF)* (1980–83). Named American Craft Council Fellow, 1983. Creates large artworks for King Saud University, Riyadh, Saudi Arabia (1983–86) and Kellogg's in Michigan (1986–88).

>

Teaches seminar at the Haystack School of Crafts, Deer Isle, Maine (1984). Awarded honorary doctorate, Rhode Island School of Design, 1984. Exhibits in Tokyo, Kyoto, Brussels, Oslo, Lisbon, Montreal, Jerusalem, New York, and San Francisco. For the exhibition *High Styles* at the Whitney Museum of American Art, New York, Hicks re-creates a version of a sixteen-foot soft-wall concept that was originally designed as *Lion's Lair* for Georg Jensen Center for Advanced Design in New York (p. 65). Awarded Medal of Fine Arts, French Academy of Architecture, 1985.

•

Fig. 83. Josef Koudelka, photograph of anthropologist William Sturtevant visiting Claude Lévi-Strauss, College de France, Paris, c. 1981. Both were mentors of the artist.

Fig. 84. Josef Koudelka, photograph of Sheila Hicks's studio associates, left to right: Son-hee Park, Eva Zeibeikis, Stephanie Lundgren, Encarnacion Mateu, Marinette Christien.

Fig. 85. Marc Riboud, photograph of Hicks's Prayer Rug series, in her exhibition *Le Tapis Mural de Sheila Hicks*, National Gallery, Rabat, Morocco, 1971.

Fig. 86. Three issues of *American Fabrics and Fashion* (*AFF*) produced while Hicks served as publisher and editor.

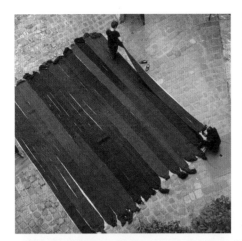

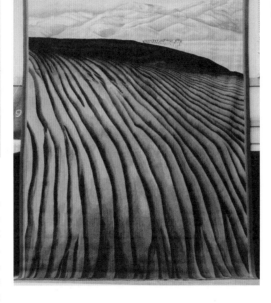

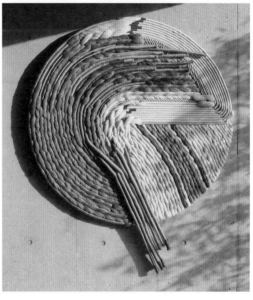

1986–2006

Exhibits in Seoul, Tokyo, Kiryu (Japan), New York, Paris, Providence (Rhode Island), Trélazé (France), and Nebraska. Decorated as Officier des Arts et des Lettres, by the French Government, 1993. Consults at Bridgestone Corporation, Tochigi, Japan, to develop applications for a new stainless steel fiber (1996). Awarded Gold Medal, American Crafts Council, 1997. Participates in *Structure and Surface: Contemporary Japanese Textiles*, organized by Matilda McQuaid, Museum of Modern Art, New York, and Cara McCarty, Saint Louis Art Museum (1999). Lectures at Getty Conservation Institute conference: "Mortality Immortality? The Legacy of 20th Century Art" (1998). Completes commission, *The Four Seasons of Fuji*, for the Fuji City Cultural Center, Japan (1999), bas-relief of five tons of linen thread in ninety colors, 338 feet long, and spanning entrances to three concert halls and theaters (pp. 140–43). Leads a team with UNESCO to establish a design center in Cape Town, South Africa, MADESA (Manufacturing and Design Academy of South Africa). Adviser to Proventus/Art and Technology Company for Kinnesand textiles and Snowcrash design, Sweden (2000).

>

Designs stage curtain (*doncho*) for Kiryu (2001). Creates large bas-reliefs in linen for cultural sites in Tokyo, Nagano, Kawasaki, and Hiroshima, Japan; and in the United States for the Rivington AIDS Care Center, New York, the Federal Courthouse, New York, and Target Headquarters, Minneapolis (2003). Lectures at the 92nd Street Y, New York ("In Search of the Red Thread," 2004). Retrospective of Hicks's small woven and wrought works, *Sheila Hicks: Weaving as Metaphor*, Bard Graduate Center for Studies in the Decorative Arts, Design, and Culture (2006), New York, accompanied by award-winning catalog designed by Irma Boom. Roundtable with Ricardo Legorreta, moderated by Paul Goldberger, at the American Society, New York.

•

2007–2010

Exhibits with Cristina Grajales, New York, and Davis & Langdale Gallery, New York. Lectures at Harvard University Graduate School of Design, Cambridge, Massachusetts ("The Materiality of Data Storage," 2007). Exhibits at Passage de Retz, Paris (*Entrelacs de Sheila Hicks; Textiles et vanneries d'Afrique et d'Océanie de la collection Ghysels*, 2007). Keynote speaker at the Getty Museum Conference "Craft at the Limits." Lectures at the Institute for Advanced Study, Princeton, New Jersey ("Half-Moon Needle in the Silk Rain Forest," 2008). Lectures at Institute de France conference, Paris (2008). Completes commission for SD26 restaurant (pp. 220–21) in New York with designer Massimo Vignelli (2009). Lectures at the Yale University Art Gallery and the Renwick Gallery in Washington, D.C. Exhibits at the Museum Boijmans, Rotterdam, and Museum of Decorative Arts, Prague (2010). Awarded Smithsonian Archives of American Art Medal, 2010.

•

Fig. 87. Cristobal Zañartu, photograph of one of Hicks's commissioned tapestries for King Saud University, Riyadh, Saudi Arabia, shown in the courtyard of her cour de Rohan studio, Paris, 1984.

Fig. 88. Sheila Hicks, *Tapestry Wall*, 1995. One of two commissions for the Foley Square Federal Court House, New York. Linen, 757 7/8 x 744 3/4 ft. (231 x 227 m).

Fig. 89. Monique Lévi-Strauss (photographed in 2010), author of the first monograph devoted to Sheila Hicks, published in 1973.

Fig. 90. Sheila Hicks, *The Desert*, 1985. Woven in Aubusson, France, 271 5/8 x 211 7/8 in. (690 x 538 cm. One of seventeen tapestries commissioned for King Saud University.

Fig. 91. Anna Seo readying for transport one of Sheila Hicks's *Eight Sumo Balls*, Paris 2009. Photograph by Enrico Martignoni.

Fig. 92. Addison Gallery Sheila Hicks team researching *Sheila Hicks: 50 Years*, at *Sheila Hicks: Soie et Ardoise*, Trélazé, France, 2005: left to right, Joan Simon, Brian Allen, Susan Faxon, Sheila Hicks.

Fig. 93. Sheila Hicks, *Diva*, 2004, Linen bas-relief, diameter 51 1/4 in (130 cm). Collection of Takahisa Suzuki, Setagaya, Japan.

Exhibition Checklist

As of 17 May 2010

All works are by Sheila Hicks (b. 1934).

For objects with variable dimensions, the measurements cited are as previously installed.

Faja II 1956
Cotton, wool
21 × 5 in; 53.3 × 12.7 cm
Private collection
Page 52

Faja III 1956
Cotton, wool
21 × 5 in; 53.3 × 12.7 cm
Private collection
Page 52

Red-Blue Painting 1956
Dry pigment with polymer on
Masonite
36 × 48 in; 91.4 × 121.9 cm
Private collection
Fig. 6

Muñeca 1957
Wool
11¾ × 4¾ in; 29.9 × 12 cm
Collection of Itaka Martignoni
Page 9

Rallo 1957
Wool
9⁷⁄₁₆ × 5⅛ in; 24 × 13 cm
Cooper-Hewitt, National Design Museum,
Smithsonian Institution (Museum purchase
from General Acquisitions Endowment
Fund, 2006-13-2)
Page 11

Selection of **Carnets de l'Artiste**
1957–2010
Bound notebooks
Various dimensions
Private collection
Figs. 12, 13; pages 95, 96, 144

Yale Thesis: Andean Textile Art
1957
Unbound book
11½ × 8¼ in; 29.2 × 20.9 cm
Private collection
Pages 48, 49

Zapallar 1957–58
Wool
9¼ × 4¾ in; 23.5 × 12 cm
Private collection
Page 10

Chonchi, Chiloe 1958
Alpaca, cotton
9⅝ × 5¼ in; 24.5 × 13.3 cm
Private collection
Page 10

Blue Letter 1959
Hand-woven wool
17¾ × 17 in; 45.1 × 43.2 cm
Museum of Modern Art, New York, N.Y.,
U.S.A. (Philip Johnson Fund, 338.1960)
Page 13

Clignancourt 1960
Leather shoelaces, silk, cotton
3 × 3 in; 7.6 × 7.6 cm
Collection of Suzy Langlois
Page 14

Dimanche 1960
Leather shoelaces
3½ × 5 in; 8.9 × 12.7 cm
Private collection
Page 14

Escribiendo con Textura 1960
Unbleached cotton
10⁷⁄₁₆ × 13 in; 26.5 × 33 cm
Cooper-Hewitt, National Design Museum,
Smithsonian Institution (Gift of Anonymous
Donor, 2006-14-4)
Page 19

Falda 1960
Wool
27½ × 15 in; 69.9 × 38.1 cm
Private collection
Page 15

Plegaria 1960
Wool
16¾ × 8¾ in; 42.6 × 22.2 cm
Collection of Cristobal Zañartu and
Rebecca Clark
Page 20

Redondo 1960
Wool
6 × 6 in; 15.2 × 15.2 cm
Private collection
Page 14

Solferino Tacubaya 1960
Wool
15¾ × 8¼ in; 40 × 21 cm
Collection of Cristobal Zañartu and
Rebecca Clark
Page 21

Tenancingo 1960
Cotton
Dimensions variable, as photographed:
35⁷⁄₁₆ × 17¹¹⁄₁₆ × 17¹¹⁄₁₆ in; 90 × 45 × 45 cm
Private collection
Page 17

Willow 1960
Cotton, wool
11⅝ × 15¹⁵⁄₁₆ in; 29.5 × 40.5 cm
Cooper-Hewitt, National Design Museum,
Smithsonian Institution (Gift of Anonymous
Donor, 2006-14-5)
Page 18

**Quadrado Obscuro-Menos
Obscuro** c. 1961
Hand-spun wool
Diptych 11 × 11⅜ in; 28 × 29 cm
each panel
Private collection
Page 22

White Letter 1962
Hand-spun wool
46½ × 38 in; 118.1 × 96.5 cm
Museum of Modern Art, New York, N.Y.,
U.S.A. (Gift of Knoll Associates, 430.1964)
Page 23

Mini Quipu 1963
Wool
8 × 5 in; 20.3 × 12.7 cm
Private collection

Squiggle c. 1963
Silk
11 × 9½ in; 27.9 × 24.1 cm
Private collection
Page 29

Cols 1964
Linen, buttons
7⅞ × 5½ in; 20 × 14 cm
Collection of Suzy Langlois
Page 27

Knoll Vidal, Black-Gray-Blue
1964–65
Wool
20½ × 23 in; 52 × 58.4 cm
Private collection
Page 30

Knoll Vidal, Gray-Orange-Blue
1964–65
Wool
20½ × 23 in; 52 × 58.4 cm
Private collection

Vanishing Yellow 1964/2004
Cotton
9½ × 8¼ in; 24.1 × 21 cm
Private collection
Page 103

He 1965
Wool
8⅞ × 5½ in; 22.5 × 14 cm
Collection of Jenelle Porter and Conny Purtill
Page 24

She 1965
Wool
9 × 5 in; 22.9 × 12.7 cm
Collection of Jenelle Porter and Conny Purtill
Page 25

Serpent à Sonnette 1965
Printed paper
8½ × 6¾ in; 21.6 × 17.2 cm
Private collection
Page 32

Banisteriopsis 1965–66
Linen, wool
Dimensions variable
The Montreal Museum of Fine Arts
(Liliane and David M. Stewart Collection)
Pages 36, 37

Gingembre 1965–67
Bamboo, cotton
5½ × 5½ in; 14 × 14 cm
Private collection
Page 33

Les Clous 1965–67
Wood, linen, nails
4¾ × 4¾ × 1¼ in; 12.1 × 12.1 × 3.2 cm
Private collection
Page 35

Sample Carrying Bag of Kerala
and Monsoon Collections fabrics,
including Nandi and Badagara
1965/73
Cotton
12½ × 15¾ in; 31.8 × 40 cm
Private collection

Badagara Blue 1966
Cotton
8 × 8¾ in; 20 × 22 cm
Private collection
Page 57

Grand Prayer Rug 1966
Wool, cotton
144 × 60 in; 365.8 × 152.4 cm
Philadelphia Museum of Art (Gift of the
Women's Committee of the Philadelphia
Museum of Art, 1994-80-1)
Pages 62, 63

**Maquette for Ford Foundation
commissions** 1966–67
Linen, silk, anodized aluminum
30 × 24 in; 76.2 × 61 cm
Private collection
Pages 38, 39

The Evolving Tapestry: He/She
1967–68
Linen, silk
Dimensions variable
Museum of Modern Art, New York, N.Y.,
U.S.A. (Given in Memory of Arthur Drexler
by Sheila Hicks, Jack Lenor Larsen, and
Henry and Alison Kates; and Department
Purchase Funds, 452.1987.a-vvv)
Pages 58, 59

Linen Lean-to 1967–68
Tapestry bas-relief
59⅛ × 82¾ × 6 in; 150 × 210 × 15.2 cm
The Metropolitan Museum of Art, New York,
N.Y., U.S.A. (Purchase, Anonymous Gift
1986, 1986.7)
Page 65

Bamian (Banyan) 1968/2001
Wool, wool twisted with acrylic
Dimensions variable
Private collection
Page 69

Cicatrices 1968
Silk
8¼ × 4¾ in; 21 × 12 cm
Cooper-Hewitt, National Design Museum,
Smithsonian Institution (Gift of Anonymous
Donor, 2006-14-2)
Page 70

Cross Over 1968
Wool
8¼ × 5½ in; 21 × 14 cm
Private collection
Page 71

The Principal Wife 1968
Linen, rayon, acrylic yarns
100 × 80 × 8 in; 254 × 203.2 × 20.3 cm
Museum of Art, Rhode Island School
of Design, Providence (Gift in memory of
Mary Josephine Cutting Blair, 2005.42)
Page 73

Banisteriopsis—Dark Ink
1968/1994
Linen, wool, synthetic raffia
42 pieces, each 42 × 19 in; 45.7 × 48.2 cm
Philadelphia Museum of Art
(Gift of the artist 1995)
Pages 60, 61

The Principal Wife Goes On
1969
Linen, silk, wool, synthetic fibers
a. 185¼ × 19 × 4 in; 470.5 × 48.2 × 10.1 cm
b. 187¼ × 9¼ × 3⅛ in; 475.6 × 23.5 × 8 cm
c. 186 × 11⅛ × 3⅝ in; 472.5 × 28.3 × 9.3 cm
d. 184⅞ × 9⅞ × 3⅞ in; 469.6 × 25 × 10 cm
e. 185⅝ × 10 × 3⅝ in; 471.4 × 25.4 × 9.3 cm
f. 189⅝ × 10⅛ × 4¼ in;
481.7 × 25.7 × 10.8 cm
Renwick Gallery of The Smithsonian American
Art Museum (Gift of S. C. Johnson & Son, Inc.)
Page 181

Study for **Fugue,** Rothschild Bank
Headquarters, Paris 1969
Linen, cotton
15¾ × 23⅝ in; 40 × 60 cm
Private collection

Bas-relief for interior of Air
France Boeing 747 aircraft
1969–77
One of eighteen works
Silk on cotton petit-point grid
53⅛ × 157½ in; 135 × 400 cm
Private collection
Pages 74, 75

M'hamid 1970
Silk, vicuña, razor clam shell
9¼ × 7 in; 23.5 × 17.8 cm
Cleveland Museum of Art (Gift of Mildred
Constantine, 1992.358)
Page 76

Move Over c. 1970
Cotton, nylon, ricrac
8⅞ × 5½ in; 22.5 × 14 cm
Private collection
Page 77

Dégringolade 1971
Cotton, wool, silk
8⅝ × 6¾ in; 21.9 × 17.2 cm
Private collection (courtesy of
Cristina Grajales Gallery)
Page 77

Trapèze de Cristobal 1971
Wool, linen, cotton, yarn
129¹⁵⁄₁₆ × 78¾ in; 330 × 200 cm
Stedelijk Museum, Amsterdam
Page 79

Lianes Nantaises 1973
Linen, wool, silk, synthetic raffia
120 × 70 in; 304.8 × 177.8 cm
Musée Jean Lurçat et de la Tapisserie
Contemporaine, dépôt du Château des
Ducs de Bretagne
Page 121

Sample Book of Indian
hand-woven fabrics 1973
Hand-bound paper book with cotton
fabric samples
20½ × 15¾ × 4 in; 52.1 × 40 × 10.2 cm
Private collection

236

Study for installation at Dresdner Bank Headquarters, Frankfurt Germany 1975
Gouache on paper
a. 17¹¹⁄₁₆ × 43⁵⁄₁₆ ɪɴ; 45 × 110 ᴄᴍ
b. 17¹¹⁄₁₆ × 43⁵⁄₁₆ ɪɴ; 45 × 110 ᴄᴍ
c. 17¹¹⁄₁₆ × 29¹⁵⁄₁₆ ɪɴ; 45 × 76 ᴄᴍ
d. 17¹¹⁄₁₆ × 29¹⁵⁄₁₆ ɪɴ; 45 × 76 ᴄᴍ
Private collection

Self-Portrait on a Blue Day (Miniatuurweefsel) 1977
Wool
7¹⁄₁₆ × 5⅛ ɪɴ; 18 × 13 ᴄᴍ
Stedelijk Museum, Amsterdam
Page 133

Footprints (Rose) 1978
Linen, cotton
8 × 3½ ɪɴ; 20.3 × 8.9 ᴄᴍ
Private collection
Page 126

Le Phare de l'Iroise 1978
Wool, linen
9⅝ × 6¼ ɪɴ; 24.5 × 15.9 ᴄᴍ
Collection of Caroline and Roger Ford
Page 127

Les Draps Carmelite c. 1978
Wool
a. 16 × 20½ ɪɴ; 41 × 52 ᴄᴍ
b. 52 × 27½ ɪɴ; 132 × 70 ᴄᴍ
c. 64 × 49 ɪɴ; 163 × 125 ᴄᴍ
d. 92 × 46 ɪɴ; 236 × 117 ᴄᴍ
Private collection
Page 185

Raining Baby Bands 1978
Cotton
Dimensions variable
Private collection
Page 125

Baby Time Again 1979
Cotton
a. 1,575 × 1,378 ꜰᴛ; 480 × 420 ᴍ
b. 1,214 × 853 ꜰᴛ; 370 × 260 ᴍ
Private collection
Fig. 26; page 112

Olympic Bravery 1979
Synthetic metallic fiber, wool
9¹⁄₁₆ × 5⅞ ɪɴ; 23 × 15 ᴄᴍ
Cooper-Hewitt, National Design Museum, Smithsonian Institution (Museum purchase from General Acquisitions Endowment Fund, 2006-13-3)
Page 129

The Silk Invitation 1983
Silk, cotton
10¼ × 7¾ ɪɴ; 26 × 19.7 ᴄᴍ
Private collection (courtesy of Cristina Grajales Gallery)
Page 130

Bonsai Tapestry c. 1986
Cotton, rayon
9½ × 5⅛ ɪɴ; 24.1 × 13 ᴄᴍ
The Metropolitan Museum of Art, New York, N.Y., U.S.A. (Gift of Edward Merrin 1990, 1990.271)
Page 210

Color Alphabet II/VI 1988
Wool, silk
74¹³⁄₁₆ × 72¹³⁄₁₆ ɪɴ; 190 × 185 ᴄᴍ
Collection of Itaka Martignoni
Page 93

Isadora 1988
Linen
9 × 6 ɪɴ; 22.9 × 15.2 ᴄᴍ
Private collection
Page 134

La Clef 1988
Rubber bands, metal key
9½ × 6 ɪɴ; 24.1 × 15.2 ᴄᴍ
Private collection
Page 131

Loosely Speaking 1988
Linen
10 × 6 ɪɴ; 25.4 × 15.2 ᴄᴍ
Private collection
Page 137

Les Etoiles 1989
Handmade paper
Private collection
Page 135

Nuage 1990
Choma
8¹⁄₁₆ × 6¹¹⁄₁₆ ɪɴ; 20.5 × 17 ᴄᴍ
Cooper-Hewitt, National Design Museum, Smithsonian Institution (Gift of Anonymous Donor, 2006-14-9)
Page 136

Kneeling Stones c. 1990
Polychrome yarns, wrapping
Dimensions variable
Museum of Fine Arts, Boston (Gift of Edward Merrin and Vivian Merrin)

Trésors et Secrets c. 1990
Silk, synthetic fibers, wool, cotton, linen, raffia
Dimensions variable;
largest 4¾ × 9 ɪɴ; 12.1 × 22.9 ᴄᴍ
smallest 1⅜ × 3 ɪɴ; 3.5 × 7.6 ᴄᴍ
Philadelphia Museum of Art (Gift of the artist, 1995-72-2a-qq)

Trésors et Secrets 1990–95
Found materials
Dimensions variable
Private collection
Pages 138, 139

Battle of Kearney 1993
Paper, linen
14⁹⁄₁₆ × 19⁵⁄₁₆ ɪɴ; 37 × 49 ᴄᴍ
Private collection
Page 144

Battle of Lexington 1993
Paper, linen
14⁹⁄₁₆ × 19⁵⁄₁₆ ɪɴ; 37 × 49 ᴄᴍ
Private collection
Page 144

Battle of Lincoln 1993
Paper, linen
14⁹⁄₁₆ × 19⁵⁄₁₆ ɪɴ; 37 × 49 ᴄᴍ
Private collection
Page 145

Battle of Omaha 1993
Paper, linen
14⁹⁄₁₆ × 19⁵⁄₁₆ ɪɴ; 37 × 49 ᴄᴍ
Private collection
Page 145

Study for **Convergence, Hermes** 1996
Linen
41¾ × 41¾ ɪɴ; 106 × 106 ᴄᴍ
Private collection
Page 147

Rapprochement c. 1998
Stainless steel fiber
9½ × 5¾ ɪɴ; 24.1 × 14.6 ᴄᴍ each
Cooper-Hewitt, National Design Museum, Smithsonian Institution (Museum purchase from General Acquisitions Endowment Fund, 2006-13-9-a,b)
Page 148

Menhir 1998–2004
Linen, cotton, stainless steel
Dimensions variable
Private collection
Page 149 (foreground)

Untitled 2001
Gouache on paper
32¹¹⁄₁₆ × 16½ × 1¹¹⁄₁₆ ɪɴ; 83.1 × 41.9 × 4.3 ᴄᴍ (framed)
Private collection
Page 149 (background)

Untitled 2001
Gouache on paper
32¹¹⁄₁₆ × 16½ × 1¹¹⁄₁₆ ɪɴ; 83.1 × 41.9 × 4.3 ᴄᴍ (framed)
Private collection
Page 149 (background)

Manoli 2001–2
Cotton, synthetic fiber, leather
9 × 5½ ɪɴ; 22.9 × 14 ᴄᴍ
Collection of James Stacey and Elizabeth Murphy
Page 194

Forêt Bleue 2002
Cotton, synthetic hat bands
13¹³⁄₁₆ × 9⅞ ɪɴ; 35 × 25 ᴄᴍ
Private collection
Page 193

Study for May I Have This Dance? 2002–3
Pastel on paper
19¹¹⁄₁₆ × 23⅝ ɪɴ; 50 × 60 ᴄᴍ
Private collection

Vagues de Phare 2003
Cotton, hand-spun wool
8⅝ × 5¼ ɪɴ; 21.9 × 13.3 ᴄᴍ
Collection of Caroline and Roger Ford
Page 195

Phare d'Acier 2003
Linen, cotton, stainless steel
9⅝ × 5¾ ɪɴ; 24.5 × 14.6 ᴄᴍ
Private collection
Page 195

Droite Gauche 2003
Linen, razor clam shell
9 1/16 × 5 7/8 in; 23 × 15 cm
Cooper-Hewitt, National Design Museum,
Smithsonian Institution (Gift of Anonymous
Donor, 2006-31-1)
Page 196

Phare Ouvert 2003
Cotton, hand-cut wool
9 × 6 in; 22.9 × 15.2 cm
Collection of Caroline and Roger Ford
Page 197

Les Escargots 2003–4
Cork, linen
Dimensions variable
Collection of Target Corporation
and the artist
Page 199

La Lettre de Rupture 2004
Cotton, handmade paper, linen
9 7/8 × 6 in; 25 × 15.2 cm
Private collection
Page 200

Moudang 2004
Stainless steel
11 × 11 13/16 in; 28 × 30 cm
Cooper-Hewitt, National Design Museum,
Smithsonian Institution (Museum purchase
from General Acquisitions Endowment
Fund, 2006-13-4)
Page 201

Diagonal I 2005
Hand-spun wool
17 1/4 × 16 1/2 in; 43.8 × 41.9 cm
Collection of Caroline Baumann
Page 202

Diagonal III 2005
Hand-spun wool
17 1/4 × 16 1/2 in; 43.8 × 41.9 cm
Collection of Caroline Baumann
Page 202

Lino Diagonal 2005
Linen
14 1/2 × 12 3/4 in; 36.8 × 32.4 cm
Private collection
Page 203

Effondrement 2005
Synthetic fibers, silk, slate
9 13/16 × 5 11/16 in; 25 × 14.5 cm
Cooper-Hewitt, National Design Museum,
Smithsonian Institution (Gift of Anonymous
Donor, 2006-14-6)
Page 204

Niña, Niña 2005
Cotton, wool
9 7/8 × 5 1/2 in; 25 × 14 cm
Collection of Ali Stritzler-Levine
Page 205

Ardoise 2006
Linen, slate, monofilament
8 1/2 × 4 1/8 in; 21.6 × 10.5 cm
Private collection
Page 206

Mozambique 2006
Linen, synthetic fibers
10 × 8 in; 25.4 × 20.3 cm
Private collection
Page 207

Inca Chinchero 2007
Cotton
9 3/16 × 5 3/8 in; 23.3 × 13.7 cm
Private collection
Page 208

Déménageur 2008
Silk
9 1/8 × 8 1/8 in; 23.2 × 20.6 cm
Private collection
Page 209

Embedded Voyage 2008
Alpaca, wool
8 1/2 × 5 1/2 in; 21.6 × 14 cm
Private collection
Page 208

A Certain Distance 2008
Cotton, silk
9 3/8 × 5 1/2 in; 23.8 × 13.9 cm
Private collection
Page 211

Cluny II 2008
Metallic
10 × 6 in; 25.4 × 15.2 cm
Collection of Itaka Martignoni
Page 211

Prophecy from Constantinople
2008–10
Linen, wool
236 1/4 × 70 7/8 in; 600 × 180 cm
Private collection
Page 213

Blessed Hand 2009
Cotton, bamboo
9 1/2 × 5 3/4 in; 24.1 × 14.6 cm
Private collection (courtesy of
Cristina Grajales Gallery)
Page 214

Etiquette 2009
Bamboo, cotton, paper
9 1/2 × 5 3/4 in; 24.1 × 14.6 cm
Private collection (courtesy of
Cristina Grajales Gallery)
Page 215 (two views)

Fenêtre I 2009
Cotton, bamboo, linen, silk
10 1/2 × 10 1/2 in; 26.7 × 26.7 cm
Private collection
Page 219

Fenêtre II 2009
Cotton, bamboo, linen, silk
10 3/4 × 10 1/4 in; 27.3 × 26 cm
Private collection
Page 216

Fenêtre III 2009
Cotton, bamboo, linen, silk
10 3/4 × 9 3/4 in; 27.3 × 24.8 cm
Private collection
Page 217

Fenêtre IV 2009
Wool
11 × 11 1/4 in; 27.9 × 28.6 cm
Private collection
Page 111

Scarlet Byways 2009
Bamboo, cotton, silk
9 1/2 × 6 in; 24.1 × 15.2 cm
Private collection (courtesy of
Cristina Grajales Gallery)
Page 218

Wrapped and Coiled Traveler
2009
Bamboo, cotton, wool, silk
8 7/8 × 5 1/4 in; 22.5 × 13.3 cm
Private collection (courtesy of
Cristina Grajales Gallery)
Page 223

Trajères 2010
Ink on paper
14 × 11 in; 35.6 × 27.9 cm
Private collection
Fig. 60

**On Peut Distinguer Quatre
Categories** 2010
Ink on paper
19 11/16 × 23 5/8 in; 50 × 60 cm
Private collection

Triumph 2010
Human hair, linen, metallic coated
paper, gold, cotton
9 1/4 × 7 1/2 in; 23.5 × 19.1 cm
Private collection

Exhibition History

*Catalogue
**Brochure

Selected Solo Exhibitions

1957
BFA Final Thesis Exhibition, Yale University School of Art and Architecture, New Haven, Connecticut, May.

1958
Sheila Hicks, Tejidos. National Museum of Natural History, Santiago, Chile, 8 January–15 March. Greta Mosney, director/curator.
pinturas de s.a.w. hicks—fotografias de sergio larrain. Palacio de Bellas Artes, Santiago, Chile, 25 April–11 May; Galeria Galatea, Buenos Aires, Argentina, 23 June–5 July. Luis Vargas, director/curator.**
pinturas de s.a.w. hicks—fotografias de sergio larrain. Galeria Galatea, Buenos Aires, Argentina, 23 June–5 July.
Sheila Hicks. Centro de Cultura, Valparaiso, Chile.

1959
MFA. Final Thesis Exhibition, Yale University School of Art and Architecture, New Haven, Connecticut, May.

1961
Tejidos—Sheila Hicks. Galeria Antonio Souza, Mexico City, Mexico, D.F., 28 September–20 October.

1962
Tejidos de Sheila Hicks. Knoll Associates, Mexico City, Mexico, D.F., 1962–63.

1963
Exhibiting Wool—Sheila Hicks. La Piña Gallery, La Jolla, California, 5 February–15 March.
Sheila Hicks. Knoll Associates, Merchandise Mart, Chicago, Illinois, 17–24 June.
The Textiles of Sheila Hicks. Art Institute of Chicago, Illinois, 16 November 1963–5 January 1964. Alan Wardwell, curator.
Sheila Hicks. Knoll International, Nuremberg, Germany; Düsseldorf, Germany; Hamburg, Germany; Cologne, Germany; Berlin, Germany; Frankfurt, Germany; Stuttgart, Germany; Basel, Switzerland; London, England. 24 March 1963–1967.

1964
Sheila Hicks. Bath Academy of Art, Corsham, Wiltshire, England, October–November.

1965
Woven Forms and Sculpture: Sheila Hicks. Interiors International (Knoll), London, England, 11 May–June. Monty Berman, curator.*
Gewebte Formen. Landesmuseum für Kunst und Kulturgeschichte, Oldenburg, Germany, 1–27 June. Dr. Kramer, director/curator.

1966
Sheila Hicks. N. K. Inredning, Stockholm, Sweden, September–October. Maurice Holland, curator.
Sheila Hicks. Artek Gallery, Helsinki, Finland, September–November. Lionel Paul, curator.
Sheila Hicks. Textilkunst und Textiltechnik. Galerie Objet, Zurich, Switzerland, 28 October–18 November. Jurg Bally, curator.

1968
Sheila Hicks. Uměleckoprůmyslové muzeum v Praze, Jindřichův Hradec, Czechoslovakia, 6 June–31 August. Milena Lamarova and Dagmar Tucna, curators.*

1969
Bensen Gallery, Bridgehampton, Long Island, New York, 29 June–8 July. Manuel Bensen, curator.
Wall Hangings. Craft Alliance Gallery, Saint Louis, Missouri, 7–29 September. Patricia Degner, curator.
Sheila Hicks: Murs et Fibres. Galerie Suzy Langlois, Paris, France, 26 November–10 December.**

1970
Sheila Hicks–Harold Cousins. American Library, Brussels, Belgium, 14 October–14 November. Hélène Baltrusaitis, curator.**
Les Formes Tissées de Sheila Hicks. L'Institut Franco-Américain, 8 January–10 February.

1971

Le Tapis Mural de Sheila Hicks. Galerie Bab Rouah, Rabat, Morocco,
18–28 February. Margot Cutter, curator.*

Formes de Fil. Musée des Beaux-Arts, Brest, France, 7 April–20 June.
Rene LeBihan, director/curator.

Sheila Hicks: Moroccan Prayer Rugs. Benson Gallery, Bridgehampton, New
York, 26 June–6 July.

Tapisseries et Tissages de Sheila Hicks. Mobilier International, Lyon, France,
6–20 December. Pierre Arrivetz, curator.*

1972

Fils Dansants, Tapis aux Murs de Sheila Hicks. American Cultural Center, Dakar,
Senegal, May–June; Abidjan, Côte d'Ivoire, November–December 1972;
Galerie Dar Lasram, Tunis, Tunisia, January–February 1973; American
Center, Milan, Italy, June–July 1973.

The Work of Sheila Hicks. American Institute of Architects Gallery, Philadelphia,
Pennsylvania, 13 July–5 August. Fritz Roth, curator.

Objects et Rituals. Francis Bouygues Headquarters, Clamart, France,
December 1972–January 1973. Noel Davoine, curator.

1973

Sheila Hicks: Wall Hangings. Krannert Art Museum, University of Illinois,
Urbana-Champaign, Illinois, 4 February–4 March.

Sheila Hicks: Tapis de Prière. Palacio Iturbe, Mexico, D.F., June. Luis Barragán
and Ricardo Legorreta, curators.

1974

Sheila Hicks. Stedelijk Museum, Amsterdam, Holland, 9 February–7 April.
Wil Bertheux and Liesbeth Crommelin, curators.*

Sheila Hicks. Modern Masters Tapestries Gallery, New York, New York,
16 May–15 June.*

1975

Sheila Hicks. Galerie Alice Pauli, Lausanne, Switzerland, 12 June–31 July.*

1976

Tapisserie Mise en Liberté—Sheila Hicks. Maison de la Culture, Rennes, France,
13 May–12 June. Françoise Chatel, curator.*

Ancient Peruvian Textiles and the Work of Sheila Hicks. Maison de la Culture,
Rennes, France, 4–28 November. Françoise Chatel, curator.*

1977

Sheila Hicks. Muzeja savremene umetnosti, Belgrade; Museum of Art, Skopje,
Macedonia; Museum of Contemporary Art, Dubrovnic, Yugoslavia;
Biblioteca Americana, Bucharest, Romania. September–December.

1978

Sheila Hicks: Vikt och Volymer [Tons and Masses]. Lunds Konsthall,
Lund, Sweden, 18 March–16 April. Marianne Nanne-Brahammer,
director/curator.*

Sheila Hicks: Baby Time Again. Galerie Suzy Langlois, Paris, France,
May–June.**

1979

Sheila Hicks—Suite Ouessantiné. Musée de Beaux-Arts, Brest, France,
8 June–29 September. Rene LeBihan, director/curator.

Miniatures: Sheila Hicks. Galerie Carmen Martinez, Paris, France,
10 October–23 November.

Textiles Taillés: Sheila Hicks. F.I.A.C., Galerie Carmen Martinez, Grand Palais,
Paris, France, 19–29 October.

Inhabited: Sheila Hicks. American Center, Paris, France, 25 October–
14 November.*

1980

See Saw: Sheila Hicks. Johnson Memorial Gallery, Middlebury College,
Middlebury, Vermont, 8 February–5 March.*

Free Fall: Sheila Hicks. Israel Museum, Jerusalem, Israel, 25 March–
10 September. Izzika Gaon, curator.* **

Small Jump: Sheila Hicks. American Cultural Center, Tel Aviv, Israel,
2 April–2 May.

1981

Carte Blanche: Sheila Hicks. Musée des Beaux-Arts, Rennes, France,
15 May–31 August. Nicole Barbier, director/curator.**

Bab-Rouah: Sheila Hicks. Maison de la Culture, Orléans, France, July–August.

Sheila Hicks. Galerie Collection d'Art, Amsterdam, Holland, 12 December–
17 January 1982.

1982

Sheila Hicks. Evanston Art Center, Evanston, Illinois, 28 February–12 April.*
Roundtable with Daniel Terra, Patterson Sims, Mary Jane Jacobs.

Sheila Hicks. Crafts Council Centre Gallery, Sydney, Australia, 11–25 April.
Joyce Burnard, curator.* Film.

Sheila Hicks. Galerie d'Art International, Chicago, Illinois, 7 May–3 June.

Formes Tissées—Tapisseries: Sheila Hicks. Abbaye Royale de Fontevraud, France,
28 May–15 July.

Sheila Hicks: Flag Art. Gallery/Gallery, Kyoto, Japan, 3–31 August.
Masakazu Kobyashi, curator.

Sheila Hicks. La Filothèque DMC, Paris, France, September–December.

Sheila Hicks. Galerie Carmen Martinez, Paris, France, October.

1983

Inventaire de la Mémoire: Sheila Hicks–Daniel Graffin. Paris Art Center, Paris,
France, 21 June–31 July.*

Soie lin, soie laine soie classique, soie exotique. Gamme dans la Maison stand at
the Salon International des Editeurs de la Décoration, Grand Palais, Paris,
France., 12–19 January 1983. Madeleine Robin, curator.

Sheila Hicks. Kunstindustrimuseet I, Oslo, Norway, 27 January–20 February.*

1985

Art Conditioned by Life: Sheila Hicks. Galerie des Femmes, Paris, France,
14 December 1985–15 March 1986. Marie France, curator.

1987

Textile, Texture, Texte—Sheila Hicks. Musée de Beaux Arts, Pau, France,
9 April–15 May.

1988

Sheila Hicks: Small Weavings. Merrin Gallery, New York, New York,
8–29 November.

Installation by Sheila Hicks. Octagon Gallery, Belfast, Ireland, 9 November–
3 December. Liam Kelly, curator.

1989

Sheila Hicks. Tomita Gallery, Tokyo, Japan, 20 May–8 June. William Hicks, curator.

1990

Sheila Hicks: Soft World. Gallery of Matsuya Department Store, Tokyo, Japan, 17–22 October.* Film.

1991

Sheila Hicks and Pierette Bloch. Chez Benno Premsela, Amsterdam, Holland, 4–21 April.

Sheila Hicks: Soft Logic. Kajima Headquarters Building Atrium, Tokyo, Japan, 17–31 May. Michelle de Souza, curator.

Sheila Hicks: Soft Logic. Seoul Arts Center, Seoul, Korea, 6–20 November; Centre Culturel Français, Seoul, Korea, 8–20 November. Pierre Cambon, curator.*

1992

Cross Cultural Exchange by Sheila Hicks. Walker's Point Center of the Arts, Milwaukee, Wisconsin, 19 January–22 November. Jane Brite, curator. Film.

Sheila Hicks v Prague. Umeleckoprumyslové Muzeum v Praze, Prague, Czechoslovakia, 22 October–22 November. Konstantina Hlavacek, curator.*

1993

Small Works. Gallery Saka, Tokyo, Japan, 25 February–13 March.

Hicks and Okada. Axis Gallery, Tokyo, Japan, 8–22 October.

Sheila Hicks: Four Seasons of Fuji. Rose Gallery, Fuji City Cultural Center, Japan. Film.

1994

Textile Magiker: Sheila Hicks–Junichi Arai. Textil Museet, Boras, Sweden, 23 January–20 March.*

1995

Sheila Hicks—Terremoto. Perimeter Gallery, Chicago, Illinois, 28 April–24 June. Mildred Constantine, curator.*

1996

The Art of Sheila Hicks: A Nebraska Celebration. Robert Hillestad Textiles Gallery, University of Nebraska-Lincoln, Lincoln, Nebraska, 22 June–28 July.

The Art of Sheila Hicks. Museum of Nebraska Art, Kearney, Nebraska, 2–28 July.**

1997

Thread Sketches. Gallery Isogaya, Tokyo, Japan, 3 March–21 March. Toshio Sekeji, curator.*

Warped, Wefted, Woofed but Free. Century Association, New York, New York, 8 April–9 May. Jonathan Harding, curator.

Sheila Hicks, The Making of a Doncho. Municipal Cultural Center Gallery, Kiryu, Gunma, Japan, 26 May–20 June. Film.

1998

Origins Reexamined. Hastings College Art Gallery, Hastings, Nebraska, 29 August–4 October. Carla Hanzal, curator. Film.

1999

Sheila Hicks: Seeds to the Wind. Contemporary Art Center of Virginia, Virginia Beach, Virginia, 29 January–14 March. Carla Hanzal, curator.* **

Trésors et Secrets. Salon des Antiquaires Galerie Fanny Guillon-Laffaille, Paris, France, 15 March–15 April.

2000

Sheila Hicks: Oeuvres Recentes. Galerie Fanny Guillon-Laffaille, Paris, France, 15 March–15 April.

Sheila Hicks. Hermés, Faubourg Saint Honoré, Paris, France, 8 September 2000–1 February 2001.

Sheila Hicks. Hermés, Ginza, Tokyo, Japan.

Treasures and Secrets. Chicago Historical Society, Chicago. 6 May. Mary Jane Jacob and Jean Brice, curators. Film.

2004

May I Have This Dance. Target Headquarters, Minneapolis, Minnesota, October. Film.

2005

Soie & Ardoise, Sheila Hicks, Petites Pièces. Anciennes Ecuries des Ardoisières, Trélazé, France, 9 September–8 October. Claude Henri Selles, curator.*

2006

Sheila Hicks: Weaving as Metaphor. Bard Graduate Center for Studies in the Decorative Arts, Design, and Culture, New York, New York, 12 July–15 October. Nina Stritzler-Levine, curator.*

2007

Entrelacs de Sheila Hicks; Textiles et vanneries d'Afrique et d'Océanie de la collection Ghysels. Passage de Retz, Paris, France, 11 July–23 September. Yvonne Brunhammer, curator.*

2008

Sheila Hicks Minimes: Small Woven Works. Davis & Langdale Company, New York, New York, 1 October–8 November.**

Sheila Hicks. Sarah Gavlak Gallery, West Palm Beach, Florida, 29 November 2008–3 January 2009.

2009

Design Miami/Basel, Christina Grajales Gallery, 9–13 June.

Selected Group Exhibitions

1956

Seventh Annual New England Exhibition. Silvermine Guild of Artists, Silvermine, Connecticut, 10 June–8 July, Javits Award for painting: *Goldoni Compote*.

Fellowship Grant Students. Yale University School of Art, Yale-Norfolk Summer School, Norfolk, Connecticut, August. Jury: Rico Lebrun, Bernard Chaet, Gabor Peterdi, Adja Yunkers, Dore Ashton.

1960

Recent Acquisitions to the Museum Collections [Exh. #678]. Museum of Modern Art, New York. 21 December 1960–5 February 1961.

The Art of the Loom. Murray State University, Murray, Kentucky.

1961

Fabrics International. Philadelphia Museum College of Art, Philadelphia, Pennsylvania, 23 September–4 November; Museum of Contemporary Crafts, New York, New York, 17 November 1961–14 January 1962.

1962

Recent Acquisitions [Exh. #715]. Museum of Modern Art, New York, New York, 20 November 1962–13 January 1963.

First National Invitational Exhibition of Textile Arts. Scripps College, Claremont, California, 20 March–12 April.

1963

Woven Forms—Alice Adams, Sheila Hicks, Lenore Tawney, Dorian Zachai, Claire Zeisler. Museum of Contemporary Crafts, New York, 22 March–12 May. Paul J. Smith, curator.*

[*Woven Forms* traveled as] *Formas Tejidas—Alice Adams, Sheila Hicks, Lenore Tawney, Dorian Zachai, Claire Zeisler*. Museo de Bellas Artes, Caracas, Venezuela, September–October.*

1964

Gewebte Formen: Lenore Tawney, Claire Zeisler, Sheila Hicks. Kunstgewerbemuseum, Zurich, Switzerland, 25 March–3 May. Kunstgewerbemuseum, Stuttgart, Germany. Erika Billeter, curator.*

For Your Home 1964. Krannert Art Museum, University of Illinois, Champaign, Illinois, 5 April–3 May.*

13th Triennial of Design. Palais de la Triennale, Milan, Italy, 12 June–27 September. Mildred Constantine and Wilder Green, curators.**

1965

Neve Formen der Textilges Talturig. Landesmuseum, Oldenburg, Germany, 7–27 June.

1967

La Tapisserie De la Conception à la Réalisation. Musée des Arts Décoratifs, Lausanne, Switzerland, 11 June–1 October. Pierre Pauli, director/curator.

3ème Biennale Internationale de la Tapisserie. Musée Cantonal des Beaux-Arts, Palais de Rumine, Lausanne, Switzerland, 10 June–1 October. Willem Sandberg, president of the jury.*

Recent Acquisitions: Design Collection [Exh. #840]. Museum of Modern Art, New York, New York, 26 September 1967–1 January 1968.

1968

Formes Tissées—Formes Architecturales. American Cultural Center, Paris, France, 17 May–15 June. Hélène Baltrusaitis, curator.*

Tapisseries Contemporaines et Internationales. Museum of Decorative Arts, Prague, Czechoslovakia, August–October. Dagmar Tucna, curator.*

1969

Perspectief in Textiel. Stedelijk Museum, Amsterdam, Holland, 17 January–2 March. Wil Bertheux and Liesbeth Crommelin, curators.*

Wall Hangings. Museum of Modern Art, New York, New York, 25 February–4 May. Mildred Constantine and Jack Lenor Larsen, curators.*

Seven Americans of Paris. Air France Gallery, New York, New York, May.*

4ème Biennale Internationale de la Tapisserie de Lausanne. Musée Cantonal des Beaux-Arts, Palais de Rumine, Lausanne, Switzerland, 13 June–28 September. Adolf Hoffmeister, president of the jury.*

Taller Artisanal Huaquen—Sheila Hicks, Juame Xifra, J. P. Beranger. Galeria Carmen Waugh, Santiago, Chile, 11–23 August.*

Quatre Américains de Paris. Musée Cantini, Marseille, France, 7–31 October; Musée des Beaux-Arts, Bordeaux, France, November–December, 1970; Musée des Augustins, Toulouse, France, 20 January–2 March; Musée Hyacinthe Rigaud, Perpignan, France, 8–22 February; Fabre Museum, Montpellier, France, June–July. Hélène Baltrusaitis, curator.*

Objects: U.S.A.—The Johnson Collection of Contemporary Crafts. Organized by Johnson Wax Company. National Collection of Fine Arts, Washington, D.C., 3 October–16 November; Boston University Museum, Boston, Massachusetts, 3–23 December; Memorial Art Gallery, Rochester, New York, 9–26 January 1970; Cranbrook Academy, Detroit, Michigan, 11 February–3 March; Herron Gallery, Herron Art Institute and Museum, Indianapolis,

Indiana, 17 March–5 April; Cincinnati Art Muscum, Cincinnati, Ohio, 23 April–10 May; Saint Paul Art Center, Saint Paul, Minnesota, 27 May–16 June; School of Fine Arts Gallery, University of Iowa, Iowa City, Iowa, 1–21 July; Arkansas Art Center, Little Rock, Arkansas, 5–25 August; Seattle Art Museum, Seattle, Washington, 17 October–1 November; Portland Art Museum, Portland, Oregon, 17 November–13 December; Los Angeles Municipal Art Gallery, Los Angeles, California, 29 December 1970–19 January 1971; Oakland Art Museum, Oakland, California, 26 January–21 February; Phoenix Art Museum, Phoenix, Arizona, 10–30 March; Sheldon Memorial Art Gallery, University of Nebraska, Lincoln, Nebraska, 14 April–4 May; Milwaukee Art Center, Milwaukee, Wisconsin, 16 May–6 June; George Hunter Gallery, Chattanooga, Tennessee, 23 June–13 July; Museum of Art, Carnegie Institute, Pittsburgh, Pennsylvania, 1–21 September; Columbia Museum, Columbia, South Carolina, 6–26 October; High Museum of Art, Atlanta, Georgia, 10–30 November; Civic Center Museum, Philadelphia, Pennsylvania, 10 December 1971–16 January 1972. International venues, 1972–74, included Musée d'Art Moderne de la Ville de Paris, Paris, France. Lee Nordness and Paul J. Smith, curators.*

Exposición Internacional de Experiencias Artístico-Textiles. Museo Español de Arte Contemporáneo, Madrid, Spain, December.

Textile Constructions. Ruth Kaufmann Gallery, New York.

1970

Exposición Internacional de Experiencias Artistico-Textiles. Salón del Tinell, Barcelona, Spain, January.*

Formen in Fäden: Olga de Amaral, Else Bechteler, Sheila Hicks. Buchholz Gallery, Munich, Germany, 3 March–10 April.*

*Národní Muzeum, Prague, Czechoslovakia. Dagmar Tucna, curator.

100 Artistes dans la Ville. Pavillon Populaire, Montpellier, France.

Le Grand Départ. Centre Artistique de Verderonne, France, 27 September.

1971

Dimension of Fiber. California College of Arts and Crafts, Oakland, California, 4–29 March.

Contemporary Weaving. University Design Center, Gallery, Memorial Union, Ames, Iowa, 8–29 March.

5ème Biennale International de la Tapisserie Lausanne. Musée Cantonal des Beaux-Arts, Palais de Rumine, Lausanne, Switzerland, 18 June–3 October. Umbro Apollonia, president of the jury.*

Deliberate Entanglements. University of California Los Angeles Art Galleries, Los Angeles, California, November–10 December. Museum of Contemporary Art, Chicago, Illinois; Portland Art Museum, Portland, Oregon; Vancouver Art Gallery, Vancouver, Canada, 28 February–31 March 1972; Utah Museum of Fine Arts, Salt Lake City, Utah, 16 April–14 May; California Palace of the Legion of Honor, San Francisco, California. Bernard Kester, curator.*

Air France et l'Art d'Aujourd'hui. Musée Galliera, Paris, France, 15 December 1971–20 January 1972.

1972

Douze Ans d'Art Contemporain en France. Grand Palais, Paris, France, 17 May–18 September. François Mathey, curator.*

Les Tendances de la Tapisserie en France. Musée d'Arras, Arras, France, 9 July–9 October.

Modern Tapestry. Parker Street 470 Gallery, Boston, Massachusetts, 7 October–4 November.

Group Show. Modern Master Tapestries, New York, New York. May/June.*

1973

Fibre Art. Halls Exhibition Gallery, Kansas City, Missouri, 15 March–21 April.

6ème Biennale Internationale de la Tapisserie. Musée Cantonal des Beaux-Arts, Palais de Rumine, Lausanne, Switzerland, 16 June–30 October. Richard Stanislawski, president of the jury.*

Portable World. Museum of Contemporary Crafts, New York, New York, 5 October 1973–1 January 1974. Paul J. Smith, curator.

Sheila Hicks and Marc Held. Musée des Arts Décoratifs, Nantes, France, 10 November 1973–7 January 1974. Pierre Chaigneau, director/curator.*

1974

Faden—Fantasien. Museum Bellerive, Zurich, Switzerland, 15 March–28 April.

First International Exhibition of Miniature Textiles 1974. British Craft Center, London, England, 5–29 November. Ann Sutton, curator.*

Fiber Forms—Past and Present. Brookfield Craft Center, Brookfield, Connecticut, 1 July–24 August.

Three Dimensional Fibre. Govett–Brewster Art Gallery, New Plymouth, New Zealand, 6 December 1974–14 January 1975. Additional venues: Waikato Art Museum, Hamilton, New Zealand, 14 January–2 February; National Gallery of Art, Wellington, New Zealand, 8–28 February; Auckland City Art Gallery, New Zealand, 11–31 March; Robert McDougall Art Gallery, Christchurch, New Zealand, 28 April–18 May; Dunedin Public Art Gallery, New Zealand, 29 May–15 June. R. H. Ballard, curator.*

1975

Des Tapisseries Nouvelles. Musée des Arts Décoratifs, Paris, France, 20 March–19 May. François Mathey, curator.*

7ème Biennale Internationale de la Tapisserie. Musée Cantonal des Beaux-Arts, Palais de Rumine, Lausanne, Switzerland, 14 June–October. Rene Berger, president of the jury.*

1976

5 x Textiel. Galerie Collection d'Art, Amsterdam, Holland, February–March.

Fiber Works—Europe and Japan. National Museum of Modern Art, Kyoto, Japan, 29 September–14 November; National Museum of Modern Art, Tokyo, Japan, 20 January–27 February 1977. Takeo Uchiyama, curator.*

1977

Artiste/Artisane? Musée des Arts Décoratifs, Paris, France, 23 May–12 September. François Mathey, director/curator.*

8ème Biennale Internationale de la Tapisserie. Musée Cantonal des Beaux-Arts, Palais de Rumine, Lausanne, Switzerland, 4 June–25 September. Rene Berger, president of the jury.*

Fibers: National Invitational Exhibition. Western Carolina University, Cullowhee, North Carolina, 27 June–18 July; East Carolina University, Greenville, North Carolina, 31 July–4 September; Agnes Scott College, Decatur, Georgia, 18 September–30 October.

Fiberworks. Cleveland Museum of Art, Cleveland, Ohio, 5 October–20 November. Evelyn Svec Ward, June Bonner, Dona van Dijk, curators.*

Tissage. Bibliothèque Forney, Hôtel de Sens, Paris, France, 26 October 1977–31 January 1978.*

8ème Biennale Internationale de Tapisserie de Lausanne. Gulbenkian Foundation, Lisbon, Portugal, 30 November 1977–15 January 1978.*

Les Mains Regardent. Centre Georges Pompidou, Paris, France, 3 December 1977–9 January 1978. Danielle Giraudy, curator.* Bibliothèque Municipale, Bordeaux, France, 17 January–17 February 1979, Puntous, curator; Musée Cantini, Marseille, France, 18 February–18 March, Latour, curator; Lons-Le-Saunier, 20 March–1 May, Bourgeois Le Chartier, curator; Abbaye de Fontevraud, Centre Culturel de l'Ouest, 1–20 May, Beauge, curator; Musée Réattu, Arles, 20 May–20 June, Moutaschar, curator; Palais de l'Europe, Menton-Biennale, 1 July–15 September, Marze, curator; Musée d'Art Moderne, Château des Rohan, Strasbourg, 15 September–15 October, Lehni, curator; Atelier d'Art Enfantin, Tours, 15 October–15 November, Besse, curator; Musée des Beaux-Arts, Angers, 15 November–15 December, Huchard, curator; Bibliothèque de la ville de Lyon, 15 December 1979–15 January 1980, Michalet, curator; Musée d'Art et d'Archéologie, Toulon, 15 January–15 February, Beaud, curator; Musée d'Art et d'Histoire, Geneva, Switzerland, 8 March–10 April, Mason, curator; Musée Royaux d'Art et d'Histoire, Brussels, Belgium, 26 April–5 June, Destrée, curator; Museum of Milano, Italy, September–October, Crespy, curator; Gulbenkian Foundation, Lisbon, Portugal, November–December, Ferreira, curator.**

1978

L'Art Moderne dans les Musées de Province. Grand Palais, Paris, France, 3 February–24 April.*

Fil. Sheila Hicks, Daniel Graffin & John Melin. Centre des Expositions, Montreuil, France, 10 December 1978–10 February 1979. Mic Fabre, curator.*

Atelier "Fil." Maison Populaire, Montreuil, France, 25 November.

1979

Traces et Reliefs: Daniel Graffin et Sheila Hicks. Musée des Tapisseries, Aix-en-Provence, France, 22 June–15 October. M. Krotoff, director/curator.*

Textiles Taillées. F.I.A.C., Grand Palais, Paris, France, 19–29 October.

1980

Greenwood Gallery: Opening Exhibition. Greenwood Gallery, Washington, D.C., 21 March–26 April.

Textielstructuren, Koninklijke. Academy for Fine Arts, Kortrijk, Belgium, 22 March–7 April.

SeeSaw: Sheila Hicks and Daniel Graffin and Members of the Kibbutzim in the Jordan Valley and Kibbutz Israel. Museum Beit Uri V'rami, Ashdot-Yaakov Meuhad, Jordan Valley, 29 March.

1981

Triennale de l'Abstraction. École des Beaux Arts, Caen, France, May.

Old Traditions—New Directions. Textile Museum, Washington, D.C., 14 May–1 August.

The Art Fabric: Mainstream. San Francisco Museum of Modern Art, San Francisco, California, 21 May–1 July; Minnesota Museum of Art at Landmark Center, St. Paul, Minnesota, 26 August–4 October; Brooks Memorial Art Gallery, Memphis, Tennessee, 21 November 1981–3 January 1982; Portland Art Museum, Portland, Oregon, 14 March–5 May; Philbrook Art Center, Tulsa, Oklahoma, 30 May–15 August; Springfield Museum of Fine Arts, Springfield, Massachusetts, 14 November 1982–2 January 1983; Akron Art Museum, Akron, Ohio, 20 February–10 April; Colorado Springs Fine Art Center, Colorado, 15 May–3 July; Memorial Art Gallery, University of Rochester, Rochester, New York, 4 September–30 October. Mildred Constantine, Jack Lenor Larsen, curators.*

Espace et Temps. École des Beaux-Arts de Fontainebleau, France, July–August. Marion Tournon-Branly, curator.

Biennale de la Tapisserie de Montreal. Galerie UQAM, Montreal, Canada, 22 September–17 October.*

1982

Space et Structures. École des Beaux-Arts, Fontainebleau, France, 1 July–27 August. Marion Tournon-Branly, curator.

Les Américains de Paris. Casino de Deauville, Deauville, France, 4–
12 September; Paris Art Center, Paris, France, 30 November 1982–
29 January 1983. Ante Gilbota, curator.

Présences des Formes. Vieux Village, Les Angles, France, 28–31 May. Nicole
Barbier, curator.*

1983

La Nature à l'Huile. Chapelle Fromentin, La Rochelle, France, 29 June–29 July.*

Six Décennies d'Expérience 1923–1983. École des Beaux Arts, Château de
Fontainebleau, France, 1 July–26 August. Marion Tournon-Branly, curator.

Exposition Sainte-Thérèse d'Avila dans l'Art Contemporain. Musée du
Luxembourg, Paris, France, 8–31 July.

Un Centenaire en Morceaux. Pinocchio à Caen. Foyers du Théâtre Municipal,
Caen, France, 12 March.

1984

The Flexible Medium: 20th Century American Fabric. Renwick Gallery,
Smithsonian Institution, Washington, D.C., 20 January 1984–
30 March 1985.**

La Part des Femmes dans l'Art Contemporain. Galerie Municipale,
Vitry-sur-Seine, France, 7 March–1 April.

Structures/Sculptures/Textiles. Le Musée du Château St. Jean, Nogent-le-Rotrou,
France, 7 July–3 September.*

Sheila Hicks—Daniel Graffin: Recent Work. Pittsburgh Plan for Art,
Pennsylvania, 6 November–5 December.

1985

Textiles for the Eighties. Museum of Art, Rhode Island School of Design,
Providence, Rhode Island, 4 January–7 February; Norton Gallery of Art,
West Palm Beach, Florida, 14 September–20 October; Bergstrom-Mahler
Museum, Neenah, Wisconsin, 9 February–6 April 1986; Montgomery
Museum of Fine Arts, Montgomery, Alabama, 4 May–29 June; Colorado
Gallery of the Arts, Arapaho Community College, Denver, Colorado, 13
July–7 September; Museé des Arts Decoratifs of Montreal, Montreal,
Quebec, Canada, 25 September–20 November; Design Center of New York,
New York, 11 January–8 March 1987. Maria Tulokas, curator.*

Vrije Vormgeving Textile, Keramiek, Glas en Sieraden. Museum Fodor, Amsterdam,
5 April–5 May.

Tapestry Movements. Textile Art International, Minneapolis, Minnesota,
20 July–7 October.

La Tapisserie en France, 1945–1985, La Tradition Vivante. École Nationale
Supérieure des Beaux Arts, Paris, France, 13 September–31 October.
Oslo, Norway, 8 February–17 May 1986; Bergen, Norway, 2 May–1 June;
Departmental Museum of Tapestry, École Nationale des Arts Décoratifs,
Aubusson, France, 5 June–5 October. Denise Majorel, curator.*

Fibres-Art 85. Musée des Arts Décoratifs, Paris, France, 13 September–
12 November.

High Styles: American Design Since 1900. Whitney Museum of American Art,
New York, 19 September 1985–16 February 1986. Lisa Phillips and
Martin Filler, curators.*

Nouvelles Tapisseries. Paris Art Center, Paris, France, 10 December 1985–
9 February 1986.

1986

Fiber R/Evolution. Milwaukee Art Museum, Wisconsin, 7 February–30 March,
Invitational Section; University Art Museum, University of Wisconsin-
Milwaukee, Wisconsin, 7 February–30 March, Juried Section; Indianapolis
Museum of Art, Indiana, 22 April–1 June, Invitational Section; Galleries of
the Claremont Colleges and University of California Riverside, California,

24 October–15 December, Juried Section; Brockton Art Museum, Brockton,
Massachusetts, 16 January–22 March 1987, Juried Section; DeCordova
and Dana Museum and Park, Lincoln, Massachusetts, 16 January–22
March, Invitational Section; Wichita Art Museum, Kansas, 15 May–15 June,
Invitational and Juried Sections. Jane Brite, curator.*

Legends in Fiber. Octagon Center for the Arts, Ames, Iowa, 16 March–30 April.

Man Ray–Sheila Hicks. Lunds Konsthall, Lund, Sweden, 7 June–31 August.
Marianne Nanne-Brahammer, director/curator.*

Le Cheminement et l'Évolution de l'Écriture Textile depuis 40 Ans. Centre Culturel
de l'Yonne, Auxerre, France, 5 July–12 October.

Craft Today: Poetry of the Physical. American Craft Museum, New York,
26 October 1986–22 March 1987; Denver Art Museum, Denver, Colorado,
16 May–5 July; Laguna Art Museum, Laguna, California, 7 August–
4 October; Phoenix Art Museum, Phoenix, Arizona, 7 November 1987–
10 January 1988; Milwaukee Art Museum, Milwaukee, Wisconsin,
12 February–10 April; J. B. Speed Art Museum, Louisville, Kentucky,
16 May–10 July; Virginia Museum of Fine Arts, Richmond, Virginia,
9 August–2 October. Paul J. Smith, curator.*

1987

Fiberscapes. Somerhill Gallery, Durham, North Carolina, 25 January–
21 February.

Decorative and Industrial Design: 1900–1986. Metropolitan Museum of Art,
New York, New York, 3 February–5 May; Philbrook Museum of Art,
Tulsa, Oklahoma, 20 September 1987–3 January 1988; Oakland Museum,
Oakland, California, 20 February–15 May; Museum of Fine Arts, Boston,
Massachusetts, 6 July–28 August; Chicago Public Library Cultural Center,
Chicago, Illinois, 24 September–30 December; Orlando Museum of Art,
Orlando, Florida, 19 March–14 May; Virginia Museum of Fine Arts,
Richmond, Virginia, 27 June–20 August. Marcia Manhart and Tom Manhart
curators.*

Vers à Soie, Vers la Soie. Musée Guimet d'Histoire Naturelle, Lyon, France,
1 October–8 November.

1988

Aubusson 88. Musée Départemental de la Tapisserie, Aubusson, France, 26
March–19 June; Musée Municipal, Sedan, France. 27 June–10 September.**

Architectural Art: Affirming the Design Relationship. American Craft Museum,
New York, 12 May–4 September; Texas Commerce Tower Rotunda, Dallas,
Texas, 15 November–30 December; Murray Feldman Gallery, Pacific Design
Center, Los Angeles, California, 28 March–5 May 1989; Huntsville Museum
of Art, Huntsville, Alabama, 23 July–17 September; Oklahoma City Art
Museum, Oklahoma City, Oklahoma, 11 October–26 December. Robert
Jensen, curator.*

Frontiers in Fiber: The Americans. North Dakota Museum of Art, Grand Forks,
North Dakota, 15 January–15 February; Ishikawa Industrial Center,
Kanazawa, Japan, 28 March–10 April; Kyoto National Museum of Art,
Kyoto, Japan, 26 April–22 May; Taipei Fine Arts Center, Taipei, Taiwan,
13 August–2 October; Walker Hill Art Center, Seoul, Korea, 20 October–
30 November; Thailand Cultural Center, Bangkok, Thailand, 23 December
1988–23 January 1989; National Art Galleries, Kuala Lumpur, Malaysia,
7 March–26 March; Academy of Fine Arts, Guangzhou, China, 14–27 April;
Metropolitan Museum of Manila, Manila, Philippines, 18 February–
21 April 1990; Hong Kong Arts Centre, Hong Kong, 3–22 May. National
Museum, Jakarta, Indonesia, 10–31 August; National Museum of Singapore,
Singapore, 10–21 October. Mildred Constantine and Laurel J. Reuter,
curators.*

Textielkunst 1945 tot heden. Enige werken uit de collectie. Stedelijk Museum,
Amsterdam, Holland, 6 May–19 June.

Figure and Place. Artemisia Gallery, Chicago, Illinois, 1–30 July.
Splendid Forms 88. Bellas Artes Gallery, Santa Fe, New Mexico, 2 July–
 31 October.
Tapestry Movements. Textile Arts International, Minneapolis, Minnesota,
 20 July–7 October.

1989

Sacré—Profane. Château de Fontainebleau, Fontainebleau, France, 8 July–
 11 August. Marion Tournon-Branley, curator.
Revolution: Flash-Back. Paris Art Center, Paris, France, 11 July–26 August.
 Ante Gilbota, curator.*
New Acquisition of the American Craft Museum: The Dreyfus Collection.
 American Craft Museum, New York, New York, 8 August–17 September.

1990

Modern Design: 1880–1990: Twentieth-Century Art. Metropolitan Museum of Art,
 New York, New York.

1991

Piles of Pile: Unconventional Pile by Contemporary Artists. Textile Arts
 International, Minneapolis, Minnesota, 29 June–12 October.
What Modern Was. IBM Gallery of Science and Art, New York, New York,
 26 February–27 April; Los Angeles County Museum of Art, Los Angeles,
 California, 30 June–25 August; Toledo Museum of Art, Toledo, Ohio,
 29 September–13 November; Nelson-Atkins Museum of Art, Kansas City,
 Missouri, 15 December 1991–23 February 1992; Baltimore Museum of
 Art, Baltimore, Maryland, 7 June–2 August; Montreal Museum of Fine
 Arts, Montreal, Canada, 18 September–30 November; Canadian Museum
 of Civilizations, Hull, Quebec, Canada, 17 February–1 May 1993. David
 Hanks, curator.*
Art in Embassies Program. U.S. Department of State, Washington, D.C.

1992

Intimate and Intense: Small Fiber Structures. Minneapolis Institute of Arts,
 Minneapolis, Minnesota, 25 April–2 August. Lotus Stack, curator.*
Tapestry and Sculpture. Sogetsu Kaikan, Tokyo, Japan, 19–23 May. Tadashi
 Sakuyama, curator.

1993

Living Treasures. Sybaris Gallery, Royal Oak, Michigan, 9 January–6 February.
Small Works in Fiber: The Collection of Mildred Constantine. Cleveland Museum
 of Art, Cleveland, Ohio, 27 January–28 March. Anna E. Wardwell, curator.*
Un Point de Vue sur le Design. Museum of Decorative Arts, Montreal, Canada,
 17 June–19 September.
Textielcollectie. Stedelijk Museum, Amsterdam, Holland, 6 June–29 August.
 Liesbeth Crommelin, curator.
Focus on Fiber Art: Selections from the Growing 20th-Century Collection. Art
 Institute of Chicago, Chicago, Illinois, 5 October 1993–27 February 1994.
 Christa Thurmond-Meyer, curator.*

1994

La Tapisserie des Années 70. Collégiale Saint Pierre La Cour, Musée du Mans,
 Le Mans, France, 21 January–20 March.
From the Beginning: The Story of the Nebraska Art Collection. Museum of
 Nebraska, Kearney, Nebraska, 4 May–25 September.*
New Works by the Artists Commissioned for the Theatre/Cultural Center. Fuji
 City, Japan, 28 June–7 October.
Donner Forme à une Idé. Passage de Retz, Paris, France, 13 September–
 7 October.*

Artextile, de l'Art du Tissu au Tissu dans l'Art. Parc des Expositions, Paris,
 France, 30 September–3 October. Linda Korecka Hartmann, curator.

1995

Made in America: Ten Centuries of American Art. Minneapolis Institute of Arts,
 Minneapolis, Minnesota, 5 February–30 April; Saint Louis Art Museum,
 Saint Louis, Missouri, 16 June–4 September; Toledo Museum of Art,
 Ohio, 13 October 1995–7 January; Nelson-Atkins Museum of Art, Kansas
 City, Missouri, 17 March–19 May; Carnegie Museum of Art, Pittsburgh,
 Pennsylvania, 6 July–6 October.*
Fiber: Five Decades from the Permanent Collection. American Craft Museum,
 New York, New York, 16 March–25 June. April Kingsley, curator.
Spirituality Show. Walker's Point Center for the Arts, Milwaukee, Wisconsin,
 21 April–27 May. Jane Brite, curator.
16ème Biennale Internationale de Lausanne: Chassés-croisés. FAE Musée d'Art
 Contemporain and Musée des Arts Décoratifs, Lausanne, Switzerland,
 17 June–3 September. Alanna Heiss, Christian Bernard, and Toni Stooss,
 curators.

1996

Sheila Hicks, curator. *[Cinq Magiciens Textile du Japon] Five Textile Magicians of
 Japan: M. Kobayashi, N. Kobayashi, H. Shindo, C. Tanaka, J. Tomita*. Passage
 de Retz, Paris, France, 27 March–2 May. Film.
*Textile Wizards from Japan presented by Sheila Hicks: Junichi Arai, Masa
 Kobayashi, Naomi Kobayashi, Chiaki Maki, Toshio Sekiji, Hiroyuki Shindo,
 Rieko Sudo, Chiyoko Tanaka, Jun Tomita*. Israel Museum, Jerusalem,
 November 1996–February 1997. Izzika Gaon, curator. Film by
 Cristobal Zañartu.
*Sheila Hicks with Seven Friends from Japan: Naomi Kobayashi, Masa Kobayashi,
 Chiaki Maki, Toshio Sekiji, Hiroyuki Shindo, Jin Tomita, Chiyoko Tanaka*.
 Brown/Grotta Gallery, Wilton, Connecticut, 21 October 1996–7 January 1997.*

1997

Threads: Fiber Arts in the '90s. New Jersey Center for Visual Arts, Summit,
 New Jersey, 12 January–2 March.*
The Amazing World of Fiber Art. Wadsworth Atheneum Museum of Art, Hartford,
 Connecticut, 8 March–5 July. Carol Dean Krute, curator.
Maedup, l'Art du Nœud, de la Mode à l'Art Textile. Centre Culturel Coréen, Paris,
 France, 6–27 May. Kim Sang Lan, curator.
The 10th Wave Part II: New Textiles and Fiber Wall Art. Brown/Grotta Gallery,
 Wilton, Connecticut, 12 July–27 September.
Waking to the World. Fulbright Association, Meridian International Center,
 Washington, D.C., 15 September–19 October.*
Sculptural and Functional Art. Brown/Grotta Gallery, SOFA, Chicago, Illinois.
 17–19 October; New York, 9–12 April.
Craft as Art/Art as Craft: Fiber, Glass and Jewelry. Katonah Museum of Art,
 Katonah, New York, 15 June–14 September. Ursula Ilse-Neuman and
 April Kingsley, curators.*

1998

Structure and Surface: Contemporary Japanese Textiles. Organized by Museum
 of Modern Art, New York, 12 November 1998–26 January 1999; in collabo-
 ration with Saint Louis Museum of Art, 18 June–15 August 1999; Musée
 des Beaux-arts de Montréal, Canada, 16 September–14 November; Dayton
 Museum of Art, Ohio. Matilda McQuaid and Cara McCarty, curators.*
SOFA NYC: Brown/Grotta Gallery. Seventh Regiment Armory, New York, 9–12
 April.
Tradition Transformed: Contemporary Japanese Textile Art & Fiber Sculpture.
 Brown/Grotta Gallery, Wilton, Connecticut, 15 November 1998–
 31 January 1999.

1999

Missing Warp-Weft: Joseph Dumbacher, John Dumbacher, Sheila Hicks.
Contemporary Art Center of Virginia, Virginia Beach, Virginia,
26 January–16 March. Carla Hanzal, curator.*

Fils Croisés. Galerie de la Maison des Arts, Évreux, France, 27 April–20 May.

*Works by Two Dozen Artists Including: Sheila Hicks, Lenore Tawney, Gyöngy
Laky, Chiyoko Tanaka, Hiroyuki Shindo, Masakazu and Naomi Kobayashi*.
SOFA NYC, Brown/Grotta Gallery, Seventh Regiment Armory, New York,
19–23 May.

2000

Mutations/Mode 1960–2000. Musée Galleria, Paris, France, 31 March–31 July.
Valerie Guillaume, curator.*

9ème Biennale Internationale de la Dentelle—Art Contemporain. Musée du
Costume et de la Dentelle, Brussels, 26 October–14 December.
Van Steyvoort-Standaert, curator.*

A Century of Design, Part 3: 1950–1975. Metropolitan Museum of Art, New York,
New York, 28 November 2000–27 May 2001.

2001

Art for Yale: Defining Moments. Yale University Art Gallery, New Haven,
Connecticut, 19 April–19 August. Susan B. Matheson, curator.*

Cheongju International Craft Biennale 2001. Cheongju Arts Center and Its
Vicinity, Cheongju, Korea, 5–21 October. Chang Dong-Kwang, curator.*

A Shriek from an Invisible Box. Meguro Museum of Art, Tokyo, Japan,
10 October–25 November.*

Jouer la Lumière. Musée de la Mode et du Textile, Paris, France, January 2001–
January 2002. Jean-Paul Leclerq, curator.*

2002

The Red Thread: Sources of Inspiration in Contemporary Fiber Art. Milwaukee
Art Museum, Wisconsin, 13 July–27 October.

Threads of the Edge: The Daphne Farago Fiber Art Collection. Museum of Fine
Arts, Boston, Massachusetts, 18 September 2002–30 March 2003.
Lauren Whitley, curator.

*Crafting a Legacy: Contemporary American Crafts in the Philadelphia Museum of
Art*. Philadelphia Museum of Art, Philadelphia, Pennsylvania, 26 September
2002–10 August 2003. Darrel Sewell, curator.*

2003

Art Textile Contemporain. Musée Jean Lurçat et de la Tapisserie Contemporaine,
Angers, France, 21 June–16 November.*

Revolution in the Air—The Sixties and the Stedelijk. Stedelijk Museum,
Amsterdam, 1 July–31 December.

Minneapolis Art Walk. Target Hall, Minneapolis, Minnesota, November.

Recent Acquisitions. Minneapolis Institute of Art, Minnesota, 22 November 2003–
18 April 2004. Lotus Stack, curator.

2004

Palm Beach Art Fair, Brown/Grotta Gallery, Palm Beach, Florida, January.

Traditions/Translations: The Changing World of Fiber Art. Wadsworth Atheneum
Museum of Art, Hartford, Connecticut, 20 November 2004–6 March 2005.
Carol Dean Krute, curator.

Small Treasures from the MONA Collection. Museum of Nebraska Art, Kearney,
Nebraska, 24 January–14 March.

New in the Collection. Mint Museum of Fine Arts, Charlotte, North Carolina,
4 September 2004–31 July 2005. Carla Hanzal, curator.

2005

High Fiber. Renwick Gallery, Smithsonian American Art Museum, Washington,
D.C., 11 March–10 July.

High Fiber—Transforming Material. Alternate Art Spaces, Charlotte, North
Carolina, May–November.

Red Is Everywhere. Rockland Center for the Arts, West Nyack, New York,
9 October–4 December. Ned Harris, curator.

Term Limits: Textiles in Contemporary Art. Museum of Art, Rhode Island School
of Design, Providence, Rhode Island, 18 November 2005–5 February 2006.
Madelyn Shaw, curator.

2006

Beyond Weaving: International Art Textiles. Flinn Gallery at Greenwich Library,
Greenwich, Connecticut, 6 April–11 May. Tom Grotta, curator.

Hanging by a Thread. Museum of Nebraska Art, Kearney, Nebraska, 20 May–
13 August. Teliza V. Rodriquez, curator.

Material Difference: Soft Sculpture and Wall Works. 15th Anniversary of Friends
of Fiber Art International, Chicago Cultural Center, Chicago, Illinois,
4 November 2006–7 January 2007. Polly Ullrich, curator.*

One of a Kind: The Studio Craft Movement. Metropolitan Museum of Art,
New York, New York, 22 December 2006–2 December 2007.
Jane Adlin, curator.

2007

*Looking Forward/Looking Back: Recent Acquisitions in 20th- and 21st-Century
Design*. Cooper-Hewitt, National Design Museum, New York, New York,
17 August–14 October. Susan Brown and Nurit Emik, curators.

2008

The Seditious Stitch. Sun Valley Center for the Arts, Sun Valley, Idaho,
15 February–9 April 2008. Kristin Poole, curator.*

Group Exhibition. Davis & Langdale Company, New York, New York,
19 February–26 April.

Curators Select: Recent Acquisitions, 2003–2008. Cooper-Hewitt, National Design
Museum, New York, New York, 12 September 2008–15 February 2009.

Tapisserie Contemporaine et Art Textile en Europe. Académie des Beaux-Arts,
Paris, France, 1–2 December.

2009

Every Thing Design. Die Sammlungen des Museum für Gestaltung, Zurich,
Switzerland, 3 April–19 July.*

Design Basel, Christina Grajales Gallery, Basel, Switzerland, 9–13 June.

elles@centrepompidou: Women Artists in the Collections of the Centre Pompidou.
Centre Pompidou, Paris, France, 27 March 2009–23 May 23 2010.
Camille Morineau and Valerie Guillaume, curators.*

Group Exhibition. Cristina Grajales Gallery, New York, October–November.

Antoine Broccaro Gallery, Pavilion of Art & Design, London, United Kingdom,
14–18 October.

2010

Group Exhibition. Davis & Langdale Company, New York, New York,
2–27 February.

4th International Textile and Fibre Art Triennial—GLOBAL INTRIGUE II. Riga,
Latvia, 9 July–5 September.*

Selected Bibliography

Writings by Sheila Hicks

"A Visit to His Silent Garden." In Yutaka Saito. *Luis Barragán*. Mexico: Noriega Editores, 1994, 238–41.

"A Visit to His Silent Garden." In Yutaka Saito. *Luis Barragán*. Tokyo: Toto, 1996.

"Green Silk Forest: A Gift to the Institute." *The Institute Letter (Institute for Advanced Study, Princeton, New Jersey)* (summer 2008): 13.

"Le Fil et l'art." *Maison & Jardin* (June 1972): 86, 94.

"Linen Longevity." In *Mortality Immortality?: The Legacy of 20th-Century Art*. Ed. Miguel Angel Corzo. Los Angeles: Getty Conservation Institute, 1999, 141–46.

"Art-phorismes-tremplin du textile et de la mode." In *Mutation/Mode*. Paris: Paris-Musées, 2000.

"Paris le village que j'ai choisi." *Le Point*, no. 174 (19 January 1976): 84–85.

"Wizard of the Sheets." *Architectural Forms* 111, no. 5 (November 1959): 154–59.

Interviews with Sheila Hicks

Clark, Rebecca. "Overheard: A Conversation Between Sheila Hicks and Josef Koudelka." Prague: Uměleckoprůmyslové Muzeum v Praze, 1992.

De Grywin, Eve. "Sheila Hicks: The Splash of Luminous Colors." *Paris Free Voice* (March 1986): 2.

"Fiber in Architecture. The First of a Series of Four Interviews with Sheila Hicks." *American Fabrics and Fashions*, no. 104 (Summer 1975): 27–30.

Lévi-Strauss, Monique. "Oral History Interview with Sheila Hicks." Archives of American Art, Smithsonian Institution, 3 February 2004.

Morrell, Anne. "An Interview with Sheila Hicks." *World of Embroidery* 47, no. 1 (March 1996): 28–29.

Steinberg, Claudia. "Fabelhafte Fäden." *Architektur & Wohnen*, June–July 2009: 51–52.

Zañartu, Cristobal. "Oral History Interview with Sheila Hicks." Archives of American Art, Smithsonian Institution, 18 March 2004.

Books and Catalogues

Adams, Henry, Richard Armstrong, Kathryn C. Johnson, and Marilyn Muller Russell. *Made in America: Ten Centuries of American Art*. New York: Hudson Hills, 1995.

Ambasz, Emilio, and John Russell. *Sheila Hicks*. Lausanne: Galerie Alice Pauli, 1975.

Les Américains de Paris. Paris: Paris Art Center, 1983.

Art for Yale: Collecting for a New Century. New Haven: Yale University Art Gallery, c. 2007.

Auther, Elissa. *String Felt Thread: The Hierarchy of Art and Craft in American Art*. Minneapolis: University of Minnesota Press, 2010.

Beks, Maarten, and Tom Sipman. *Een harnas met een Zachte Voering en andere Kunstwerken in het Provincienuis Van Noord-Brabant*. Malmberg, Holland: Uitgeverij, 1983.

Beljon, J. J. *Twaalt omgevingen*. Amsterdam: Wetenschappelijke Uitgeverij, 1976.

———. *Waar Je Kijkt . . . Erotiek*. Amsterdam: Uitgeverij N. V., 1967.

Bertheux, Wil, and Liesbeth Crommelin. *Sheila Hicks*. Amsterdam: Stedelijk Museum, 1974.

Billeter, Erika. *Gewebte Formen: Lenore Tawney, Claire Zeisler, Sheila Hicks*. Zurich: Kunstgewerbemuseum, 1965.

Brunhammer, Yvonne. *Entrelacs par Sheila Hicks; Textiles et vanneries d'Afrique et d'Océanie de la collection Ghysels*. Paris: Passage de Retz, 2007.

Carte Blanche: Sheila Hicks. Introduction by Nicole Barbier; essays by Genevieve Breerette and Izzika Gaon. Boutonniere/Buttonhole 4, Rennes, France: Musée de Beaux Arts, 1981.

Cazals, Henri de. *L'Art moderne dans les musées de province*. Paris: Éditions des Musées Nationaux, 1978.

Chadwick, Whitney. "When Is a Grid Not a Grid: A Tale of Two Works and Multiple Histories." In *Contemporary Feminist Studies and Its Relation to Art History and Visual Studies*. Gothenburg: Acta Universitatis Gothenburgensis, University of Gothenburg Press, 2010, 12–31.

Chaigneau, Pierre René, and Marie-Anne Leferme. *Sheila Hicks*. Nantes, France: Musée des Arts Décoratifs, 1973.

Constantine, Mildred. *Sheila Hicks: Terrimoto*. Chicago: Perimeter Gallery, 1994.

Constantine, Mildred, and Jack Lenor Larsen. *The Art Fabric: Mainstream*. New York: Van Nostrand Reinhold, 1981; reprinted Tokyo: Kodansha International, 1985.

———. *Beyond Craft: The Art Fabric*. New York: Van Nostrand Reinhold, 1973; reprinted Tokyo: Kodansha International, 1985.

———. *Wall Hangings*. New York: Museum of Modern Art, 1969.

Constantine, Mildred, and Claude Lévi-Strauss. *Le Tapis Mural*. Introduction by Margo Cutter. Rabat, Morocco: Galerie Nationale Bab Rouah, 1971.

Constantine, Mildred, and Laurel Reuter. *Whole Cloth*. New York: Monacelli, 1997.

Danto, Arthur C., Joan Simon, and Nina Stritzler-Levine. *Sheila Hicks: Weaving as Metaphor*. New Haven: Yale University Press, 2006.

Deliberate Entanglements: An Exhibition of Fabric Forms. Los Angeles: UCLA Art Galleries, 1971.

Design Since 1945. Organized by Kathryn B. Hiesinger; edited by Kathryn B. Hiesinger and George H. Marcus; Max Bill et al., contributors. Philadelphia: Philadelphia Museum of Art, 1983.

Diamondstein, Barbaralee. *Handmade in America: Conversations with Fourteen Craftsmasters*. New York: Harry N. Abrams, 1983.

———. *Visionaries of the American Craft Movement*. New York: American Craft Museum, 1995.

Dimension of Fiber. Oakland: California College of Arts & Crafts, 1971.

Douze ans d'art contemporain en France. Introduction by François Mathey; essays by Claude Lévi-Strauss, François Barré, Jean Clair, Daniel Cordier, Maurice Eschapasse, Serge Lemoine, Alfred Pacquement, and Gaëtan Picon. Paris: Editions des Musées Nationaux. 1972.

Eidelberg, Martin, ed. *Design 1935–1965: What Modern Was: Selections from the Liliane and David M. Stewart Collection*. Essay by Paul Johnson; Kate Carmel et al., contributors. Montreal: Musée des Arts Décoratifs de Montréal; New York: H. N. Abrams, 1991.

Fiber Forms Past and Present. Brookfield, Connecticut: Brookfield Craft Center, 1974.

Fiber R/Evolution. Essay by Jane Brite. Milwaukee, Wisconsin: Milwaukee Art Museum and University Art Museum, University of Wisconsin-Milwaukee, 1986.

Fiber Works: Europe and Japan. Kyoto: National Museum of Modern Art, 1976.

Fibers: National Invitational Exhibition. Cullowhee, North Carolina: Western Carolina University, 1977.

Fibres Art 85. Paris: Musée des Arts Décoratifs, 1985.

FIL—Sheila Hicks, Daniel Graffin, John Melin. Introduction by Mic Fabre. Montreuil, France: Centre des Expositions, 1978.

First International Exhibition of Miniature Textiles. London: British Crafts Centre, 1974.

Formas Tejidas. Caracas, Venezuela: Museo de Bellas Artes de Caracas, 1963.

Formen in Fäden. Munich: Galerie Buchholz, 1970.

Gaon, Izika. *Free Fall: Sheila Hicks at the Israel Museum/Tseniha hofshit, Shilah Hiks be-Muze'on Yisrael*. Jerusalem: Israel Museum, 1980.

Geske, Norman A. *Art and Artists in Nebraska*. Lincoln, Nebraska: Sheldon Memorial Gallery, 1983.

Greenwood Gallery: Opening Exhibition. Washington, D.C.: Greenwood Gallery, 1980.

Guillaume, Valérie. *Mutations/Mode 1960–2000*. Paris: Paris-Musées, 2000.

Hall, Julie. *Tradition and Change: The New American Craftsman*. New York: Dutton, 1977.

Hanzal, Carla. *Seeds to the Wind*. Virginia Beach: Contemporary Art Center of Virginia, 1999.

Hida, Toyojiro. *Thread Sketches: Sheila Hicks Recent Works*. Tokyo, Japan: Gallery Isogaya. 1997.

High Styles: Twentieth-Century American Design. Introduction by Lisa Phillips; essays by David A. Hanks, Martin Filler, et al. New York: Whitney Museum of American Art in association with Summit Books, 1985.

Hlaváčková, Konstantina. *Sheila Hicks*. Prague: Uměleckoprůmyslové Muzeum v Praze, 1992.

International Contemporary Fiber Art Now. Introduction by Se Duk Lee and Margo

Shermata. Kyongju, Korea: Sonje Museum of Contemporary Art, 1992.

Jarry, Madeline. *La Tapisserie: Art du XXème siècle*. Fribourg, Switzerland: Office du Livre, 1974.

Jensen, Robert. *Architectural Art: Affirming the Design Relationship*. New York: American Craft Museum, 1988.

Kaufmann, Ruth. *The New American Tapestry*. New York: Reinhold, 1968.

Kingsley, April. *Fiber: Five Decades: Selections from the Permanent Collection*. New York: American Craft Museum, 1995.

Kirwin, Liza. *Speaking of Art: Selections from the Archives of American Art Oral History Collection, 1958–2008*. Washington, D.C.: Archives of American Art, Smithsonian Institution; Falls Village, Connecticut: Winterhouse Editions, 2008.

Kraatz, Anne. *Dentelles*. Paris: Adam Biro, 1988.

Kuenzi, Andre. *La Nouvelle Tapisserie*. Geneva, Switzerland: Bonvent, 1973.

La Tapisserie. Introduction by Pierre Pauli. Lausanne: Musée des Arts Décoratifs, 1967.

La Tapisserie en France. 1945–1985. La Tradition Vivante. Paris: Ecole Nationale Supérieure des Beaux-Arts, 1985.

Legends in Fiber. Ames, Iowa: Octagon Center for the Arts, 1986.

Lévi-Strauss, Monique. *Sheila Hicks*. Paris: Pierre Horay & Suzy Langlois, 1973; London, England: Studio Vista, 1974.

———. *Sheila Hicks Soie & Ardoise, Petites Pièces*. Trélazé, France: Anciennes écuries des Ardoisières, 2005.

Lubel, Cecil. *Textile Collections of the World: The United States and Canada*. New York: Van Nostrand Reinhold, 1983.

Man Ray–Sheila Hicks. Introduction by Marianne Nanne-Brahammer. Lund, Sweden: Lunds Konsthall, 1986.

Manhart, Marcia, and Tom Manhart, eds. *The Eloquent Object*. Carol Haralson, coordinating editor. Tulsa: Philbrook Museum of Art; Seattle: University of Washington Press, 1987.

Mathey, François. *Des Tapisseries Nouvelles*. Paris: Musée des Art Décoratifs, 1975.

McCarty, Cara, and Matilda McQuaid. *Structure and Surface: Contemporary Japanese Textiles*. New York: Museum of Modern Art, distributed by Abrams, 1998.

Miller, R. Craig. *Modern Design in the Metropolitan Museum of Art 1890–1990*. New York: Metropolitan Museum of Art; Harry N. Abrams, 1990.

Munro, Eleanor C. *Originals: American Women Artists*. New York: Simon and Schuster, 1979.

Nordness, Lee. *Objects: U.S.A.—The Johnson Collection of Contemporary Crafts*. New York: Viking, 1970.

Nouvelles tapisseries. Texts by Ante Glibota, Gaston Diehl, Keith Patrick. Paris: Paris Art Center, 1986.

Perspectief in Textiel. Introduction by Edy de Wilde; essay by Wil Bertheux. Amsterdam: Stedelijk Museum, 1969.

pinturas de s.a.w. hicks—fotografias de sergio larrain. Introduction by Jorge Sanouesa. Santiago, Chile: Museo de Bellas Artes, 1958.

Pleynet, Marcelin, and Michel Ragon. *l'Art abstrait 5, 1970–1987*. Paris: Maeght, 1988.

Plazy, Gilles. *Sheila Hicks*. Chicago: Galerie d'art international; Paris: Cimaise, 1982.

Quatre Américains de Paris: Anita de Caro, Joe Downing, Sheila Hicks, John Levee. Toulouse: Musée des Augustins, 1970.

Ramljak, Suzanne. *Crafting a Legacy: Contemporary American Crafts in the Philadelphia Museum of Art*. Philadelphia: Philadelphia Museum of Art; New Brunswick, New Jersey: Rutgers University Press, 2002.

Recent Acquisitions: A Selection 1985–86. Introduction by Philippe de Montebello. New York: Metropolitan Museum of Art, 1986.

Rubinstein, Charlotte Streifer. *American Women Sculptors: A History of Women Working in Three Dimensions*. Boston: G. K. Hall, 1990.

Schmertz, Mildred F. *Sheila Hicks: Soft World*. Tokyo: Ginza Matsuya, 1991.

See-Saw. Introduction by John Hunisak. Middlebury, Vermont: Johnson Art Gallery, Middlebury College, 1983.

Seven Américains de Paris. New York: Galerie Air France, 1969.

Sheila Hicks. Amsterdam: Stedelijk Museum, 1974.

Sheila Hicks. New York: Modern Master Tapestries, Inc., 1974.

Sheila Hicks Joined by Seven Artists from Japan. Wilton, Connecticut: Brown/Grotta Gallery, 1996.

Sheila Hicks, Reliefs; Daniel Graffin, Traces. Aix-en-Provence: Musée des Tapisseries, 1979.

Sheila Hicks. Warren Platner. Formes Tissées, Formes Architectural. Preface by Hélène Baltrusaites. Paris: Centre Culturel Américain, 1968.

Smith, Paul. *Woven Forms: Alice Adams, Sheila Hicks, Lenore Tawney, Dorain Zachai, Claire Zeisler*. New York: American Craftsmen's Council, 1963.

Smith, Paul J. *Craft Today: Poetry of the Physical*. New York: American Craft Museum; Weidenfeld & Nicholson, 1986.

Strizler-Leine, Nina, ed. *Sheila Hicks: Weaving as Metaphor*. New Haven: Yale University Press, 2006.

The 10th Wave: A Celebration of the Brown/Grotta Gallery's 10th Anniversary. Wilton, Connecticut: Brown/Grotta Gallery, 1997.

Textile Constructions. New York: Ruth Kaufmann Gallery, 1970.

3e Biennale Internationale de la Tapisserie. Lausanne: Musée de Beaux Arts, 1967.

Threads: Fiber Arts in the 90s. Summit, New Jersey: New Jersey Center for Visual Arts, 1996.

Tomiyama, Hideo. *Crafts of the World*. Kyoto: National Museum of Modern Art, 1993.

Tons and Masses: Sheila Hicks. Introduction by Marianne Nanne-Brahammer. Lund, Sweden: Lunds Konsthall, 1978.

Tradition Transformed: Contemporary Japanese Textile Art and Fiber Sculpture. Wilton, Connecticut: Brown/Grotta Gallery, 1999.

Trésors et Secrets. Introduction by Mary Jane Jacob. Chicago: Lycée Français Artist-In-Residence Project, 2000.

20th Anniversary Art Exhibition. Washington, D.C.: Fulbright Association, 1997.

Tulokas, Maria. *Textiles for the Eighties*. Providence: Museum of Art, Rhode Island School of Design, 1985.

Ullrich, Polly. *Material Difference: Soft Sculpture and Wall Works*. Western Springs, Illinois: Friends of Fiber Art, International; Seattle: University of Washington Press, 2006.

Waller, Irene. *Designing With Thread*. New York: Viking Press, 1973.

———. *Textile Sculptures*. London: Studio Vista, 1977.

———. *Thread: An Art Form*. London: Studio Vista, 1973.

Woven Forms and Sculptures by Sheila Hicks. Introduction by Monty Berman. London: Interiors International–Knoll, 1965.

Articles and Reviews

Adam, Georgina. "Fibre On Film." *Hali* 33, no. 9 (January/February/March 1987): 4.

Adrian, Dennis. "Fabric Art Comes of Age in a Show of Twists and Tangles." *Chicago Sun-Times* (November 1972).

"Aix-En-Provence; Graffin-Hicks" *L'oeil*, no. 290 (September 1979): 68.

Allen, John. "The Art of the Stitch." *New Stitches*, no. 38 (June 1996): 32–33.

Amaral, Cis. "What Is Tapestry?" *Art & Artists* (August 1977): 5–7.

"American Craft Council Awards." *American Craft* 57, no. 5 (October/November 1997): 85.

"Amerikanst I Borås." *Sköna & hem* (1993): 88.

Amos, M. A. "Textiles by Sheila Hicks." *Handweaver* 14 (1963): 28.

Annas, Teresa. "Celebrating the Fabric of Our Lives." *Virginian-Pilot* (7 March 1999): E8.

———. "The Art of Conversation." *Virginian-Pilot*, 6 February 1999: E1–E2.

Arai, Junichi. "Doncho Commission for Sheila Hicks." *Kiryu Times*, Japan (December 1995).

"Art & Fabrics." *Styling*, no. 46 (August 1991): 8.

Aubert, Marie-France. "Ce que Sheila Hicks tisse." *Connaissance des arts*, no. 224 (October 1970): 100–3.

———. *Connaissance des arts* (September 1973): 86.

Auer, James. "Artist's Craft Invigorated by Children." *The Journal, Milwaukee* (18 January 1992): 1, 5.

"Ausstellung im Haus der guten Form." *Interior*, Dusseldorf (1965).

Auther, Elissa. "Classification and Its Consequences: The Case of Fiber Art." *American Art* 16, no. 3 (autumn 2002): 2–9.

———. "Fiber Art and the Hierarchy of Art and Craft, 1960–80." *Journal of Modern Craft* 1, no. 1 (March 2008): 13–34.

Ballatore, Sandy. "The Art Fabric: Mainstream." *American Craft* 41, no. 4 (August/September 1981): 34–39.

Barry, Naomi. "Bas-Reliefs in Thread for Modern Walls." *International Herald Tribune* (24 February 1970).

Benezra, Neal. ". . . But Is It Art? The Always Tenuous Relationship of Craft to Art." *New York Times* (19 October 1986).

Billeter, Erika. "Neue Gestaltungsmöglichkeiten des Wandteppichs." *Speculum Arts* (February 1965): 32–38.

———. "Sheila Hicks: Knoll International in Düsseldorf." *Schoner Wohnen-Germany* (October 1966).

Billioud, François. "Pari tenu pour l'université du désert." *Le Figaro*, Paris (17 July 1984): 8.

Bindis, Ricardo. "Exposicion Hicks y Larrain." *La Nacion*, Santiago, Chile (6 May 1958).

Bird, Junius. "Technology and Art in Peruvian Textiles" *Motive Contents* 26, no. 2 (November 1965): 21–25.

Bovey, Louis. "Tapisserie Partout!" *Construire*, no. 28 (11 July 1973).

Breerette, Geneviève. "Sheila Hicks au centre américain." *Le Monde*, Paris (4–5 Novembre 1979).

Brehmer, Debra. "Collaboration: Sheila Hicks' Cross Cultural Trapeze." *Fiberarts* 19, no. 2 (September/October 1992): 12–13.

Brière, Annette. "Un art né du quotidien." *Sud Ouest*, Cedex, France (10 April 1987): G.

Brunskill, Joan. "Fiber Artist Balances Strong and Soft." Associated Press (30 September 1994).

Burnard, Joyce. "Sheila Hicks in Australia." *Craft Australia* 3 (spring 1982): 49–56.

C. A. "Pionnière entreprenante." *Ateliers d'art* (July–August 2004): 19.

Campbell, Mary. "She's a 'Gun-for-hire for Culture.'" *New York Times* (6 June 1987).

———. "The World's Longest Tapestry." *Arab News* (17 April 1994): 15.

Carlsen, Peter. "American Craft Museum: Design into Art." *ARTnews* 87 (May 1988): 61–62.

Carvacho, Victor. "Exposición de pintura y fotografía." *El Debate* (30 April 1958).

Cénac, Laetitia. "Neuf femmes à l'oeuvre sculpture." *Madame Figaro* (1995): 29.

Chaintrier, Jean-Paul. "L'expo est à toucher." *Sud Ouest*, Cedex, France (9 April 1987): C.

Color Design 26, no. 2 (1979): 26–29.

Conroy, Sarah Booth. "American Contemporary Crafts: Too Individualistic for Label." *New York Times* (3 October 1969): 48.

———. "High Fiber." *New York Times* (25 January 1984).

Constantino, Valerie. "Textile: An Event in Time." *Fiberarts* 22, no. 2 (September/October 1985): 48–53.

Cullinan, Helen. "Fiberworks: Cleveland Museum of Art; Exhibit." *ARTnews* 76 (December 1977): 119–20.

Dahlin-Ros, Inger. "Lekfullt mote mellan historia och framtid." *Borås Tidning*,

Borås, Sweden (21 January 1994): 12.

Dallier, Aline. "Le Soft art et les femmes." *Opus International* 52 (September 1974): 49–53.

———. "L'Exposition – Habited / Inhabited." *Opus International* 76 (1980).

———. "Review of Sheila Hicks, the American Center, Paris." *Opus International* 76 (1980): 58.

Danickova, Sylva. "Vypoved, obraz, cin." *Nedele* (5 December 1992): 1.

De Llosa, Martha. "DMC: 200 Pounds of Embroidery Thread in the World's Largest Needlepoint for Texas." *American Fabrics and Fashions*, no. 123 (1981).

Degner, Patricia. "Modern Tapestry Turns a Wall into Art." *Everyday Magazine* (23 September 1983): 7.

———. "Tapestry Settings." *Everyday Magazine* (25 September 1969).

Demornex, Jacqueline. "La Magie Blanche de Sheila Hicks." *Gap* (April 1979): 51–52.

Duncan, Rea Lubar. "Monumental Architectural Tapestries." *Woman* (March 1996): 32.

Eakin, Julie Sinclair. "Spinning Yarns." *Architecture* 95, no. 9 (September 2006): 42.

Espedahl, Martha. "Tapestry Took Year to Finish." *Evening Journal*, Wilmington, Delaware, 9 (June 1972).

"Experimental Textiles by Sheila Hicks and Seven of Her Students Exhibited in London." *Handweaver* 16 (1965): 26.

"Focus: Sheila Hicks." *American Fabrics and Fashion* 118 (winter 1979): 94.

Freudenheim, Betty. "A Lone Foreign Woman Weaves Her Magic in a Reluctant Saudi Arabia." *Chicago Tribune* (17 August 1986): Section 15, p. 11.

———. "A Woman Artist Amid 12,000 Men." *International Herald Tribune* (27 June 1986).

———. "American Craft Museum's New Acquisition." *Fiberarts* 16, no. 4 (January/February 1980): 53–54.

———. "Sheila Hicks: With a Little Help from Her Friends." *Fiberarts* 23, no. 1 (summer 1996): 59.

———. "12,000 Men and a Woman: U.S. Artist's Saudi Role." *New York Times* (23 June 1986): B8.

Fry, W. Logan. "Mildred Constantine's Small Works Collection." *Fiberarts* 20, no. 1 (summer 1993): 12.

Gaon, Izika. "Free Fall." *American Fabrics and Fashions* 120 (fall 1980): 80–81.

"Garn Är Mjukt och Rart." *Trollhättan Trolhättans Tidning*, Stockholm (19 September 1966).

"Georg Jensen Design Center in New York." *L'oeil*, Paris (1968).

Gerlach, Pat. "Fabric Creations the Fiber of Artist's Life." *Sunday Herald* (31 May 1981): Section 5, p. 5.

Gibson, Michael. "An Exhibition Raises a Question." *International Herald Tribune* (18–19 June): 7.

Glueck, Grace. "From Curvy Organic Shapes to Hip and Playful Pop." *New York Times* (1 December 2000): E36.

———. "Fun with Studio Crafts: When the Traditional Gets Quirky." *New York Times* (12 January 2007): E45(L).

Goldberger, Paul. "A Presence for Craft." *American Craft* (March 1987).

Goodman, Deborah Lerme. "Flexible Medium: A Seminar at the Smithsonian Institution." *Fiberarts* 12, no. 6 (November/December 1985): 37.

———. "The Flexible Medium: Art Fabrics from the Museum Collection." *Fiberarts* 11, no. 5 (September/October 1984): 71.

Grand, Paul-Marie. "Formes et tapisseries à Nantes. Sheila Hicks et Marc Held chez les ducs de Bretagne." *Le Monde* (8 December 1973): 22.

———. "Le temps de la decantation: Du côté des trois grandes." *Le Monde*, Paris (8 June 1977).

Greenberg, Blue. "Fiber Pioneer at Somerhill." *Chapel Hill Newspaper* (25 January 1987).

Gustafsson-Seife, Inger. "En av de riktigt stora." *Konstperspekti* (January

1999): 22–27.

Guth, Christine. "Structure and Surface." *American Craft* 59, no. 3 (June/July 1999): 54–59.

Hageneier-Lorsch, Else. "Gewebte Formen." *Landes Museums*. Oldenburg, Germany, 1965.

Hand, Gail Stewart. "Fibers. International Exhibition Opens Some New Frontiers." *Grand Forks Herald* (15 January 1988): 1C, 6C.

"Hangings Now Produced in Germany." *American Fabrics* 71 (1966): 88.

Harris, Patricia, and David Lyon. "Made by Machine: Textiles for the Eighties." *Fiberarts* 12, no. 5 (September/October 1985): 34–37.

Heezen, Henriëtte. "Abakanowickz en/and Hicks." *Stedelijk Museum Bulletin* 5/6 (2003): 36–46.

Hennum, Gerd. "Billig-billett til Norge." *Aftenposten*, Oslo (29 January 1983).

Herman, Stanley. "Sharing and Caring for Africa's Future." *Cape Times* (26 May 2000): 20.

Hicks, Sheila. "Retrospect and Reciprocity." *American Fabrics and Fashions* 120 (fall 1980): 4.

Hill, June. "One Artist's Solution to Today's Functional and Utilitarian Architecture." *Chicago Tribune* (16 August 1981).

Hoffman, Marilyn. "Humanizing Raw Space." *Christian Science Monitor* (14 July 1988): 23.

Hohenboken, Steve. *New Art Examiner* (May 1992): 36–37.

Holg, Garrett. "Sheila Hicks Perimeter." *ARTnews* 94, no. 7 (September 1995): 148.

Holtzer, Marilyn Emerson. "Sheila Hicks." *Shuttle, Spindle and Dyepot* 16, no. 1 (winter 1984): 43.

Huml, Irena. "The Lausanne Biennale." *Sztuka* (1974): 30–35.

Huxtable, Ada Louise. "A Home to Work In: Ford Foundation." *New Yorker* (30 December 1967).

———. "Ford Flies High." *New York Times* (26 November 1967): D23.

"Insecurity Blanket." *Village Voice* (27 March 1990).

"Intimate and Intense: Small Fiber Structures." *Asian American Press* (17 April 1992).

"Invitation to the Museum of Applied Art." *Prague News* (13–26 November 1992).

Ireland, Richard. "Artist-in-residence Works with Thread." *Middlebury Campus* (31 January 1980): 8–9.

Jackson, Lesley. "Hand-made Revolution." *Crafts* 154 (September/October 1998): 30–33.

Japan Interior Design, no. 214 (January 1977): cover photo and 20–24.

"Jerusalem; Sheila Hicks." *L'oeil*, Paris, no. 299 (June 1980): 74.

Johansson, Lillemor. "Borås en total textil upplevelse." *Väv Magasinet* no. 3 (1994): 32–33.

Joppollo, Giovanni. "Non finito Notes sur Sheila Hicks." *Opus International* 77 (summer 1980): 35–37, 56–57, 59–60.

JTB and CRS. "Charity Begins at Home." *Progressive Architecture* (February 1968): 95–105.

Kappes, John. "World-famous Artist to Give Freeman Lecture." *Missoulian* (2 May 1986): A4.

Kellogg, Craig, ed. "High Fiber." *Interior Design* 77, no. 8 (June 2006): 47.

Kester, Bernard. "Old Traditions—New Directions." *American Craft* 41, no. 2 (April/May 1981): 2–7.

Kiang, Jacqueline. "Interview with Sheila Hicks." *Du* (1985): 80–81.

King, Elsje. "The Fiber Experience." *Craft International* 6, no. 4 (1988): 19.

Kingsley, April. "Unraveling the Weave." *Fiberarts* 21, no. 5 (March/April 1995): 45–51.

Klein, Jody. "Fiber/Art Conditioned by Life: A Workshop with Sheila Hicks." *Fiberarts* 12, no. 5 (September/October 1985): 58–60.

Koenigsberg, Nancy. "Sheila Hicks: An Affinity for Architecture." *Fiberarts* 12, no. 5 (September/October 1985): 60–61.

Koplos, Janet. "International 'Fiber Art' Exhibitions in Europe . . ." *Art in America* (1996).

Lachmann, Claire. "'Free Fall.' Sheila Hicks im Israel-Museum, Jerusalem." *Textilkunst* (June 1980): 43–45.

Larsen, Ayelet Lindenstrauss. "Bigger Isn't Always Better." *Fiberarts* 30, no. 1 (summer 2003): 26–31.

Larsen, Jack Lenor. "The New Weaving." *Craft Horizons* (March–April 1969): 23–32.

———. "Two Views of the Fifth Tapestry Biennale." *Craft Horizons* (October 1971): 23, 62.

———. "Woven Forms." *American Fabrics* (1964): 93–95.

"Le Monde Restaurant." *Interior Design* (April 1971): 134–35.

"'Les Américains de Paris' au casino de Deauville." *Ouest-France* (8 September 1982).

Lévi-Strauss, Monique, and William C. Sturtevant. "Un Art Réinventé." *Le Courant d'Art*, no. 7 (November 1979): 1–3.

Lewis, Frank. "Fiber Show Interlaces Past and Present." *Milwaukee Sentinel* (10 February 1986).

Liebenson, Beth. "From Here and Abroad, the Artistry of Fiber." *New York Times* (10 December 1995): A1.

"Living Treasure." *Detroit News* (29 January 1993): 12D.

Loercher, Diana. "Textile Renaissance Intrigues Art World." *Christian Science Monitor* (27 October 1972): 13.

"Loose Weaves." *Time* (1 June 1970).

Malarcher, Patricia. "Facing the Mortality of Art." *Surface Design Journal of the SDA* 23, no. 3 (spring 1999): 40–41.

———. "The 'Flexible Medium' Reviewed." *American Craft* 45, no. 9 (1985): 96.

Marein, Shirley. "Sheila Hicks: Modern Master Tapestries, Inc." *Craft Horizons* 34 (1974): 55.

"MGIC Plaza: An Acropolis for Milwaukee." *Interiors* 133 (1973): 84–97.

Miller, Carol. "Constructions in Wool Exhibited at the Antonio Souza Gallery in Mexico City." *Craft Horizons* (November 1961): 40.

Miller, R. Craig, Lisa M. Messinger, and Amelia Peck. "Twentieth Century Art." *Recent Acquisitions*, no. 1985/1986 (1985–1986): 56–69.

Moats, David. "Threading Her Way." *Valley Voice* (30 January 1980): 15.

Nakagawa, Kunihiko, and Monique Lévi-Strauss. "Special Feature: Sheila Hicks-Communication Between Weaves and Materials." *Design*, no. 5 (July 1978): 11–48.

"Nantes retrouve son Musée Des Arts Décoratifs." *Connaissance des arts* 261 (1973): 148.

Nelken, Margarita. "Pinturas con lanas de Sheila Hicks." *Excelsior* (8 October 1961): 2.

"Office Design: Kellogg's." *Interior Design* 59, no. 6 (April 1988): 244.

Oka, Takashi. "Art: That Controversial Grand Palais Exposition." *Christian Science Monitor* (10 July 1972): 10.

Park, Betty. "Conversation with Mildred Constantine." *Fiberarts* (November–December 1981): 14–15.

Perl, Jed. "Private Lives." *New Republic* (24 December 2008): 27–32.

Plazy, Gilles. "Sheila Hicks." *Cimaise* 158 (May–June 1982): 17–28.

Plumb, Barbara. "And Add Character." *New York Times* (27 October 1968): SM106.

Price, Sandra. "Velvet and Pile: The Story of a Museum Collection." *Fiberarts* 18, no. 4 (January/February 1982): 30–34.

Prior, Mary. "Unravelling the Magic Carpet of Sheila Hicks." *Réalités* 244 (March 1971): 60–63.

Prunet, Pierre. "Le Chateau des ducs de Bretagne." *L'oeil*, Paris, no. 224 (March 1974): 2–11.

R. G. "Sheila Hicks: Une américaine à Aubusson." *Aubusson* (24 September 1985).

Rae, Christine. "SEE/SAW: The Fine Art of Teaching." *American Fabrics and Fashions* 119 (spring 1980): 76–79.

Rawsthorn, Alice. "Reinventing the Look (Even Smell) of a Book." *International Herald Tribune* (19 March 2007): 9.

Reif, Rita. "Antiques View; the Met's Design Gallery." *New York Times* (1 February 1987): H37.

———. "International, with a Nordic Accent." *New York Times* (12 June 1968): 42.

———. "Sheila Hicks: Unusual Weaver." *New York Times* (17 May 1974): 34.

———. "Tapestries? Well, Not in the Classic Sense." *New York Times* (8 March 1971): 43.

———. "The Met's Design Gallery." *New York Times* (1 February 1987): H37.

Reuter, Laurel. *Artpaper*, no. 8 (April 1992): 9.

"Revolutionnaire? La tapisserie d'Aubusson prepare le bicentenaire et veut s'affirmer comme un art résolument branché . . ." *La Montagne*, Centre-France (5 July 1988): 18.

Rodriguez, Ida. "En Torno A Los Tejidos De Sheila Hicks." *Arquitectura Mexico*, no. 77 (March 1962): 62.

———. "La Magia del Arte Textil." *Novedadesa* (26 March 1961): 1.

Romera, Antonio R. "Sheila Hicks–Sergio Larrain." *El Mercurio*, Santiago, Chile (6 May 1958).

Ronnen, Meir. "World of Thread." *Jerusalem Post* (18 April 1980).

Rostagny, R. "Musée Cantini, quatre américains de Paris." *Le Méridional-La France*, Marseille (26 October 1969).

Rousseau, Nita. "Lady Indigo." *Nouvel Observateur* (3–9 January 1986): 7.

Russell, John. Review of Sheila Hicks exhibition at Modern Masters Tapestries in "An Unnatural Silence Pervades Estes Paintings." *New York Times* (25 May 1974).

Schlumberger, E. "Huit personnages en quête d'objets." *Connaissance des arts* 295 (September 1976) : 56–69.

———. "Sheila Hicks: Ce que je lis dans les tissages pre-incaiques cést l'écriture de la main." *Connaissance des arts* 295 (1976): 59.

"Sculptural textil." *Dagens Nyheter*, Stockholm (16 September 1966).

"Sculptures Textiles." *L'Art vivant*, no. 1 bis (March–April 1969): 23.

Seife, Inger Gustafsson. "Lausanne Fibre Arts Biennale Textile and Contemporary Art." *Siksi* 3 (1995): 57–58.

Selz, Peter. "Knots and Bolts." *Art in America* 70, no. 2 (February 1982): 105–15.

Shattuck, Kathryn. "In the Woof and Warp of Miniatures, Interlocking Metaphors and Journeys." *New York Times* (4 September 2006): E3.

"Sheila Hicks." *Demeures & Chateaux En France*, no. 6 (autumn 1979): 32–37.

"Sheila Hicks." *Svensk Damtidning*, Stockholm (19 October 1966).

"Sheila Hicks, Doctora Honoris Causa de RISD." *Excelsior* (10 July 1984): 21, 23.

"Sheila Hicks in Prague." *Prague News* (3–9 November 1992): 10.

"Sheila Hicks Monograph—A Celebration of Weaving." *Interiors* 134 (1975): 8.

"Sheila Hicks Visited Knoll-International in Düsseldorf." *Schöner Wohnen* (October 1966): 40.

"Sheila Hicks: Weaving as Metaphor." *Fiberarts* 33, no. 3 (November/December 2006): 57.

Skudera, Gail. "Sheila Hicks." *New Art Examiner* 9, no. 8 (May 1982): 19.

"Skulptur av garnkaskader." *Borlänge Tidning, Ludvika Tidning, Mora Tidning*, Stockholm (24 October 1966).

"Skulptur av garnkaskader." *Skaraborgs Läns Annonsblad*, Stockholm (30 September 1966).

Slivka, Rose. "The New Tapestry." *Craft Horizons* (1964): 10, 48.

Smalley, Diana. "Kajima sponsors fabric sculptures." *Japan Times* (26 May 1991).

Smith, Roberta. "Conference Ponders Nature of Crafts." *New York Times* (22 January 1990): C13.

Sorkin, Jenni. "Treasures and Secrets." *Fiberarts* 27, no. 3 (November/December 2000): 19.

———. "Way Before Craft: Thinking Through the Work of Mildred Constantine." *Textile* 1, no. 1 (2003): 29–47.

Stanley, Alessandra. "Who Put the Art in Artisanry?" *Paris Metro* (4 January 1978).

Talley, Charles S. *Väv Magasinet*, no. 3 (1986): 9–10.

Tamulevich, Susan. "Riding the Wave: Brown/Grotta Celebrates Its Tenth Year."

Fiberarts 24, no. 4 (January/February 1998): 38–45.

Taylor, Robert. "Tapestries: Picasso to Trova." *Boston Globe* (12 October 1972).

Temin, Christine. "Craft Objects at MFA Are Truly Eloquent." *Boston Sunday Globe* (10 July 1988): 82.

"Textile Artworks Weave 'Soft Logic.'" *Korea Times* (3 November 1991): 7.

"The Granite, Glass, and Garden Community." *Fortune* (April 1968).

"The Silk Cobblestones of My Memory." *U.S. Japan Business News* (19 June 1989): 45.

"Thread of Conversation." *Industrial Design* 21 (1974): 10, 12.

"Triptych Tapestry." *Interiors* 133 (1973): 86.

Tsalmona, Tigael. "Visits of a Lady." *Maariv*, Tel Aviv (4 April 1980).

Tucná, Dagmar. "Textilie. Sheila Hicks-Zanartu." *Domov* (1971): 22–25.

Tuteur, Marianne. "Fiber Art: Today's Tapestry." *Town & Country* 139, no. 5058 (March 1985): 197–202.

"U.S. Designer for India Looms." *American Fabrics* (1966).

Vogel, Carol. "Celebrating American Design." *New York Times* (15 September 1985): SM 44.

Von Behr, Karin. "Textilreliefs von Sheila Hicks." *Architektur & Wohnen* 2 (June 1981): 170–74.

"Weavings of Sheila Hicks." *American Fabrics* 53 (1961): 52.

Weigle, Edith. "A Wooly New Art Form." *Chicago Tribune Magazine* (10 November 1963): 52.

Weiss, Suzanne. "Prestige Art Panel Explores Social Issues." *Pioneer Press Newspaper* (25 February 1982): D5.

Wells, Jonathan. "Everyday Textiles Are Precious. Everyday Textiles Communicate." *American Fabrics and Fashion*, no. 114 (fall/winter 1978): 92–95.

Werther, Betty. "American Designs New Life for Age-Old Moroccan Craft." *International Herald Tribune* (10 March 1971).

———. "Radical Rugs in Rabat." *Design* 270 (June 1971): 48–53.

———. "Sheila Hicks at Rabat." *Craft Horizons* 31, no. 3 (June 1971): 30–33.

West, Virginia. "The Tapestry Biennial at Lausanne." *Craft Horizons* (October 1975).

"Wilson Bentley, Sheila Hicks at Davis & Langdale In NYC." *Antiques and the Arts Weekly* (10 October 2008): 75.

Wortmann Weltge, Sigrid. "Sheila Hicks. Weaving as Metaphor." *American Craft* (February–March 2007): 82–85.

"Woven Forms by Sheila Hicks." *Interiors* 122 (June 1963): 14.

Wroblewska, Danuta. "Tkanina w Lozannie." *Projekt* (July 1975): 10–16.

Yarrow, Andrew L. "Companies Discovering Many Values in Artworks." *New York Times* (2 April 1989): NJ1.

Zimmer, William. "New Dimensions in Working with Fiber." *New York Times* (23 February 1997): NJ14.

Zinsser, William. "A Grant to Beauty." *Life Magazine* (29 March 1968): 90–98.

Znamierowski, Nell. "Sheila Hicks. *Minimes*: Small Woven Works." *Fiberarts* 35, no. 5 (April/May 2009): 58.

Films and Videos

Brice, Jean. *Treasures and Secrets*. L'école de l'Alliance Française, Chicago.

Conversation between Claire Zeisler and Sheila Hicks. Minneapolis Institute of Fine Arts.

Conversation between Sheila Hicks and her father, Ray Hicks. Chicago, School of the Art Institute of Chicago.

Interview with Sheila Hicks and Dr. William Hicks. Art Education for Children. Milwaukee Center for the Arts. Wisconsin, 1992.

Krause, Tower, and Cristobal Zañartu. *Stepping Stones*. Paris, 1991.

Masters of Linen—Sheila Hicks. Produced by the International Linen Association, Paris and New York, 2001.

Monsigny, Bernard. *Hicks, Tissages Métissés*. Produced by the Ministry of Culture, France; distribution by Les Films d'Ici, 1987.

Schlubach, Itaka. *Traditions of Tomorrow: Weaving Africa*. Produced by Kip Films, Cape Town, South Africa, 2000–2001.

Torey, Claude. *Naked Blouses, Empty Bodies*. Produced by Tom Woods and Pierre de Ronan Chabot; distribution by Transatlantic Video, 1980.

Zañartu, Cristobal. *Five Textile Magicians of Japan: M. Kobayashi, N. Kobayashi, H. Shindo, C. Tanaka, J. Tomita*. Paris, 1996.

———. *May I Have This Dance*. Target Headquarters, Minneapolis, Minnesota, 2003.

———. *Opening the Archives*. Paris, 1994.

———. *Sheila Hicks: Four Seasons of Fuji* (Fuji City, Japan). Produced by Rebecca Clark, Tokyo and Paris, 1993.

———. *Sheila Hicks: Soft World*. Tokyo, Japan, 1990.

———. *Sheila Hicks, The Making of a Doncho*. Kiryu, Gunma, Japan, 1995.

———. *Soie et Ardoise*. Trélazé, France, 2005.

———. *Textile Wizards from Japan Presented by Sheila Hicks: Junichi Arai, Masa Kobayashi, Naomi Kobayashi, Chiaki Maki, Toshio Sekiji, Hiroyuki Shindo, Rieko Sudo, Chiyoko Tanaka, Jun Tomita*. Jerusalem, 1996–97.

Zañartu, Cristobal, and Rebecca Clark. *Basho to Spun Steel*. Paris, 1998.

———. *The Textile Magicians*. Paris, 1998.

Index

Page references in *italics* indicate illustrations.

Lenders to the Exhibition

Caroline Baumann
Cleveland Museum of Art, Ohio
Cooper-Hewitt, National Design Museum,
 New York
Caroline and Roger Ford
Sheila Hicks
Bob and Lynn Johnston
Suzy Langlois
Itaka Martignoni
Metropolitan Museum of Art, New York
Montreal Museum of Fine Arts, Canada
Musée Jean Lurçat et Musée de la Tapisserie
 Contemporaine, Angers, France
Museum of Art, Rhode Island School of Design,
 Providence
Museum of Fine Arts, Boston
Museum of Modern Art, New York
Robert S. Peabody Museum of Archaeology,
 Phillips Academy, Andover, MA
Philadelphia Museum of Art, Pennsylvania
Jenelle Porter and Conny Purtill
Private collections
Private collection, Courtesy of Cristina Grajales
 Gallery
Renwick Gallery of The Smithsonian American
 Art Museum, Washington, D.C.
James Stacey and Elizabeth Murphy
Stedelijk Museum, Amsterdam
Ali Stritzler-Levine
Target Corporation
Cristobal Zañartu and Rebecca Clark

Photography Credits

Unless listed below, photographs were taken or
supplied by lending institutions, organization, or
individual credited in the picture caption. Individual
photographers' names are provided when available.
Every effort has been made to obtain permission
from image rights holders. Any information on
unlocated rights holders forwarded to the museum
will be acted upon for future editions.

Courtesy of Magdalena Abakanowicz Studio, fig. 45
© Air France, page 75 (lower right)
© 2010 The Josef and Anni Albers Foundation /
 Artists Rights Society (ARS), New York, figs. 3,
 4, 5, 34, 66
David Arky, pages 36–37
© 2010 Artists Rights Society (ARS), New York /
 SIAE, Rome, fig. 39
Baba, fig. 93
Luis Barragán, fig. 69
Melvin Bedrick, fig. 15
Julie Bernson, fig. 10
Ferdinand Bosch, figs. 36, 71
Ernest Boyer, figs. 8, 59, 63, 65
Beatriz Cifuentes, page 220
John Cohen, figs. 2, 64
© Éditions Jos Le Doaré, fig. 30
Martine Franck, fig. 81
Marlene Gerber, fig. 43
Matias Goeritz, fig. 37
Erik Gould, page 73
© Ann Hamilton, fig. 58
© The Estate of Eva Hesse. Hauser & Wirth, fig. 47
Sheila Hicks, frontispiece, pages 38 (top), 39,
 figs. 14, 16, 17, 21, 26, 32, 33, 38, 49, 78
Courtesy of Sheila Hicks archives, pages 62, 81,
 figs. 40, 53, 61, 72, 73, 76, 77
David Housez, figs. 54, 80, 82
© Israel Museum, Jerusalem, Israel, fig. 27
Josef Koudelka, figs. 83, 84
Sergio Larrain, fig. 68
© Jos Le Doaré, fig. 30
© Thom Lepley 2009, fig. 88
Catherine Lévi-Strauss, fig. 89
Matthieu Lévi-Strauss, pages 74 (lower right),
 75 (lower left)
© Lund Konsthall, Sweden, fig. 50
Masa Kobayashi, page 125
Leslie Maloney, fig. 1
© 2010 Agnes Martin / Artists Rights Society (ARS),
 New York, fig. 52
Enrico Martignoni, figs. 28, 91
Trus Melin, Lund, Sweden, fig. 23
Image copyright © The Metropolitan Museum of Art /
 Art Resource, NY, pages 65, 210 (left)

Jean Michelon, Paris, pages 58, 59, fig. 51
© Musées d'Angers, cliché Pierre David, page 121
Museum für Gestaltung Zürich, Kunstgeweb
 Sammlung. Marlen Perez © ZHdK, fig. 41
Digital Image © The Museum of Modern Art/
 Licensed by SCALA / Art Resource, NY,
 pages 13, 23, fig. 44
Image Courtesy of the Board of Trustees, National
 Gallery of Art, Washington, figs. 46, 55
© Robert S. Peabody Museum of Archaeology,
 Phillips Academy, Andover, Massachusetts,
 photographs by Frank E. Graham, figs. 6, 7
Pierre Plattier, pages 93, 149, fig. 22
Reinaldo Armas Ponce, fig. 35
Marc Riboud, figs. 67, 75, 79, 85
© Stedelijk Museum, fig. 11
Faith Stern, fig. 70
Ezra Stoller © Esto, pages 38 (bottom), 66–67, 82,
 83, 84, 85
© Bastiaan van den Berg, all endpapers and
 chapter dividers, pages 9, 10, 11, 14, 15, 17,
 18, 19, 20, 21, 22, 24, 25, 27, 29, 30, 31, 32, 33,
 35, 48, 49, 52, 57, 69, 70, 71, 74–75, 77, 103,
 111, 126, 127, 129, 130, 131, 134, 135, 136, 137,
 144, 145, 147, 148, 185, 193, 194, 195, 196, 197,
 199, 200, 201, 202, 203, 204, 205, 206, 207, 208,
 209, 210 (right), 211, 213, 214, 215, 216, 217,
 218, 219, 223, figs. 12, 13, 18 (left, upper right,
 and lower center), 19, 20, 24, 25, 29, 53, 57,
 60, 62, 86
William Vandever, page 86
Han Vu, Bard Graduate Center: Decorative Arts,
 Design History, Material Culture, fig. 18
 (lower left)
Graydon Wood, pages 60–61, 63
Cristobal Zañartu, cover, pages 138–39, 141, 142,
 143, 150–51, 221, figs. 31, 42, 48, 87, 89, 90

256

Sheila Hicks: 50 Years

Organized by the Addison Gallery of American Art, Phillips Academy, Andover, Massachusetts

Generous support for this exhibition and publication was provided by grants from J. Mark Rudkin Charitable Foundation, The Coby Foundation, Ltd., Saundra B. Lane, The Poss Family Foundation, Nancy B. Tieken, Able Trust, Target Corporation, The Friends of Fiber Arts International, Dirk and Lee Born, and several anonymous donors.

The presentation of this exhibition at Institute of Contemporary Art, University of Pennsylvania in Philadelphia, is primarily sponsored by The Pew Center for Arts and Heritage through the Philadelphia Exhibitions Initiative.

Exhibition Dates

Addison Gallery of American Art, Phillips Academy
Andover, MA
November 5, 2010–February 27, 2011

Institute of Contemporary Art, University of Pennsylvania
Philadelphia, PA
March 25–August 7, 2011

Mint Museum of Craft + Design
Charlotte, NC
October 1, 2011–January 29, 2012

Editor: Joseph N. Newland, Q.E.D.
Copyeditor: Jeffrey Schier
Indexer: Kathleen Preciado
Designer: Purtill Family Business
Printer: The Joe Avery Group at Shapco Printing, Inc., Minneapolis
Frontispiece: Sheila Hicks, *Self-Portrait, Ibiza*, c. 1962–63. Private collection

THE COBY FOUNDATION, LTD.

friends of fiber Art International

TARGET.

Published by Addison Gallery of American Art, Phillips Academy in association with Yale University Press

© 2010 Addison Gallery of American Art, Phillips Academy, Andover, MA
All artworks by Sheila Hicks © 2010 Sheila Hicks

All rights reserved.
This book may not be reproduced, in whole or in part, including illustrations, in any form (beyond that copying permitted by Sections 107 and 108 of the U.S. Copyright Law and except by reviewers for the public press), without written permission from the publishers.

Addison Gallery of American Art
Phillips Academy
180 Main Street
Andover, Massachusetts 01810
www.addisongallery.org

Yale University Press
302 Temple Street
P.O. Box 209040
New Haven, Connecticut 06520–9040
www.yalebooks.com

Library of Congress Cataloging-in-Publication Data

Simon, Joan, 1949-
 Sheila Hicks : 50 years / Joan Simon and Susan C. Faxon ; with an essay by Whitney Chadwick.
 p. cm.
 Catalog of an exhibition held at the Addison Gallery of American Art, Phillips Academy, Andover, Mass., Nov. 5, 2010-Feb. 27, 2011, the Institute of Contemporary Art, University of Pennsylvania, Philadelphia, Pa., Mar. 25-Aug. 7, 2011, and the Mint Museum of Craft + Design, Charlotte, N.C., Oct. 1, 2011-Jan. 29, 2012.
 Includes bibliographical references and index.
 ISBN 978-0-300-12164-3
 1. Hicks, Sheila, 1934---Themes, motives--Exhibitions. I. Hicks, Sheila, 1934- II. Faxon, Susan C. III. Chadwick, Whitney. IV. Addison Gallery of American Art. V. University of Pennsylvania. Institute of Contemporary Art. VI. Mint Museum of Craft + Design. VII. Title.
 NK3012.A3H52 2010
 746.092--dc22

 2010020483

A catalogue record for this book is available from the British Library.

This paper meets the requirements of ANSI/NISO Z 39.48-1992 (Permanence of Paper).

10 9 8 7 6 5 4 3 2 1